Musical Resilience

D1596278

Shalini R. Ayyagari

MUSICAL RESILIENCE

Performing Patronage

in the Indian Thar Desert

Wesleyan University Press Middletown, Connecticut

Wesleyan University Press
Middletown CT 06459
www.wesleyan.edu/wespress

The author gratefully acknowledges the support of the
AMS 75 PAYS Fund of the American Musicological Society, supported
in part by the National Endowment for the Humanities and the
Andrew W. Mellon Foundation.

This book's epigraph is from Linda Hess, *Bodies of Song: Kabir Oral
Traditions and Performative Worlds in North India* (New York: Oxford
University Press, 2015).

Library of Congress Cataloging-in-Publication Data
NAMES: Ayyagari, Shalini R., 1978– author.
TITLE: Musical resilience : performing patronage in the Indian Thar desert /
Shalini R. Ayyagari.
DESCRIPTION: [First.] | Middletown, Connecticut: Wesleyan University
Press, 2022. | Series: Music/culture | Includes bibliographical references
and index. | Summary: "Ethnomusicologist Ayyagari shows how
professional low-caste musicians from the Thar Desert borderland of
Rajasthan, India have skillfully reinvented their cultural and economic
value in postcolonial India"— Provided by publisher.
IDENTIFIERS: LCCN 2022020532 (print) | LCCN 2022020533 (ebook) |
ISBN 9780819500090 (cloth) | ISBN 9780819500106 (trade paperback) |
ISBN 9780819500113 (ebook)
SUBJECTS: LCSH: Music—Social aspects—India—Rajasthan. | Musicians—
India—Rajasthan—Social conditions. | Music—India—Rajasthan—
History and criticism. | Resilience (Personality trait)—India—Rajasthan.
CLASSIFICATION: LCC ML3917.I4 A89 2022 (print) | LCC ML3917.I4 (ebook) |
DDC 780.954/4—dc23/eng/20220805
LC record available at https://lccn.loc.gov/2022020532
LC ebook record available at https://lccn.loc.gov/2022020533

5 4 3 2 1

pothī paḍh paḍh jag muā, panḍit bhayā na koī
do ākhar prem kā, paḍhe so pandit hoī.

Reading books upon books, everyone died
and none became wise.
Four letters: love.
Read those and be wise.

Kabir
transliterated and translated
by Linda Hess

CONTENTS

PREFACE

I first saw the mural pictured on this book's cover in January 2019 when I was living in Jaipur City in Rajasthan, India. I was on my way home from a meeting and recording session with one of my key research interlocutors, Dara Khan. He and his group of accompanying musicians had arrived in Jaipur from his village Hamira for a commissioned performance. The drive should have been short at any other time of day, but at the height of rush-hour, my taxi crept through the city's thick and diverse traffic—cars, buses, motorcycles, bicycles, camels, and pedestrians filled the dusty street.

Halfway home, my taxi screeched to a halt at a stoplight on New Sanganeer Marg, next to the New Aatish Market metro station. As I looked out my car window from the taxi's back seat, I saw a larger-than-life mural painted on the wall outside the entrance to the station (figure FM.1). Painted by Shunnal Ligade, a Bangalore-based freelance artist, the mural features a musician playing the *kamaicha* instrument (bowed lute). The musician is obviously from the Manganiyar community because they are the only community to play such an instrument. The late afternoon winter sun cast a warm glow just above the musician, placing him in a shadow. He has a white handlebar mustache and wears a blue turban and matching blue coat. A caricature of a *kamaicha* rests in the musician's lap on top of his white dhoti, with the instrument's body unrealistically misshapen and its strings and bridge haphazardly painted on like an afterthought. A thin black line represents the bow being pulled across the instrument. To the musician's left is a burnt orange silhouette of a sitting camel, but the musician does not see the camel.

As I looked at the mural, my gaze panned out to see the surrounding context. The musician seems to hover above a dusty brick sidewalk, unbothered by the long ditch filled with rocks, dust, and trash that runs in front of him and frames

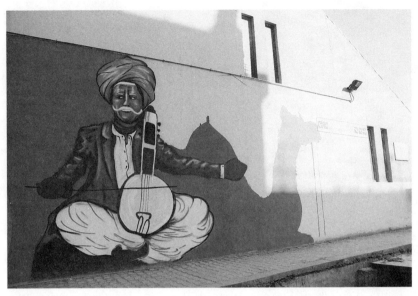

FIGURE FM.1 Mural of Manganiyar musician playing the kamaicha at New Aatish Metro
Station. Painted by Shunnal Ligade in 2016. Jaipur, 2018. Photo by author.

the bottom of the mural. The silhouette of the camel to the musician's left points
towards a slanted peach colored wall that stands out against the winter blue sky
behind it. As I made the visual connection of the blue of the musician's turban
and coat to the sky, it was as if the cement wall between them disappeared and
I was transported with the musician to the Thar Desert.

I heard a truck horn from behind my taxi in the traffic and I was brought back
the busy intersection in Jaipur. My gaze was then drawn away from the kamaicha
and camel to the musician's more realistically painted eyes and furrowed brow.
The painted musician looks worriedly to his upper-right at something in the
distance. It is as if he is flatly placed in the Thar Desert atop the large cement wall
but is actively looking toward something beyond his painted world—something
new and uncertain. I rolled down the taxi door window and peered up, following
the painted musician's line of vision along the geometric and sharp lines of the
building's cracked cement wall to the tall cement metro station and the raised
train platform above. A metro train whizzed by on the raised tracks. I was not
sure if I imagined the musician slightly cringing and bracing himself in response
to the speed and noise of the metro train. When the traffic light turned green
and my taxi started back on the route home, I convinced myself that the slight

movement I thought I saw of the flatly painted Manganiyar musician was just the vibration of the building in response to the metro train.

Ligade's interpretation of a Manganiyar musician painted on the side of a modern urban metro station in front of a bustling road full of international brands of cars and trucks honking their horns and spewing exhaust continued to haunt me long after the car ride. Throughout the writing of this book, I have been pulled back to Ligade's image as I thought about Manganiyar musicians torn between tradition and modernity, an imagined past and an envisioned future, and the nuances and contradictions of Manganiyar traditional patronage and postpatronal relations.

NOTE ON TRANSLATION
AND TRANSLITERATION

Throughout the book I use popular romanized spellings of personal names, proper names, geographic locations, and words that are commonly used in English. Using romanized script, I have transliterated words that are taken from standard Hindi language and Marwari dialects. I chose not to use diacritics for ease of reading, and instead I used adjusted transliterations for ease of pronunciation. For example, I use "aa" instead of "ā" to designate a long vowel sound. This excludes personal names, proper names, geographic locations, and terms that are used in English and have a standardized spelling. These common terms that have entered the English lexicon appear without diacritics, adjusted transliterations, or italics but are defined at first use to make clear how I am using them. Non-English words are italicized at first use in each chapter and definitions are not repeated in every chapter. The English plural suffix -s has been used instead of Hindi and Marwari plural forms for ease of readability in English.

ACKNOWLEDGMENTS

Kabir, as one of India's most influential poets of vernacular devotion and mysticism, has inspired musical traditions throughout the Thar Desert borderland. Manganiyar songs embody Kabir's enticement to listen, to be connected to each other and the world through the ephemerality of sound and spirit. Embedded in so many of Kabir's poems is a signature line that both identifies the poem as being by Kabir and embraces the important act of listening: *Kahe Kabir suno* (Kabir says, listen).

Throughout my years of listening to Manganiyar music, I found myself drawn to those songs in which Manganiyar musicians set Kabir's poetry to music. I listened for the signature line and the pithy, spiritual message that followed. The irony of Kabir's inspiration is that it encourages the listener to engage with life not through the written word but through embodiment and experience. Yet, throughout the research for and writing of this book, I sought inspiration from Kabir, often saying to myself, "Kahe Kabir, research!" or "Kahe Kabir, write!" In this book, I barely touch the surface of Manganiyar life and musical practice, but I hope that glimpses of Manganiyar stories and my embodied research experiences shine through its pages.

My acknowledgments span decades, continents, institutions, and desert borderlands. Needless to say, I have accumulated many debts of gratitude while on this journey. Here I barely touch the surface, but I attempt to thank and acknowledge some of the most transformative connections I have made while researching and writing this book.

My biggest debts and appreciation go to the Manganiyar community. Many musicians and their families gave their time, patience, and music to help me better understand their worlds. Khete Khan Hamira was the first Manganiyar musician I met. He welcomed me to Hamira Village with open arms in 2002.

He went on to become a friend and noteworthy interlocutor for my research. He opened the door to his entire extended family again and again, year after year. I need to mention many musicians just in Hamira Village. First and foremost, Padma Shri Sakar Khan (the Hamira Village Manganiyar patriarch and a renowned musician) provided hours of conversation, interviews, and music. It is from him that I learned the most about Manganiyar patronage, postpatronage, and musical practice. Sakar Khan's four sons all sensational musicians in their own right, taught me a great deal, and need to be mentioned by name: Ghewar Khan, Firoz Khan, Dara Khan, and Sattar Khan. Pempe Khan (Sakar Khan's brother) was patient with my questions and presence in his home. His sons, Khete Khan (mentioned above) and Chuge Khan, both taught me a great deal and accompanied me on numerous field trips. I must also acknowledge the Manganiyar women in Hamira Village with whom I spent many nights learning about their worlds and telling them about mine. I especially treasure the conversations I had with the wives of Sakar Khan, Pempe Khan, Ghewar Khan, Firoz Khan, and Khete Khan, as well as with Ghewar Khan's daughter, Gudiya.

Many Manganiyar musicians beyond those in Hamira Village welcomed me into their homes and helped me with my research. I thank the Manganiyar women performers with whom I spent time: Rukma Bai, Ankla, Daria, and Sonu, all of whom are amazing musicians in their own right and courageous public figures. I also thank Gazi Barna for inviting me to his homes in Jaisalmer City and Barna Village and to performances in India and abroad. Likewise, Mame Khan took time out of his busy touring schedule to talk with me about his music and postpatronage experiences. I value the information Mame Khan provided and the photographs he gave me permission to use for this book. I have always drawn inspiration from Hakam Khan's virtuosic kamaicha performances. His music, captured in many lengthy and soulful recording sessions, motivates this work. I also thank Padma Shri Anwar Khan Baiya, Padma Shri Lakha Khan, Imam Khan Alam Khana, Hakim Khan Hardwa, Sarwar Khan Alam Khana, and Rais Khan for insightful conversations and recording sessions. I hope that Manganiyar musicians will treat any misunderstandings or inaccuracies in this book with lenience and forgiveness. Any errors are completely and only mine.

My PhD advisor Bonnie C. Wade was there for me from the beginning of this project, steadfast and patient as I found my way in my research. She was and continues to be my strongest advocate, and I cannot thank her enough for her kindness, support, and advice over the years. Her dedication to the field of ethnomusicology and attunement to music scholarship continue to inspire me.

During my time at the University of California, Berkeley, many other people were of great help. Jocelyne Guilbault took the time to mentor me and taught me how to write. Alan Pred and Alan Dundes, whose graduate seminars I took, inspired me to think about my research as not just writing but as engagement with people and their lives. I also learned a great deal from Lawrence Cohen, Prachi Deshpande, and Usha Jain while at Berkeley.

I have been blessed to have so many scholars whom I consider close friends and advocates. My colleagues from graduate school who kept me going with love and support include Marié Abe; Pamela Schnupf; Pattie Hsu; Ezra Wood; Matt Rahaim; Carla Brunet; Bill Quillen; Christina Sunardi; Jeff Packman; Kendra Salois; Donna Kwon; and, last but not least, Eliot Bates and Rebecca Boden-heimer, co-members of the Fast-Track Dissertators Club. A number of scholars of South Asia have left indelible intellectual marks on this book. Their inspirational scholarship and countless conversations have helped me shape my work. They include Carol Babiracki, Peter Manuel, Daniel Neuman, Suzanne and Lloyd Rudolph, Kathleen O'Reilly, Anna Schultz, Zoe Sherinian, Sarah Morelli, Stefan Fiol, Jayson Beaster-Jones, Anna Morcom, Gregory Booth, Bradley Shope, Gabi Kruks-Wisner, Anaar Desai-Stephens, and Max Katz. I also thank close friends I have made along the way through my institutional affiliations: C. Annie Claus for her constant motivation, Andrea Emberly for her support, and Caroline Faria for her camaraderie.

I worked on parts of this book while at four universities. First, as a graduate student at the University of California, Berkeley, I traveled to India for exploratory research with a Graduate Opportunity Fellowship. With the help of a Foreign Languages and Area Studies grant, I was able to improve my Hindi language skills through the American Institute for Indian Studies' Hindi language program in Jaipur. My doctoral work was funded by a Fulbright IIE Fellowship and UC Berkeley's Department of Music. I had the wonderful opportunity of finishing the writing my dissertation and teaching two courses while holding a Marilyn Yarbrough Dissertation Writing and Teaching Fellowship at Kenyon College. It was there that I was given the time and space to finish the dissertation and start thinking about this book.

While at Dartmouth College on a Mellon Postdoctoral Fellowship in the Humanities, I began to develop the project that has resulted in this book. Thanks go to Theodore Levin, my faculty mentor at Dartmouth, and Adrian Randolph, the director of Dartmouth's Leslie Center for the Humanities. I must also thank Christian Wolff, professor of Music, emeritus, for the space to live and write

and for the farm hikes. I worked on parts of this book while on the faculty of the Department of Performing Arts at American University. Thanks go to my former colleagues in the department for their support: Fernando Benadon, Daniel Abraham, and Nancy Snider. Thank you to Lindsey Green-Simms, for co-teaching an amazing course that led me to think about my work differently. I am also indebted to a number of amazing undergraduate students with whom I had the opportunity to work and think. These include Allie Martin, Ellen Rice, and Jackson Anthony. At American University, research for this book was funded by a Faculty Research Support Grant and an International Travel Award that enabled me to travel to India for follow-up research.

I have many people to thank during my time so far at the University of Pittsburgh. To my colleagues in the Department of Music, especially Adriana Helbig, Mathew Rosenblum, Michael Heller, Dan Wong, and Olivia Bloechl, thank you for your continued support and friendship. Outside of the department, the small community of South Asianists on campus, including Mrinalini Rajagopalan, Neepa Majumdar, and Joseph Alter, have been a wonderful group of colleagues. I have benefited from conversations and teaching undergraduate and graduate students at Pitt. I wish to thank my former student Stephanie Jimenez for designing the map for this book, and graduate student YuHao Chen for his help in preparing my manuscript for submission. Pitt has been generous in its research funding and has supported this book every step of the way through an Initiative to Promote Scholarly Activities in the Humanities Grant, a Global Studies Center Faculty Research Grant, a Central Research Development Fund Small Grant, a Hewlett International Grant, a Type I Third Term Research Stipend, a Summer Term Research Stipend for Untenured Faculty, a Dr. Mohinder and Saroj Bahl Book Grant, and a book subvention from the Richard D. and Mary Jane Edwards Endowed Publication Fund.

There are many people to thank in India. During my fieldwork, the Archives and Research Centre for Ethnomusicology (ARCE) was my home away from home. Shubha Chaudhuri is an important mentor who provided fieldwork advice, contacts, ideas, and support. But more importantly, she is a friend who helped me get through a number of difficult research stints. Also at ARCE, Umashankar Manthravadi was a delightful colleague and gave me invaluable microphone and recording advice. In Jodhpur, I had the opportunity to meet Komal Kothari before he died in 2004. Even in our one short meeting, he inspired me to pursue my research. Kuldeep Kothari (his son, and the current director of Rupayan Sansthan), opened up the world of Manganiyar music to me: in 2002, he became the

first person to connect me with Manganiyar musicians. Throughout the many years of my research, he has served as a contact, organizer, and host for several research projects. I thank the American Institute of Indian Studies and the generous Senior Research Fellowship I received to spend an extended period of time in India in 2018. In Jaisalmer, I would not have felt at home without Arun Ballani's accommodations at Hotel Swastika. While I was initially invited to stay there as a tourist, he treated me like a family member during the many months I lived there. I greatly appreciated the friendship, conversations, and humor shared over tea and biscuits almost every afternoon at Hotel Swastika with the "Fagdard Fouj." I survived my dissertation fieldwork with the help of two fellow Fulbright scholars in particular, Anjali Deshmukh and Siddarth Puri. I also benefited from conversations with Tanuja Kothiyal in Delhi and Faith Singh in Jaipur.

Presenting my research to engaged audiences over the years in the United States and India has encouraged me to think differently about various aspects of this book. Presenting my work at Berkeley's Center for South Asian Studies and the Tourism Studies Working Group initially helped me shape my ideas about postpatronage. Institutions where I have given research talks include the Leslie Center for the Humanities at Dartmouth College, Asia Society in New York, Dhar Center for Indian Studies at Indiana University, University of California, Los Angeles (through its Mohinder Brar Lecture Series at the Herb Alpert School of Music), Boston University, University of Maryland at College Park, Swarthmore College, Gandhi Memorial Center in Bethesda, and Eastman School of Music. The archival and media work I was able to do at the Ethnographic Video for Instruction and Analysis Digital Archive at Indiana University allowed me to think about my work in a different way than just the written word. While in India, I had the opportunity to give talks at a number of institutions and received valuable feedback. These include the Indian Institute for Technology at Gandhinagar, University of Hyderabad, Trivedi Center for Political Data at Ashoka University, and Jaipur Virasat Foundation. I presented conference papers on segments of this book as a member of numerous conference panels, including national or international conferences of the Society for Ethnomusicology, American Anthropological Association, Association of Asian Studies, American Musicological Society, and International Council for Traditional Music, as well as at the Annual Conference on South Asia.

I thank the people at Wesleyan University Press who have helped me so much in the past few years and have made the publishing process extremely clear, engaging, and creative. In particular, I thank Deborah Wong, Jeremy Wallach, and

Sherrie Tucker, the editors of the Music / Culture series, for their encouragement of this project. I am extremely grateful to my editor Suzanna Tamminen for her unerring patience, calm, and dedication in seeing this project through in a timely manner. I am grateful to the two anonymous readers of my manuscript. While they were both kind and generous in their reviews, they gave me critical feedback that pushed me to clarify my thoughts and provide added nuance to my arguments. I also give credit to others involved in the publishing of my book. Also at Wesleyan University Press, I thank marketing manager Jaclyn Wilson and publicist Stephanie Elliott Preito. And I wish to thank production coordinator Jim Schley.

My family members have quietly supported me through this long journey. I thank my parents, Venkata and Gay Morrison Ayyagari, for their unwavering love. My sister Sujatha Ayyagari Nigam and my brother Raj Ayyagari have always been there for me, encouraging me with a much-needed sense of humor. I consider my oldest and dearest friend Carrie Grable to be a member of my family: she has been a constant in my life since the age of six. While Shanti Ayyagari did not live to see this book come to fruition, I always appreciated her nudges (and barks), encouraging me to take much-needed work breaks, walks, and life one moment at a time.

Finally, I cannot thank enough my partner and the love of my life, Andrew N. Weintraub. Through the many years of research and writing that went into this book, he has not only put up with me but has been my biggest fan. His ideas, interlocution, and inquisitiveness have marked every page of this book. He will never know just how much he inspires me to be a better thinker, scholar, and person. This book is for our son, Amir, the greatest optimist I have ever known, who shows me what it means to imagine the ultimate bright and resilient future ahead.

Musical Resilience

INTRODUCTION

Musical Resilience

MURDER IN THE THAR DESERT

On the night of September 27, 2017, Aamad Khan, a member of the Manganiyar community of hereditary musicians was murdered in Dantal Village, in the remote Thar Desert on the borderland between India and Pakistan. This violence shook the entire Manganiyar community. In the aftermath of his death, sadness and turmoil led to community-wide concern and protest, culminating in the uprooting of the Manganiyar families that had called Dantal Village their home for hundreds of years. Because of this dislocation, the Manganiyar families from Dantal were forced to abandon the only occupation they had known for centuries, performing music for hereditary patrons.

It does not seem like a coincidence that Aamad Khan's murder took place during Navratri, a nine-day Hindu religious festival that celebrates what the Manganiyar community calls *lachila*, or resilience. Navratri valorizes the power of the Hindu goddess Durga, symbolized by her nine manifestations of lachila. It also recapitulates the Hindu god Ram's adventures through nine nights of theatrical performances of the *Ramlila* (Lord Ram's play), which is based on the *Ramayana*, a Sanskrit epic. In the *Ramlila*'s final act, on the ninth night of celebration, the actor playing Lord Ram slays the demon Ravana and declares victory of good over evil, displaying his own lachila as he sets an effigy of Ravana ablaze with fireworks. Lachila is celebrated throughout the Hindi Belt in north India on the last day of Navratri: the many Hindu neighborhoods in Jaisalmer City in western Rajasthan (the largest state by area in India) and surrounding

villages in the Thar Desert are lit up with bonfires as people communally celebrate the resilience mustered in living another year in the harsh desert.

It was during these annual Navratri festivities that Aamad Khan was summoned to one of Dantal Village's temples to perform a *jaagaran* (awakening), an all-night ceremonial performance of Hindu religious music that sometimes involves dance and spiritual possession. Jaagarans hosted by *jajmans* (hereditary patrons) and performed by Manganiyar musicians in the Thar Desert, like this one in Dantal in 2017, are usually adjudicated by a temple's Hindu *bhopa* (faith healer and priest) and include musical performance interspersed with religious ceremony. Although the members of the Manganiyar community are Muslim, their traditional patrons, determined by ancestral hereditary relations, are predominantly Hindu. Local patronal relations dictate that Manganiyar musicians perform at the life-cycle ceremonies (births and weddings) and religious festivals of their jajmans, who in turn support their musicians. In this borderland region, where the line between practiced Hinduism and Islam is blurry, it is not uncommon for Muslim musicians to perform in Hindu temples, especially when traditional patronal relations are at play (Piliavsky 2013). According to his brother Bariyam Khan, Aamad Khan's task at the jaagaran was to conjure up the spirit of the locally worshipped *sati ma* goddess, Rani Bhatiyani, so that it entered the body of Ramesh Suthar, the temple's bhopa, enabling the possessed bhopa to properly perform his religious healing duties while in a trance.[1] During the ceremony, the bhopa supposedly accused Aamad Khan of making musical mistakes that prevented him from entering a state of trance. Aamad Khan contested this accusation and questioned the bhopa's faith. In a fit of anger, the bhopa broke Aamad Khan's harmonium, the portable reed organ keyboard instrument he used to accompany his singing. Late that night, Aamad Khan was abducted from his home. His dead body was found the next morning on the outskirts of Dantal.

Grief-stricken, terrified, and in fear of more violence directed against them, Aamad Khan's family did not have time to investigate questions about or possible motives for the killing. They approached their jajman, traditionally a trusted confidante and the first point of adjudication for Manganiyar families, who told them Aamad Khan had died from a heart attack. The jajman encouraged Aamad Khan's family to bury his body quickly and quietly, which they did without ceremony. The next day, Bariyam Khan inquired further about his brother's death, having seen lacerations and dried blood on his body before burying him. He was then told that Aamad Khan had been killed for making musical mistakes during his Navratri jaagaran performance. Could it be true that a Manganiyar

musician had been murdered for making musical mistakes? Were there other motives for his murder that involved village politics, religious differences, or caste issues? If so, why would his jajman have lied? When members of the family went over the jajman's head and approached Dantal Village's *panchayat* (local self-governing council) with questions about the nature of Aamad Khan's death, they were met with silence and grew suspicious of the panchayat, whose elected officials included their jajman.

Only when Bariyam Khan began to carry out his own investigation in the days after his brother's murder did he learn that their jajman was involved in and perhaps responsible for the murder of Aamad Khan. Bariyam Khan knew the weight of the political power their jajman wielded in Dantal because he was an high-caste Hindu Rajput and an important panchayat official. Likewise, Bariyan Khan was aware of his family's political powerlessness as low-caste, Muslim village musicians who historically served at the beck and call of their jajman. Without his jajman's protection and support, Bariyam Khan's only way to find answers about his brother's death was to turn to the Merasi Samaj (Artists' Society), the overarching social and political organization of the entire Manganiyar community. When Bariyam Khan threatened his jajman with taking the case public, the jajman offered him a small amount of money to keep the matter quiet, which Aamad Khan's family refused. What amount of money could make up for the death of a husband, father, and the family's main breadwinner?

Aamad Khan's family made the long journey to Jaisalmer City to visit Bax Khan Gunsar, an outspoken member of the Manganiyar community. He is recognized by the community as the founder of the local organization called Gunsar Lok Sangeet Sansthan (Gunsar Folk Music Organization; "Gunsar" is the name of his Manganiyar subcaste) and as a community organizer with connections to local politicians, the cultural tourism industry, and well-known international Manganiyar performing artists. After arriving in Jaisalmer, Aamad Khan's relatives were directed to the organization's headquarters, located in the Kalakar Bhawan (Artist Building; the Manganiyar community center). Located next to the Jaisalmer Kalakar (Artist) Colony neighborhood where most of the Jaisalmer City–based Manganiyar families live, the Kalakar Bhawan sits on a piece of government land donated to the Manganiyar community and today is home to both Bax Khan's organization and the Merasi Samaj's headquarters. Bax Khan suggested that Bariyam Khan not only seek answers to questions about Aamad Khan's murder but also justice for his death. With Bax Khan's support, Aamad Khan's family decided to not settle the matter through the usual routes of

jajmans or village panchayats, both of which have been proven to be prejudiced against low-caste communities and Muslims. Instead, the family reported the murder to the Jaisalmer District superintendent of police.

With the support of the larger Manganiyar community, Jaisalmer District officials had Aamad Khan's body exhumed from its makeshift burial site. An autopsy revealed that he had died from trauma inflicted on his body—not from cardiac arrest, as suggested by the jajman and the panchayat in their statements to the police. A week after Aamad Khan's murder, Ramesh Suthar, the low-caste bhopa present at the Navratri jaagaran, was arrested for the murder of Aamad Khan, and a warrant was issued for the arrest of the bhopa's two brothers, who had absconded. Fearing retaliation from their jajman for this transgression, the entire Dantal Village–based Manganiyar population (over two hundred people) sought refuge in Jaisalmer City, where they were temporarily housed at the Kalakar Bhawan, in the hope that the government would give them land in the city where they could settle permanently.

Using his media savviness and social connections, Bax Khan ensured that Aamad Khan's death was reported by local news sources. However, he could not have predicted the unprecedented national and international media attention paid to the murder and its aftermath, most of which reported the case as part of a larger issue of communal strife between Hindus and Muslims in Rajasthan. Most news sources did not call the Manganiyar community by its specific name but referred to its members as "the Muslims," pitting them against Hindu village authorities (Firstpost Staff 2017). One reporter went so far as to link Aamad Khan's murder to the lynching of a Muslim cow trader by a right-wing Hindu cow protection vigilante group in another part of Rajasthan (Ibid.). Another added the case to a list of Hindus killing Muslims with the headline "Mapping Killings That Make Rajasthan 'Hate Crime Capital of India'" (D. Roy 2017). Aamad Khan was Muslim, and those responsible for his murder were Hindu. However, the case was appropriated for larger national religious and political causes that had little to do with the specific circumstances of the murder: localized rural religio-caste politics (entanglements of religion and caste) in the Thar Desert.

Protests by Manganiyar activists continued for more than a year after Aamad Khan was murdered. Perhaps taking a lead from the media, which had appropriated the murder to make national religious and political arguments, Bax Khan and others from the Manganiyar community ingeniously drew on religious rhetoric to bolster their case of community-wide marginalization and victimization. By conceding that Aamad Khan's murder was simply another in a

long line of religious hate crimes in which high-caste Hindus kill Muslims, they were able to continue to draw attention to a case that was by then over a year old.

Most of the Dantal Manganiyar families settled informally in a *basti* (unofficial settlement) on the outskirts of Jaisalmer City. They completely severed their ties with their jajman: return to Dantal was not an option. Some performed music in local hotels and at desert safari camps for Indian and foreign tourists. Others supplemented the meager income they received performing in the seasonal tourism industry with work as manual laborers building and repairing local roads. They continued to regularly visit the Jaisalmer District Collector's Office to ask the city to give them land. Ramesh Suthar was convicted of murdering Aamad Khan and sent to prison, even though he was most likely a scapegoat for the more powerful, high-caste, Rajput jajman. Ramesh Suthar's two brothers and supposed accomplices were not found.

In 2018, the year after his death, Aamad Khan's family members did not celebrate the Hindu festival of Navratri because their celebrations had always been directed at their Hindu jajman in Dantal. No bonfires of lachila or burning demon effigies were found in their basti in Jaisalmer City. In their new urban life, they were no longer living in fear of their jajman or the Dantal panchayat. They were grateful to the Manganiyar community for coming together to support them and hoped that the government would give them land to settle on in Jaisalmer. They were resilient. The situation in Dantal Village was quite different. By the time of Navratri 2018, Aamad Khan's former jajman had invited a Hindu Dholi family of musicians to settle in Dantal to replace the Manganiyars who had left.[2] The practice of traditional patronage in the Thar Desert, it turns out, is also resilient.

TEXTURES OF RESILIENCE

I was not in India when Aamad Khan was murdered, but I did observe the media frenzy via social media as the story made local, national, and international news. Manganiyar musicians posted pictures and videos on social media of Aamad Khan's exhumed body, his family, and the protests that followed the murder. As I scrolled through social media posts at home in the United States, it became clear to me that these members of the Manganiyar community, many of whom I had known for the past twenty years of my ethnographic research, were enduring drastic changes in community lifestyle and position.

I made a short field visit to the Thar Desert in 2019 to learn more about Aamad Khan's murder and its aftermath. I met with his family members in Jaisalmer

City, who were adamant that his murder was not the result of a simple religious dispute as reported in the press. Instead, they told me that localized and complicated religio-caste struggles had plagued Dantal Village for years. The Dantal Manganiyar families had for several years been trying to escape religious persecution and overt casteism in their village, striving to achieve social freedom and societal respect. Aamad Khan's relatives interpreted his murder as a threat (the last and most drastic in a long line of prejudiced infractions directed against them), intended to convince them to remain in their submissive low-caste position as Muslim village musicians. According to one of Aamad Khan's family members, they had not been forced to leave Dantal because of Aamad Khan's death. They believed that Aamad Khan had blamed the bhopa's lack of devotion rather than his own musical ability for the bhopa's not going into a trance on that fateful Navratri night in 2017. Because they had questioned Aamad Khan's death and had not subserviently followed their jajman's and panchayat's advice to leave the matter alone, they had been forced to leave Dantal.[3]

Aamad Khan's murder was extreme but only the latest in a long series of acts of prejudice, abuse, and neglect against Manganiyar musicians by their jajmans and larger society. Aamad Khan's family's search for justice not from their jajman or the panchayat but from a governmental entity like the police demonstrated a change in approach for the Manganiyar community. It triggered unprecedented reactions in the Manganiyar community against traditional jajmans, village panchayats, and broader religio-caste norms in the Thar Desert. It ignited a debate among members of the Manganiyar community about how best to exert their rights and balance traditional patronal relations and village dynamics with nonpatronal performances and international recognition.

I spoke with Bax Khan during my field visit and asked him why he had advised Aamad Khan's family members to take their case to the Jaisalmer District superintendent of police. Bax Khan told me that he was aware that the police force is often corrupt and unjust, as well as arguably more prejudiced against low-caste communities and Muslims than Hindu high-caste Rajputs and village panchayat members. Perhaps more poignantly, he knew that the act of going to the police would sever the family's centuries-old ties to its jajman. Bax Khan told me that although severing traditional patronal ties would cause the family to lose its musical livelihood and societal place in Dantal Village, it was time for the Manganiyar community to make this move away from traditional patronal relations when they do not serve the musician. He spoke about patronal relations in terms of dependence: "Since independence, we have continued to follow the

old system, which keeps us dependent on our patrons. We do not have anything of our own and are completely dependent on our jajman for everything. If they are good to us, things are good. But if they don't treat us well, things are bad. It is not good to be so dependent on others. There should be a logical link between the time and labor we give and the wages we get, but that does not exist in our community. This needs to change."[4]

This book grew out of an attempt to grasp the basic terms under which members of the Manganiyar community desire to lead respectable and successful lives through the textures of resilience, as recounted through stories of my fieldwork experiences and experiences related to me by interlocutors. I seek to understand the structural and community-wide upheavals that have utterly reshaped contemporary life for Manganiyars. I follow the concept of resilience through different sites, spaces, and temporalities to explore how some Manganiyar musicians came to search for and find economic, cultural, and community resilience through music. While the focus of the book is on Manganiyar musical practice and those musicians who have been considered by the larger Manganiyar community to be resilient, I tangentially engage with those members of the community who are not considered to be resilient, those who are not performers (nonmusician men and women), and their audiences (jajmans and nonpatronal audiences). What does it mean to live a life that is resilient? How does a person or community muster resilience—that is, where and how do they find it? Who defines resilience and with what authority? What does undesirable resilience look like, when, for example, the practice of patronage is beneficial for high-caste Hindu jajmans, but is life-threatening for Manganiyars?

There are several reasons why resilience is a compelling concept with which to understand Manganiyar music. First and foremost, the language of resilience pervades everyday Manganiyar life. Seen and heard throughout the Thar Desert in the context of local NGO (non-governmental organization) projects, large-scale canal and water irrigation schemes, international tourism, and neoliberal development, resilience is touted as not just a survival tactic, but a strategy for thriving. Throughout my many years of conducting fieldwork in the Thar Desert, lachila was a common trope invoked by Manganiyar musicians to relate their state of prospering as traditional patronal musicians and taking advantage of new and innovative performance opportunities.

Second, resilience, far from being unique to the Manganiyar community, may be one of the most salient terms of our time, invoked in moments of intense struggle to describe people's actions, survival, and humanity in the face of dev-

astation. There is an aesthetic pleasure in stories of resilience and overcoming. Narratives of resilience inspire people to find their own inner strength and develop capacities for survival. Most recently at the time I was writing this book, resilience was contextualized in relation to the worldwide Covid-19 pandemic, the Black Lives Matter and Me Too movements in the United States, caste and class uprisings in India, increasing turbulence in the natural environment, complexities in human engagement with technology, and uncertainty in contemporary world financial systems. Resilience has been championed as a descriptor of artists in all corners of the world who are historically enmeshed in local performance contexts and are increasingly working in global performance situations while grappling with anthropogenic climate change, postindustrial economics, and drastic political regime shifts.

Third, resilience is a multifaced term that, when explored in all its dimensions, reveals power dynamics. During my 2019 field visit to the Thar Desert, I realized that what haunted me the most about Aamad Khan's murder and its aftermath was not the violence that was inflicted on a Manganiyar musician on that 2018 Navratri night in Dantal, but the stubbornness of the practice of patronage itself, even at the cost of human life. Aamad Khan's jajman's sense of entitlement to traditional patronage and his unerring position of power despite the egregious act of murder displayed a different kind of resilience. Lord Ram's lachila in the *Ramlila* performance of Navratri, symbolized by the burning effigies of Ravana throughout Jaisalmer and surrounding villages, came to mind as I decided to use the concept of resilience as this book's analytical framework. However, the stories of resilience I tell are not the black-and-white tales of good conquering evil seen in the *Ramlila*. Resilience is not found only in winning as opposed to losing. Resilience does not always look like prosperity, and it does not always result in redemption.

RESILIENCE AS A TRANSDISCIPLINARY FRAMEWORK

A traditional Marwari saying advises: "Ghoda kije kaath ka, pind kije pasaan; / baktar kije lohe ka, phir dekho Jaisan" (Turn your horse into wood, make your body rock-like; / Wear clothes like iron, then only can you see Jaisalmer).[5] At the heart of this couplet is resilience. I made my first field visit to the Thar Desert and met my closest Manganiyar interlocutors in August 2003. The monsoon rains that flooded and wreaked havoc in other parts of the subcontinent that year produced only a few minutes of rain in the desert. I remember my first

afternoon at the homestead of the world-famous Manganiyar *kamaicha* (bowed lute) player, Sakar Khan, in Hamira Village. I sat with his son, Ghewar Khan (a renowned kamaicha player in his own right), discussing Manganiyar music inside a small brick shack in the desert summer heat. As sweat ran down my face, Ghewar Khan made a fist and said to me in Hindi, "You have to have lachila to be a Manganiyar musician. Life is difficult in the desert. It is very hot, and it is very cold, never in between. We work hard all day long tilling fields, playing music for our jajman."[6] The lachila Ghewar Khan spoke of reflects the resilience seen and heard in Manganiyar lives and their music.

"Lachila" is a term that most likely is derived from Urdu but is now used throughout the Hindi Belt to mean flexibility, elasticity, and pliability. It is often used in reference to bodily flexibility in dance. Its use in the Thar Desert to mean resilience relates to the human body but is often used at the community level. For the Manganiyar, the rhetoric around resilience is as important as the act of being resilient: speaking about resilience has consequences for musical aspirations among the community. To shape this book, I also draw on the English word "resilience"—which derives from the Latin "resilire," to remove oneself from an agreement or pull out of a legal contract. "Resilience" has been used as a framework to explain human and natural actions across diverse disciplines since the fifteenth century. From its earliest uses in relation to recoiling or echoing (Bacon and Rawley 1670) and the elastic or springy reactions of gases, liquids, and solids to imposed pressure (Gott 1670), resilience has been most closely associated with the physical sciences to describe the capacity of materials to withstand disturbances (Baho et al. 2017).

Perhaps resilience's most salient application has been in the field of ecology. The Canadian ecologist Crawford Holling (1973) applied resilience to the natural environment, defining it as the time needed for an ecosystem to return to the stability of its predisturbance condition after a disaster. Holling was the first ecologist to apply resilience to climate change, and his notion of an ecological system's persistence as a measure of its resilience applied for decades in ecology (Pimm 1991). By the early 2000s, however, predisturbance ecological conditions were viewed no longer as being stable but rather as constantly changing and adapting (Gunderson 2000; Gunderson, Allen, and Holling 2009; Walker and Cooper 2011). Resilience became associated with a sustainability change model, in which there was no predisturbance static formation (Folke et al. 2010). Instead, resilience was viewed as the capacity to adjust to shocks and the ease with which natural systems transition to new temporary stabilities.

It is from this last ecological application of resilience that scholars adapted resilience as a concept to bridge disciplinary boundaries. Scholars from diverse disciplines applied the ecological conception of resilience to people, communities, and objects (Bhamra, Dani, and Burnard 2011). Resilience has been used in psychology to "show interest in the issue of regaining individual and social psychological stability, with the emphasis on recovery from war experiences and catastrophes" (Hellige 2019, 33) (for an example of resilience's applications in psychology, see Bonanno 2005). In anthropology, resilience has been applied to community-wide recovery after catastrophic events (Adger 2000). The word has made its way into business studies to describe how businesses strategize and predict future conditions to ensure the use of best practices (Hamel and Välikangas 2003; Linnenluecke 2015). In music studies, resilience has not yet become a pervasive concept, although it has been applied to the examination of music's philosophical ties to racism and sexism (James 2015) and American Black music in the face of systemic racism (Lordi 2020), and in music therapy (Letwin and Silverman 2017).

Ethnomusicologists have skirted around the concept of resilience, applying instead the frameworks of sustainability and ecology to music culture. The metaphorical trope of ecology has been applied to music and sound to study the "effects of the acoustic environment or soundscape on the physical responses or behavioral characteristics of creatures living within it" (Schafer 1977, 271). Daniel Neuman (1980, 18) referred to the way a Hindustani musical system "continues to maintain its integrity and autonomy in a world so vastly changed from that which gave it birth." Based on Schafer's definition, Steven Feld (1994) coined the term "echo-muse-ecology" to describe a different engagement with sound and its relationship to the environment. More recently, literature on sustainability in ethnomusicology has explored relationships among people, the environment, and music (Feld and Basso 1996; Schippers and Grant 2016; Titon 2009a, 2015, and 2018), also known as social ecological systems. Ethnomusicologists and anthropologists of sound have given the name "ecomusicology" to studies of sustainability in music and sound, which address the complex and adaptive networks that link people to nature and view people as part of a broader definition of nature rather than being detached from it (Titon 2009b). Using this approach of including humans as a part of nature, Jeff Titon proposed an ecological move towards preservation, which he called "stewardship of musical resources" (Titon 2009a, 5).

While sustainability continues to be used as a guiding principle in ethnomu-

sicology, its application has been criticized as having shortfalls. First, ethnomusicologists have cautioned against making a direct analogy between ecological sustainability and diversity in music cultures, fearing that such a move could easily turn into a neocolonial enterprise of salvage ethnomusicology (Erlmann 1996; Stokes 2004). Second, sustainability has been applied to music culture only in positive ways. Can unsustainability guide ethnomusicological studies of music used in negative terms?[7] Third, discussions of sustainability in music studies tend not to engage with the influence of technology on music and instead pay more attention to connections between music and the natural world.

In response to these critiques of the applicability of sustainability in ethnomusicology, Titon has proposed that the term "resilience" be used to refer to the capacity of a system to recover and bounce back from a disturbance. His use of the term acknowledges the pervasive influences of technology on traditional cultures, allowing cultures to "use whatever means necessary to develop its music now and in the foreseeable future" (Titon 2015, 157). Here, the same connections between music, culture, and nature are woven together through an activist lens of social justice (Allen and Titon 2019; Allen, Titon, and Von Glahn 2014).

This book can be read as being in conversation with readings of musical sustainability, ecology, and resilience. While resilience has been criticized for its universalization of individual experiences and overuse in scholarly contexts, the case of the Manganiyars creates space for a broader interpretation of resilience as an anchoring concept to meld perspectives from a variety of disciplines (for discussions of resilience's disciplinary overuse, see Bahadur, Ibrahim, and Tanner 2013; Carpenter et al. 2001). While I use Titon's model of resilience in terms of positive thriving to provide a framework for understanding the ways Manganiyar musicians are prospering as musicians outside of traditional patronal contexts, it is not enough to build resilience with the single goal of sustaining a culture (Titon 2016).[8] A multifaceted conceptualization of resilience can help us understand why music culture persist and change. Throughout this book I draw on three different dimensions to resilience.

The first dimension of resilience explored in this book is "wicked" resilience (Rittel and Webber 1973). Horst Rittel and Melvin Webber formulated the concept of "wicked problems" in the context of design theory. Wicked problems are societal problems that are resilient, meaning they are complex, always shifting, and do not have one simple solution (ibid.). In this dimension, resilience is not always a positive condition. In some cassess resilience can be stubborn or undesirable. In other cases, resilience can be positive for some but negative for

others. Examining resilience in all its forms reveals its interconnections with persistent, recurrent problems for which there are no perfect solutions (Churchman 1967). Patronage itself can be considered a resilient practice in the sense of a wicked problem for which there is no simple answer. While many members of the Manganiyar community have prospered because of traditional patronal relations, others have been subjected to marginalization and discrimination and live in poverty because of their traditional patronal relations. While resilience acknowledges the very real feelings of hopelessness resulting from such wicked problems, it also offers a foundation for adjusting social capacities and finding ways to cope with wicked resilient problems (Kolko 2012).

The second dimension of resilience that I explore is psychological resilience, viewing it as a means of recovery after loss and trauma. If resilience means leaving a previous state behind, it also means not being able to return to that previous state. This liminal state of trauma and the realization that a past normality is gone create vulnerability (Shaw et al. 2016). It is in moments of vulnerability when people's lives are most precarious (Snehashish Bhattacharya and Kesar 2020). But it is also in this vulnerable state when people have the capacity to make changes, accept them, and grow (Arnold 2013; Butler 2016).

An example of the second dimension of resilience, psychological resilience, can be found with Aamad Khan's family members who were vulnerable without the protection of their jajman and village panchayat. Without their traditional support network, they became neoliberal subjects and were expected to recover from Aamad Khan's death and its aftermath by fending for themselves throuogh innate coping strategies.(Bracke 2016, 59).

It is here that we can approach a third dimension of resilience: neoliberal resilience. Resilience is a characteristic and enabling force of the contemporary Indian neoliberal economic regime that continues to trap the Manganiyar community in poverty. Rather than a process or externally imposed state of being, resilience is presented as a personal property or attribute—the mental state of being able to withstand stress, the capacity to recover quickly, and resistance to being affected by the shocks of future disaster (Lentzos and Rose 2009, 242). By positioning subjects as resilient, the state can further promote neoliberal forms of governmentality; encourage political passivity; and step away from state-led initiatives to help shelter subjects from social exclusion, marginalization, and poverty. In this way, resilience becomes a governmental strategy that grants the "illusion of autonomy" and the "reward of freedom," even though it is a disguised form of top-down market-based disciplinary action (Joseph 2013, 47).

The result is a shift from the state as provider to the state as promoter of self-reliance. The neoliberal state can withdraw support for its subjects and stop being responsible for them while still capitalizing on their overcoming. Resilience becomes a celebration of the abdication of social and political responsibility. Neoliberal subjects are expected not only to survive but to prosper through individual determination. Those who succeed are considered heroic and resilient, and those who do not are considered failures and unresilient. For Aamad Khan's family, the moments after his death were ones of intense vulnerability. It was in this traumatic vulnerability that they realized their safety and freedom were more important to them than maintaining their centuries-old patronal relations with their jajman. They made the decision to leave their village and traditional patronage behind.

I take the concept of resilience in all these diverse contexts to heart, and throughout this book I show how these diverse faces of resilience exemplify the Manganiyar community's striving to contribute to and adapt a musical life in a constantly changing world through ethnographic moments of destabilization, precarity, and vulnerability. Through a pursuit of resilience, Manganiyar musicians are not just rupturing and resisting their subaltern history of being subjugated caste musicians chained to traditional patrons through duty and necessity. Rather, they are embracing this history and using it as a catalyst to create new Manganiyar futures of musical livelihood.

SOUNDS AND HISTORIES

At the heart of the Manganiyar community is a historical and environmental continuity that links the contemporary interlocutors in this book with their ancestors, local contours of geography and environment, and histories of patronage and subjugation. The Manganiyars, who number close to twenty thousand people, are a hereditary community of professional musicians. Their professionalism stems from music as their main means of sustaining a living and supporting their families, while the hereditary nature of their profession refers to musical practices passed down from father to son and kept within tightly knit extended family units (figure I.1).[9]

Manganiyar families are tied to jajmans, hereditary patron families. Manganiyar musicians provide jajmans with family genealogies, oral histories, and ceremonial music mostly at life-cycle ceremonies. In turn, jajmans remunerate Manganiyar families with payment in the form of money, land, animals, grain,

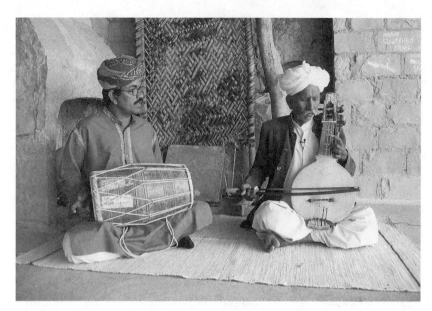

FIGURE I.1 Sakar Khan (right) playing kamaicha, with his son Firoz Khan (left) playing the dholak, at a jajman function. Hamira Village, 2006. Photo by the author.

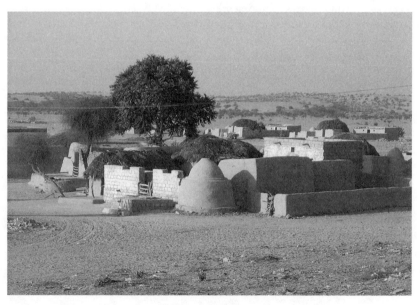

FIGURE I.2 Manganiyar dhani on the outskirts of Sanawara Village, 2010. Photo by author.

financial support, insurance, and overall security. While patronal relations waned in post-independence India due to postcolonial political and economic rearrangements, these relations have persisted. Manganiyars continue to be necessary in legitimizing jajmans' family status.

Their community and caste name, Manganiyar, can be translated as "one who begs" or one who exchanges something for payment. The first known mention of the name is found in Sir Richard Burton's accounts of his travels in Sind (1877, 140).[10] The *Mardumshumari Rajmarwar* (the 1891 Indian census) states: "Manganiyars are Muslims and their khamps are Dedhra, Ved, Barbi, Kalumbha, Jaria, Sonaliya, Paudiya, etc. The khamps reveal that they previously went by the name Dholi. They play the sarangi or the rabab and sing in a strange vibrant style" (Munshi Singh 1991, 363). Before this, there is extensive documentation of musical performance in the Thar Desert. While the name Manganiyar is not mentioned, oral histories narrated by Manganiyar musicians date their profession and patronal relations back at least three hundred years.[11]

Locating the Manganiyars

The Thar Desert covers western Rajasthan State, southern Punjab State, and northern Gujarat State, as well as Pakistan's eastern provinces of Sind and Punjab—especially Tharprakar District. Covering 446,000 square kilometers (10 percent of India's geographical area) and having an average annual rainfall of 180 millimeters of rain, the Thar Desert ia a unique region in South Asia. The remote villages where Manganiyar families live in the Thar Desert are interspersed throughout rolling stretches of desert and separated by hillocks and sand dunes. Spread throughout the Thar Desert, Manganiyar families are mostly concentrated in Jaisalmer and Barmer Districts in western Rajasthan.[12] Most members of the community continue to live rural lifestyles in *dhanis*—small hamlets on the edges of villages (figure I.2). Beginning in the 1970s, there was unprecedented migration of Manganiyar musicians and their families to Jaisalmer and Barmer Cities (in Jaisalmer and Barmer Districts, respectively). Both cities have a Kalakar Colony on their outskirts that was established by the government for the Manganiyars and other artist communities.[13] Despite this migration, most Manganiyars continue to have roots in their ancestral Thar Desert villages through family ties, landownership, and traditional patronage.

The Thar Desert constitutes a frontier zone, which refers to the interconnected nature of the desert environment and obscures the division of the region by

the India-Pakistan border (Kothiyal 2016, 2). The culture of the Thar Desert in western Rajasthan has much more in common with that of its counterpart, the Tharprakar Desert in eastern Sindh (in Pakistan) than with other parts of India like the Deccan Plateau. The Thar Desert's itinerant and peripatetic people, culture, and music knew no borders until independence and the partition of India and Pakistan in the late 1940s. Older Manganiyar musicians told me stories of growing up and learning music in what is now Pakistan. They remember long-lost relatives now on the other side of the border and learning music in royal courts now in Pakistan; and they sing songs about Pakistani places like Umarkot, Khokropar, and Larkhana.

The repercussions of these historical ties are palpable in Manganiyar songs about places in Pakistan, songs and stories recounted in the Sindhi language, and the lack of new kamaicha instruments due to the inability to reach instrument makers now in Pakistan. Therefore, a history of mobility (through nomadism and peripateticism, shared foodways, limited water supplies, specific flora and fauna, and a tradition of music and genealogy keeping) straddles today's artificial state and international political borders in this region, creating this continuous frontier zone (Ayyagari 2012). Despite these similarities across an international border, the partition of India has cast long shadows and continues to affect the region. Likewise, differences between India and Pakistan in religious philosophies relating to the arts, governmental support, and cultural tourism make the border very real for musician communities like the Manganiyar.[14]

Members of the Manganiyar community live mostly in two Rajasthan districts, Jaisalmer and Barmer. During my longest stint of fieldwork, I lived in Jaisalmer City, in the heart of Jaisalmer District. However, the Thar Desert region is home to several other peripatetic and nomadic hereditary communities whose members are entwined in patronal relations, and some, like the Langa, are also professional musician communities.[15] Jaisalmer City was established in 1156 CE by a Bhati Rajput clan led by Rawal Jaisal, who shifted his community from its former nearby capital of Lodhruva to the top of a large hill called Trikuta, where they built Jaisalmer Fort, known as the Golden City (figure I.3). Prior to independence, Jaisalmer was a royal principality of the conglomerate of princely states known as Rajputana, ruled by Bhati Rajput kings. Notwithstanding the harsh climatic conditions, Jaisalmer has been continuously inhabited by people of various religions, castes, and tribes who engaged in numerous occupations like seasonal agriculture, animal husbandry, trade and commerce, and handicrafts. In the twelfth century, Jaisalmer City came to prominence and prosperity as a

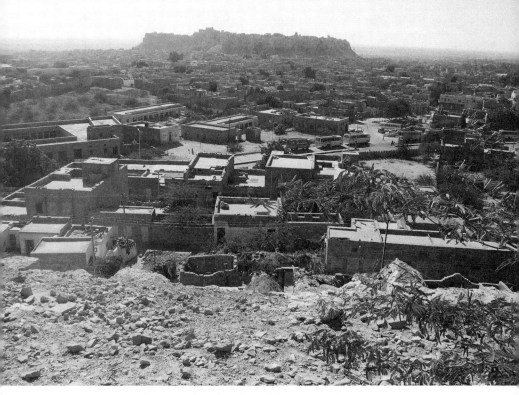

FIGURE I.3 View of Jaisalmer City from the Kalakar Colony, where Manganiyar
artists and members of other performing communities live. Trikuta Fort looms
on the horizon in the distance. Jaisalmer, 2007. Photo by the author.

gateway to the northern plains of the subcontinent, a stopping point for cara-
vans traveling into and out of the subcontinent, and an important locus for the
opium trade. As a cosmopolitan city defined by mobility, Jaisalmer prospered
from caravan levies into India's colonial period.

After the British established the East India Trading Company in 1757, solidify-
ing Great Britain's colonial hold over India, overland trade routes proved slow
compared to ocean routes. Coastal cities like Bombay, Madras, and Calcutta
became central city ports, while inland cities like Jaisalmer languished. It was not
until the 1970s that Jaisalmer again became a hub, and this time its importance
was in relation to border security and cultural tourism. The Indo-Pakistani War
of 1971 closed the entire Indo-Pakistani border. Eventually the Indian govern-
ment developed the Border Area Development Programme, which provided

infrastructure and military presence on the Rajasthan border (Hun 2020; Planning Commission of India 2006). With improved roads, transportation, and access, Manganiyar musicians were drawn away from their villages to Jaisalmer City, where they had opportunities for upward mobility and diversified musical performance.

While Jaisalmer is a cultural center for the Manganiyar, much of the Manganiyar community lives throughout Barmer District, with a concentration of Manganiyar families who relocated from their villages and now live in Barmer City. Although Barmer also historically played a significant role in the overland caravan trade, it lacked the central importance that Jaisalmer had because it lacked a royal court and was part of Jodhpur Princely State. Likewise, Barmer never witnessed a boom in tourism as Jaisalmer did, and it continued to depend on local industry until the early 2000s — when large reserves of oil were discovered nearby (Dolson et al. 2015). This led to fast-paced development that has been transforming the district over the past two decades. Oil and investments have recently brought large amounts of capital to Barmer City, resulting in a larger and more diverse population, revenue stream, and industrial sector. In turn, this has created additional performance opportunities for the Manganiyar community in the city, increasing the musicians' prosperity.

Musical Practice

According to a proverb, "Jab ham gaate hai tho devi detta hamse milne aate hai" (Gods and goddesses come down to meet us when we sing). The proverb describes Manganiyar musicians as being considered *manglik* (auspicious) for jajmans, and hence jajmans' life requires the presence of a Manganiyar at the beginning, end, and every auspicious occasion in between. Manganiyar musicians are said to perform only at their patrons' auspicious occasions — the births of male children, weddings, and religious observances and festivals. However, some of my interlocutors have disputed this, telling me that they also attend their patron's funeral rites and observe twelve days of mourning for a patron, during which time they are not allowed to play music. The settings for their traditional music are patrons' weddings, births, and festivals. The kamaicha is the most iconic instrument of the community, although it has few contemporary players (figure I.4). Notorious for being difficult to make, play, and tune, the kamaicha is often replaced by the harmonium for providing vocal accompaniment. A customary performance consists of a family of male musicians — a singer, a kamaicha

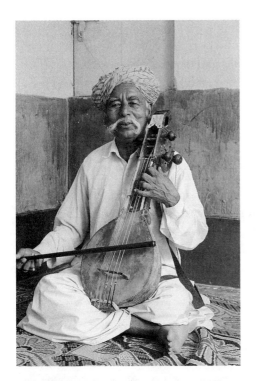

FIGURE I.4 *left* Hakam Khan accompanying his singing with kamaicha at his home. Sunawara Village, 2012. Photo by author.

FIGURE I.5 *below* A typical contemporary Manganiyar performance ensemble led by Thanu Khan (second from left) during a recording session with the author. The ensemble features the following instruments (left to right): khartal, harmonium, clapping, dholak, and another khartal. Khudi Village, 2006. Photo by author.

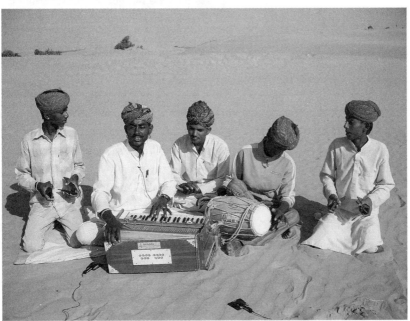

or harmonium player, a drummer with a *dholak* (double-headed barrel drum), and a percussionist with a *khartal* (idiophone made from a pair of flat pieces of wood, played with one pair in each hand) (figure I.5).

Because Manganiyars are present at all important additions and subtractions of family members in a jajman family, they perform the significant role of genealogy keepers for their patrons. At the beginning of every performance in traditional patronal contexts, Manganiyar musicians recite a *shubhraj*, an acknowledgement of the relationship between the musician and his jajman. This acknowledgement could take different forms which include a monotone recitation of a list of names of the jajman's ancestors; a sung poem that exalts the jajman or his caste; a sung story that tells of the jajman's and his ancestors' bravery or good deeds; or a sung poem in praise of a Thar Desert location or even the *raga* being performed. When a poem is sung as a shubhraj, it is in the form of *dohas*, or fixed rhyming poetic couplets. In all of these forms, a shubhraj is usually sung in a monotone voice with small melodic embellishments at the end of phrases and at a fast tempo.

This is perhaps the most important function that Manganiyar musicians provide to their jajman. The shubhraj acts as a way for jajmans to maintain their dominance as jajmans through a legacy of ancestors that only a Manganiyar musician can recite. In some cases, a jajman calls on their Manganiyar to only recite a shubhraj without an accompanying musical performance. In this way, the Manganiyar musician is able to make or break a jajman's reputation through reciting their shubhraj.

Beyond shubhrajs, Manganiyars provide music to accompany jajmani family births, weddings, religious festivals, and rituals. Musicians typically divide their repertoire into two forms, both of which contain many songs for different circumstances: *chhota git* (small songs) and *mota git* (large songs) (Kothari 1994, 227).[16] Chhota git are songs that have an immediate function and are directly associated with festivals, ceremonies, processions, and other events (figure I.6). For example, there are several songs that Manganiyar musicians sing at patrons' weddings, each corresponding to specific times in the wedding when certain ceremonies and rituals are performed.[17] One song is sung when the party of the groom (*banaa*) arrives at the house of the *banni* (bride) or touches the *toran* (a wooden ornament featuring a bird that has been hung by the *khati*, or family carpenter, above the entrance to the house) with his ornamental sword; other songs describe the beauty of the banni and the gifts of family members and guests. There are also chhota git that are sung at the birth of a patron's son that might

FIGURE I.6 Manganiyar musicians from the Alamkhana playing a large dhol drum. The one holding the drum plays the left head with a wooden stick and the right head with a hand. A second musician crouches near and plays the bottom of the right head with plastic sticks. Diwali celebration in the courtyard outside Jaisalmer City Palace in Trikuta Fort, 2007. Photo by the author.

describe the beauty of the baby, comparing him to Lord Krishna or a beautiful peacock. Chhota git tend to be structurally simple and usually consist of verses with a repeated refrain. In contrast, mota git are often performed in intimate connoisseur listening sessions called *kacheris* (Kothari 1994, 217–18). At these sessions, male patrons are often relaxing, imbibing opium, and appreciating the music. Mota git have been described to me as praise songs for patrons, gods, or specific *ragas* (musical modes or melody types).[18] Mota git begin with dohas that are sung in non-metered rhythm and without the accompaniment of the dholak.

Because the Manganiyars use the concept of raga and their music is highly theorized in relation to other regional music practices in South Asia, their music has often been compared with Hindustani classical music (Jairazbhoy 1977).[19] Daniel Neuman and Shubha Chaudhuri suggest that the raga is a concept foreign to the Manganiyar musical tradition and was most likely incorporated into the Manganiyar repertoire within the past few hundred years, most likely from Hindustani classical music (Neuman and Chaudhuri, with Kothari 2006, 105–11). However, most Manganiyars with whom I spoke claim that their use of the term "raga" is an indigenous one that is unique to their community. One can only speculate about to what degree that is true, or whether elements of raga have been picked up from the Manganiyars' exposure to Hindustani classical music and ethnomusicologists. It is clear that ragas are not standardized across the

FIGURE I.7 Two young Manganiyar musicians, Hanif Khan (left) and Latif Khan (right), learn to play the dholak as family gathers around and their grandfather, Sakar Khan, rests in the background on a charpai. Hamira Village, 2005. Photo by author.

Manganiyar community. The corpus of ragas varies greatly from one musician to the next, even within the same immediate family, and sometimes even from a single musician when asked at different times (for comparisons of Hindustani and Manganiyar raga theorization, see ibid., 96–103). Historical documentation and court records indicate that Manganiyar musicians had contact with Hindustani classical musicians in Rajasthani court performances (Erdman 1985). In the past fifty years, Manganiyar musicians have shared national and international stages with Hindustani classical musicians, from Ravi Shankar, the internationally renowned sitarist, to Vishwa Mohan Bhatt, the innovative Jaipur-based Mohan veena (modified Hawaiian guitar) player.

An old Manganiyar proverb states, "Manganiyar ka baccha rota hai, toh woh bhi sur mein rota hai" (Even when a Manganiyar child cries, he cries in tune). Children are said to pick up music by cultural osmosis: being exposed to music consistently from birth; watching their older male relatives play music; and attending patronal functions with their fathers, grandfathers, uncles, and other

male relatives (figure I.7). When speaking about musical transmission, many musicians say that children learn but are never taught. While this is often not the case today—Manganiyar children are now learning music in formal settings set up by Manganiyar community members and for Manganiyar musical transmission—the children still mostly learn music in informal settings.

Caste Orientations

I met Sarwar Khan, a musician and founder of the organization Lok Kala Sagar Sansthan (Ocean of Folk Music Organization), early in my dissertation fieldwork in the Thar Desert. In one of our first conversations, I asked him about his personal religious practices and those of the larger Manganiyar community. He first corrected me and asked me to not use what he believed to be a derogatory term for his community (Manganiyar) instead of what he considered to be a more neutral designation (Merasi). He then said bluntly to me, speaking in English: "I am whatever you want me to be. If you want Merasi to be Hindu, we will be Hindu. If you want us to be Muslim, we will be Muslim. If you want us to be neither, then it will be so."[20]

There is much to unpack in Sarwar Khan's statement in terms of religious and caste dynamics, flexibilities, and identities. Sarwar Khan's response to my question about Manganiyar religious practices speaks to the political and constantly shifting nature of community designation and self-identification in relation to caste, which often results when a low-status community seeks to raise its status, and the syncretic nature of religious practices of the Manganiyar community. This encounter made clear to me that religion and caste are intimately entangled for the Manganiyar community. I use the term "religio-caste" to describe the inseparable, entangled, fluid, and deeply local nature of Manganiyar lived experience.

Despite their importance for their higher-status jajman, Manganiyars' own status as low-caste musicians often ensures that they are treated poorly by the very patrons who need musicians for their cultural and social legitimacy. Manganiyars are therefore tied to their patrons through social and economic dependence, and because of this dependence, they are subject to their patrons' musical whims and rely on their financial generosity. Because the community members live within India's political borders as Indian citizens, they must abide by national policies of caste designation, the government regulated reservation system for school and political offices, and nationalist religious rhetoric of Hinduism and Islam. Their borderland location in the Thar Desert in western Rajasthan and their

proximity to Pakistan influences their syncretic religious practices and shifting caste affiliations. Such borderland practices need to be understood as social and historical processes (Piliavsky 2013).[21]

Sarwar Khan has made it his organization's mission to encourage musicians, scholars, and audiences to disavow the name Manganiyar, which he and many other Manganiyar musicians translate to mean *mangneywalle* (one who asks; beggar). The root of the community's name, *mangna*—which can be translated from Hindi as "to beg"—has been used historically throughout South Asia in the context of ascetic ritualistic and religious asking for alms (Saria 2019, 142).[22] Instead, he has chosen the designation Merasi, which is heavy with its own genealogical associations with hereditary Muslim musicians and accompanists (Lybarger 2011; Neuman 1980, 124–29). Many other Manganiyar musicians agree with Sarwar Khan's translation of their name but choose to still use it because of its contemporary recognition in the national and international performance world. However, Manganiyar musicians have changed their name, caste, and affiliation over the past several hundred years for various reasons having to do with migrations, adaptions, and new identity formations (Kothari 1990).

To complicate matters, the genealogy of the Manganiyar community can be very different, depending on who you ask. One musician told me that community members are Dalit, but many other Manganiyar musicians vehemently disputed this designation, stating that Muslims cannot be Dalit—despite the communities' common experience of subordination and poverty (Mosse 2018).[23] Another told me that the Manganiyar and Dhadhi hereditary musician communities are subgroups of a larger Dholi community and are differentiated only by their religion (Manganiyars are Muslim, and Dhadhis are Hindu). Manganiyar was the name that Komal Kothari, the folklorist and cultural impresario who first took Manganiyar musicians to national and international stages, chose to use for the community. Several Manganiyar musicians have chosen to be called Manganiyar to reclaim the derogatory name as their own in contemporary contexts.

In 1877, Sir Richard Burton (1877, 140) observed that while "beggar" may sound impolite in English, it is not an impolite work in Sindh: "An Oriental would generally prefer being under any kind of obligation to his superiors, than lack connection with them." He continued:

The Lángho is politely and accurately termed *Manganhar*, or "asker"; and his caste is the most peremptory and persevering of mendicants in Sind. Anciently, all the great clans had their own minstrels, whose duty was to preserve their

traditions for recital on festive occasions and, like the Highland piper, to attend the chief in battle, where they noted everything with an eagle's eye, praising those that fought, and raining showers of curses, taunts, and invectives upon all who fled. This part of their occupation is now gone: they subsist principally by the charity of the people, and by attending at the houses in which their professional services, at marriages and other ceremonies, are required. They are idle as well as fond of pleasure, dirty, immoral, and notoriously dishonest (ibid.).[24]

Questions arise as to the efficacy of caste for the Manganiyar. Has the social practice of caste dissipated since independence? Is the historical link between caste and occupation still intact, or has it been eroding since India's economic liberalization (Panini 1996, 60)? Is it possible for Manganiyars to experience mobility and marginalization at the same time? It is impossible to approach these questions without paying attention to the religious identity of the Manganiyar community.

Religion in Practice

Manganiyar religious identity has tended to be flexible to sustain livelihood through musical performance. While the community now identifies itself as Sunni Muslim, this has not always been the case. There seems to be a consensus within the community that its members converted to Islam from Hinduism in the early eighteenth century, along with many other similarly positioned communities throughout South Asia.[25] While historical records do not shed light on how and when various communities in north India converted to Islam, the transition most likely happened for an assortment of overlapping reasons: personal convictions and the spiritual influence of Muslim religious figures like Ismaili missionaries and Sufi mendicants, political aspirations and opportunities that arose because of Islam's inherently egalitarian and anticaste nature, forced conversion because of localized Hindu practices,[26] and safeguarding against violence and pillage from prevalent Muslim invasions in the region. One possible reason for Manganiyar conversion from Hinduism to Islam that I find particularly compelling was the fact that converting expanded the pool of audiences for their music. Hindu musicians were restricted by custom to having patrons from certain castes and were forced to maintain hierarchical relationships that reflected caste norms. In contrast, Muslim musicians were free to perform for diverse castes and communities of Hindus and Muslims.

Yet religious conversion did not mean the wholesale adoption of religious practices for the Manganiyars but was most likely partial (Mayaram 2003). Conversion "presupposes a binary logic, as well as a transformation of religious belief and practice 'from' one given state 'to' another" (Mayaram 2011, 37). Conversion to Islam among the Manganiyars was nominal. In fact, their religion can be viewed as a discursive practice, a strategy which allows us to examine practices in localized contexts without essentializing them in terms of authenticity and orthodoxy (Vatuk 1996). A more normative egalitarian form of Islam contrasts sharply with Manganiyar Muslim syncretic lived religious practice in the Thar Desert, where strong principles of hierarchy and unequal relations remain central. In this way, Manganiyar religion cannot be untangled from caste. Manganiyars do not study the Qur'an or follow Hadith. While they do follow Muslim cultural practices like circumcision and burial of their dead, for the most part they follow Hindu cultural traditions rooted in the local systems of caste society in the Thar Desert. Members of the Manganiyar community tend to use their religious identity to strengthen their affiliation with their jajmans as a way of achieving upward social mobility. This means that even though they are Muslims, they adapt their religious and cultural practices to align with those of their Hindu jajmans.[27]

Although the Manganiyar community converted to Islam over three centuries ago, there has been increasing Islamization, or the diffusion of custom-centered Islamic practices, in the community in recent decades.[28] In the case of the Manganiyar, Islamization does not usually refer to bringing various facets of life into accordance with the teachings of Islam but instead refers to changes in the community's cultural practices.[29] The community's identity creates a unique and liminal Muslim self, rooted in local practices. In practice, Islamization has meant changes in mostly outward appearances: giving babies Islamic names, eating meat only if it is halal, and men wearing kurta pajamas instead of dhotis and sporting beards rather than just mustaches. Islamization has also affected other cultural practices like education (sending children to madrassas); religious practices like *sunnat* (circumcision), *nikah* (Islamic wedding practices), and *janaja* (coffin burial); and political affiliations with Muslim political groups and parties in India and Pakistan, as I discuss in chapter 4. Even Manganiyar music shows Muslim influences, with many more musicians performing a Sindhi Sufi repertoire.[30]

Islamization has been identified by many Manganiyar musicians as being one of the most important factors in seeking contemporary performance op-

portunities.[31] As Manganiyars Islamicize, there is a partial unlinking of caste from performance, and they no longer depend solely on traditional patronal relations and their jajmans for their own community's status. Inherent in this process is urbanization. Beginning in the 1970s, with increased performance opportunities in the local tourism industry and travel to other parts of India and abroad, Manganiyar musicians began spending more time in cities like Jaisalmer, Barmer, and Jodhpur.[32] In the past decade, entire Manganiyar families have moved to urban centers, established households there, sent their children to city schools, and continued to establish urban performance connections and opportunities.

As traditional patronal ties with Hindu jajmans become less lucrative for Manganiyar musicians, they feel less bound by the traditional exchange inherent in their relationships with their jajmans and can therefore more easily relocate to escape inherent village casteism and prejudice (Manuel 1996, 122; Neuman 1980, 26–27; Panini 1996, 60). Some musicians told me they enjoy anonymity in the city, where they are freer in their movements and actions and are less restricted by caste-based discrimination and livelihood. Many Manganiyar musicians still have homesteads in their villages and return for patronal functions. Due to their improved financial situation, they can own their own cars and motorcycles and can access public transportation (trains and buses) to easily travel between rural and urban homes. Thus, both Islamization and urbanization have weakened ties between Manganiyar musicians and their traditional patrons, allowing the former to take advantage of new performance contexts.

It should be noted, however, that Islamization is not necessarily a unidirectional process that leads to orthodoxy. Instead, it is contextual, reversible, and constantly shifting (Mattison 1975). Furthermore, it is inherently tied to other shifting social identities such as status, caste, and locality. The Manganiyars continue to be rooted in Hindu-based caste society. Their practice of Islam does not allow them to fully escape hierarchical and sometimes violent caste discrimination, as in the case of Aamad Khan. No amount of auspiciousness attributed to their shubhraj and ritual performances will rid them of the perceived impurities that keep them tightly bound to their low-caste position in their villages. For the Manganiyar, then, their religio-caste practices are dynamic and intertwined with larger politics of marginalization and mobility in the Thar Desert region and both India and Pakistan.

Women of the Manganiyar Community

While Manganiyar men are expected to perform outside the home as a traditional livelihood, Manganiyar women are expected to stay in the homestead, spending their days cooking, cleaning, and taking care of children. They are often not allowed to leave the village without the company of a male family member. They practice purdah, which in the Manganiyar community means that after marriage, women wear *ghoonghat*, a sheer cloth that covers the head and face, and they are expected to stay out of the sight of men and therefore reside mostly in the inner household of their homestead in the village. Yet they are often regarded as the heads of households, in charge of household and extended family finances.

Historically, Manganiyar women performed a separate women's repertoire in traditional patronal contexts for women jajmans only. Their repertoire was very different from the Manganiyar male repertoire, revealing the women's intimate worlds and shedding light on religious practices, rituals, kinship ties, family gender roles, and sexuality. Their songs tended to be rhythmically simple, based on short melodic compositions, and were sung heterophonically. Manganiyar women tended to sing in groups of three to ten women, who sat on the ground, huddled around one woman accompanying them on a *dhol*, a large, double-headed frame drum (figure I.8). These music sessions still happen at intimate gatherings within the Manganiyar community. I have attended several of them, in which women participate in singing with great enthusiasm and lack of inhibition.

After independence, economic, political, and social changes shifted women's role in public performance contexts. Beginning in the nineteenth century and based on colonial era influences, Indian social reformers' and urban intellectuals' attention was drawn to forms of women's entertainment (by women and for men and women). The reformers and intellectuals sought to adhere to Victorian notions of domesticity and gendered spaces and to change women's social behavior that threatened to disrupt the patriarchal societal order (Jassal 2012, 4). As communities aspired to become more cultured and upwardly mobile, women were restricted, restrained, and forced to withdraw from the workforce. Women's actions do not emerge from free will but from dictates of custom, tradition, and coercion (Mahmood 2005, 208). If women stayed at home, that gave their household more status and the men in their family more respectability, so Manganiyar women were discouraged from performing publicly.[33] Kothari, who began working with the Manganiyar community in the 1960s to craft their performances for outside audiences, encouraged male Manganiyar musicians

FIGURE 1.8 A group of Manganiyar women in ghoonghat sit around a dhol drum, singing wedding songs in celebration of the young bride, who is sitting behind them. The woman in the center plays the dhol with her hands as those around her sing together and Manganiyar children listen. Barna Village, 2006. Photo by author.

FIGURE I.9 Rukma Bai was the first contemporary Mangani-
yar woman to sing publicly, encouraged by Komal Kothari to
perform onstage after she was widowed at a young age.
Barmer City, 2008. Photo by author.

to sing songs from the Manganiyar women's repertoire to keep the songs in
circulation.[34] As a result, several Manganiyar chhota git are derived from the
women's repertoire and are sung from the viewpoint of women. Although not
uncommon, this strategic move of repertoire maintenance has been read as an
appropriation of women's music, used to "displace its defiant voice" from women
onto men (Fleuckiger 1996, 3).

There are exceptions to women's not performing publicly. Rukma Bai was
most likely the first woman from the Manganiyar community to sing publicly in
the second half of the twentieth century (figure I.9). Almost abandoned by her
family due to her disability (she suffered from polio as a baby and was never able
to walk) and status as a widow (her husband died when she was very young, in
a community where being a widow is considered taboo), she began performing
music to support herself. She began her public performance career in local village
temples and shrines, and was later encouraged to perform publicly by Kothari.[35]
By the early 2000s, after numerous national and international performances
with Kothari, Rukma Bai became one the Thar Desert's best-known voices. Her
female relatives, most notably Akla Bai and Dariya Bai followed suit and began
to perform on the stage as well. Similarly, but outside the purview of this book,

Mai Dhai has become a famous public singer just over the border in the Thar-prakar Desert, in Pakistan. She formed a band called Mai Dhai Band and has performed publicly on international stages and most notably on the Pakistan national television shows *Coke Studio Pakistan* and *Lahooti Live*.[36]

From Patronage to Postpatronage

The spaces in which Manganiyar male musicians traditionally perform for patrons are liminal, which means that musicians can transcend religio-caste boundaries through the power of music (Katherine Brown 2007; Fiol 2010). The paradoxical power the musicians harness is confined to the spatial and temporal context of the musical event. For the Manganiyar, this means that outside of pa-tronal performance spaces, they are considered low-caste (despite their religious adherence to casteless Islam); are generally treated poorly in public settings; live in poverty on the outskirts of villages; have little access to village resources like education, water, and electricity; and have no hope (in this generation or future ones) of escaping their low musician caste status.

With the support and interest of Komal Kothari and his organization, Ru-payan Sansthan, and later with the rise of cultural tourism in the Thar Desert, Manganiyar musicians began to perform throughout India and then on in-ternational stages around the world.[37] I define this as a postpatronage, when patronal musicians use traditional patronage as a model and cultural capital to create new performance contexts and relationships within the contemporary cultural milieu. Postpatronage encompasses the complicated and messy nature of contemporary Manganiyar performance practice and refers to a constellation of situated knowledges that are innovatively constructed and facilitated through networks of cultural brokers (individuals, organizations, governments, local and international festivals and music circuits, and virtual fan bases). My use of this term takes into consideration the hybrid spaces in which Manganiyars perform today. In postpatronage, patronal musicians entwine themselves in market econo-mies, seek social prestige, and insert themselves in cultural dimensions outside of customary patronage, all while maintaining a sense of pride and lineage through their ties to their jajmans and traditional patronage.

In many respects, postpatronage is a form of resilience. While both postpa-tronage and resilience are ways of thinking through how the Manganiyar com-munity is surviving (even thriving) after the collapse of traditional patronage, postpatronage as a form of resilience requires musicians to draw on traditional

patronal relations that they have known for centuries, changing them to fit contemporary contexts. However, they must remain rooted in a previous way of life centered on patronage. I claim that this rootedness and dedication to music as a livelihood is what has enabled Manganiyars to be resilient as musicians. This story is not unique to the Manganiyars but is increasingly common and therefore relevant, as artists around the world who have historically been enmeshed in local performance systems are increasingly changing their performance practices to fit into global performance contexts.

ETHNOGRAPHIC TECHNIQUES

The term "participant observation," which describes the act of peering into people's lives, observing them, and participating in them, obscures the relationship between ethnographers and their interlocutors and is burdened with certain assumptions about the relationships between ethnographers and the communities with whom they work. Instead, I use the term "ethnographic techniques" to invoke the combination of skills, craft, and maneuvers that I have used in the research conducted for this book as well as those techniques used by the many interlocutors who contributed to this book in the ways they shared their musical knowledge with me. The term also captures the "intimate distance" (or the gaps, mediations, and misunderstandings) that is inherent in the ethnographic fieldwork whose results I discuss in this book (Bigenho 2012).

This book is based on countless interviews, informal conversations, car rides, recording sessions, concert tours, and the months at a time that I spent living with Manganiyar families, mostly in the Thar Desert. I did all this in the hope of learning about their musical lives. I listened closely to them as they told me their stories, sang their songs, and showed me their worlds. But ultimately this book is written from my perspective, based on my interpretations of the ethnographic moments I witnessed and shaded by my prior experiences and assumptions of who the members of the Manganiyar community were, are, and will be. I toggle back and forth between contemporary moments of ethnographic accounts, historical oral traditions, and speculations about the future. Whenever I can, I use quotations and stories that were told to me to include Manganiyar musicians to the best of my ability in the format of ethnography. I place myself in this ethnography because I was there. I intertwine these firsthand accounts with my own experiences and observations of contemporary Manganiyar musical life.

FIGURE I.10 Mixed group of Thar Desert musicians on tour in the US.
From left to right: Gazi Khan Harwa, the author, Chanan Khan, and
Habib Khan Langa. Gambier, Ohio, 2008. Photo by author.

After I completed my doctoral work of twenty-four intense and uninterrupted
months of fieldwork in India (2005–2007), I continued to make short field trips
to western Rajasthan, usually once a year for a few months at a time. Between
these field trips, I kept my fieldwork relationships going through social media,
phone calls, and in-person visits when musicians were on tour outside of India
(figure I.10). I managed to host and visit with Manganiyar musicians performing
in the United States, Canada, and Europe. After I had a baby, my trips to the Thar
Desert became fewer and further between. I was forced to substitute short visits
for extended fieldwork stints. As my trips with interlocutors grew into visits with
old friends but became increasingly shorter, a more multidimensional picture
of their lives over years emerged for me. I hope that throughout this book I give
readers a sense of how my ethnographic life intertwined with my interlocutors'
musical lives.

I place myself at the center of this ethnography: every story, observation, and
quotation from a musician is shaped by my point of view, my presence, and my

responses to interlocutors' words spoken to me. I therefore constantly turn the lens on myself, through reflections on ethnographic moments and the work that goes into research and writing. In the past decade, autoethnography has emerged as a critical ethnographic methodology (Spry 2016). Autoethnography works to "capture the complexities of intersecting power relations" by producing multiple and diverse perspectives and voices (Collins 2016, 135). Such techniques take into consideration the ethical implications of not just the people ethnographers study, but also the insertion of ourselves as ethnographers into their lives and the lives of our readers.

How might this book have been different if I had not identified myself as a woman in a musical world where women do not participate? Would I have had the same access to musicians and their families if I had not been South Asian American with phenotypically South Asian features? If I were differently abled, would I have been able to access the villages in which I worked, with their lack of electricity and transportation and their distance from medical care? People of the "wrong" gender, age, class, and ability are often excluded from participating and observing (Barz and Cheng 2019). By turning the research lens around, we can expose the many limitations of traditional ethnography (Shah 2017). For me, it is imperative and urgent to do so: I believe that our job as ethnographers is as much to study "us" as it is to study "them."

For me, the biggest research hurdle was being a woman in a region where women are not independent and for the most part reside in gender-segregated spaces. I struggled with how to observe traditional musical practice in male-dominated contexts where at best women are not welcome and at worst they are harassed and assaulted. I learned early on that I needed to conduct my fieldwork using ideas of feminine presentability and Manganiyar masculinity. I was discouraged from attending all-night music events due to concerns for my safety, advice that I heeded with worry and alarm. I therefore simulated traditional Manganiyar performances by inviting and paying musicians to travel from their villages to my rented apartment in Jaisalmer City, which attracted neighbors' attention, speculation, and gossip. I was not able to focus my research too closely on performance practice in traditional contexts for this reason.

Being a woman did have its advantages. Although this book focuses on male-dominated music practices, I became very close to the Manganiyar women who are the wives of my male interlocutors. I would not have been able to enter women's spaces if I had been a male ethnographer. During my fieldwork visits to

villages, most Manganiyar male interlocutors would encourage me to enter the women's domain of their homestead, usually an inner room off the courtyard of their house or the dark kitchen. It is in those spaces that I had illuminating conversations about Manganiyar women and learned about their lives, which influenced the ways I think about their husband's lives as professional performers.

Throughout the research and writing of this book, I struggled with ethnography as a mode of communication. Personal stories of ethnographic field methods and working with living, breathing, and feeling people are too often left out of ethnographic representations. Yet these personal stories may be the most important unwritten or invisible part of ethnography. Working with people can be messy and difficult: lines are crossed or avoided, and relationships are made and broken. Is written ethnography—the representation, description, and interpretation of fieldwork—the best way to share the world of the Manganiyars and their music? Is it the best way to communicate the stories I want to tell? This book is a testament to my belief that it is. However, I am very aware of what gets left out of written ethnography: the sounds of laughter, tears, and the tuning of instruments; the awkward silences and heavy pauses in conversations; the texture of the desert sand in my hair, shoes, and recording equipment; and the unbearable heat in the summer and cold in the winter.

A ROAD MAP OF RESILIENCE

This book charts the significant forces that fashion Manganiyar resilience—patronal and postpatronal— including tourism and touring, development and its failures, and political action, and the ways music engages these. There are whispers (and at times shouts) in one chapter that resonate in another: such is the nature of ethnographic messiness. Despite this, the book generally follows a chronological timeline.

Having laid out the key framework of resilience, I begin in chapter 1 by outlining the practice of musical patronage in South Asia among the Manganiyars and their traditional patrons. Following a historical thread, I trace the diminishing practice of musical patronage in western Rajasthan through India's independence (1947) and the abolition of the *jagirdari* (land tenure) system, an authoritarian land tenure system that dates from the thirteenth century and thrived during Mughal rule. With these changes, so too did musical life change in postcolonial Rajasthan. In my discussion, I think through the historical reasons for both

patrons and musicians to maintain the practice of patronage. I introduce the concept of postpatronage to better understand Manganiyar musical life outside of traditional patronage. Postpatronage (a concept based on postcolonialism), uses traditional patronage as a platform for new performance contexts and relationships with new cultural brokers to support music in innovative ways. I introduce Kothari, whom I consider to be the Manganiyars' first postpatron. I examine formative experiences from his early life that shaped his postpatronal philosophies and that have affected Manganiyar contemporary life. Using the case study of a contemporary Manganiyar musician producing his own crowdfunded album to demonstrate postpatronage, I conclude that postpatronage is a form of resilience, a way for the Manganiyar community to survive and thrive after the collapse of traditional patronage.

In chapter 2, I carry the framework of resilience forward to the realm of cultural tourism and touring abroad for the Manganiyar community as postpatronage in postindependence India. I tell the extraordinary story of the rise of cultural tourism in Rajasthan, supported by early Rajasthan State sponsorship and nationalizing postcolonial institutions like the Sangeet Natak Akademi (Music and Acting Academy) and the Indian Council for Cultural Relations. Using thick descriptions of Manganiyar presentations of culture and music, I coin the term "subaltern chic," which describes the material ways Manganiyar musicians navigate a postpatronal world in terms of dress, instrumentation, repertoire choices, and presentation style and refers to their constant harking back to patronal relations as a marker of authenticity and heritage. Well-known as bearers of tradition by Indians, international tourists who have visited India, and concertgoers the world over, Manganiyar musicians have become national and international representatives of traditional Indian culture. Their presence has come to represent a past Indian grandeur, while quintessential Indian ideals of simplicity, innocence, and a pastoral timeless India pervade Manganiyar music and its representations.

Through the lens of postpatronage, I follow Kothari's engagement with the Manganiyar community from their first meeting to his death. I use the case study of the enormously popular contemporary theatrical production "The Manganiyar Seduction" to stabilize my arguments about the ways Manganiyar musicians come to signify and materialize subaltern chic. It is precisely through the act of personifying nostalgic subaltern chic that Manganiyars can imagine futures for themselves. At the end of chapter 2, I return to an unanswered question—namely, why might musicians and patrons continue to practice traditional patronage in

contemporary times? In other words, why might Manganiyars continue to feel beholden to their jajmans in the face of capitalism, national and international recognition of their music, and their greatly expanded performance opportunities?

In chapter 3, I further reveal the complexity of resilience through the Manganiyar community's involvement in localized development. In the early 2000s, almost every village where Manganiyar musicians lived had at least one Manganiyar-founded *sansthan* (organization or registered NGO) dedicated to various development-based causes important to the Manganiyar community. The causes included musical preservation; improving access to water; documenting sung poetry; campaigns to outlaw the use of the name "Manganiyar," which — as noted above — some considered to be disrespectful and derogatory; reviving the art of making traditional instruments like the kamaicha that were no longer being made; and promoting cultural and ecotourism in the Thar Desert. Musicians were using development rhetoric to speak about their community and music through what I call "development imaginaries," in which Manganiyars imagined development not as mirroring actual practices but as representing ideas of what development by and for their community could and should look like (Escobar 2012; C. Taylor 2004). As they established their own sansthans, they negotiated new postpatronal positions, weathered the environmental shifts of climate change, and navigated the rise and fall of developmental NGO culture in a region where promises outnumbered deliveries. How did Manganiyar development imaginaries reflect or deflect common development practices in the region? What influences did development have on musical practice, and how did Manganiyar development imaginaries coincide with common teleological development narratives?

By 2013, most of the sansthans were no longer functional. What happened to aspirations for localized development? How could a practice that seemed integral to Manganiyar life in the early 2000s fade so quickly from their lives? Instead of working for their sansthans, they were feverishly networking and making connections to perform more often, both in India and abroad. With their busy touring schedules, musicians no longer had time for development. Had development failed to materialize for the Manganiyar, and they had thus given up on it? Or did the concept of development imaginaries — future imaginings of what development would be for the Manganiyar — take on different aspirational meanings for the community?

I use the lens of resilience again to analyze this moment of breakage. Manganiyar musicians were able to take the skill sets they learned from local development

practices and their development imaginaries and apply them to new musical practices, a process that was manifested as an emerging regime of commercial self-promotion and touring. Through resilience, Manganiyars have been able to move through different states or temporary equilibria—some more desirable than others—in response to inevitable series of ecological and social events and disturbances (Worster 1993, 149–50). In this way, resilience is not about returning to some sort of predisturbance equilibrium after an event, but about the existence of temporary equilibria: multiple ways of living and being that arise from going through difficult times and ecological or systemic changes.

In chapter 4, I develop the theme of political action among the Manganiyar. Historically the community was not involved in electoral politics—by which I mean supporting candidates through campaigning, singing campaign songs, and soliciting resources from politicians. Nor were community members invested in any overtly political ideas. They depended on their traditional patrons, rather than politicians, for resources. With a transition to postpatronage, Manganiyars have been forced to turn elsewhere for resources and, because of their rising international profile, have begun to invest in local and regional politics.

I use the 2014 Lok Sabha (House of the People; the lower house of India's Parliament) election in Barmer District of western Rajasthan as the main case study in this chapter, grounding Manganiyar musicians in contemporary political action. I claim that while this was not necessarily the first time that Manganiyar musicians campaigned for a political candidate, the constellation of events that led up to Manganiyar involvement in this election has served as an impetus for Manganiyar musicians to become political activists since then. Using postpatronage to turn traditional patronal practices to the service of contemporary political involvement, Manganiyar musicians are involved in politics now more than ever: they campaign for candidates, speak out against inequalities, and ask for resources for their villages and community. Manganiyar political involvement is now destabilizing regional power relationships. The Manganiyar community's newfound ability to organize indicates how their circumstances have allowed them to distance themselves from dependence on patrons and thus increase their resilience as independent musicians.

In the conclusion, I draw out the methodological implications of the book, pointing to the importance of resilience in the sustainability of music as a livelihood for the Manganiyar community. I come full circle in my analysis of postpatronage as a contemporary performance model for the Manganiyar community by returning to ethnography. I conclude by describing a transmedia project that

relies on participatory media and collaborative storytelling to offer new paths for merging ethnography and community outreach (Jenkins 2007 and 2019). In this project, Manganiyar musicians create their own video and audio content using recording kits and technological platforms that already permeate their everyday lives (iPads, smartphones, Facebook, youtube.com, Instagram, and so on). I encouraged them to share content and collaborate through remixing, reusing, and collaborating. These methods reveal multiple layers of stories that are continuously made and distributed to the community and fans through postpatronal networks. In future stages of the project, I will set up community viewing and listening sessions for musicians to share their collaborations and foster conversations about issues important to them and the Manganiyar community. Using transmedia as a methodology, my goal is to create not simply a film about an issue but an enterprise that calls international, Indian urban, and Manganiyar community audiences and participants to work as a commons, setting in motion the production, assessment, and archiving of more stories in the community and beyond.

In the chapters that follow, I narrate the ethnographic experiences and stories of Manganiyar musicians to demonstrate different interpretations of resilience and the ways Manganiyar musicians both thrive and fail through its embodiment. These stories provide poignant examples of how musicians are harnessing resilience to adapt to cultural change and technology, while simultaneously drawing on notions of tradition and nostalgia to continue to make music a relevant livelihood in a contemporary world.

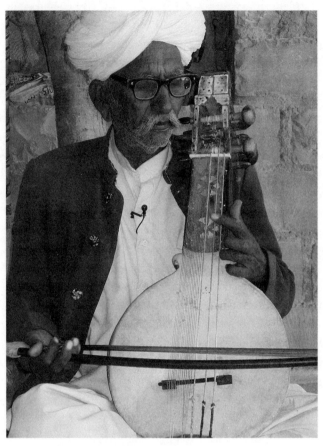

FIGURE 1.1 Sakar Khan playing the kamaicha at a jajman
function. Hamira Village, 2006. Photo by author.

ONE

(Post)Patronage

IS IT ENOUGH OR TOO LITTLE?

In 2012, on the first morning of one of my many stays in Hamira Village during my fieldwork, I awoke early to see Sakar Khan tuning his *kamaicha* near the *charpai* (traditional woven bed with a wooden frame) where I slept, in the inner courtyard of the home. It was a cold winter morning, and the sun was just beginning to peek above the misty sand dunes in the distance. Most members of Sakar Khan's extended family were still sleeping, but I could hear the clattering of metal cookware coming from the kitchen, a small dark room off the courtyard. Sakar Khan was a close interlocutor for my dissertation research (figure 1.1). I spent weeks on end living in Hamira Village with his extended family during my dissertation fieldwork. All four of his sons are renowned musicians, and I learned much from the family. Sakar Khan grew up in a traditional Manganiyar household in Hamira Village and, unlike many other Manganiyar musicians of his generation, had always maintained close familial ties and personal relationships with his *jajmans*. He began working with Komal Kothari in the late 1960s and went on numerous national and international performance tours—first with Kothari, then with government sponsorship and as part of various organizations. Sakar Khan was an unassuming and humble musician despite the many national and international awards he received for his playing, the decades of international touring he did, and the countless students he trained.[1]

Sakar Khan sat on a wool rug on the dusty sandstone floor. He coughed as he lit a bidi and put the match out by rubbing it on the wool blanket. Leela, one of his daughter-in-laws, tiptoed out of the kitchen with her face covered in

ghoonghat and placed in front of Sakar Khan a steaming hot metal bowl of chai and a metal plate with last night's warmed-up dinner—*daal* (lentil soup) and *sogra* (flat bread made of pearl millet). He took a long drag on his bidi, acknowledged Leela, and tied his turban on his head before he slurped his chai and ate his breakfast. As he packed up his kamaicha, he noticed I was awake and told me that he was going to his patron's house to perform for the wedding of his patron's daughter. I had never witnessed Manganiyar musicians performing at a jajman's wedding (it is a rare occurrence for outsiders to observe traditional patronal relations in practice) and wanted to go with him. But I knew I should not ask to go, since that request might put him in a difficult position with his jajman. I watched Sakar Khan bundle himself into his faded and tattered black wool coat, which he wore over a white T-shirt and dhoti. After he left the house, with his kamaicha slung over his shoulder, I drifted back to sleep.

That evening after dinner, I sat outside under the stars with Sakar Khan as he played for me what he called "Ma-Raat," a wedding song he had played for his jajman earlier that day. After he finished, he told me that he has songs for every happy occasion for his jajman, counting at least twenty-five different song types and then describing to me a few songs that a Manganiyar performs to accompany the most minute of tasks associated with a jajman's wedding.[2] "Kenku Patri" and "Pili Chawal" are performed when the *khawas* (barber) delivers rice stained with yellow turmeric (symbolizing wealth and fertility) and wedding invitations to invited guests at their homes. He even described a song performed when the village tailor measures the *banni* for her wedding dress (for a detailed list and description of songs sung at weddings, see Neuman and Chaudhuri, with Kothari 2006, 54). Sakar Khan then flashed a rare smile. He told me that he had asked his jajman if I could observe one day of the wedding festivities, and he invited me to accompany him the next day. I already knew that relations between Sakar Khan's family and his jajman had remained fruitful and that the jajman family had been magnanimous over the past several generations.

When we arrived at the jajman's home the next morning, I saw a large *dhol* sitting on the dusty porch. Sakar Khan told me that he had placed it there during a performance of "Sanji Dena," which accompanies the ceremony announcing the beginning of the wedding festivities. To the right of the dhol was a large open space in which a colorful tent had been erected, and approximately fifty men were sitting and lying in the tent on thick wool blankets. The musicians were gathering on the ground to one side of the tent where they were to perform. Before joining them, I was taken into the home to meet the *banni* and her father and mother as

she was being dressed. The inner courtyard was full of women and girls, mostly dressed in red, and it was difficult to pick out the banni, who was also wearing red. I was finally taken to meet her. I gave her father a gift of a thousand rupees and was then escorted out to the tent and asked to join the musicians.

The family of Manganiyar musicians had already begun playing music when I was invited to sit down in a chair to the side near the Manganiyars. Sakar Khan was playing kamaicha and singing; his oldest son, Ghewar Khan, was also playing kamaicha; his second son, Firoz Khan, was playing the *dholak*; and Latif, his fifteen-year-old grandson, was playing the *khartal*. Ten-year-old Dilip, another grandson, was sitting without an instrument and observing. The musicians began to play a song from the *chhota git* genre of *banni git* (bride songs), singing about the beauty of the banni, her wedding dress, and the *mehndhi* (henna) on her hands.

Soon after this, a private bus arrived from Jaisalmer City carrying the *banaa* and his extended family. More of Sakar Khan's male relatives had arrived, and two young boys began playing the large dhol that had been placed on the jajman's front porch to welcome the banaa and his family to the banni's home. The *baraat* (groom's party) danced to the beats of the dhol as they approached the home. When they reached the entrance, the drummers stopped playing and Sakar Khan began to play "Toranio," a song about the *toran*. Sakar Khan sang, accompanying himself on the kamaicha as Firoz Khan played the dholak. The banaa, dressed in a formal suit with a *safa* (colorful tied turban), a *mala* (flower garland) around his neck, a sword at his waist, and a large red *tika* (a mark worn for special occasions or worship rites) on his forehead, approached the entrance of the banni's home and was greeted by the women of her family. He was given a branch of a neem tree and unsheathed his sword, touching both to the toran as part of the ceremony to ward off the evil eye from the marriage.

Sakar Khan then played "Sambela," a song sung when the banni's mother and other women from her family greet the banaa with a ceremonial plate filled with sweets. Sakar Khan's playing preceded the *aarti* (fire worship), and it was as if the patron's family members were using his music as cues to guide the ceremony. The women fed the banaa *kacchi aarti* and *pakki aarti* (raw and cooked sweets fed to the banna as a form of worship). All the while, Sakar Khan and the other musicians remained seated under the tent and continued to play music, following what was going on as part of the wedding but also playing *riyan* (musical interludes) to entertain the guests between wedding events. The transitions between musical pieces were seamless.

The banaa was then seated on an ornamental chair in the tent while men from his and the banni's families embraced, exchanged pleasantries, and sat down together on the rugs placed in the tent. After chai had been served to the men (there were nearly a hundred now) seated or lying in the tent, Sakar Khan and his older sons began what has been described by Kothari (1994, 217–18) as a *kacheri*. They began with a *shubhraj* and continued by performing *Raag Kamaichi*, which lasted more than twenty minutes. During this time, the male members of the jajman family and other wedding guests listened and chatted. At the end of a poetic stanza sung by Sakar Khan or a poignant melody played on the kamaicha, a few of the Rajput wedding guests would express their appreciation by raising an arm with the hand open and exclaiming loudly "Wah!" (Whoa!) or "Kya baat hai!" (What expression!)—interjections also made by appreciative and knowledgeable audiences of Hindustani classical music (Rahaim 2012, 7). The kacheri continued with an opium ceremony in which the banni's father fed each of the older male wedding guests ceremonial opium mixed with water from his hand. Occasionally a guest presented *ghol*, money given as a tip to musicians that is first waved around the head of the banaa and then placed in front of the musicians on the ground or on their instruments.

After the kacheri had lasted an hour, the musicians finished playing, packed up their instruments, gathered the ghol in a cloth decorated with hand-block printing that Sakar Khan had had wrapped around his neck for much of the day, and said goodbye to their jajman with bows and greetings of *khamaghani* (literally, "many greetings and blessings"; the term refers to a respectful Marwari greeting given to members of a higher social class). The bonds between Manganiyar musician and jajman were evident throughout the day. Sakar Khan and his family were entrusted with performing important musical and spiritual functions at the wedding in the jajman's family, and the festivities could not have happened without the musicians' presence. The jajman and guests sat and listened respectfully to Sakar Khan and his family perform: it was clear that they were knowledgeable about the songs and other music performed. Although they were working throughout the wedding, Sakar Khan and his family were treated like guests, fed, and praised. The longevity of the patronal relationship was demonstrated by the multiple generations in attendance—three generations of musicians performing or learning how to perform for jajmans and three corresponding generations of jajmans appreciating the music and observing how to be patrons.

As we walked back to Sakar Khan's home, he told me that the musicians would be going back late that night to perform for the marriage *pheras* (the banni's and

banaa's ceremonial walking around the marriage fire). He also told me that the next day, after the festivities finished and the banni and banaa had left, he would remove the dhol from the jajman's front porch, signaling the end of the wedding, and he would be given a coconut and cloth for *lehenga-choli* (traditional women's dress) for the women in his family. I asked him if that was all he would receive from his jajman. He told me that the *bhati* (payment given by a jajman to the Manganiyars for a jajman's daughter's wedding) would be delivered to his family intermittently over the course of the few years after the wedding and would consist of a combination of livestock (a camel, a horse, goats, and sheep), gold, and grain. I asked him if the payment was enough or too little to provide for his large family. He chuckled and then was silent on the rest of the walk, clearly not wanting to discuss traditional patronal relations and tired after a long day of performing.

Sakar Khan's reluctance to speak about patronage in terms of economics rather than art left me with more questions than answers. What is the nature of the relations between Manganiyars and their traditional patrons? Why might Manganiyar musicians, especially those considered resilient and successful in national and international performance contexts outside of traditional patronage, continue to maintain ties with their traditional patrons? In other words, how has traditional patronage continued to be a resilient practice in contemporary neoliberalizing capitalist India?

In this chapter, I tell the story of Manganiyar patronage by first providing a historical overview of traditional patronage relations in the Thar Desert. I then look at the factors contributing to the decline of patronage and the effects on Manganiyar musicians. Because of this decline, many Manganiyar musicians began supplementing traditional patronage with more lucrative contemporary forms of musical performance through the cultural tourism industry, international touring, and other music-related venues. I place these contemporary performance contexts in the frame of what I call postpatronage. With deep roots in traditional patronage, postpatronage encompasses new performance opportunities and ties with international and cultural institutions. While post-patronal performance contexts are distinct from traditional musical patronal practices, they are still rooted in and defined by the deep traditional patronal relationship of which Manganiyars have been a part for centuries. Manganiyar musicians engaged in postpatronal relations model their interactions with diverse contemporary audiences on their traditional patronal relations with jajmans. In this way, Manganiyar musicians can be resilient in their musical performance by finding new ways to sustain that performance as a livelihood.

THE HISTORY AND DECLINE OF MUSICAL PATRONAGE

For music to thrive in hereditary communities, there must be a social structure in which artists are not only financially stable but also socially secure enough to have the means and impetus to make music and pass musical knowledge on to their descendants. Artists do not create art in a vacuum or in isolation but must rely on networks and institutions to bear the costs of artistic production. But these networks and institutions must be able in turn to appropriate some of the value of the artistic creation they are supporting. Patronage thus refers to a reciprocal network in which goods, services, support, and (in the case of the Manganiyar) music are exchanged for payment. Payment is often nonmonetary, and because of this, patronal relations have tended to flourish where formal in-stitutionalized central authority is weak or not able to provide adequate goods, services, and security to local people. This is the environment in which musical patronage relations between Manganiyars and their jajmans have flourished for centuries in the Thar Desert region.

From the earliest anthropological studies of South Asian patronage, scholars devised a system to frame patronage (Wiser 1936). Scholars placed the jajmani system at the heart of structuring a predominantly Hindu society (Dumont 1980), conflated the Hindu caste system with patronage (Hocart 1968), and foregrounded the role of landownership as structuring patronage (Fuller 1989).[3] Such interpretations glossed over the diversity of regional patronal practices of exchange, the role of religion in patronage, and specific case studies of lived experience. Using a methodology that was rooted in a comparative tradition of scholarship, scholars of patronage pitted an India based on the jajmani system against Western capitalist economies and ideologies, thus eliding inevitable diachronic changes to patronage in favor of imagining a timeless, monolithic, and archaic village India. Ethnomusicologists, following anthropological trends, continued to use the term "jajmani system" well into the 2000s (Jairazbhoy 1977, 50; McNeil 2007 and 2018; Qureshi 2002; Snodgrass 2004, 265; Wade and Pescatello 1977, 298).[4]

In the context of music in Rajasthan, the oft-recounted teleological narra-tive of the patronage system is taken for granted: existed on the subcontinent in premodern times, flourished under Mughal rule, declined when the British established colonial rule in the nineteenth century, declined further after inde-pendence in 1947, and eventually vanished, to be replaced by a "new commercial environment fraught with economic and artistic uncertainty" (Farrell 1993, 32).[5]

This narrative simplifies a more complicated history. In the seventeenth century, the title of Rajput was given to Indian men who had served in the military and were given land on which to settle after serving. As these diverse military land-owning endogamous clans abandoned their nomadic and peripatetic lifestyle in favor of settling permanently, they began to be collectively known as Rajput.

The *jagirdari* system helped solidify Rajput rule in the Thar Desert. While maharajas and Rajput chiefs in Rajputana ran their domains roughly in the pattern of a Mughal court in miniature and paid lip service to the Mughal Empire, the lack of central Mughal power in the Thar Desert enabled regional courts and states like Rajputana to cement and expand their local authority through ruling practices that diverged from those of the Mughal Empire (Kothari 1994, 209). A hierarchical structure related to land access, natural resource use, and social organization, the jagirdari system was used as an organizing structure in the Thar Desert and remained predominant until 1947.

Under this system, a local ruler's land was granted as estates (*jagir*) to sovereign intermediaries (*jagirdars*) in exchange for military service and tribute payments (Rosin 1987, 470). When Rajput jagirdars settled on the land they had been given, they brought with them enough people to establish a village and provide services to the newly formed community. The sparse population of the Thar Desert and the long distances between villages necessitated this localized community structure. The people who came with the jagirdar and made up the original village community were referred to as *kasabi* (families of service castes or communities). The kasabi usually contained a musician family.[6] Each kasabi family was expected to not only serve the Rajput jagirdars but also the other kasabi families in the village. Importantly the Manganiyar community, who claim today that their jajmans are Rajput, often also have jajmans from other castes or communities who were historically part of the kasabi.[7] Landownership was therefore central to the establishment of patronal relations between jajmans and Manganiyars (A. Gold and Gujar 2002).[8]

The title of Rajput is not a self-evident category. Instead, it was a fluid designation that slowly became fixed and synonymous with martial clans, rulers, and landholders through a process called Rajputization (D. Gold 1995).[9] Through Rajputization, it was possible to become Rajput by acquiring land and practicing chivalry and bravery (Erdman 1994). For Rajput jagirdars to retain their land and maintain their powerful positions in the region, they needed strong kinship networks, filial relationships, and claims to genealogical pedigree. Traditional patronal relations played a key role in the Rajputization of local military chiefs

and landowners. Manganiyar musicians were tasked with providing Rajputs with a lineage, even just an invented one, to legitimize their powerful position.

The revenue gained by jagir allowed Rajput jagirdars to enjoy the status of patrons of village musicians. Rajput jagirdars were able to maintain their positions of power by patronizing musicians, who — through reciting genealogies and stories and performing songs — imparted power to Rajput jagirdars (Snodgrass 2006). As this status solidified over generations, they became jajmans. Scholars of Mughal courtly patronage have reached a similar conclusion: music was a form of cultural capital for patrons and an audible form of power (Katherine Brown 2007; Qureshi 2002; Wade 1998). Music connoisseurship displayed the patrons' cultural competence: to appreciate music, patrons must have knowledge of the theory, traditions, and etiquette of that music. Patrons' financial ability to employ musicians demonstrated wealth and high social rank. For those patrons who were not wealthy or of high social rank, musical patronage may well have been particularly important, serving as a means of upward mobility. It was in this context that music and culture prospered in the Thar Desert region. Local wealth and landholdings allowed Rajputs to lead wealthy and settled lives with a sense of heritage, pride, and grandeur, expressed through the accounts of musicians. In this way, hereditary musicians played a key role in the Rajputization of their jajmans. By the late nineteenth century, Rajput had become an official Indian census designation of the British Empire, further cementing Rajput hierarchical religio-caste identity.[10]

Inherent in Rajput identity was a distinct brand of masculinity related to histories of bravery in warfare. Stories and songs, often based in truth and recounted with increasing hyperbole over multiple generations, depended on jajmans' benevolence bestowed on Manganiyar musicians. Therefore, Manganiyar musicians have defined and dictated ideals of Rajput masculinity through song. The brand of masculinity conveyed through Manganiyar women's repertoire (now mostly sung by Manganiyar men) focuses on physical attributes of masculinity: appearance, ornaments, dress, and charm. In contrast, Rajput masculinity in Manganiyar men's repertoire foregrounds courageous strength in warfare, political intelligence, sacrifice, and fulfilling Rajput *dharm* (divine caste obligation). The Rajput paragon is one who struggles alone, dies in battle, and sacrifices himself for women, society, and dharm (Harlan 2003, 155).

While it is often claimed that royal patronage in India ended with independence in 1947, patronage in the Mughal court context began to wane as early as the

death of the Mughal emperor Aurangzeb in 1707, when short reigns and repeated succession struggles in the Mughal Empire fractured imperial power and strained the Mughal treasury. One of the first financial cuts to be made was in musical patronage, and Mughal court music and its performers were directly affected by the failing of the empire (Erdman 1985). Rippling repercussions of the waning of musical patronage in the Mughal court were felt all over the subcontinent. These declines in musical patronage continued over time until independence, when postcolonial rearrangements of property, taxes, and financial allocations rendered musical patronage obsolete in many contexts.

In the Thar Desert, the jagirdari system was abolished in 1956, soon after the princely states of Rajputana merged to form Rajasthan State (S. Rudolph 1963). The princely states of Rajputana had remained autonomous for two years after independence, but in 1949 the Rajasthan State was established through a merger of Rajputana's nineteen principalities and two chieftainships (L. Rudolph and Rudolph 1984). The name "Rajasthan" was chosen for the state because it "eliminated the reference to the Rajput social order while preserving the regal significance by combining 'Raja' (king) with 'sthan' (land of)" (L. Rudolph and Rudolph 1984, 43). Jagirdars were given heritable and transferable land but were also brought into direct relationship with the new democratic state through the use of privy purses—national government payments made to the ruling families of the princely states of Rajputana as part of their agreement to become part of the Indian nation. Eventually, postindependence land reforms and distribution changed jagirdari rights and jagirdars' social status. The twenty sixth amendment of the Indian constitution, passed by the Indian government in 1971, abolished the privy purses paid to former rulers of princely states which were incorporated into the Indian Republic and other official symbols of princely India that Rajputana had initially been able to keep in its negotiations with the newly formed country regarding Rajputana's annexation as Rajasthan State (Dhabhai 2020).[11] Without these allowances, rulers and landowners were left without disposable income for patronizing musicians.

At this time, a common trope about South Asian patronal relations was that a traditional and rural mode of village exchange was under attack by the forces of modernization and was not consistent with the spread of a growing cash economy (Kolenda 1978, 52–54). The presentations and exchanges in the context of "the *jajmani* 'system' are only understandable, and possible, in relation to a conception of land based at least partially on principles that are not of the

market" (Raheja 1988, 13). A decline in a nonmonetary barter system in a world increasingly shaped by market and other monetary forces made traditional means of making a living through patronage less important.

A CONTINUING TRADITION OF PATRONAGE

The Manganiyar community is perhaps best known to the Indian and international public for its perceived adherence to its traditional patronal relations in a part of the world where hereditary musician communities that once thrived on patronage alone are now few and far between (McNeil 2018). It is in the Thar Desert that everyday musical patronage has endured. This is in part because most jajmans in the Thar Desert are not particularly wealthy, and the postindependence land redistributions and the Deregulation of Princes Act did not affect jajmans in this region. Despite the colonial and postcolonial decline of courtly patronage, traditional patronage in the Thar Desert has continued to be resilient. To this day, patronal relations shape not only Manganiyar music but also their day-to-day lives and place in society, providing a continuing sense of community and familial structure.

The Manganiyar community derives its name (one who begs) from its relationship of seeking and receiving from its traditional patrons. From grain allotments to wedding dowries, a jajman traditionally contributes to every important expenditure that his Manganiyar incurs through a social contract. Manganiyar musicians are attached to individual jajman families.[12] However, what makes this relationship lasting and unusual is the entanglement of entire family lineages over many generations, which has created strong ties of social and economic codependence. These relationships require financial support from jajmans, but even more important, they involve social impetus and obligation on both sides. Manganiyar musicians are important for maintaining a sense of community and familial structure for their patrons. Because of their historical family ties, Manganiyars serve as genealogists for their patron families: they are usually able to recite the names and narrate the deeds of at least the past twenty generations of their jajman's family. And because these musicians know family histories for many different jajman families, they also serve as essential advisors on the arranged marriages in their patron families.

While many Manganiyars historically had wealthy landowning jagirdars as jajmans, the vast majority of the Manganiyar community have always had a base of patronage support outside of the royal courts. There is one exception: the

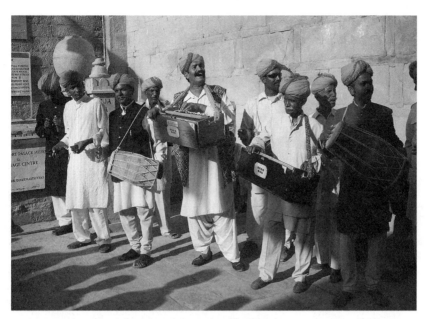

FIGURE 1.2 Members of the Alamkhana at Jaisalmer City's Dussehra Festival celebration, performing as the Jaisalmer Maharawal exited the palace for a procession through the city. The harmonium players are the patriarchs of Jaisalmer's Alamkhana: Hasan Khan (left) and Akbar Khan (right). Jaisalmer, 2007. Photo by author.

Alamkhana, a subcaste of the Manganiyar community whose members serve as the official court and hereditary musicians of the Jaisalmer City royal family in the court's Department of Music and Arts (figure 1.2).[13] For centuries, the Alamkhana have symbolized the ceremonial significance of the Jaisalmer royal family, having been called on to perform for royal occasions, religious ceremonies, and cultural festivals. Furthermore, musicians from the Alamkhana traditionally accompany members of the royal family whenever they appear in public (Jairazbhoy 1977; for a discussion of the interactions between the Alamkhana and classical musicians in Rajasthani royal court contexts, see Ayyagari 2012). While the royal family has continued to hold onto the Alamkhana for their symbolic importance, the dilapidated state of Kallu ki Hatta—the Alamkhana's property and residence in Jaisalmer City given to them by the royal family over two hundred years ago—speaks to the postcolonial decline of courtly patronage in Jaisalmer since independence. The Alamkhana are contemporarily considered to be a family unit of court musicians and distinct from the rest of the Manganiyar community,

serving as the community's titular head and symbolic lawmaking body. However, pigeonholed as court musicians, most of the contemporary Alamkhana have not been able to escape the grip of royal patronage and remain economically disadvantaged compared to many other Manganiyar families who now thrive in postpatronal performance contexts.

There are four defining characteristics of traditional patronage for Manganiyar musicians involved in patronage outside of court contexts. I describe them here so that we can better understand postpatronage. First, the relationship between Manganiyar families and their jajmans is tied to tradition, genealogy, and self-fashioning. The relationship is informal: there is no written contract binding musician and patron together. However, it is made public and official through a ceremony called *pagh bandhai* (the tying of the turban), which symbolizes the tying of familial bonds and the patron's acceptance of the Manganiyar family as their hereditary responsibility. After this ceremony, the relationship is expected to persist for future generations of Manganiyars and jajmans. While this relationship is fairly standardized across the community in terms of performance contexts, repertoire, and intergenerational practices, relationships are personal, varying from one jajman to the next and one village to the next. This is because the uniqueness and durability of the relationship stem from its personal nature: the musicians know their jajman families intimately. In addition, villages in the Thar Desert were historically isolated by distance, lack of transportation, and limited technology, which resulted in individualized traditions.

Second, the longevity of patronal relationships over generations enables Manganiyar musicians to serve as genealogists for their jajmans—telling stories, keeping traditions, maintaining collective memories, and establishing status. The patronal services provided to jajmans by Manganiyars are collectively called *birat*, which specifically refers to the hereditary and intangible nature of music and sung poetry as opposed to other kinds of nonmusical patronal services. In addition, shubhrajs hold an important function in the relationship between Manganiyar musicians and their jajmans, validating the status of jajmans and their legacy.

Third, patron families are are passed down like property from father to son among Manganiyar families and divided equally when there is more than one son. This stretches patronage far beyond the musical performance or ritual space. Manganiyars' relationships with their jajmans span their lives as well as those of past and future generations. The hereditary and reciprocal nature of these relations ensure both a temporal span and a continued need for patronage despite potential financial and social hardships on both sides of the relationship.

For example, even when a male born into the Manganiyar community cannot perform (possible reasons include a lack of interest, a lack of musicality, and a disability that makes performing impossible), he is still remunerated by his jajmans for simply being present and being a Manganiyar. It is assumed that when a jajman provides for a Manganiyar who does not perform music, he is not only being a philanthropist, but he is also ensuring that his own descendants will have the opportunity to be jajmans and patronize the descendants of his Manganiyar musician.

Therefore, once pagh bandhai has taken place between a Manganiyar and jajman, their relationship is expected to persist permanently. When a jajman dies, the Manganiyar musician sits at the jajman's cremation ground and tomb daily at sunset for twelve days, reciting the jajman's shubhraj and *mars* (poem of remembrance of the dead). After a period of mourning, a *khan baras* (succession) ceremony takes place, during which the successor of the dead jajman (usually his son) is given a new turban to symbolize the passing down of the relationship. Likewise, when a Manganiyar musician dies, his patrons are divided among his sons (whether they are musicians or not), who are entitled to perform for and receive payment from the same jajman family.

Fourth, the nature of exchange between Manganiyars and jajmans is one of codependence and reciprocity. Musicians perform for their jajmans, and their reimbursement is sometimes monetary. However, it may often consist instead of *dhan* (a percentage of the harvest of a yearly crop), land, gold jewelry, camels, or other livestock (Neuman and Chaudhuri, with Kothari 2006, 42–43). The long-standing importance of jagirdari feudal landownership and animal husbandry in the region is demonstrated by the diversity of in-kind payments granted to Manganiyars throughout the agricultural year.[14] In addition, Manganiyar families often are entitled to receive ritual meals, uncooked food, gifts, and other donations given to village Hindu temples or during religious festivals.

Perhaps the most important remuneration that Manganiyar musicians receive form their jajmans is intangible: it takes the form of a kind of insurance. Manganiyar families can collect money and resources from patrons not only at designated times but also in times of need (because of death, illness, natural disasters, and so on). During famines, Manganiyars can recover the losses they have incurred. They can also call on jajmans for financial help for their daughters' weddings, *dham* (death anniversary celebrations), or domestic purposes like buying a tractor or building a house. Manganiyars without the insurance support of their jajmans are at the mercy of the welfare state for resources, and

being members of a low-caste Muslim community, Manganiyars cannot always access or depend on government-provided resources.[15]

RECIPROCITY

The above characteristics of patronage are important in defining the relationships between Manganiyars and their jajmans but do not explain why traditional patronal relationships continue to be maintained despite social and economic changes for both the Manganiyar community and their jajmans. For musical patronage to endure and remain useful, musicians must have a reason for performing for their jajmans, and jajmans must have a reason to support musicians. Why do musicians maintain ties to traditional patrons when some make more money and garner fame from performing in the cultural tourism industry, on reality television, and abroad on tours and in festivals? What do musicians have to gain from upholding traditional patronal relations? And why might jajmans maintain ties to Manganiyar musicians in contemporary times when there is much less social and financial need to do so? In other words, what makes traditional patronal relations between Manganiyars and their jajmans resilient?

Manganiyar musicians historically had much to gain from patronal relations, including payment (both monetary and in kind), insurance in times of sickness and death, land, and community and caste status. While there are Manganiyars who have abandoned traditional patronal relations altogether, such cases are rare. Traditional patronage allows them to maintain a village structure in which they know their place in society. For many Manganiyars, traditional patronage still has significant cultural and sacred importance in their lives. For others, it is a way to maintain traditional repertoire and performance practice.

This sentiment was evident when I interviewed Gazi Khan Harwa, one of my interlocutors and a famous talented Manganiyar vocalist (not to be confused with Gazi Barna). Over lunch at my home in Gambier, Ohio, during an international tour, he told me, "I gave up a performance in New York City!"[16] He went on to say that at another time, he had withdrawn from another scheduled international tour to Europe and the United States because it conflicted with a patron's wedding. Why did he tell me this? I pursued my line of questioning, and he told me that his traditional patronal relations are more important to him than touring abroad. Contemporary performances outside of traditional patronage may pay better in the short term, he explained to me, but his jajman is the one who gives him inspiration as a musician. He continued: "If it were not for my jajman, there

would be no reason for me to sing; I perform for them. Even when I am touring abroad, I am doing it for them."

This is a common trope: other Manganiyar musicians have told me similar stories of giving up more lucrative and seemingly prestigious postpatronal performances for the everyday opportunity to perform for their traditional village jajmans. What accounts for the dedication that musicians have to their jajman? How does Gazi Khan Harwa's sentiment make sense in a contemporary world, where Manganiyar musicians live a musical life of paradox: they are sometimes treated poorly by their jajmans, are treated like superstars in postpatronal contexts, yet they consistently choose their jajmans over postpatrons? Despite poor treatment by their jajman, Manganiyar musicians have always touted their own artistic achievements and the benefits of patronage as cultural capital in part because drawing attention to and enhancing their patrons' status brings value and status to the musicians—whose reputation rests on that of their patrons. In chapter 3, I argue that patronal artistic achievements have importance not only in a traditional patronage system but also in neoliberalizing contexts.

Despite the many instances of decline in patronal relations between Manganiyars and their patrons, the relationships persist and in many cases continue to be an important social structure in rural village life in western Rajasthan. For some Manganiyars, albeit an increasing minority of the community, their only means of livelihood continues to be their jajmans. These are Manganiyars who live far from urban centers like Barmer and Jaisalmer, have no contact with postpatronal organizations and figures, and have not participated in the tourism industry. Other Manganiyars supplement their traditional patronal relations with postpatronal performances in the tourism industry and abroad, using a hybrid approach. Families containing multiple musicians often have one foot in traditional patronage and the other in postpatronal performance: one male member of the family might remain in the village, performing for traditional jajmans, while at least one other male family member performs in postpatronal contexts. In this way, postpatronal practices do not necessarily follow patronal practices chronologically but coexist and overlap with traditional patronage. On the other end of the spectrum, some Manganiyars have abandoned traditional patronal relations for more lucrative performance opportunities and sometimes professions outside of music altogether. These decisions are based on the musical aptitude of the Manganiyar musicians, the benevolence of their jajmans, and other factors like the number of musicians in the family, opportunities to study, and distance from their village to the nearest urban center.

We must also examine the impetus for jajmans to patronize Manganiyar musicians. Contemporary jajmans are for the most part Hindu Rajput. However, Manganiyars also have jajmans who are Muslim and from different communities. Due to postcolonial redistributions of land and wealth, today jajmans are not always more wealthy than their Manganiyars. For those jajmans who are not wealthy, musical patronage may well be particularly important, serving to shore up their social position. Perhaps the most important function of Manganiyars for their contemporary jajmans involves genealogy keeping. Musicians not only account for and recite genealogies for their patrons but do so publicly through praise songs performed in front of jajmans and their guests. For this reason, Manganiyar musicians are involved in arranging marriages for their jajmans. Their presence at religious festivals and family ceremonies is still required, legitimizing any jajman's function. Contemporary jajmans view musical performance and consumption of Manganiyar music as direct communication with a divine and glorious cultural heritage.

In November 2019, I had a remote conversation via social media with a jajman in Hamira Village. Since Sakar Khan's passing, his four sons have taken on the task of performing for this jajman's family. In our online conversation, I asked the jajman about contemporary patronal relations. He told me that Rajputs have been Rajputs only if there have also been Manganiyars, and that a jajman is only as big as the turban he places on his Manganiyar's head.[17] The jajman then sent me a ten-minute video of a performance in celebration of the Hindu festival of Diwali he had recorded with his smartphone earlier that day.

The video takes place in a *kotri* (a small windowless room) off a central courtyard at the jajman's home in Hamira Village that is no different from the rooms in Manganiyar homes. Four men sit at the back of the room on a wool blanket around a shared *thali* (stainless steel plate) of food sitting on a *bajotha* (a small, decorated table used to serve food to guests sitting on the floor). Each man has a glass of beer and smokes a bidi. They eat, drink, smoke, and chat. A few other men are in the room, two sitting on the floor and one (an old man) sitting on a charpai. The room's door is open, and it looks out to the front porch. There, sitting in the sun are two of Sakar Khan's sons, Ghewar Khan and Dara Khan. Ghewar Khan plays various unaccompanied melodies in *raag sameri* on his kamaicha. The music seems to be in the background, with the food consumption and interactions among the audience members in the foreground.

It is difficult to tell who is a jajman and who is a guest until one man who has been sitting near the thali stands up, pulls a few money bills from his pocket,

and steps over the other guests as he makes his way to the musicians sitting just outside the door in the sun. Dara Khan, who is sitting on the ground and not playing music, looks up at the jajman standing above him and shakes his clasped hands at the jajman in reverence before stretching out a hand. The jajman puts the money in Dara Khan's hand. As the transaction takes place, Ghewar Khan stops playing a song, bows a drone on his instrument, and recites a shubhraj for the jajman—a monotone recitation that quickly lists ancestors. After thirty seconds of recitation, Ghewar Khan begins to play the song again—more loudly and forcefully, and transitioning from raag sameri to *raag soob*. He recites soob's shubhraj and then sings a song accompanying himself on the kamaicha. The audience becomes quiet and pays attention to the performance. After approximately ten minutes, the video ends with the jajman turning his phone around so that the viewer can see his smiling face. He twirls his mustache before the camera and stops recording.

While I had experienced jajman functions previously, I had always accompanied Manganiyar musicians and had experienced the functions with them and from my point of view as a woman. Although I was not physically present at this jajman function in 2019, the surreal experience of seeing patronal relations through the smartphone of a male jajman revealed much about contemporary jajmans. Based on descriptions of musicians and scholars, interactions between jajmans and Manganiyar musicians have not changed drastically over the years. It was obvious that the jajman treated their Manganiyar musicians with a certain amount of reverence, appreciating their music and genealogy recitation. But at the same time, the musicians were seated on the ground outside the room where the jajmans were, having left their shoes before entering it. The musicians were paid only a small amount of money for the performance. They were subject to the whims of the jajmans and expected to perform continuously. Yet the jajman's home did not indicate any more wealth than a Manganiyar home, and the jajmans and musicians were dressed the same. At the end of my online conversation with this jajman, he wrote: "We will have auspicious futures because of Manganiyar musicians. Even though we pay the Manganiyar, it is us who earn the wealth." Perhaps this jajman treated the Manganiyar musicians with respect because he was recording a video. Perhaps he would have treated musicians less famous than Ghewar Khan and Dara Khan with less respect. While this traditional patronal interaction may be different depending on circumstance and musician, it does demonstrate that despite patronage's waning, it persists.

PATRONAL PATHOLOGIES

While patronage has served as job security for Manganiyar musicians, it has also shored up asymmetrical and power-laden relationships between jajman and musician (Piliavsky 2014). Despite their importance to their jajman, Manganiyar musicians depend on the musical whims and financial generosity of their jajman. The Manganiyars' own status as low-caste musicians has ensured that they are exploited within profoundly unequal relationships. Ironically, they are often treated poorly by the very jajmans who need them to legitimize their cultural and social position: "As patronage power reinforces the jajman's caste and social rank, so, too, does the dependence of gamins [service providers] reaffirm their lower rank" (Wade and Pescatello 1977, 281). Manganiyar musicians, along with other hereditary musicians, have been feted as "artists with 'court jewel' status, yet exploited as servants" (Qureshi 2002, 87).

The relationship between Manganiyar and jajman is personal, private, and not understood by outsiders. The details of exploitation remain shrouded for outsiders and even other Manganiyar community members. Musicians are not always treated respectfully by their jajmans: they are sometimes given inadequate compensation for their patronal performances, shunned by their jajmans, or (as in the extreme case of Aamad Khan) killed because of poor jajmani relationships or performances. Many Manganiyar musicians choose not to share negative aspects of patronal relations or harsh treatment for fear that such aspects would reflect negatively on their aptitude as musicians. This is because the basis for any patronal exchange is not only economic, or at least not principally so, but also social (Neuman and Chaudhuri, with Kothari 2006, 42). Gloria Raheja (1988) convincingly argues that patronage is not mostly about economics or exchange and that it is the ritual of giving and receiving that fix the participants' caste and status. Since Manganiyars traditionally define their own status by that of their patrons, they may choose not to divulge negative aspects of their own patronal relations.

Herein lies another form of resilience: the wicked resilience of patronage. Resilience is often assumed to be the normative and positive goal of musical and cultural sustainability work because resilient social systems are always thought to foster positive attributes such as fairness, inclusivity, and diversity. However, this assumption ignores resilient pathologies such as inequality, poverty, and (in this case) traditional patronage—pathologies that have frequently been described in the social sciences as "sticky" or "wicked" problems (Ackoff 1974). Indeed, resilience is not always a good thing: "a highly resilient system may reside in un-

desirable states and may even be described as pathologically resistant to change" (Katrina Brown 2016, 158–59). I suggest that the use of resilience as an analytical tool can help us understand undesirable aspects of patronage (for discussions of undesirable resilience and wicked problems, see Churchman 1967; Crona and Bodin 2010; Rittel and Webber 1973).

I draw on the other meaning of the verb "patronize" (to treat condescendingly, look down on, or treat with disdain) to describe the condescension that continues to fuel patronal relations between many Manganiyars and their patrons. Paradoxically, while jajmans take musical patronage seriously, they patronize the musicians they employ to be present at the most important rituals and times in their family lives (Garber 2008). Patronage relationships are thus problematic, leaving musicians patronized—both supported by their jajmans and being treated in a condescending manner.

It is this very wicked resilience that has inspired some Manganiyar musicians to break with resilience. Such breaking is just as important as the sustainability of other aspects of Manganiyar musical culture. An interpretation of resilience that fails to consider resilience breaking as part of resilience management may strengthen existing power structures, something which is often at odds with work that supports sustainability (Desai 1996). Resilience breaking is inspired by the exploitative and resilient conditions of traditional patronage. Through resilience breaking, some Manganiyar musicians are finding more respectful and lucrative ways of earning a living through musical performance. By breaking down the patronizing and resilient structure of traditional patronage, they seek neoliberal forms of postpatronage through musical entrepreneurship. This neoliberal outlook moves Manganiyars toward thinking of survival as an individual responsibility instead of as a matter of depending on the social fabric of traditional patronage or even the larger Manganiyar community. Manganiyar musicians can use traditional patronal relations as cultural capital for their very escape from such patronage. Patronage has the potential to be a site for resilience—both positive and negative.

TACTICS OF RESILIENCE

Manganiyar musicians are expected to be subordinate to their jajmans by the nature of the unequal power dynamics of traditional patronal relations. If they are not in reality subordinate, they are expected at least to act as if they are.[18] Beyond their musical and poetic praising, Manganiyar musicians always greet

their jajmans formally with khamaghani and sometimes even touch their jajman's feet as they would the feet of an elder or a statue of a Hindu deity. Musicians bow down in front of and sit lower than their jajmans: if their jajmans sit in chairs or on charpais, the Manganiyar is expected to sit on the floor. Manganiyars tend to not speak unless spoken to, asked to speak, or asked to perform.

But while Manganiyars have a subservient and minority status in their villages, Manganiyar musicians are indispensable to their jajmans due to their specialized occupational skill set, intimate knowledge of jajman families, and exclusive rights to perform in patronal contexts. They are keenly aware of their position of power, being indispensable to patrons because of their specialized skills and services as musicians and genealogists with intimate knowledge of the patrons' families. This places jajmans at a disadvantage and gives musicians bargaining strength and power in what is otherwise a top-down relationship. Manganiyars have demanded patriarchal benevolence on the part of their jajmans and have been known to assert their right to receive financial aid when they need it. Jeffrey Snodgrass's (2006, 274) remarks about kingly patronage are relevant not only for historical Rajput patronage but also for contemporary, postcolonial village jajmans: "In the past, bards possessed the power to make or break kingly reputations, to guard or besmirch kingly honour, and thus literally to forge royal identity. As curators of collective memories, skilled praise-singers vested kings with noble lineages stretching back to the sun or the moon. If they felt that their services were not adequately valued or rewarded, they had the power to tell the world that their lords were mere pretenders and their titles false or illegitimate."

Manganiyar musicians have told me about three techniques they can employ in extenuating circumstances to exert power over their jajmans and in some cases resist abuse from jajmans. First, the isolated nature and sparseness of population of Thar Desert villages has ensured that for the most part, there has been only one Manganiyar family per village: the descendants of the Manganiyar musician who was part of the kasabi that first settled the village. Although this changed after independence and the Indo-Pakistani wars, most Manganiyar families have always had more than one jajman, while each jajman has always had only one Manganiyar family. This has resulted in the absence of competition: jajmans have not historically had the ability to choose which Manganiyar family to attach to their own. This has enabled Manganiyar musicians to be able to choose their jajmans and even play jajmans off against each other to garner more patronage and resources. I have heard stories of Manganiyar musicians telling one jajman

how much remuneration another jajman gives them. In other cases, Manganiyar musicians may be overbooked and need to choose to perform for one jajman instead of another.

While Manganiyar musicians may be required to perform for their jajmans on certain occasions, they have the freedom to choose the musical repertoire they perform. This is the second technique that Manganiyars can use to exert power. They usually sing songs that celebrate the occasion at hand and praise their jajman. However, musicians may choose to sing songs that are less laudatory in nature, depending on how the jajman treats and pays the Manganiyar musician. Sakar Khan described to me this choice in repertoire as *lachila*, a way to support or resist patronage, depending on the situation. There tend to be two kinds of recitation performed for jajmans beyond the shubhraj. *Mujras* are acknowledgments and glorification of the superiority of the jajman, in the form of stories and poems of great deeds and accomplishments. While mujras are based in truth, they may be embellished from one situation to another, or from one generation of musician to the next, depending on the reputation of the jajmans and how they treats their Manganiyars. The other kind of recitation is *bhund*, songs of abuse that recount bad deeds by a jajman's ancestors. If a jajman is benevolent to his musician, the bhund of the jajman's ancestors can disappear, with Manganiyars choosing not to sing them or pass them down to the next generation of musicians.

Third, Manganiyar musicians can combat abuse and treatment by a technique called *talaq* (divorce). According to Kothari, there is a ritualized practice of threats leading to talaq, which includes burying a kamaicha's strings in the sand outside the jajman's home as well as tying an effigy of the jajman to a donkey's tail and beating the donkey with a stick (Bharucha 2003, 221).[19] Beyond talaq, Manganiyar musicians can desert their village (ibid.). Desertion poses a threat to jajmans, who depend on their Manganiyar musicians for family-specific rituals and musical knowledge. This action was described in the introduction as a reaction to Aamad Khan's murder.

Thus, Manganiyar musicians can use tactics of resilience through musical performance to assert their preferences, power, and hereditary rights over jajmans, who otherwise have the upper hand in patronal relationships. As a result, there is space in traditional patronage relations for musicians' preferences and new ways of being, offering Manganiyars possibilities for resilience in their professional lives in traditional patronage contexts.

POSTPATRONAGE AS RESILIENCE

While some members of the Manganiyar community languish on the outskirts of remote desert villages and some musicians live in poverty, making a pittance from traditional patronal relations, an increasing number of musicians from the community are finding novel ways to make a living through musical performance outside of traditional patronage. I call this postpatronage and define it as the practice of patronal musicians using traditional patronage to create new performance contexts and relationships within a contemporary cultural milieu. The term "postpatronage" refers to two concepts. First it encompasses contemporary Manganiyar performance practice that is complicated. Second, postpatronage refers to a constellation of situated knowledges innovatively constructed and communicated through networks of cultural brokers (individuals, organizations, governments, local and international festivals and music circuits, and virtual fan bases). Postpatronage as a concept takes into consideration the hybrid spaces in which Manganiyars perform today. Through postpatronage, patronal musicians entwine themselves in market economies, seek social prestige, and present themselves in cultural dimensions outside of customary patronage, all the while maintaining a sense of pride and lineage through their ties to traditional patronage.

As a form of resilience, postpatronage requires musicians to draw on the traditional patronal relations that they have known for centuries, changing them to fit contemporary contexts, and becoming resilient in their techniques of livelihood. Bonnie Wade and Ann Pescatello (1977, 317) referred to this as a "new 'patronage' relationship," which they defined as an increasingly economic one, although this new relationship still retains traditional ritualistic elements that defined a traditional patronal relationship. This does not discount the continuing centrality of traditional patronal relations for many Manganiyar musicians. Most of the Manganiyar musicians who engage in postpatronal performances do so in addition to continuing their traditional patronal performances. Manganiyar musicians use traditional patronage ties to maintain a sense of pride and lineage while bolstering their authenticity as hereditary musicians in postpatronal contexts.

Postpatronage has its roots in postcolonialism, which is marked by both resistance to and engagement with colonialism and its lasting cultural and political legacy. Postcolonialism is a dialectical concept that marks the broad historical moments and achievements of decolonization and acknowledges the continuing imperialistic nature of social, economic, and political realities—which are still

influenced by colonialism. Just as colonialism as a form of domination has seeped into all aspects of postcolonial life in India, so patronage has influenced post-patronage for the Manganiyar community, in both negative and positive ways. Postpatronage tends to have the same top-down power structures that traditional patronage possessed, with Manganiyar musicians at the bottom. However, some Manganiyar musicians have been able to romanticize their membership in an age-old patronage system to use the cultural capital of traditional patronage to make a living in new international and tourism markets.

While postpatronage uses traditional patronage as a platform for new performance contexts and relationships, the audiences and their reasons for patronizing Manganiyars and their music tend to be different. Traditional patronage is built on connoisseurship and exclusion, while postpatronage is built on nonspecialization and inclusion. At the heart of traditional patronage in the Thar Desert are jajmans who possess musical knowledge and elite cultural taste. Only certain people (based on heredity, caste, and class) could be jajmans, and it is those jajmans with refined musical taste who are most respected in their villages.[20] Academic sources on Western arts patronage tend to view its scope broadly, from governments' funding arts programs to individuals' purchasing tickets for performances and churches' and wealthy families' commissioning works of art (DeNora 1991; Garber 2008). In postpatronal contexts, this has not been the case in the Thar Desert until recently. Manganiyar musicians began performing for nonspecialist audiences with the prompting of Kothari in the late 1960s. First on local stages and then on international stages around the world, Kothari taught Manganiyar musicians how to translate their jajman-specific music for audiences not familiar with their music or language. The musicians' early transition from patronage to postpatronage gave them the skills to translate their music into disparate performance contexts—from working in a Bollywood playback studio to a performance on an American university campus, and from playing in a hotel in Jaisalmer City catering to foreign tourists to a s performance for the prime minister of India in New Delhi.

In this way, postpatronage is a form of resilience for the Manganiyar community. Manganiyar musicians use postpatronage as a tactic for surviving and thriving in the face of waning traditional patronage, drawing on traditional patronal relations they have known for centuries and changing them to fit contemporary contexts. Although I feature Kothari in chapter 2 as an impresario of Manganiyar international performance, he needs to be mentioned next as the Manganiyar community's first postpatron.

FIGURE 1.3 Framed photograph of Komal Kothari listening to field recordings in Rupayan Sansthan's archive. This photo is at Arna-Jharna, the museum Kothari established just before his death in 2004, which is currently run by his son Kuldeep Kothari. Moklawas Village, 2016. Photo by author.

KOMAL KOTHARI, MANGANIYARS' FIRST POSTPATRON

Kothari took on the role of the Manganiyar community's first postpatron at his first contact with the community in the late 1950s (figure 1.3).[21] He went on to curate their performance style and repertoire, present them on stages throughout India and the world, and encourage Manganiyar musicians to craft their own roles in postpatronage. To understand Manganiyar postpatronage involvement, we must understand how Kothari became the Manganiyar community's first postpatron. His subsequent work with the community through his organization, Rupayan Sansthan, is explored in chapter 2.

Kothari's upbringing and experience influenced the philosophical underpinnings of Rupayan Sansthan, which in turn resonates through the contemporary history of the Manganiyar community and their engagements with postpatronage. Born in 1929 to a prominent family in Jodhpur City, Kothari came of age as India gained its independence and embraced a new postcolonial identity.[22] Kothari was deeply influenced by the Gandhian philosophy of *sarvodaya* (upliftment of all) and the socialist ideal of development through community uplift espoused by Jawaharlal Nehru, India's first prime minister.

In his early twenties, Kothari moved to the former colonial city of Calcutta to pursue a writing career. Through his writing about the arts, he was inevitably exposed to the radical politics of arts organizations like the Progressive Writers and Artists Association and the Indian People's Theatre Association (Damodaran 2017).[23] The printing press as a form of widespread technology was central to the work of these organizations and others, which used the printed word to spread messages about politics and culture and to critique elitist arguments about culture (Chatterjee 1986). According to his son Kuldeep Kothari, it was through the lens of these organizations that Komal Kothari picked up ideas of urban cultural awakening through rural, indigenous, and folk culture.[24] Since he already had an established interest in Rajasthani regional culture, his experiences in Calcutta inspired him to imagine ways of using print culture as a tool to contest social hierarchies in his newly formed postcolonial home state of Rajasthan (Ghosh 2006).

Inspired by his time in Calcutta, Kothari returned to Jodhpur in 1953 and coauthored two literary periodicals with his school friend Vijay Dan Detha: the scholarly journal *Prerna* (Inspiration) and the quarterly magazine *Parampara* (Tradition). Both periodicals were founded on the belief that the printing and circulation of song texts has the potential to expand literate society and unite urban intelligentsia with rural subaltern communities. Using recordings of the songs of local Jodhpur-based musicians from the Langa community of hereditary musicians Kothari and Detha transcribed and translated song texts from Marwari dialects into Hindi and provided literary descriptions and analyses of the songs (Bharucha 2003, 23–24 and 237–38). However, Kothari quickly realized that the use of the written word to unite disparate communities and castes which he saw in literate, urban Calcutta did not translate easily to mostly illiterate rural populations in Rajasthan.

Ever the innovator, Kothari was able to find other regionally appropriate ways of reaching and educating audiences without abandoning his leftist leanings. In 1953, he hosted his first live musical performance in Jodhpur, featuring the same Langa musicians whose songs he had transcribed and published.[25] This concert made him realize the possibilities of educating the masses through musical performances by lesser-known regional musicians rather than through the written word. He began this work in earnest in his first job at the newly opened All India Radio (AIR) station in Jaipur City. Established in 1936, AIR played a central role in the establishment of a new Indian national identity through music (Lelyveld 1994). Although AIR emphasized classical music traditions to promote national-

ism, Kothari found a niche at AIR and began to promote regional artists through radio.[26] He then took a job as the secretary for the Rajasthan branch of the Sangeet Natak Akademi, where he promoted regional artists as live performers on state and national platforms (Bake 1963).

Throughout his time at these national organizations, Kothari continued his work with Detha, and the two founded Rupayan Sansthan in 1960. Both founders strongly believed that for music and regional culture to thrive, they needed to be in their traditional context. As a result, the organization was based in Borunda, a village seventy miles east of Jodhpur. According to Kuldeep Kothari, his father "wanted our institution, Rupayan Sansthan, to be wholly saturated with the oral tradition of the inhabitants."[27] As Rupayan Sansthan became entrenched in Borunda's life, the village became a hub where regional musicians and artists could share their crafts with those interested in learning about them. Most of these musicians and artists were still entrenched in traditional patronage relations in the 1960s. However, these relationships were not lucrative and were losing their importance in postindependence Rajasthan.

In this way, Rupayan Sansthan became a postpatronal organization. By the mid-1960s, there was a constant stream of Indian and international scholars passing through Borunda in search of Kothari's and Detha's expertise and research assistance. Throughout the remainder of his career, Kothari prioritized collaborations with Indian and foreign anthropologists, folklorists, and ethnomusicologists.[28] The first international tours sponsored by Rupayan Sansthan were done in collaboration with scholars and researchers whom he had met through the organization. Due to its role in the study of music and culture of Rajasthan, Rupayan Sansthan became a documentation center, audio and video archive, library, and publisher.[29] While Kothari's major contribution was through the work Rupayan Sansthan did with artists and his collaborations with international scholars, he also published his own writings on Rajasthan, music, and culture.[30]

Eventually Kothari and Detha came to have different visions for their work. Kothari moved Rupayan Sansthan to Jodhpur City in 1964, and Detha remained in Borunda.[31] Rupayan Sansthan was registered with the Indian government as an official NGO in 1965. Kothari and the institute remained in Jodhpur until his death in 2004. In chapter 2, I trace Kothari's deep relationship with the Manganiyar community through cultural tourism and international touring. I turn next to a case study to demonstrate the nature of postpatronage in practice with a focus on the musician Mame Khan and his crowdfunded album, *Mame Khan's Desert Sessions*.

A CROWDFUNDED ALBUM:
MAME KHAN'S DESERT SESSIONS

Mame Khan and his 2015 album serve as a case study to allow us to better understand postpatronage, contextualize contemporary Manganiyar performance, and see how the structure and identity of traditional patronal music and relations have both been maintained and changed in a postpatronal context. Khan has been able to establish himself outside of his community as a solo performing artist and contemporary music star while drawing on his Manganiyar identity, which is ingrained in traditional patronal relations. He has become a model for a young generation of Manganiyar musicians hoping to build music careers outside of traditional patronage in the Thar Desert.

Mame Khan, forty-two, has been one of the most successful musicians from the Manganiyar community for his transpositions of traditional Manganiyar music to popular songs in postpatronage contexts (figure 1.4). Postpatronal performance has been deeply ingrained in his musical upbringing. His father, Rana Khan, was a well-known Manganiyar singer from Satto Village who had close ties to his village jajmans, performed at the Satto temple dedicated to Rani Bhatiyani, and was known for his teaching of traditional performance practice to his children and the younger generation of Manganiyar musicians. Beginning in the 1970s, Rana Khan worked closely with Kothari and other scholars and documentarians and went on to perform extensively throughout India and abroad. Mame Khan grew up performing in traditional patronal contexts with his father and other male relatives in Satto. Mame Khan uses the Hindustani classical music concept of *gharana* (house), a system of apprenticeship and lineage of musical practice and style, to describe his father's role as a mentor for and musical influence on him. Later, Mame Khan was invited to tour throughout India and internationally, first with his father and then with various troupes of Manganiyar musicians. One of his first large-scale postpatronal performances was as the lead vocalist for the international production "The Manganiyar Seduction."

Khan's promotional video for his 2015 crowdfunded album was funded using an online crowdfunding platform hosted by Wishberry Online Services Private Limited. The video opens with what seems like an advertisement for Jaisalmer as a cultural tourism attraction. A beautiful backlit shot of Gadsisar Lake, an image of sandstone *chhatris* (umbrella) dome-shaped pavilions or cenotaphs marking Jaisalmer's deceased Rajput royalty lit up like gold by the setting sun, and a picturesque time-lapse shot of Jaisalmer's medieval sandstone fort are brought

FIGURE 1.4 Mame Khan. Mumbai, 2012. Photo courtesy
of Mame Khan and Anjuli Chakraborty.

to life by the opening riffs of *raag khamaichi* played on the kamaicha. Mame
Khan's echoing voice enters with an open-throated *alaap* (an improvised open-
ing section of a Hindustani musical performance), but his singing voice quickly
fades as the camera zooms in on a medium close-up shot of Mame Khan himself.
With a traditionally colored and tied turban on his head, he speaks directly to
the audience watching his online video, saying "Khamaghani, sa" (the greeting
generally reserved for traditional jajmans). He speaks in clear Hindi instead of
the local Marwari dialect spoken in the Thar Desert, with subtitles in English for
viewers who do not speak Hindi. In the two-minute-long video, Khan describes
his humble beginnings in the Thar Desert village of Satto and his descent from a
long line of musicians, who have sung what he calls *lok sangeet* (folk music) for
the past fifteen generations of Manganiyar musicians. He describes the project
for which he is seeking funding—performing old songs that have been heard
by very few people. He uses the English phrase "folk and Sufi songs" to describe
the album's repertoire, promising to add new flavor to these old songs. Through
striking visuals of the Thar Desert and the musical expertise backed by fifteen

generations of hereditary musicians in his family, Mame Khan boosts his credibility as a musician working in postpatronal contexts.

After many years of interacting with Mame Khan informally in Jaisalmer City and at performances, I had the opportunity to formally interview him in 2019. I was living in Jaipur City at the time, and he had just arrived there from Mumbai for a private wedding performance. He performs at many such private functions all over India for wealthy postpatrons who have the financial means to host a Bollywood film industry performer like him. At his suggestion, we met over cocktails at an upscale bar in the heart of Jaipur. Mame Khan told me that he had had his first break in 2002 when Ila Arun, the nationally popular Indian actress and singer of Indian pop and Rajasthani regional music, invited him to perform at her daughter's wedding in Mumbai.[32] It was there that Shankar Mahadevan, a Bollywood film singer and composer, first heard Mame Khan sing and subsequently invited him to perform as a Bollywood playback singer for the song "Baawre" in the film *Luck by Chance*. After that, Mame Khan's career as a solo artist took off. The music director Amit Trivedi invited him to perform the hit song "Chaudhary" on the national television show *Coke Studio India* (officially titled Coke Studio @ MTV) in 2012.[33] Mame Khan has gone on to have a successful solo singing career in Mumbai, with several Bollywood film songs and internationally acclaimed performances to his name.

In our interview, we discussed his 2015 album, the project in his career of which he is most proud. On September 29, 2015, Mame Khan released what he called his crowdfunded "dream project" album, *Mame Khan's Desert Sessions*, with the record label Living Media India Ltd. (figure 1.5).[34] He told me that he was especially proud of his work on this album for three reasons. First, it was his first independent album. Second, it was the first crowdfunded album made by any Manganiyar musician (he had collaborated and performed on many albums but had never before cut one of his own). Third, it is arguably the first solo album released by any musician from the Manganiyar community. One of Mame Khan's motivations for releasing his own solo album was to set a precedent for the recognition of individual musicians from the community. In our interview, he told me that when Manganiyar musicians perform outside of traditional patronal contexts, their individual identities are lost since they are marketed as groups. They are not introduced with individual names, nor can their names be found in album liner notes or concert program notes. Instead, Manganiyar musicians are presented nondescriptively as a Manganiyar troupe or traditional musicians from Rajasthan. It was therefore important to Mame Khan to have an

FIGURE 1.5 Cover of
Mame Khan's album "Desert
Sessions." 2015. Creative
concept by Anjuli Chakraborty;
photo courtesy of Mame Khan.

album title that featured his name as an individual, not just the general name of his community. While he does not use the title Manganiyar professionally, he told me that he is proud to be part of the Manganiyar community, having been raised attending traditional patronal functions for his family's jajmans with his father. He has harnessed his lineage as a hereditary patronal musician while not losing his individual identity as a performing artist in his own right to garner fame and recognition.

Mame Khan used the crowdfunding website and platform Wishberry.com to support his album.[35] Crowdfunding consists of collecting small amounts of money from large numbers of people. This is usually done through an open call "for the provision of financial resources either in form of donation or in exchange for some form of reward and/or voting rights to support initiatives for specific purposes" (Scheienbacher and Larralde 2010, 372). Wishberry's mission is to discover and empower creative ideas originating in India. Founded by the Indian entrepreneurs Anshulika Dubey and Priyanka Agarwal, Wishberry was launched in 2011 with the slogan "Go fund yourself," and as India's first crowd-funding platform, it has managed to fund both social and creative projects. Like other online crowdfunding platforms, Wishberry.com does not give monetary returns to its donors (whom they call patrons). Instead, it gives rewards such as special early access to the project they funded and limited-edition merchandise

(Chakravorty 2020). In addition, Wishberry.com uses an all-or-nothing system that it calls "fan-ancing," in which pledged money is transferred to creators only if funding goals are met by a given deadline (Cumming, Johan, and Zhang 2019; S. Scott 2014, 170).). This ultimately gives artists freedom unencumbered by the pressure of monetary returns or investors' dictating terms.

Here I compare the role of crowdfunders who supported Mame Khan's project with contemporary patrons. While the number of people who support crowd-funded projects is usually vastly greater than the number of supporters in one-on-one traditional patronal relations, there is an exchange of value in both cases. Like traditional patronage, crowdfunding is "not just about money, it is about social validation. With many people funding your project, you can get access to direct distribution, creative independence since there is no investor, and a community that can support your creative ambitions for life!" (Wishberry Crowd-funding Basics 2019). In addition to funding one immediate project, the goal of crowdfunding in the arts is to create or expand a fan base, create a community around the project, and give the featured artist exposure for future projects, all using technological innovation on the internet. Mame Khan seems to have placed his "fan-ancers" (S. Scott 2014, 170) and members of the public supporting his project in the role of patron. Indeed his welcoming "Khamaghani-sa" greeting at the beginning of his promotional video for his 2015 crowdfunded album appeals to viewers as both potential crowdfunders and patrons.

While crowdfunding tends to create a community around projects and has the potential to both fund and spread the word about them, a direct comparison between traditional patrons and crowdfunders oversimplifies the intricate and fragile relationships of traditional patronage and the very different reasons for patronizing music in each case. The differences between traditional patronage and postpatronage are striking. For example, the power dynamic between musi-cian and audience is very different in the two cases. Even in the contemporary traditional patronal contexts in Mame Khan's village of Satto, he remains def-erential to his jajmans, bowing before them, sitting on the ground. Yet Mame Khan could himself be viewed as a kind of patron. One of his goals is to promote the Manganiyar community and support its members in transitioning to similar postpatronal performance careers. In our interview, he told me that some people think folk music is dying, but this is not the case. He believes that Manganiyar music is adaptable and needs to change with the times—and that this is what it means for music to be folk.

In this context, Mame Khan founded what he calls his "folk fusion group," Rock'n'Roots Project. This mixed ensemble features Manganiyar musicians and Indian popular musicians. In our interview in 2019 he told me that one of his goals in the formation of this group is to give his fellow Manganiyar musicians as much exposure as he can. Through their scheduled public performances throughout India, Mame Khan hopes that the travel and exposure will encourage and enable Manganiyar musicians to hold onto their traditional music.[36]

The music on *Mame Khan's Desert Sessions* demonstrates the sonic differences between postpatronal and traditional patronal performances. Mame Khan uses postpatronal techniques to curate and orchestrate his songs during the album's forty-two minutes. He presents contemporary interpretations of seven songs, which he calls "traditional and Sufi Manganiyar songs." According to Mame Khan, his album captures the essence of Rajasthan and the Manganiyar community through reinterpretations of traditional Manganiyar songs with a "modern twist." With his team of artists, Mame Khan recorded the songs for this album "on clip," which he described to me as recording each instrument separately and then combining the recordings. In describing the challenge Manganiyar musicians face in recording on clip in the studio, Mame Khan told me the story of his first studio recording. He had been called to a studio in Mumbai by Mahadevan. Assuming that he would be performing live, Mame Khan wore his performance costume—a fancy kurta, jewelry, and a turban. But when he entered the studio, he found that no one else was dressed up and there was no stage. Instead he was to make his first playback studio recording for the song "Baawre," from the 2009 film *Luck by Chance*. Mame Khan used this story to describe the difficulty Manganiyar musicians have creating the same emotions of traditional performances alone in a small sound box while performing repeated takes. It does not come naturally to them, and even those Manganiyar musicians who record their music in studios usually do so in live group performances (Ayyagari 2013). Mame Khan therefore asked his musicians to forget their traditional patronal performance context in the studio when they recorded his 2015 album. He told me: "Manganiyar music is all oral tradition. There is so much room for change and improvisation in our music. If you master your art well, you can do anything musically."

The album opens with the song "Saawan."[37] The song is based on the traditional Manganiyar song "Lunagar," sung during Saawan, the month in the lunar calendar that falls in the late summer monsoon season. *Lun* means salt in Marwari, and it refers to the Luni River that flows through the southern Thar Desert in Barmer District. The Luni River is unusual: it is one of only four west-running

rivers in India, is a saltwater river, and does not drain into a larger body of water but evaporates after the monsoon rains each year. The traditional Manganiyar song is sung from the point of view of a woman missing her husband, who is traveling for work. He was expected to return home during the month of Saawan but has not returned. The wife laments that even the Luni River has returned, but her husband has not.

A one-minute kamaicha solo opens "Saawan" in the traditional manner by introducing the listener to the song's melodies played in *raags sorath* on top of a synthesized drone. But unlike the drone with an unchanging pitch that accompanies traditional Manganiyar music and classical Hindustani music, this drone provides a slowly moving bass line, implying harmony. This one-minute kamaicha solo is followed by a shubhraj sung by Mame Khan and dedicated to *raag sorath*. Khan sings in a traditional Manganiyar vocal style of *khola avaaz* (open voice) and keeps to the centered pitch with the occasional melodic flourish. He invokes the raga through a set poetic text. Just after two minutes, nontraditional hand clapping can be heard introducing the traditional *rupak tala* (a rhythmic pattern consisting of three beats followed by four more beats), which leads into an extended dholak solo. The song continues in a traditional fashion, with sung poetry in a stanza-and-refrain musical form that includes short punctuating traditional vocal interjections and instrumental solos.

The second-to-last track on the album, "Bichhudo" (scorpion), is similarly based on a traditional Manganiyar sung story and melody. It is about both the meandering path of a scorpion crawling in the desert and a woman who was recently married and wants to spend time alone with her new husband. Too shy to ask her in-laws for privacy with him, she tells them she is going to the desert to collect firewood, and she secretly meets her husband there. When she returns late to the homestead, her in-laws ask her why she was gone so long, and she tells them she was stung by a scorpion on her ankle. If the story and melody are distinctly Manganiyar, Mame Khan's instrumentation and arrangement are anything but traditional. The track begins with a thirty-second *bansuri* (bamboo transverse flute) solo, followed by a perfectly timed thirty-second saxophone solo, and both instruments are foreign to Manganiyar music. These solos are accompanied by the same synthesized drone-like bass line heard in "Saawan." In place of a shubhraj, Mame Khan then performs a short vocal introduction. After a short, strummed *tambura* (a plucked drone instrument used to accompany instrumental or vocal performances) and *morchang* (metal mouth harp) interlude, Mame Khan enters again with the song's refrain, a distinctive melody using

sung vocables that onomatopoetically represent the playful scorpion scurrying through desert sand. Using syncopated sung lines, calls and responses between Khan and various instruments, and subtle synthesized orchestral flourishes, "Bichhudo" was recorded with postpatron audiences in mind.

Four of the other five songs on *Mame Khan's Desert Sessions* are based on the traditional Manganiyar repertoire, but like "Saawan" and "Bichhudo," they use diverse nontraditional musical forms and instrumentation. However, throughout the album, Mame Khan stays true to his Manganiyar roots in terms of his vocal timbre and khola avaaz style of singing. While older Manganiyar musicians lament the demise of traditional patronage, it has not gone away. The case of Mame Khan shows that the postpatronal process is a complex one, in which traditional patronage can continue to exist and flourish in and beside postpatronal performances, like that of Mame Khan on his crowdfunded album. As that album demonstrates, postpatronal performances are not so different from traditional patronal ones, and the two often go hand in hand. A postpatron fulfills the same duty as a traditional jajman by giving support in return for a promised product from a producer. However, jajmans and postpatrons have very different motivations to patronize music.

IT IS BOTH ENOUGH AND TOO LITTLE

I return to Sakar Khan's chuckle and ensuing silence when I asked him if the payment he received from his jajman was enough or too little to provide for his large family. I received an answer to my question the next day. Shortly before I left Hamira Village for Jaisalmer City on the local train, Sakar Khan pulled me aside and took me to a back room off the main courtyard of his home. He handed me a dusty box wrapped in an old scrap of women's dress material. I looked at him and he nodded, motioning for me to open the box. Inside I found a stack of many passports. I opened a few and saw that they were all Sakar Khan's expired and canceled passports, filled with visas, stickers, and stamps from his many years of international travel. I looked at him with surprise. He smiled and said to me in Marwari, "Yes and no."[38] Sakar Khan's words caught me off guard. I then remembered his brushing off my question the day before about jajmans' remuneration being enough or too little. In showing me his stack of passports, Sakar Khan was signaling to me that traditional patronage was not enough for him to make a living as a professional musician. Nonetheless, his participation in his jajman's wedding and devotion to his jajman the day before demonstrated

that he still gets something from traditional patronal relations, even if it not in tangible form.

While Manganiyar musicians still rely on their rootedness in their villages and traditional patronal relations, they also look to their future participation in a larger and more diverse world of musical performance. Sakar Khan's simple response of "yes and no" helps us understand the nature of contemporary traditional patronal relations. His response speaks to the resilience that Manganiyar musicians harness: they experience occupational vulnerability as their traditional means of support are somewhat hollowed out, but they can reconfigure their musical practices to survive as hereditary professional Manganiyar musicians.

In this chapter, I have demonstrated that Manganiyar musicians and their jajmans participate in traditional patronal relations for diverse and complicated reasons. Many musicians continue these traditional relations despite their poor treatment and payment. Manganiyar postpatronage is a hybrid of traditional patronage and a new form of music making in an economic context. For centuries a highly sophisticated system guaranteed the economic, political, and cultural endurance of traditional patronage, controlling and dominating the Manganiyar community. Manganiyars' use of postpatronage as a hybrid practice subverts the narratives of patronal power and dominance. The exclusionary practices on which traditional patronage was premised have been deconstructed by Manganiyars as inclusionary and mainstream, as Mame Khan's professional singing career and crowdsourced album demonstrate. While many Manganiyar musicians continue to maintain relationships with jajmans for the varied reasons I have listed in this chapter, they also use traditional patronal relationships as cultural capital. In chapter 2, I demonstrate how Manganiyar musicians not only draw on the knowledge and repertoire of traditional patronage to be better postpatronal musicians but also rely on tropes of nostalgia and the authenticity of traditional patronage to market themselves to new postpatronal audiences.

TWO

Performance

A TREASURE TROVE OF TOURS

I first noticed the large metal storage chest when Leela pointed it out to me in 2007. As the wife of Sakar Khan's eldest son, Ghewar Khan, Leela is the oldest *bahu* (daughter-in-law) in the family. She has three younger bahus and a daughter to help her run the homestead. While she spends her days cooking, washing clothes, and keeping track of the family's finances, she can take breaks and spend time with me chatting over a cup of chai or engaging with me as she completes tasks around the homestead like cooking. I had spent time at Sakar Khan's extended family's homestead in Hamira Village on and off for years, but somehow I had never before seen the large chest, which was under a towering pile of hand-sewn, tattered blankets that were unfurled each night to keep the many children in the extended family warm.

Ghewar Khan had asked me to put together a résumé for the website his nephew was building for the family. This was three years after Komal Kothari's death, in 2004. Many Manganiyar musicians who had worked closely with Kothari, including Sakar Khan and his four sons, had depended on Kothari and Rupayan Sansthan to book concert tours and other gigs for them. Since Kothari's death, Sakar Khan's family was fending for itself and finding it difficult to navigate the world of tourism and international performance, which was not only very different from traditional patronal performance but had shifted to an online world, completely foreign to Sakar Khan's sons, now the eldest musicians in the family who had only been educated until the age of ten. Having a website, younger family members believed, would make it easier for them to be called

on for national and international tours in postpatronal performance contexts. I told Ghewar Khan that I needed a list of past performances and additional information to write a résumé for his family. In turn, he asked Leela to show me the metal storage chest.

Leela took me to the back room, pulled the blankets off the chest, and opened it. I peered inside and was overwhelmed by the smell of the mothballs that had been placed inside to keep the contents safe from the desert flora and fauna. Inside the chest I saw an overwhelming number of disheveled piles of papers of different sizes. I reached in and carefully lifted out one pile. Dusty, dry, and stuck together after languishing for decades in the harsh desert heat and cold, the pile contained documentation of Sakar Khan's and his extended family's life performing in postpatronal contexts. Leela told me that whenever the men return from their travels, she empties their suitcases and pockets into the chest before washing their clothes. Award certificates, concert programs, photographs, plane tickets, and various other documents had been haphazardly thrown into the chest over the years.

Excited by the opportunity to learn more of the history of Manganiyar post-patronage through the treasures found in this chest, I spent a week hardly no-ticing the dark, unventilated, and hot back room in which I sat sorting through the chest's dusty contents. Leela spent much of that time with me, helping sort through the documents, and for the first time paying attention to the details of her husband's past tours. Leela cannot read English, so she often passed pro-grams to me, asking me to read them out loud to her. She had her own stories of life while her husband was traveling abroad and took the opportunity to travel down her own memory lane of those times. Her stories gave me a fuller picture of postpatronage for the Manganiyar community. Not only has it changed the musicians and their music while they are abroad, but it has affected the way of life of their families and *jajmans* at home in their villages.

On the most minute level, each object in the chest—from concert programs to matchbooks—was a singular piece, telling me something about individual moments in Manganiyar postpatronal lives. I spread the contents of the archive out over the room's floor, placing papers and objects in piles of rough chronologi-cal order and grouping them by location: Paris, Tokyo, New York, and Sydney. Whenever a member of Sakar Khan's family came into the room to bring me chai, tell me dinner was ready, or just check on me, they would help me place the objects, recounting a memory of a performance in this or that city.

For example, Ghewar Khan came into the room one afternoon and sat down

next to me. He saw an old photograph I had set aside to find out more about it. The tattered black-and-white photograph featured a horse in what looked like a circus ring. Ghewar Khan proceeded to tell me about a 1994 Paris tour, when he had spent months with other Manganiyar musicians and Bartabas, the French equestrian theater director, performing in the equestrian show "Chimera" with Bartabas's troupe, Théâtre Équestre Zingaro. What the photo does not show is the sad story of Shafi Khan, which Ghewar Khan recounted to me while looking at the photo. Shafi Khan was a young musician on his first international tour in 1994, charged with cooking meals for the older Manganiyar musicians on the tour. One night after a performance, while he was cooking in his hotel room, he was badly burned in a gas stove fire, and he died a few days later. By placing such photographs and other documents together, I was able to make connections between musicians, institutions, tour promoters, and scholars who had worked with the Manganiyar musicians over the past several decades. But more important, I learned personal stories of Manganiyar musicians and their experiences while on tour, like that of Shafi Khan. I realized that I had in front of me an archive of postpatronage and Manganiyar memory.

Another photograph features ten musicians and dancers from the Manganiyar, Langa, and Kalbelia hereditary musician communities. It was taken somewhere in Europe during an international performing tour in the mid-1970s, and it shows the performers standing on a platform in front of a high-speed train, suitcases at their sides and instruments slung over their shoulders. The performers look tired, no doubt thanks to jet lag and a rigorous tour schedule, but their eyes are filled with the electric excitement of being in a new place. This photograph demonstrated to me the unusual ways in which Manganiyar musicians were often thrown together with musicians from different regional castes and communities and expected to perform together. These early tours shaped the way Manganiyar musicians now easily adapt their music to diverse performance contexts.

In this chapter, I examine the transition of the Manganiyar performers from village servants for their jajmans in traditional patronal contexts to autonomous international *kalakars* and professional entrepreneurs. While patronal relationships are based on long-standing family ties, the power differential between jajman and Manganiyar necessarily places the musician in a subaltern position in their village. Even if Manganiyars are not financially dependent on their jajman, they are still subordinate and socially dependent on them. For example, Anwar Khan, an internationally acclaimed Manganiyar vocalist and winner of a 2020 Padma Shri Award, told me that when he visits his jajman in Baiya, his

FIGURE 2.1 Padma Shri award
winner Anwar Khan Baiya
during a recording session at
Rupayan Sansthan. Jodhpur,
2006. Photo by author.

native village, he makes sure to sit on the ground lower than his jajman and remains deferential to them (figure 2.1).[1] He also does not show any signs of conspicuous consumption when he is in his village, keeping his car, television, and other expensive belongings at his home in Barmer City so as to not arouse envy in his jajmans.

If traditional patronal relations have waned so significantly that Manganiyar musicians can no longer maintain a livelihood through them alone, why do so many Manganiyars engaged in extremely lucrative and status-bearing postpatronal performance contexts still maintain traditional ties with their jajmans? For Manganiyar musicians engaged in postpatronage, traditional patronage becomes cultural capital to bolster postpatronal opportunities. Indian and international postpatronal audiences long for a sense of nostalgia that musicians who are part of a traditional lineage and history of patronage legitimize through their performances. The idea of traditional patronage in postpatronal contexts conjures up a mostly imagined past of serving grandiose royalty figures while living in rustic simplicity. Traditional patronage, then, serves as cultural capital in a postpatronal economy. But since Manganiyars are not engaging in traditional patronage on

stage for postpatronal audiences, why do they continue to participate in traditional patronage rather than just presenting themselves as doing so? In other words, what do Manganiyar musicians still get from traditional patronage that they do not get from postpatronage? This chapter teases out the complicated and varying reasons for Manganiyar musicians to maintain traditional patronal ties.

SUBALTERN CHIC

For the Manganiyar, being successful in postpatronal performance contexts depends not just on musical skill but also on certain aspects of their personas. Traditional patronage becomes a powerful cultural narrative that Manganiyar musicians use to articulate a brand of performed cultural identity in postpatronal performance contexts. Through their performances of music and self, the musicians encourage tourists and spectators to see them as bearers of tradition. In this case, tradition does not refer to the Manganiyar community's actual history of subjugation, oppression, and exploitation through traditional patronage (A. Gold and Gujar 2002), which most postpatronal audiences know little about. Instead, tradition refers to the imagined subaltern past that the musicians create for themselves.

Here, I return to the concept of resilience. While resilience is often interpreted as a reaction to external action, in the case of Manganiyar, their proactive actions in postpatronal contexts demonstrate resilience. I use the term "strategic resilience" to describe this kind of proactive resilience. While this term is used in business studies as described below, I am also drawing on strategic essentialism to demonstrate how Manganiyar musicians become resilient actors in postpatronal contexts through action rather than reaction.

In this case, strategic resilience necessitates constant and flexible changes to take advantage of potential opportunities that technology and cultural trends provide through future-centered entrepreneurship. In business studies, strategic resilience dictates that innovators must abandon strategies that were previously successful to prioritize potential opportunities and maximize future benefits. To be successful in the future, innovators must first abandon "organizational legacies," or strategies that have proven to be successful in the past or may even be currently working well in the present ("Strategic Resilience 2018," 28). Once these legacies have been removed, innovators will be able to see opportunities in the unknown, anticipate what will work in the future, and find the capacity to change before the need for change becomes obvious (Hamel and Välikangas

2003, 54; Linnenluecke 2015). A strategically resilient entrepreneur, then, is shape-shifting and competitive.

For Manganiyar musicians involved in postpatronage, strategic resilience means constantly changing musical forms, instrumentation, presentation styles, and personas to embody what they think audiences desire. Manganiyar musicians who fail to adjust their music and persona accordingly quickly lose their relevance, audiences, and financial support. An example of this was Kothari's organizational legacy of concert program presentations, in which a few Manganiyar musicians performed on stage with a few Langa musicians and a Kalbeliya dancer in a fixed program of six or seven songs, each lasting close to ten minutes. This standardized presentation became outdated in the 2000s, and those performers who continued to depend on it in postpatronal contexts were not successful. The case of "The Manganiyar Seduction," explored in this chapter, demonstrates strategic resilience through the innovative changes in music and presentation employed by the production's director and a select few Manganiyar musicians.

A strategically resilient Manganiyar musician is one who is constantly designing his desirable future rather than defending or denouncing his past. But what does strategic resilience mean for Manganiyar musicians when postpatronage in the form of performance futures necessarily depend on marketing themselves using romanticized and exaggerated notions of nostalgia and the past? In other words, how can Manganiyar musicians look to their futures in postpatronage by looking to their pasts in traditional patronage? The strategic resilience model falls short in this case because it does not account for the ephemeral nature of music, its nostalgias, and its exoticizations.

The sociological concept of strategic essentialism can fill some of the gaps in Manganiyar postpatronage that business strategic resilience leaves out (Spivak 1996). Strategic essentialism assumes that a group of people has defining features that are exclusive to the members of that group. While essentialist discourse is based in an imperial mode of interpretation that preserves structures of hegemony, it is often used as a political strategy in which group differences are downplayed to achieve group goals (ibid., 214). As Manganiyar musicians are storytellers, inventors of histories, and hagiographers, self-essentialization comes naturally for many of them. Because tradition is always in conversation with histories as imagined in the present, Manganiyar musicians can shape tradition to fit into contemporary and future contexts of performance. However, strategic essentialism does not map seamlessly onto Manganiyar postpatronal music and

its performance, since it does not account for the constant shape-shifting that Manganiyar musicians must do to remain relevant and popular. For Manganiyar musicians to be successful in postpatronal contexts, it is not enough for them to act on or anticipate change or simply essentialize certain aspects of their personas. Instead, they must do both at the same time.

I call the kind of resilience that Manganiyars employ in postpatronal contexts "subaltern chic." Subaltern chic combines constantly shifting strategic essentialism with an eye on the future of performance practice for diverse audiences. It relies on and reinforces the trope of Manganiyar subalternity.[2] Traditional patronal relations link Manganiyars to a subaltern position, which serves the ideological power of their jajmans (Mahalingam 2003). But here, it is a reclamation of being subaltern that not only celebrates Manganiyar commercial success but also creates new associations that ensure the cultivation of a different kind of future.

Subaltern chic carries certain connotations that need to be contextualized in relation to the fashion industry. The term "Indo-chic" has been used to refer to the fusion of South Asian and Western European styles in urban and upper-class contexts.[3] In India, clothing conveys messages about caste, marital status, moral character, and class aspirations, and it serves as a visible marker of difference and power (Shukla 2015; Tarlo 1996 and 2000). Indo-chic depends on identifying these markers in low-caste or low-class clothes and reinscribing them with cosmopolitan meaning (Fernandes 2006). Examples of Indo-chic include Western-style clothing that uses uniquely South Asian textiles traditionally worn by low-caste villagers, like cloth using mirrorwork, embroidery, hand-block prints, or *bandini* (tie-dye).[4] Indo-chic was dependent on two historical events. First, the Festival of India (and other similar festivals) perpetuated the idea of village India through diverse arts, crafts, dress, foods, and music from various parts of India, which were lumped together to represent a made-up cohesive image of "traditional" India (R. Brown 2017, 43). Second, India's liberalization in the early 1990s instilled marketing and consumption differentiation between Indian and non-Indian products that encouraged competition and globalization (Mazzarella 2003).

Manganiyar subaltern chic is indebted to Indo-chic in the ways it draws on such signifying markers as dress, colorful turbans, long mustaches, and the use of the kamaicha. A subaltern chic ambience for the Manganiyars is simple, innocent, and pastoral—both ancient (precolonial) and timeless. Subaltern chic is used as a contestatory practice whereby those donning these signifying markers and embodying this ambience can control the narratives that they wish to project into

the future concerning their lived histories. For the Manganiyar, then, subaltern chic is a practice of strategic resilience. It is a business tactic that necessitates adapting tradition to the future. It depends on strategic essentialism to create a unified image of the Manganiyar community for postpatrons. It relates to Indo-chic in its decontextualization of style. I now turn again to Kothari, who was described in chapter 2 as the Manganiyar community's first postpatron. Here, I provide a history of Manganiyars' interaction with Kothari and contextualize their use of subaltern chic with Kothari's presentational postpatronage.

KOMAL KOTHARI'S BRAND OF SUBALTERN CHIC

I first paid attention to the black coats worn by Manganiyar musicians when performing on postpatronle stages when I saw them worn by all of the male performers on stage in an old photograph I found in the treasure chest in Sakar Khan's home. The photograph had been shuffled between a concert program from a performance at the Sydney Opera House and Sakar Khan's 1991 certificate for the prestigious national Sangeet Natak Akademi Puraskar (award), which is the highest national award for practicing artists in India. The photograph features musicians from the Langa and Manganiyar communities posing proudly on stage after what must have been one of their first international staged performances. As the first incarnation of Manganiyar subaltern chic, the black coat has since been worn by Manganiyar musicians when performing in postpatronal contexts. It is closely fitted and knee-length, cut from black wool, and features a Nehru collar, gold buttons down the front and on the cuffs, and a few slit pockets.

Kothari had the coats tailored in Jodhpur City to fit the specific musicians who traveled with him on the first postpatronal performances. However, since the black coats were not being traditionally worn in the Manganiyar community at that time, Kothari believed that Manganiyar musicians needed to wear other garments to project themselves as kalakars (a term that is often used to connote Hindustani classical musicians in the Hindi Belt) for postpatronal audiences. Rustom Bharucha documented Kothari speaking about their dress: "Earlier, they behaved like ordinary Manganiyars, now they have become kalakars" (Bharucha 2003, 256). Kothari's comment makes clear that he wished to differentiate what he called "ordinary" Manganiyars from those who performed professionally and on par with (and sometimes shared stages with) Hindustani classical kalakars.[5] The black coat became a symbol of professionalism and respectability for Manganiyar musicians. The black coat demonstrates strategic resilience in the way

that Manganiyar musicians were able to don it and make it uniquely their own to compete in a postpatronal economy.

The ubiquitous black coat is resilient, having withstood the test of time and performances, and its use marks a moment in time for the Manganiyar community, the beginning of the postpatronal era. The black coat is a physical reminder of the Manganiyars' engagement with postpatronage. It represents Manganiyars' tours abroad and participation in cultural tourism, as well as their rise to international stardom and embracing of postpatronage as a way of life. Today, the black coats that Kothari had tailored for Manganiyar musicians are frayed at the edges, missing buttons, and faded on the shoulders from years of exposure to the unforgiving Thar Desert sun and international stage lighting. Yet they are still important, symbolizing the elite Manganiyar musicians—those chosen by Kothari when postpatronage was new and traditional patronage was fading. Older Manganiyar musicians still wear their black coats at home in the Thar Desert's cold winter months to keep them warm. They wear the coats like medals to traditional patronal performances for their jajman, even in the hot summer months, as a visible display of their status as internationally touring musicians for their jajman. Those musicians who worked with Kothari in early postpatronal contexts and have died have passed their black coats on to their sons, who now wear them with pride in their fathers' legacy.

I began this section with the ubiquitous black coat to demonstrate just one small example of the legacy of Kothari's work with the Manganiyar community. Kothari first learned who the Manganiyars were in 1958, when he saw a musician in Jodhpur City with a kamaicha, an instrument he had never seen before (Bharucha 2003, 237). At this point, the Manganiyar community was already experiencing the waning of its traditional patronal relations because of the impact of postindependence political and economic restructuring. In 1962 Kothari conducted his first recordings of Manganiyar musicians in Jaisalmer City with the help of Akbar Khan, a Manganiyar musician from the Alamkhana subcaste. It was soon after this, in 1964, when Kothari moved Rupayan Sansthan from Borunda Village to Jodhpur City, that his musical and professional interests turned to the Manganiyar community.[6] While Kothari worked with various castes and communities throughout Rajasthan over his long career, he is best known for his work with the Manganiyar community, since he significantly changed the community through his promotion of, engagement with, and interventions in their musical lives and performance.[7]

In addition to his work with national organizations like the Sangeet Natak

Akademi and All India Radio, as well as his work through Rupayan Sansthan with international scholars, Kothari was beginning his career as an impresario. In 1967, he traveled to Sweden for the first international performance of a group of musicians from the Manganiyar, Langa, and Kalbeliya hereditary communities of performers.[8]

After these initial performances with Manganiyar musicians, Kothari began to craft their postpatronal performances. One way he did this was through frequent trips to Jaisalmer and Barmer to meet the musicians in their villages and talk with them about performing. This eventually led to the establishment of what he called "camps," which he hosted throughout the late 1980s and 1990s. In the first camp, held in 1987, Kothari hosted a hundred Manganiyar children, fifteen young musicians, and ten senior musicians for a week-long intensive training camp in which senior musicians taught younger ones. According to Anwar Khan, a senior Manganiyar vocalist who taught at all of Kothari's camps and went on to win the Padma Shri Award in 2020, "It is one thing to play with your father, but there is another way that can be useful for young musicians. If they stay in one place together for ten days eating and drinking music — playing, singing, learning, and talking with each other, they will learn more and be better musicians."[9] These camps encouraged Manganiyar musicians to perform for each other, teach each other, and learn from each other intensely during several days and nights together.

The ways Manganiyars taught and learned music had not previously been codified in institutionalized settings. While Manganiyar musicians speak fondly about the camps, some have mentioned their negative impacts. Anwar Khan told me: "Through the camps, only certain songs were encouraged. We were not encouraged to innovate and try new things based on music we were listening to. Sometimes we wanted to play the harmonium and learn Bollywood film songs. Komalda [Kothari] did not encourage this. We were not allowed to play the harmonium."[10] Kothari codified repertoire for the first time as old and traditional versus new and nontraditional, with old and traditional songs given preference over new and nontraditional ones. Manganiyar musicians from different villages across the Thar Desert were for the first time performing for each other rather than only for their immediate families or jajmans. Thus, the camps codified the ways Manganiyar musicians taught, learned, categorized, and canonized their musical repertoire.

The camps instilled performance styles and encouraged the use of repertoires that Kothari thought fit for tourist performances and international tours. Kothari

also used these camps to search for talent for future tours. Not every Manganiyar community member benefited from Kothari's interventions, because he chose musicians who had skill sets that he thought would be useful in postpatronal contexts: good looks, dynamicism, outgoing personalities, and a willingness to learn new things and have new experiences. However, Kothari did make a conscious effort to spread the wealth of postpatronal exposure throughout the Manganiyar community as much as he could, choosing different artists for each new performance opportunity (for a discussion of Kothari's recruitment and choice of Manganiyar musicians for the international tours, see Bharucha 2003, 249–50).

Drawn from disparate communities, the musicians and dancers chosen by Kothari to represent Rajasthani music on international tours had never performed together, let alone interacted in everyday life. Each community represented in Kothari's performances had its own unique repertoire and individualized instrumentation (Bharucha 2003, 215). Although Kothari did not intentionally promote cross-fertilization of musical practices, instrumentation, and repertoire on stage, this inevitably happened (Joncheere 2017). One result of this cross-fertilization for Manganiyar performance was the adaptation of multiple vocalists singing together, a practice traditionally more associated with the music of the Langa musician community and picked up during the many performances and international touring experiences shared among musicians from both the Manganiyar and Langa communities.

The contexts for the international performances first staged by Kothari involved a medium-size ensemble typically consisting of seven to ten musicians, each expert on different instruments to showcase variety for nonspecialist audiences. For example, musicians performing vocals or playing the kamaicha, *dholak, khartal,* or a wind instrument (often the *murli,* a double-reeded wind instrument made from wood and coconut shell, or *satara,* a vertical double flute sometimes called *algoja*) were accompanied by one or two dancers. In these touring contexts, musicians were no longer performing at life-cycle ceremonies but were performing on stage for foreign audiences who did not know the customary performance contexts, nuances of the repertoire, or sung language. When Kothari first began to accompany the Rajasthani musicians on international tours, he devised a typical concert bill that showcased a variety of instruments and simple songs that highlighted not the message conveyed through the song texts but the dynamic musicians and their stage presence. The performances often featured calls and responses between instruments, virtuosic solo improvisations, and audience participation, all characteristics not previously heard in traditional

Manganiyar patronage performance contexts. This concert bill was replicated for years by Manganiyar international performers.

Kothari believed that the individuality and distinctiveness of Manganiyar music resided in its traditional instrumentation. Maintaining the use of traditional instruments would not only help the Manganiyar community maintain their distinctive musical specializations and stand apart from other musician communities and mainstream music, but it would also ensure the sustainability of the musicians' livelihood. Throughout his time working with Manganiyar musicians, Kothari told them that they could sustain their music only by doing what they know best, not by borrowing from or copying other kinds of music and using instruments not indigenous to their community.

However, Chanan Khan, a Manganiyar kamaicha player from Bissu Village who toured with Kothari for many years and passed away in 2016, told me that Manganiyar musicians did not often play the dholak and khartal (percussion instruments) in traditional patronal performances until the 1960s, a time that coincided with Manganiyar musicians' performing in postpatronal contexts on stage with professional musicians and dancers from other communities for the first time.[11] Before this, he told me, the kamaicha generally provided its own melodic accompaniment through a rhythmic and percussive style of bowing. When he told me this, he showed me the bells that were attached to his own kamaicha bow and demonstrated a bowing technique on his kamaicha that provided the beat with accents and jingling bells when he was playing. He told me that as the kamaicha fell out of favor and the harmonium became more popular, the dholak become an important instrument in rhythmically accompanying the harmonium player and singer (often the same performer).

Chanan Khan also told me that if the khartal was played at all in traditional patronal performances before the 1960s, there was only one pair, and the singer would hold that pair in one hand so he could gesture with his other hand. In these contexts, the khartal was simply used to keep the beat, providing rhythmic accompaniment to the singer. However, with the rise of postpatronage, the khartal became a virtuosic instrument in its own right. The instrument now consists of two pairs of khartal, one held in each hand. It is now played by a separate musician who specializes in the instrument, and takes featured solos in performances. Most Manganiyar concerts for tourists intersperse vocal pieces with virtuosic rhythmic solos and *sawal-jawab* (question-and-answer) passages between the khartal and the dholak instruments.[12] This musical form was inspired by the rise of tabla solos in Hindustani classical music performances.

While Kothari allowed some changes in instrumentation and repertoire to enter Manganiyar performance practice, he did not allow others. When Kothari saw musicians preferring to play the harmonium rather than the kamaicha or *sarangi* (a bowed lute similar to the kamaicha but found throughout the Hindi Belt) as the vocal accompanying instrument of choice, he banned the harmonium from being played in his presence or on his tours.[13] By the 1980s, the number of sarangi and kamaicha players in the Manganiyar community was dwindling. Kothari encouraged musicians to keep making, learning, and playing those two instruments, believing that abandoning the kamaicha in particular would mean abandoning an entire repertoire of traditional music. With the support of grants from the National Folklore Support Centre and the Ford Foundation, Kothari hosted a kamaicha and sarangi building project, which paired Manganiyar musicians with carpenters to build a hundred new instruments to be distributed to young Manganiyar musicians to learn and play. The results of this project still resonate throughout the Manganiyar community and its members' continuing access to kamaichas.

Although Kothari encouraged Manganiyar women like Rukma Bai to perform in public, he observed that women were generally singing professionally for jajmans much less than they had in previous generations, due to the increasing practice of purdah in the Thar Desert.[14] He encouraged men to learn songs from their mothers and grandmothers in the hope of keeping the repertoire alive (Bharucha 2003). Manganiyar women's repertoire tends to be simpler in form than the songs sung by Manganiyar men at patronal functions in *kacheri*. For that reason, much of the repertoire performed in postpatronal contexts today has its roots in women's repertoire.

Kothari's interventions over his fifty years of relationships with Manganiyar musicians changed the course of hereditary musical life in western Rajasthan. Throughout his career, Kothari was reflective about what the Manganiyar community was gaining and losing from the transition from customary patronal performance contexts to international postpatronal performances in staged concerts. His motivation for working with the community initially stemmed from his desire to help its members enhance their livelihood as professional musicians. He realized that their music was at the heart of Thar Desert culture and saw it as worthy of preservation. But as he helped the Manganiyar community, Kothari resorted to processes of codification, adaption, and exclusion based on his own personal preferences that were seemingly antithetical to preservation). He saw how their performance practice could benefit him and

Rupayan Sansthan both financially and ideologically. He knew that he could promote Manganiyar musicians to make a profit for them and himself. Ultimately, Kothari was instrumental in selling Manganiyar musicians through reinterpretating and reinventing them.

ROMANTICIZING RAJASTHAN

The musical changes described in the previous section in relation to touring abroad would not have happened without the rise of cultural tourism in India generally and in Rajasthan specifically. For the Manganiyar community, touring abroad is closely linked to cultural tourism at home in the Thar Desert: one cannot exist without the other. International touring often depends first on international audiences' and concert organizers' experiencing Manganiyar music in tourism contexts in the Thar Desert. Conversely, cultural tourism in Rajasthan depends on international representations of India bolstered by international concert and festival performances. In addition, Manganiyar musicians depend on cultural tourism at home to sustain themselves financially between international performance opportunities, which can be sporadic.

Rajasthan is a leading state for tourism revenue in India, accounting for 11.2 percent and 3.3 percent of India's foreign and domestic tourists (Planning Commission of India 2006). This is impressive, considering the state's remoteness and dependence on seasonal tourism due to the harsh desert climate. For Indian and international tourists alike, a trip to Rajasthan becomes a trip to the "real" India (Henderson and Weisgrau 2007, xxv). This is ironic considering that this region of India is very different from the rest of the subcontinent in terms of landscape, climate, princely states history, and culture. Rajasthan has become the most heritage-laden and traditional state in India precisely because of the master narratives and stories spun about an imagined place. Beginning in modern history with James Tod's *Annals and Antiquities of Rajast'han*, which he wrote during his time as political agent to the western Rajput States in 1818–22, travel narratives have shaped the way both the foreign and the local gaze consume place as heritage (Tod 1997). I turn now to Rajput royal tourism in the Thar Desert, since it is the master narrative of that tourism that has shaped contemporary Manganiyar performance in cultural tourism contexts.

When the former Rajput princely states united to form Rajasthan State in 1949, laws of postindependence India dealt a sharp blow to the previously independent Rajput landowners' wealth and livelihood. Increasingly restrictive

laws were passed until 1971, when formerly royal privy purses were abolished, and the Urban Land Ceiling and Regulation Act of 1976 forced landowners to rent or sell parts of their properties (L. Rudolph and Rudolph 2011, 110). Wealthy landholders, mostly Rajput *jagirdars* who had formerly been jajmans, were forced to relinquish centuries- and generations-old responsibility to and patronage of communities like the Manganiyar.

One possible loophole in abiding by restrictive government and laws for former royals and landowners was to turn private landholdings into commercial land. According to anecdotes told to me by Lloyd and Susanne Rudolph, political scientists and scholars of Rajasthan, they encouraged one of the first transitions from Rajput royal jagirdar to hotelier.[15] Mohan Singh Kanota turned the Narain Niwas Palace into a hotel in 1982.[16] However, Narayan Niwas was not the first or the last historic palace to become a heritage hotel in Rajasthan (Taft 2003, 128). While Jaipur's Rambagh Palace has been credited as the first palace to become a hotel, with the establishment of the Indian Heritage Hotel Association in 1990, other palaces followed suit—first in Jaipur and then farther west in Udaipur, Jodhpur, and eventually Jaisalmer (ibid., 131–32). For Rajput royals and jagirdars, these transitions not only kept them financially afloat and their inherited properties in the family but also allowed them to maintain their way of life and Rajput identity. In this way, former royals and wealthy landowners in Rajasthan were able to turn their own pasts into a unique economic asset on which to capitalize (Vecco 2010). In postcolonial Rajasthan, this brand of heritage based on former royal life was one of the factors linking disparate former royals and princely states together (Appadurai and Breckenridge 1999).

In these precarious postcolonial times, jajmans' livelihood hinged on narratives and discourses of heritage. Their loss of power, land, and money served as an explicit incentive for the performance and expansion of their royal rituals and cultural displays. Manganiyar musicians made themselves indispensable to these displays of heritage through their genealogy keeping and storytelling. While Manganiyar musicians continued to perform for their jajmans in traditional performance contexts in the Thar Desert, they were also placed in cultural tourism contexts, performing in their jajman's hotels, restaurants, and desert safari camps for Indian and foreign tourists to continue legitimizing their jajman. As royals engaged in "hands-on hospitality," in which tourists were given the opportunity to meet and mingle with royalty (Jhala 2007, 142), Manganiyars also mingled with tourists through their performances, which led to connections and opportunities in the local tourism industry. The shift from traditional

patronage to postpatronage was initially imposed on Manganiyar musicians by laws and their jajmans but proved to be an opportunity for the musicians to be strategically resilient in their transition to postpatronal performance contexts (Linnenluecke and Griffiths 2010).

The 1990s, influenced by liberalization and an increased Indian military presence on the western desert border with Pakistan, brought infrastructural improvements to the Thar Desert. Better roads, increased railway access, electricity, improved water access, and development in the Indian Thar Desert led to government-sponsored tourism, with Rajasthan being especially aggressive in its promotion of Jaisalmer and the Thar Desert as tourist destinations. Numerous ad campaigns in the form of print, television commercials, and online videos promoting tourism in India feature the Thar Desert.[17] It has been noted how the combined imperatives of globalization and nation branding prompt the use of simplified and idealized images to reinforce colonial stereotypes that connect with the tourist imagination (Edwards and Ramamurthy 2017).

Jaisalmer City, with its unique picturesque landscape, Rajput royal history, and long-standing traditional village practices, has been touted as a tourist destination that should not be missed and described as a place that should exist only in the imagination. Jaisalmer is famous for its massive turreted fort that rises like a sandcastle from the flat Thar Desert landscape below, as well as its crowded mazes of bazaars that cater to both locals and tourists. Tourist images of Jaisalmer often show nameless desert landscapes, include no markers of time, feature sand dunes hardly touched by human existence, and present traditional cultural practices unencumbered by modernity and technology. However, the realities of a borderland and marginalized city are left out of these images. Tourism campaigns choose to ignore the realities of everyday life in Jaisalmer, with segregated Muslim and low-caste communities living in slums, open sewers, air and noise pollution due to overcrowding and motorcycle traffic, and a limited infrastructure not built for tourism.[18]

The Manganiyar community has played a large part in the tourism industry of Jaisalmer and the surrounding Thar Desert region. Community members' contemporary position as well-known bearers of tradition and representatives of Indian culture are not a given but rather a result of their strategically resilient self-fashioning. It is through their use of subaltern chic that their community has come to represent quintessential Indian grandeur and pastoralism through such signifying markers as their dress, colorful turbans, long mustaches, acoustic instruments, and rural lifestyles.

INSTITUTIONS AND FESTIVALS

Any examination of Manganiyar involvement in Rajasthan cultural tourism must include a discussion of the state's cultural institutions and festivals as a sustaining factor in the Indian tourism industry. Throughout his decades of working with the Manganiyar community, Kothari was critical of state sponsorship of the arts. He is known to have criticized the state for "museumizing" regional arts, believing that only communities themselves can sustain their traditions and that learning and performing music in formal settings leads to a deep loss of a certain kind of knowledge based on cultural and ecological diversity (Mayaram 2004). He believed that Manganiyar music had survived only because of traditional patronage and the integral role of music in the musicians' and their jajman's daily village lives. Yet Kothari began his career by working in cultural institutions. Furthermore, he went on to found his own, Rupayan Sansthan, which had lasting repercussions on institutionalization within the Manganiyar community.

Many institutions that were inspired by Rupayan Sansthan have worked closely with Manganiyar musicians over the years, collectively taking the place of Manganiyars' jajmans as postpatrons through outreach or community service, concert sponsorship, and the use of Manganiyar music and performance as a tool to spread awareness about institutional work and important social issues. Kothari continued to work with the Manganiyar community and others through Rupayan Sansthan until he died in 2004. What follows is a brief discussion of other important organizations and their work with the Manganiyar community.

By the early 1980s, national sponsorship of regional culture and music became a priority of the Indian government. Three national institutions dominated state sponsorship of music in and out of India—the Indian Council for Cultural Relations, Sangeet Natak Akademi, and All India Radio (for historical information about these organizations and Manganiyar involvement in them, see the appendix). In addition, other cultural organizations that have influenced music and postpatronage for regional musician communities like the Manganiyars include the Indira Gandhi National Centre for the Arts (established under India's Ministry of Culture in 1985) and the West Zone Culture Centre (one of seven culture zones established by the Indian government to preserve and promote India's cultural heritage in 1986).

Inspired by these national institutions, the Indian government sponsored the Festival of India first in London in 1982, in Washington, DC in 1985, and New York in 1986. The Festival of India has been viewed as a watershed moment when

India first proclaimed itself to be an international tourist destination on the world's stage (R. Brown 2017).[19] The festival showcased India's performing arts, marketed its arts and crafts, and presented a unified brand of Indian national heritage that promoted a "new understanding of the continuity and change, the unity and plurality of Indian culture, its ability to carry forward the India of the past into the present and future" (ibid., 204). Government officials called on Kothari to develop the festival's music programming, who proved to be an influential shaping figure in the festival as a whole, which featured Manganiyar and Langa musicians. Due to Kothari's influence, it is no coincidence that of the thirty-nine performers taken to London, Washington, DC, and New York during the festival to represent all of India, half were from Rajasthan (Rosin 2018, 239).

The Festival of India marked the most prolific period of state institutional support of Indian music and culture. After India formally liberalized in 1991, state institutions continued to function and sponsor Manganiyar musicians in performances, but private foundations and organizations took center stage as postpatrons for the Manganiyar community. Three private organizations—the Barefoot College at Tilonia, Uttari Rajasthan Milk Union Limited Trust (commonly known as URMUL) and its Gaavaniyar collective, and Jaipur Virasat Foundation (commonly known as JVF)—have been formative for postpatronage for the Manganiyar community (for historical information about these organizations and Manganiyar involvement in them, see the appendix).

Here, I briefly focus on JVF as an organization that was clearly influenced by Rupayan Sansthan but had different guiding principles. JVF is a multidisciplinary nonprofit trust and is dedicated to a very different type of music promotion that includes the conservation of Rajasthan's cultural and built heritage.[20] Capitalist at its core, JVF was modeled by its founders (the entrepreneurs John and Faith Singh) on their world-renowned clothing business, Anokhi (the name means "unique"). JVF's mission seems to be aligned with that of Rupayan Sansthan. Through JVF's most recent endeavor, the Rajasthan Rural Arts Programme, commonly known as RRAP and established after John Singh's death in 2016, promotes "sustainable heritage-based social and economic development to increase livelihood opportunities in Rajasthan" (Jaipur Virasat Foundation 2022).[21] RRAP houses a museum, performance space, and courtyard in the heart of Jaipur City that hosts musicians, classes, and programs for the local Jaipur community to learn about and understand hereditary communities like the Manganiyar. According to the organization's website, "The RRAP Music Museum & Hub is Jaipur Virasat Foundation's first step towards actualizing its RRAP vision. The

museum aims to disseminate, promote, enliven and conserve these musical traditions and shed light on the unique knowledge they express. Centre stage are the rural musicians and musician communities of the region who are tradition-bearers of the state's vast intangible folk heritage"[22] However, while Kothari did capitalize from his work with the Manganiyar community, Rupayan Sansthan was not founded with the goal of creating a business. Contrastingly, JVF was founded on the business model of capitalization from the cultural preservation sector—specifically the festivalization of culture.

One of JVF's first endeavors was the Jaipur Literature Festival, which began as a small segment of the JVF's Jaipur Heritage International Festival first held in 2006. Although the Jaipur Literature Festival made JVF a a well-known organization in Rajasthan, JVF withdrew from hosting the Jaipur Literature Festival in 2008, when it became a separate entity. The annual festival now functions internationally and independently from JVF while JVF still runs the annual Jaipur Heritage International Festival. JVF started a trend that has continued into the twenty-first century of focusing on privately organized festivals, many of which are held throughout Rajasthan to maintain tradition and sustain customary cultural performance among many hereditary communities of musicians, dancers, and artists of the state, including the Manganiyars (for a list of some of the festivals that take place in the Thar Desert, see the appendix).

While Manganiyar musicians, their music, and their world have changed because of institutionalization and festivalization, much of their self-presentation has been imposed on them—first by Kothari and Rupayan Sansthan, then by other state-based and private institutions, and now by foreign concert promoters and festival organizers. While Manganiyar musicians lose control of their music and presentation in these performance contexts, their retain their agency in making musical choices and choosing the concerts in which they participate. "The Manganiyar Seduction" demonstrates that the Manganiyar musicians who have participated in it and continue to do so are not merely objects of presentation but have chosen to participate.

"THE MANGANIYAR SEDUCTION": A CASE STUDY OF SUBALTERN CHIC

It is in the context of sponsorship, festivals, and international touring that "The Manganiyar Seduction"—one of the largest and longest-running revenue-providing postpatronal performance opportunities for the Manganiyar commu-

FIGURE 2.2 Pre-performance rehearsal for "Manganiyar Seduction." The musicians are seated in their boxes with Devu Khan standing in the foreground, ready to conduct the rehearsal. Washington, DC. 2012. Photo by author.

nity—was established. "The Manganiyar Seduction" serves as a case study to demonstrate the ways Manganiyar musicians have learned and practiced ways of using subaltern chic and strategic resilience in their postpatronal performances of themselves and their music. A staged musical and theatrical performance, "The Manganiyar Seduction" was produced and directed by Roysten Abel, a Delhi-based playwright.[23] It premiered at the Osian's Cinefan Festival of Asian and Arab Cinema in New Delhi in 2006.[24]

The set for "The Manganiyar Seduction" is an imposing and looming four-story structure of thirty-three boxes in which Manganiyar musicians sit and perform (thirty of the boxes contain just one musician each; three boxes have multiple musicians). The boxes, made of wood with hidden metal scaffolding at the back, have red curtains—one on each side that partition them from neighboring boxes and one on the back, and one on the front that each musician pulls back to reveal himself when his performance begins. Each box is adorned

with white lightbulbs for framing and lighting the musicians (figure 2.2). Each musician wears a stark white *band angarkha* (a traditional Thar Desert men's wrapped shirt with ties), dhoti, and a colored turban tied in the traditional Manganiyar way.

The story that Abel told me about his introduction to Manganiyar musicians and their music in 2005 became a trope he proceeded to repeat in subsequent interviews. In 2005 he was in Spain for a theatrical performance. The troupe included two accompanying Manganiyar musicians, the vocalist Mame Khan (discussed in chapter 1), and the dholak player Manjoor Khan. When Abel expressed interest in their music, they proceeded to serenade him on multiple occasions. He described being seduced by their music as if he had no choice in the matter. That is when the idea of a production featuring Manganiyar music came to him. He went on to audition nearly a thousand Manganiyar musicians and chose fifty to participate initially in "The Manganiyar Seduction." One Manganiyar musician, Devu Khan, stood out for Abel as a musical leader and was chosen for the conductor role in "The Manganiyar Seduction."[25]

Enticing Visuals

Most striking about "The Manganiyar Seduction" is the physical structure and stage space, which shape the presentation and frame the music (Tan 2013). There is never a written or spoken text for the audience to use in following the performance, only a range of visual cues that signal place, context, and meaning. While reviewers have described the set as looking like an illuminated chocolate box or the set for the American television game show *Hollywood Squares*, Abel provocatively described the set as a comingling of Rajasthani traditional music with the red-light district of Amsterdam. His inspiration for the production came from the concept of seduction. In a 2009 conversation he told me, "I thought that seduction was just a one-time thing, but with the Manganiyars, even after hearing them a thousand times they still keep seducing me."[26]

Abel has also given credit to the Hawa Mahal (Palace of Winds) as an inspiration for the set design. Part of the City Palace in Jaipur City, the Hawa Mahal is an iconic structure of Rajasthan State. Historically, the women of the Jaipur royal family practiced purdah.[27] The Hawa Mahal was a private space where the women of the royal family of Jaipur could sit behind the *jharokha* (intricately carved stone latticework) that ensured they would not be seen by the public as

they peeked out of the stacked, window-like balconies to observe the Seredeori Bazaar, one of the most bustling markets in Jaipur.[28]

Immediately after "The Manganiyar Seduction" premiered, Abel did not discuss openly the provocative juxtaposition of royal women in purdah with female prostitutes in Amsterdam's red-light district, the contrasting but equally important inspiration for the production's set. It was not until "The Manganiyar Seduction" received international recognition that he began discussing this controversial inspiration openly. In stark contrast to the Hawa Mahal, Amsterdam's red-light district is an area famous for its display of female prostitution, sex shops, strip clubs, and debauchery (Ashworth, White, and Winchester 1988, 201). While the Hawa Mahal conceals the female body, Amsterdam's red-light district displays it. Women parade their bodies, illuminated by red lights, in small, red-curtained parlor windows in Amsterdam's area of street prostitution called Zeedijk.[29]

Despite their obvious differences, the Hawa Mahal and Amsterdam's red-light district have commonalities (figure 2.3). First, both refer to urbanity, and cities have the potential to be urban texts in which meaning is produced through engagement and signs. Second, both structures engage the gaze, drawing the viewer's attention away from the women inside to the architecture and surrounding space. The Hawa Mahal, as a structure that was designed to lead the male gaze away from its feminine interiors, ironically calls the public's voyeuristic attention to itself, with its looming, artistic, and architecturally noteworthy structure. In Amsterdam's red-light district, the beauty of the architecture, bridges, and canals dominates the gaze of people walking by, distracting them from the women's bodies in the windows. Third, both iconic places have become primary attractions for hundreds of thousands of tourists, and for many people, these sites are iconic symbols of their cities. Tourists constantly stop traffic to photograph the Hawa Mahal from the outside and sit behind the latticework and look out, imagining what it must have been like to be a royal woman in purdah. Similarly, tourists and spectators crowd Amsterdam's red-light district, wandering down cobblestone lanes lined with fourteenth-century structures to experience the quaint environment and erotic objectification of the female body.

As seductions, these two sights' common repackaging of otherness into exotica is readily consumed by tourists. They reflect singular aspects of two very different cultural practices—purdah and prostitution, both of which have been exoticized in modern cultural tourism contexts, albeit at opposite ends of the continuum

FIGURE 2.3 The Hawa Mahal viewed from the back, showing the façade structure, the boxes where royal women keeping purdah could sit, and the windows in the lower left corner featuring jharokha, intricately carved latticework to allow women to look out without being seen. Jaipur, 2018. Photo by author.

of possible representations of the female body (Jamison 1999). Both possess culturally feminine attributes: the delicately carved red sandstone latticework of the Hawa Mahal's jharokha and the lingerie and red lights that display the feminine figure in Amsterdam.

True to traditional Manganiyar performance practice, "The Manganiyar Seduction" has an all-male cast.[30] Manganiyar musicians have come to symbolize the epitome of masculinity in the public imagination both in India and abroad, due to their historical associations with Rajput jajmans. The most chivalrous, brave, and heroic men in India are stereotypically thought to inhabit Rajasthan, whose name literally means "land of kings." These qualities are typified in the Manganiyar musician with his regal, brightly colored turban and his long mustache. The same boxed structure looms over the entire performance as authoritative and reiterative, reminding audiences of the gender norms of the places being performed (Butler 1993, 2). The lack of set change in the sixty-minute perfor-

FIGURE 2.4 The façade of a bordello called "Moulin Rouge" in Amsterdam's red-light district, De Wallen. The windows of the building are lit with red neon lights and drawings of women's bodies. Amsterdam, 2013. Photo by author.

mance reinforces the feminized setting, giving the audience the opportunity to see the same feminine space constantly renewed and reworked through a show of boxes being lit up and then darkened, with lightbulbs flashing over the entire structure at climactic junctures in the performance. The sexualization of the body that was to be hidden behind the façade of the Hawa Mahal and flaunted in the windows of the red-light district is ever present in "The Manganiyar Seduction." However, the music retains its Manganiyar masculinity. While it may seem that Abel is mapping a female-gendered space onto the performing Manganiyar musicians, I claim that Manganiyar musicians are using strategic resilience to perform a brand of Manganiyar masculinity—perhaps even a hypermasculinity, when it is reinforced by the feminized set backdrop.

Sounds of Seduction

While the most iconic feature of "The Manganiyar Seduction" is undeniably the visuals of the distinctive set, the power of the production lies in its aural quality. Even before the audience can see the set, they hear a single simple melody played on the kamaicha, the quintessential sound of the Manganiyar community, resounding in complete darkness. One single cubicle at the bottom left corner of the large structure then lights up, revealing the Manganiyar musician who is playing the kamaicha. Three vocalists enter, singing an unaccompanied and rhythmically loose *shubhraj* while the kamaicha provides a drone. As they finish and the percussion instruments—dholaks, dhols, and khartal—enter, Devu Khan runs out on stage in front of the set. He looks up at the musicians with a pair of khartal in each hand, seemingly using his motions and khartal rhythms to conduct the performance. As the conductor of the group, Devu Khan gives the show its essential energy, showmanship, and professional dedication. Devu Khan motions the musicians to enter the performance one by one, as their cubicles are lit up with the framing bare white lightbulbs. The performance contains solos and musical passages featuring the entire ensemble, highlighting instruments, distinctive voices, and virtuosic solos. Devu Khan alternates between taking improvised rhythmic solos on the khartal and running back and forth across the stage, signaling to musicians in the stacked boxes to play their instruments at specific times, and controlling their dynamics and tempo. Continuing through musical conversations between instruments, there is a gradual increase in instrumental and vocal layering that culminates in a climactic finale of rhythmic

intensity, mesmerizing patterns of flashing lights, and large musical gesturing by the production's conductor.

The repertoire for the performance remains fixed, having been arrived at after many trials, rehearsals, and performances. Only three songs have been included in the performance. The main song—"Alfat in bin un bin" (God, known as the first letter of the alphabet, "A," is the same from this end to that end) is based on the poetry of Bulle Shah, a seventeenth-century Punjabi poet, and in the *kafi* poetic form—belongs to the Manganiyar Sindhi Sufi repertoire. Sung in Sindhi, the song is largely associated with South Asian Muslim Sufi devotion. The refrain can be translated as, "The only letters of the alphabet that I ever learned were the letters of love." Featuring this song brings to the foreground the contemporary importance of Sufi repertoire for the Manganiyar community.

The two secondary songs in "The Manganiyar Seduction" are more typical of the repertoire performed for Manganiyar patrons (Kothari 1994, 227). One of the songs, "Halariya" (Birth) is sung in the local Marwari language at jajmans' ceremonies for the birth of a male child, and it describes the birth of the Hindu god Krishna. In the song, people of various castes are summoned to the home and asked to provide services for the newly born child: the carpenter is asked to build a cradle, the goldsmith to make ornaments, the Brahmin priest to provide a horoscope, and so on. Another song, "Neendarli" (Sleepiness), is also part of the traditional Manganiyar repertoire and is performed at jajmans' weddings. The lyrics of the song describe a wife showing love and affection for her husband, thinking of many excuses for him not to go to sleep so that she can spend time with him. The performance presents no breaks or apparent differentiation between these three very different songs. In fact, it alternates freely between the three songs, beginning and ending with "Alfat in bin un bin,"

While Abel proudly admits to introducing a certain amount of spectacularization and dramatization into the production, he claims not to have changed Manganiyar music for it. His statement assumes that there is something constant and audible in Manganiyar music to begin with. Manganiyar musicians have always been highly flexible in their music making, receptive to jajmans' needs and wants. Over the past several decades of performing in cultural tourism and international performance contexts, Manganiyar musicians have become increasingly flexible. Just because Abel did not tamper with the music does not mean that the music has not changed in this staged setting. It is not surprising that the Manganiyar musicians would take the initiative to change their music

to fit this new and innovative setting, aligning their repertoire and performance styles with what they believe their audiences want to hear.

Another change in "The Manganiyar Seduction" is performer communication. The set design adds a new dimension to Manganiyar music. In traditional patronal contexts, Manganiyar musicians are usually seated in a semicircular configuration on the ground, which enables verbal, musical, and nonverbal communication. Verbal communication consists of musicians speaking to each other. Musical communication involves dynamic changes, accents, and the use of *tihai*.[31] Nonverbal communication consists of eye contact, head movements, and motioning using instruments. These movements are necessary for changing tempos, taking solos, and cueing the beginnings and endings of sections. However, in "The Manganiyar Seduction," the compartmentalization of the musicians isolates them within their own boxes, separated by curtains. They have no visual contact with musicians in other boxes and are guided only by the conductor. Thus, the conductor and the audience are the only ones who can witness the visual collectivity of "The Manganiyar Seduction."

However, according to Chuga Khan Hamira (Sakar Khan's nephew, not Chuga Khan Barna, Gazi Barna's father), who has been on several tours with the production, the musicians could perform the entire concert by rote, having rehearsed and performed the show numerous times.[32] From his perspective, it did not matter that the artists could not see each other, because there was no improvisation in the performance. This constitutes yet another change in Manganiyar performance practice in postpatronal contexts. The program never changed, and once the pieces and their order were decided, solos and improvisations were confined to the same places and times in each performance. While this contradicts Abel's earlier statement that he did not change the music, it shows his perception that context and improvisation are not inherent in music.

Mame Khan—the first lead singer of the group, who then left for other performance opportunities—described early rehearsals for the production as frustrating. He told me in an interview that the musicians were not able to communicate well with Abel in the beginning.[33] It took them time to realize his vision of the production, including three years to finally agree on the musical form and format that the production currently has. From Abel's perspective, the process was not easy either. He told me that the musicians are not used to structures or rehearsals. He used the word "free-spirited" to describe their musicality, qualifying that to mean playing whatever they feel like.[34] While Manganiyar musicians in this performance embody a sense of nostalgia and timelessness for audiences,

their music is situated in the present and is responsive to contemporary trends, audience demands, and changing musical tastes.

Awareness and Agency

Some Manganiyar musicians are aware of the cultural associations that are being produced in "The Manganiyar Seduction," and others are not. But they are all sharply aware of their stereotyped role as bearers of tradition, a role they adopted even in earlier traditional patronal contexts. Their motivations for their involvement in "The Manganiyar Seduction" are financial and experiential. When I visited the Thar Desert in 2013 after a yearlong hiatus from fieldwork, I found young Manganiyar musicians who knew the "The Manganiyar Seduction" musical repertoire and played it over and over. Older Manganiyar musicians were keenly aware of the potential for such a production to give younger Manganiyar musicians who lacked familiarity with cosmopolitan musical values and production a way to learn about postpatronage and make it possible for them to perform abroad in international postpatronal contexts for the first time in the company of many other Manganiyar musicians.

The production provides an easy and reliable income. It never changes, so musicians can continue to participate in the production year after year without having to learn new repertoire or acquire new performance skills. The international exposure gives them clout as internationally touring musicians for future performance opportunities, gets them visas to many countries, and allows them to practice being international musicians in the comfort of a large group of musicians that include family members and close friends. Beyond these tangible benefits, I claim that Manganiyar participation in "The Manganiyar Seduction" allows them to practice strategic resilience. While Manganiyar musicians in the production have no control over the form or content of the presentation and representation in "The Manganiyar Seduction," they choose to participate. This participation allows them to strategically involve themselves in contemporary postpatronage and opens doors to futures of postpatronal opportunities.

MUSICAL ENTREPRENEURSHIP

I have used "The Manganiyar Seduction" to demonstrate the ways Manganiyar musicians involved in postpatronage are strategically resilient. Public discourse about music as art requires professional musicians to conceal the capitalistic

nature of their music (Attali 1985). Musicians are expected to stand apart from the rest of society and capitalism, even though music is very much a commodity to be produced and consumed. To be successful, musicians are forced to hide their entrepreneurship behind a veneer of romantic, pure artistry (T. Taylor 2015). But ultimately, it is entrepreneurship that allows Manganiyar musicians to be strategically resilient (Ellmeier 2003). Manganiyar entrepreneurs are musicians who are not only talented and dynamic but who also continually strategize about and innovate their musical performance—where innovation refers to the creation, development, and implementation of new musical concepts, performances, instrument configurations, and collaborations.

One of the main differences between music in traditional patronage and contemporary postpatronal contexts for the Manganiyars is whether its economics are revealed or concealed. In traditional patronage, a clear reason for jajmans to maintain traditional patronal ties to Manganiyar musicians is to demonstrate their wealth. The economic transaction between Manganiyar musician and jajman is not only transparent but on display, as jajmans give public gifts to Manganiyar musicians. In traditional patronal contexts, the qualities of entrepreneurship are not rewarded. Patronage is property passed down from generation to generation. This is not the case for those Manganiyar musicians engaged in postpatronage. There they are expected to be talented musicians. The most successful Manganiyars today tend to be those who can hide the economics of their profession by emphasizing their artistry, musicality, and passion as the driving force of their music.

In this chapter, I have told the story of a fading traditional patronage system and the rise of cultural tourism and touring abroad as postpatronage for the Manganiyar. I have posited that Manganiyar musicians use traditional patronage as cultural capital to create a sense of subaltern chic through the practice of strategic resilience. We are left with a question: If servitude of the Manganiyar community is inherent in traditional patronal relations, why do Manganiyar musicians continue to engage in its practice? Why cannot Manganiyar musicians draw on traditional patronage as a cultural narrative of tradition and heritage without practicing it?

On a practical level, maintaining ties to traditional jajmans provides Manganiyar musicians with year-round income, even if that is meager. While postpatronal performances have proven to be more lucrative than traditional patronage for Manganiyar musicians, they are also unpredictably scheduled and dependent on government and private funding, visa acquisition, and international con-

tacts. Traditional patronage still provides a small but predictable income for Manganiyar musicians—especially during hot summer months, the off season for the tourism industry. So even though the musicians may compromise their own status by performing for traditional patrons, they are gaining economic rewards (Mosse 2018). In addition, such performing allows both young and old Manganiyars to maintain their musical practice year-round. Members of the younger generation of Manganiyar musicians who do not get formal musical training must rely on traditional patronal functions to learn music. Members of the older generation who are not able (or have no desire) to travel abroad still perform in traditional patronal contexts. In addition, people in the Manganiyar community are not given government pensions, nor do they have insurance. Traditional patrons still serve as a kind of insurance in times of need for the community.

Another motivation for maintaining traditional patronal relations lies in what Manganiyar musicians call *adhikar* (privilege). In conversation, Manganiyar musicians expressed to me the ritualistic importance they have for their jajmans and their ability to legitimize jajman's family functions. They consider this work as devotion that brings them closer to God. Many musicians see performing for jajmans as their divine duty, the form of employment for which they were destined.

Adhikar is closely related to caste. On the surface, it may seem that maintaining traditional patronal ties embeds members of the Manganiyar community in their low-caste and marginalized position. By engaging in traditional patronal relations, Manganiyar musicians seem to be condoning casteism and upholding discriminatory practices. However, it does not necessarily mean that they are subscribing to a dominant caste hierarchy. Instead, Manganiyar musicians are responding to caste dynamics. By engaging with jajmans in different ways because of increased income, respect, and internationalization, they are recontextualizing this traditional relationship to gain social status and a new identity as hereditary music specialists. At the end of an international tour, Manganiyar musicians must return home to their families and villages. They must find their place in their village and interact with their communities. Traditional patronal relations ensure that they still have a place in those communities.

While it is true that traditional relations between Manganiyars and their patrons are now less prevalent and strong than they were historically, they continue to be resilient. This resilience is in part because a market system provides flexibility for musicians to not depend solely on their jajmans for money and resources,

as well as to use traditional patronal relations as cultural capital to be more marketable in the local tourism industry and internationally. Postpatronage and traditional patronage reinforce and support each other. In chapter 3, I examine a shift in Manganiyar musical practice. Soon after Kothari passed away, Mangani-yar musicians began to organize their own international tours individually and independently, based on connections made through the local tourism industry and previous experiences touring abroad. As Manganiyar musicians continued to adapt their music and social organization to modern cultural tourism, the global arts economy, and a technology-driven music industry, their performance lives began to change their lives at home in the Thar Desert. Wanting and demanding better futures for themselves and their community led Manganiyars to involve themselves in local manifestations of development practices.

THREE

Development

FLOODING

In late August 2006, the same rain that has featured in Manganiyar songs like "Panihari" (Women who fetch water from the well) with reverence suddenly became the cause of havoc and destruction. Parts of the usually drought-ridden Thar Desert were struck by flash floods when twice as much as the usual annual amount of rain fell on Jaisalmer and Barmer Districts in the span of just three days. In the contemporary reality of global warming, the monsoons nourish and devastate, bring anticipation and dread, and create life and death in the Thar Desert. The 2006 floods were a calamitous surprise in a desert where every drop of water is precious.

When the floods struck, I was in Delhi conducting archival research. Before I had the chance to read about the floods in the news, I received phone calls and text messages from several of my Manganiyar interlocutors. One called to make sure I was safe, not knowing I was in Delhi. Another called to tell me about his family members, who were stranded in Kawas Village. Gazi Barna called to ask me to return to Jaisalmer right away and accompany him to the areas affected by flooding. Under the auspices of his *sansthan*, which he founded and modeled after Rupayan Sansthan, he had plans to deliver resources to Manganiyar families. "It is for your research, but it is also for our community," he told me over the phone.[1] I bought a train ticket for Jaisalmer City and planned to take a bus from there to Barmer to meet Gazi Barna in two days.

The next day, I settled into my train bunk for the journey across Rajasthan State. On the journey I dug into the stack of newspapers and magazines I had

purchased at the train station. I read that the flooding had damaged several low-lying villages in Barmer District and was especially bad in Kawas and Malwa Villages, twenty miles from Barmer City. The Thar Desert's ground layer of thick gypsum combined with underground reserves of clay had prevented much of the floodwater from soaking into the ground. The water from rains as far away as 150 kilometers north in Jaisalmer had flowed down to Barmer via dried-out riverbeds. As a result, the floodwater was close to nine meters above ground level in some villages (A. Sharma and Chauhan 2013, 270).

In the days and months that followed, I learned that the affected area housed a population of approximately fifty thousand, almost all who had been forced out of their homes by the floods. The Government of Rajasthan's Irrigation Department and the national Indira Gandhi Canal Project built *anicuts* (dams) and *tankas* (underground tanks that collect rainwater), dug canals, and installed pumps to drain the water, but to no avail. Even five months after the floods, some villages remained submerged. Most troubling were the death tolls and damage: 139 people were initially killed by the floods, and at least 45 died later from malaria due to mosquitoes in standing floodwater; over 75,000 cows perished; and the damage to fields, crops, homes, and public property totaled 1,300 crore rupees ("Rains, Floods Claim 85 Lives in Rajasthan" 2006). Unsurprisingly, most of the people displaced by the floods were from low-caste communities, whose members had for centuries been forced to live in the low-lying outskirts of villages. The number of Manganiyar musicians from Kawas and Malwa Villages who had been affected by the flooding was especially disheartening. Those who had been stranded on roofs and sand dunes in their flooded villages for days on end had no one to help them. Their jajmans, who for the most part were no longer able to support musicians, did not come to their rescue when they lost their homes; the little land and livestock they owned; and, most important, their instruments—which allowed them to earn their livelihood as professional musicians.

After a much-delayed train ride to Jaisalmer City, I immediately got on a bus that took me to Barmer City. On the journey, I saw entire villages decimated and the bodies of animals that had drowned and been washed onto the roads. Some roads were completely gone, and several times the bus got stuck in mud and had to take an alternative route (figure 3.1). After a ride that took three times as long as usual, I finally arrived in Barmer City. There I met Gazi Barna and his convoy of trucks and jeeps, which had arrived from Jaisalmer a day earlier. Each vehicle had colorful hand-painted banners in Hindi script hung on its side, advertising the relief efforts and the name of Gazi Barna's sansthan, Pehchan. I was quickly

FIGURE 3.1 View from a bus traveling from Jaisalmer to Barmer, one month after the 2006 floods. Much of the desert in the distance is submerged. A building in the foreground was washed away, leaving just two windows of the former structure. Barmer, 2006. Photo by author.

put to work helping men from the Manganiyar community unload and deliver boxes of food and other necessities to flood refugees.

Hours later, Gazi Barna and I took a break in the shade of his jeep. He told me about his involvement in flood relief work:

> I collected more than ten lakh rupees ($14,000) to put toward the cause. As soon as I heard what happened, I called my friend Rahulji [Rahul Vohra, a Mumbai-based actor and film director]. He sent money and resources right away to help my community. I called different companies—Airtel, Hutch, and banks—to collect a lakh from each. Vishwaji [Vishwa Mohan Bhatt, a Jaipur-based Mohan veena player] also helped a lot. I bought all the urgent necessities on credit and with my sansthan's money in Jaisalmer to deliver to Barmer within a few days of the flooding—*atta* [flour for making chapatis], ghee, blankets, and water. I did it myself.[2]

While the Indian government was quick to act, with the army and air force evacuating 3,600 people from rooftops and sand dunes and delivering 76,000 food packets to people affected by the flooding, I heard a different story from members of the Manganiyar community. Due to the continued waterlogging and lingering of livestock carcasses long after the floods, drinking water was poisoned and made inhabitants critically ill; and malaria, chikungunya, dengue, typhoid, and jaundice threatened local populations.[3] According to Gazi Barna, government officials ignored the villagers' needs, did not want to go to the remotest areas where there was real need, or felt that they had already delivered adequate relief immediately after the floods. While Gazi Barna delivered water, vegetables, tea, and atta to affected Manganiyar families in the days following the floods, he predicted that Manganiyars would need the most assistance months afterward.

I met some of the Manganiyars affected by the floods in Malba Resettlement Colony on the outskirts of Barmer City in October 2006, two months after the floods. I went with Fakira Khan, one of my interlocutors and a Manganiyar musician from Barmer revered for his social and political work in the Manganiyar community. As we walked into the camp, he told me that he had just come from a meeting with Vasundhara Raje, then chief minister of Rajasthan, to discuss the needs of the community after the flooding.

I sat down with a Manganiyar musician who had lost his home and asked him to tell me about the flooding. According to him, the real disaster was taking place months after the floods, when the Indian government and media had forgotten about the affected people. With a shaky voice, he said: "The government helped us immediately after the flooding. But after that, they felt they had done their good deeds and could go back to Jaipur. Meanwhile, we have languished in this camp. Actually, we are lucky we have a place here. Many Muslims and poor people were threatened and chased away by Hindu Rajputs and had to leave. I can't go back to my village because it is still underwater. They [the government] do not know our real needs anyway."[4]

Despite the lack of government assistance claimed by this musician, the response of the Manganiyar community to Gazi Barna's flood relief work in 2006 was mixed. Some musicians told me that they were thankful to Gazi Barna for the work he continued to do for the Manganiyar community after the flood. They believed that because Gazi Barna is a Manganiyar, he had a better idea of the needs of the community than the government, which they believed to be self-serving and corrupt. For some, this made his contributions more legitimate,

genuine, and sustainable: accepting those contributions was considered to be keeping things in the family.

However, others in the Manganiyar community thought that Gazi Barna was doing charitable work only to gain publicity for himself and his sansthan, and they used his perceived vanity and media savviness as evidence. Two months after the floods, Gazi Barna handed out new harmoniums and *dholaks* to Manganiyars from the flooded villages. These instruments had the name of his sansthan painted on them. He made sure that television camera crews and newspaper reporters were present at this ceremony, hosted by his organization, to see and document his good deeds. One musician told me, "Nisvaarth achchhe karm maujood nahin hain" (there is no such thing as a selfless good deed), referring to Gazi Barna's work.[5] These Manganiyars said that they accepted Gazi Barna's assistance not because they wanted to but because they had no other option.

This ethnographic experience left me with a series of questions about Manganiyar access to resources. Did those Manganiyars who fled their villages have jajmans? If so, I wondered why they did not or were not able to help in this time of need. Despite initial government support, what do we make of the Manganiyars' assessment of the lack of sustained governmental disaster support in the months after the floods? In other words, how have the Manganiyars' expectations of resources changed with the waning of traditional patronage and the waxing of postpatronage? What kinds of contemporary support systems do the Manganiyars have, when they can no longer rely solely on their jajmans in times of need? Is access to resources across the Manganiyar community even? If not, what causes uneven distribution of and access to resources?

In this chapter, I tell the story of the first decade of the twenty-first century, with its unlikely intersection of music and development. After Komal Kothari died in 2004, Manganiyar musicians began founding their own organizations to help them grapple with the musical and cultural changes that came with postpatronage. Rupayan Sansthan had formerly replaced traditional patronage and the welfare state as an alternative community support system used by Manganiyar musicians in times of need. While the organization continued to function after Kothari's death, it was run by his son, Kuldeep Kothari, who focused it on building a museum and developing local cultural and environmental education programs rather than sponsoring international performance tours for Manganiyar musicians. For several reasons that I discuss in this chapter, Manganiyar community members had come to depend less on governmental support from

the welfare state and more on themselves and other members of the Manganiyar community, like Gazi Barna. Thus, Gazi Barna's intervention and others like it can be considered yet another form of postpatronage: Manganiyar musicians like Gazi Barna became both the patron and the patronized.

The story of the 2006 floods demonstrates the varied and uneven response of Manganiyar musicians to the changing world around them (Chandler 2014). Instead of sitting back and waiting for assistance to come to them, Manganiyar musicians like Gazi Barna asserted control over situations like the 2006 floods, used resources available to them from postpatronal performance contexts, and established their own individual forms of development to provide resources for themselves and their community. But what did Gazi Barna gain from his community-based development work and aid distribution to the Manganiyar community? How is this kind of entrepreneurship an effect of postpatronage and the neoliberal development state that the Thar Desert region of western Rajasthan became by the early 2000s?

No longer beholden to their jajmans, Manganiyar musicians like Gazi Barna who by 2006 had moved into postpatronal contexts foresaw better lives for themselves and their community outside of their subaltern existence as traditional patronal musicians. Manganiyar musicians had begun stepping into new arenas that allowed them to access resources at unprecedented levels, using the techniques of strategic resilience discussed in chapter 2. Despite gaps in resource development and uneven access across the community, those Manganiyar musicians working in postpatronal contexts ingeniously found ways not only to make ends meet financially, but also to thrive in multiple contemporary, capitalist, and international performance arenas. In this context, a turn to development seemed a logical step in the quest for Manganiyar resilience. But what did resilience mean in the first decade of the twenty-first century? Had it taken on a new neoliberal meaning, given the rise of a development state?

MUSIC AND DEVELOPMENT

When the 2006 floods struck, I was in the midst of twenty-four continuous months of fieldwork in the Thar Desert (2005–2007). While the floods devastated lives in the region, some Manganiyar musicians like Gazi Barna saw them as an opportunity. Manganiyar musicians had already begun to organize their own performance tours throughout India and abroad after the wake of Komal Kothari's death in 2004. They used contacts, connections, and skills acquired during

the past several years of working in postpatronal contexts to seek new musical futures for themselves and their community. But as Gazi Barna's flood relief efforts bring into focus, Manganiyar musicians were feeling empowered by their growing financial and professional independence from traditional patronage. For many of them, postpatronal development was at the heart of empowerment for the Manganiyar community in the first decade of the twenty-first century.

The intersection of music and development for the Manganiyars was again brought to the forefront of my ethnographic research in late September 2006, at the World Tourism Day celebrations and performances in Jaisalmer City, sponsored by Jaisalmer's Department of Tourism. It was there that I first met Thanu Khan Manganiyar, who went on to become a research interlocutor. I commended him on the virtuosic performance I had just heard him give (figure 3.2). Assuming that I was a visiting tourist, he pressed his raised palms together, said "namaste," handed me his business card, and began to walk away. I looked down at the card he had given me and noticed that it was unlike most other Manganiyar business cards I had seen. While many Manganiyar musicians possessed their own business cards touting their musical specializations, the number of international tours on which they had performed, or the awards they had received for their music, Thanu Khan's card read in bold black letters across the top: "Chhaila Mama Sansthan. Sustainable development. Eco-village tourism." I caught up with Thanu Khan and invited him to chat over a cup of chai.

Thanu Khan agreed, and we walked to a nearby dusty roadside chai stand, one that we both knew served members of the low-caste Manganiyar community, unlike some restaurants in the city. We sat on benches in the shade from the late summer heat and sipped hot chai. I remember Thanu Khan being surprised that I wanted to discuss his sansthan and promotion of community development rather than the cultural tourism performance I had witnessed. He told me about his experiences growing up as a Manganiyar musician in Khuri, a village near Jaisalmer with large sand dunes that had become an off-the-beaten-path tourist destination in recent years because it provided desert camel safaris and village homestays to adventurous tourists.[6] Reflecting on his early musical experiences and the ways both his family and his jajmans had taken the plunge into postpatronage through village cultural tourism, he revealed his feeling that the Manganiyar community was not benefiting from cultural tourism in the ways that it could. He had hopes of turning his small sansthan into a well-known NGO to help bring together music, village tourism, and development of the Manganiyar community.[7]

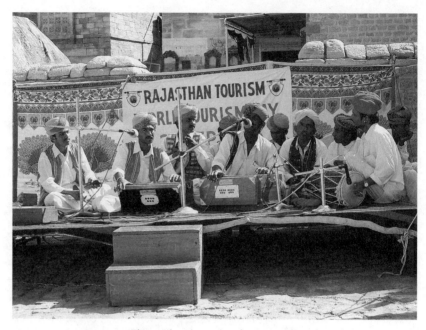

FIGURE 3.2 Thanu Khan (center) and group performing at the
World Tourism Day celebration hosted by Jaisalmer's Rajasthan Tourism
Department in Jaisalmer City, 2006. Photo by author.

Thanu Khan's involvement in development stemmed from his concern about
the future of his community and its music. He saw that the Manganiyar com-
munity had the potential for greatness. But this potential was not something new.
By 2006, Manganiyar musicians had been steeped in development happening
all around them in the Thar Desert, including Kothari's Rupayan Sansthan; the
building of the local Indira Gandhi Canal (construction started in 1952, and the
canal was completed in 1971) and its environmental aftermath, related to the new
industrial systems and farming technologies known collectively as the Green
Revolution; various international, national, and regional Thar Desert develop-
ment projects; and a blossoming cultural and ecotourism industry supported by
the government of Rajasthan. "Development" was a word that was already on
every Manganiyar musician's mind. Musicians used development rhetoric and
the rights-based language associated with wider political and social struggles to
speak about their community and music. Terms such as "intangibility," "sustain-
ability," "preservation," "uplift," and "empowerment" were thrown around by
musicians—some of whom knew the meaning of these terms and some of whom

did not. The actual meanings of the words were not as important as the ways the musicians were using them to envision and demand development, access, and accountability in relation to the specific resource needs of the Manganiyar community.

It was clear to me that development was not just an English word being super-imposed onto their everyday language about status but was a concept that was being embedded into the community and had the potential to shape their lives. Its use and application meant a future for musicians. Hopes for a Manganiyar brand of development were high, as I learned in the months following my interaction with Thanu Khan. Almost every village where Manganiyar musicians lived in the Thar Desert had at least one Manganiyar-founded sansthan dedicated to causes Manganiyars interpreted as development. These causes ranged from musical preservation to improving water access and from traditional poetry documenta-tion to campaigns to outlaw the use of the name "Manganiyar" (considered by some to be disrespectful and derogatory)—as well as reviving the art of build-ing traditional instruments like the kamaicha, which was no longer prevalently being made, and promoting cultural and ecotourism in villages and the Thar Desert. Based on these conditions of possibility, I speculated at the time that these beginnings would lead to new localized forms of development, initiated and maintained by Manganiyar musicians.

DEVELOPMENT DISCOURSE AND IMAGINARIES

"Development" has been a hotly contested term, being both complex and am-biguous. I draw on a development discourse approach to analyze the myriad ways Manganiyar musicians talked about development in the first decade of the 2000s. I use a sociological understanding of discourse as language reflecting so-cial order, but also as language shaping social order and individuals' interactions with society. After decades of international Western development interventions throughout the Global South, scholars and practitioners of development ac-knowledged the power of its discourse and affirmed that the ways development was discussed directly affected how it was implemented and received. Given this turn to discourse, development was not only praxis but was also entrenched in localized ideas that shaped reality and framed human relationships.

In the case of the Manganiyar community, ethnographic accounts of their language, imagery, and music as development discourse can reveal the ways Manganiyar musicians place themselves and their community in the present

and future. How might language and imagery be underlain by power relations? Who has the power to talk about development, and using whose terms (Escobar 2012)? I draw on Charles Taylor's (2004, 106) social imaginary as being the way "ordinary people 'imagine' their social surroundings." If Taylor's social imaginary is "that common understanding that makes possible common practices and a wide shared sense of legitimacy" (ibid.), then the term "development imaginaries" can be used to describe Manganiyar development discourse and its impact. Development imaginaries, then, do not necessarily mirror actual practices but represent hopes, dreams, and possible futures of development. It is therefore social understandings and popular narratives that shape development, ideas about development on the ground, and what I call development imaginaries (R. Chatterji 2020; Markham 2021).

Even before development was brought to the forefront of my research after the 2006 floods, I noticed Manganiyar musicians using development rhetoric to speak about their community and music. English terms such as "sustainability," "resource access," "empowerment," "ecology," and "preservation" peppered everyday conversations and even occasionally made their way into songs. Through speaking about their futures in a way that put development front and center, Manganiyar musicians created development imaginaries that did not simply mirror others' discourse but represented aspirations of what development by and for the Manganiyar community could look like. But ascertaining what Manganiyar musicians meant by their use of development imaginaries is complex, and meanings varied from musician to musician. These development imaginaries need to be viewed against the backdrop of the Manganiyars' history of centuries of caste discrimination, poverty, and servitude to jajman. Traditional patronage in the Thar Desert had provided an infrastructure on which development could grow. Scholars have shown that development practices in the Thar Desert emulate traditional patronal relationships (O'Reilly 2010).

In the early 2000s, development had inevitably entered Manganiyar discourse, and almost every aspect of Manganiyar lives was tinged by development. Manganiyars saw development discourse's potential as leading to social mobility and escape from entrenched societal patterns of economic and social deprivation. Musicians spoke about their involvement with established development projects in the region, aspired to found their own sansthans, and incorporated development rhetoric into their everyday conversations. While only a few Manganiyar musicians followed through on their development dreams of founding their own sansthans, many—including Thanu Khan—started down the path toward doing so.

At the end of my first conversation with Thanu Khan on World Tourism Day in 2006, after he had told me about his development imaginaries, he seemed embarrassed by the aspirations he had shared with me. I wondered why and realized later that development imaginaries are very personal, sometimes intimate and dream-like. They are about a potential, a future that may never exist. This and other anecdotes in this chapter point to the complex, personal, yet universal nature of development imaginaries in the Manganiyar community during the first decade of the twenty-first century. Manganiyar development imaginaries both reflected and deflected common development practices in the region. Some were very public, like Gazi Barna's flood relief efforts, and others were private and personal, like Thanu Khan's aspirations.

THE RISE OF DEVELOPMENT

This chapter was inspired by a body of scholarship concerning development, postdevelopment, and critique of both through observations of and participation in ethnographic realities. While development is often thought of in terms of building roads and infrastructure, providing food and public health services, and educating people, it can also be conceptualized more broadly—encompassing cultural interventions and institutions that address the challenges of alleviating poverty, addressing social injustices, and engaging communities in initiatives and projects.

To understand the Thar Desert development landscape in which the Manganiyar community found itself in the early 2000s, we must first contextualize the history of postcolonial rearrangements, governmental shifts, and the economic changes that led to those shifts. I start in 1951, when the newly independent India rolled out its first five-year plan. The plan adopted aggressive economic policies and plans of industrialization, development, and sustainable food production.[8] As discussed in chapter 1, one of the government-imposed reforms was the redistribution of landholdings for royals and jagirdars in Rajasthan State.[9] By 1980, much of the land formerly owned by jagirdars had become government land and was used for public-sector industrial, infrastructural, and farming purposes (Rosin 1981).

Because of land reforms and distributions, previously unregulated common land used for pastoralism and migration was easily privatized and turned into farmland (Jodha 1985). The Green Revolution allowed previously infertile and dry desert land to be converted to productive farmland. Starting in Punjab State

and spreading to neighboring states, including Rajasthan, the Green Revolution incentivized farmers and pastoralists with subsidies for abandoning the practice of pastoralism and growth of traditional desert crops in exchange for the farming of high-yielding crops. The Indira Gandhi Canal spurred the Green Revolution by providing new access to water in a desert region that had previously depended on sparse seasonal rains to grow small crops. In the Thar Desert, this meant that there was a stark shift from the predominant pastoralism and small-scale agriculture to large-scale agriculture.

While agriculture in the Thar Desert benefited in the short term, leading to more lucrative but intensive farming, the Green Revolution caused other occupations that depended on natural resources of the desert, such as livestock rearing, to decline significantly (Robbins 2001). People who took up farming depended on new technologies including irrigation, chemical fertilizers, pesticides, and mechanization to make farming possible in the harsh desert environment (Bandyopadhyay 1987). Crop acreage was increased by cutting down already sparsely scattered trees. Although this was not evident at the time, the widespread use of state-subsidized high-yielding crop varieties had long-term negative effects on farmers, the land, and the environment, causing soil erosion, deforestation, and depletion of groundwater.

All of this constituted a significant impetus for the liberalization of economic policies to fill in the gaps left by the failure of the Green Revolution to promote privatized industrialization (Levien 2018). Because India already had an infrastructure for the privatized industrialization that the Green Revolution spurred, the nation began to open up to international trade relations and the use of private capital in the 1980s. But it was not until 1991 that India officially accepted global capitalism by adopting a liberal economic path. After a balance of payment crisis during which India borrowed money from the World Bank, World Trade Organization, and International Monetary Fund, conditions of structural adjustment were imposed on India that involved the adoption of new economic policies: government-regulated licenses and controls were lifted, as were restrictions on foreign investment and trade; tariff barriers were removed; markets were deregulated; and the national economy was privatized (Nair 2008).

Liberalization led to unprecedented economic growth and prosperity for many people, and members of India's new middle class were able to enjoy a lifestyle of prosperity.[10] It was hoped that under India's liberalization policies, poor, low-class, and low-caste people would for the first time be positioned as consumers, entrepreneurs (London and Hart 2004), and an emerging class with aspirations

for improvement. Previously ignored areas like the rural and borderland Thar Desert were primed to become markets of untapped potential and aspirations for development. However, the results of liberalization were uneven and marginal. Although India's economy grew under liberalization, widespread poverty persisted and, in some cases, worsened due to liberalization policy restrictions on welfare funding for health, education, and development. The income gap between rich and poor widened (Pal and Ghosh 2007). While liberalization won the support of educated urbanites working in the private sector who were able to assert their caste and class power, it left poor, low-caste, and rural populations without dependable access to resources.

It was during this opening up of India that development took center stage. For the first time, international development organizations were allowed in the country. Nations in the Global North, positioning themselves as paragons of achieved development, technology, economic power, and materialism, were invested in the economic progress of their previously colonized nations and viewed their teleological progression as the only clear path toward social change, progress, and development. In this context, the idea of development had connotations of advancement, transformation, improvement, and potential. Development was discursively produced as an inherent teleology of progression that forces aspirations along a path from one kind of underdeveloped status toward a standardized and finished status of developed, as defined by Western standards.

As the dark underbelly of liberalization—especially inequity and failed development—was exposed in the late 1990s, a postdevelopment critique emerged that acknowledged development as being based on a colonial legacy and dependent on neocolonial terms (Escobar 1992; Sachs 1992, 2–4). Inherent in the critique was an assumption that the postwar epoch of development had ended (Escobar 2012; Li 2007; Mosse 2013; Mosse and Lewis 2005). Development was now thought of as "hopelessly evolutionary, of being colonial in intent, masculinist, dirigiste, and a vehicle for depoliticization and the extension of bureaucratic state power" (Corbridge 2007, 180). But in remote parts of India like the Thar Desert, development was not dismantled altogether and persisted as a discourse.

NGO CULTURE IN THE THAR DESERT

The idea of a welfare state as a service and resource provider was deeply ingrained in postcolonial India (Mosse 2005). Although India was primed for capitalism and private industrialization that began in the 1980s, liberalization in 1991

brought a clear break from the unwieldy development initiatives of nationally and state-run institutions of the Indian welfare state's five-year-plan era. Under liberalization, the national government cut public and welfare expenditures drastically, making room for regional projects that often had international financing. While these more localized projects used innovative technology and infrastructure from outside of India, they were characterized by the same national developmentalist mentality. Thus, despite drastic changes that came with liberalization, the idea of the welfare state as a service and resource provider remained deeply ingrained in India, especially in rural and remote areas of the country like the Thar Desert. Development continued to be administered top-down, but this was now done through hybrids of liberalized private businesses that were entangled with government-related service providers.

It is in this context that private-sector NGOs took over much of the localized resource management and delivery, with a focus on granular approaches to development as locally specific interventions in rural India. Suggesting community-based participation, the term "NGO" quickly became internalized in regional contexts (Unnithan and Heitmeyer 2014). And taking on localized meanings, the term no longer referred only to charitable, autonomous, not-for-profit organizations founded on principles of social justice and community empowerment (Fressoli, Dias, and Thomas 2014).[11] Although "NGO" is often viewed as pejorative due to its many slippery and confusing meanings, I use the term because Manganiyar musicians use it interchangeably with "sansthan" through the process of vernacularization. They describe NGOs as small, individually founded and maintained organizations that operate with outside funding that may be provided privately or by the government.

Rajasthan State, with its distinctive post–princely state subnational identity and its Thar Desert region, lacked a strong history of political mobilization due to its high numbers of tribal and low-caste communities, strict caste relations, political oppression, and traditional patronal relations. For these reasons, the Thar Desert became a focus of intense development interventions in the 1980s that promised modernization as India began liberalizing its economy.[12] Rajasthan became known as an epicenter for development initiatives, NGO activism, and organizational culture (P. Bhargava 2007; Government of India 2002).[13] In 1986, the Government of India established the Border Area Development Programme (BADP) with the goals of developing infrastructure and increasing the military presence on the border with Pakistan. The BADP's first large-scale initiatives advocated for renewable energy using solar and wind power. However, it quickly

became clear that top-down development initiatives like the BADP involved little to no local participation, co-opted local farming and herding lands for their projects, and were not delivering the outcomes to local communities that had been originally promised.

External development interventions bolstered external profit while ignoring their impacts on local communities and cultures. It is in this context that community participation replaced top-down development initiatives, offering a different kind of development that was supposedly coherent, equitable, and carried out by the people the organizations aimed to help (McCarthy 2005). However, community participation often follows the same patterns of top-down development, exclusivity, and regressive behavior that result in uneven resource allocation. Community participation in NGOs challenges neocolonialism and top-down development in theory, but it often opens yet another domain for neoliberalism and commodified social relations to thrive through the commodification and control of provisions and deliveries of development and resources. Such models of development pay lip service to terms like "sustainability" and "resilience" but end up reproducing inequalities at the grassroots level (Hall, Gossling, and Scott 2015). In these instances, women and the poorest and most vulnerable people are excluded, are not invited to participate, or choose not to participate because they do not feel welcomed to do so (O'Reilly 2007).

With the waning of traditional patronal relations, many Manganiyar musicians became involved in postpatronage. Without the support system that they formerly had with their jajman, they turned to local NGO projects and community participatory initiatives like Rupayan Sansthan, URMUL, and Social Work Research Centre, hoping to gain support and resources from them. While the relationships between developer and developed remained hierarchical, they were immediate and personal—like those between musician and jajman (Weisgrau 1997, 92). In this way, traditional patronal relationships were ingrained in updated practices: they were reimagined and reenacted in postpatronage. Development that uses community participation often ends up representing the better-off and more outspoken people from the communities being helped. Not coincidentally, it was the musicians who had toured with Kothari who worked with local NGOs. Within just a few years, the same musicians were able to draw on their experiences performing abroad and working for NGOs to use their own development imaginaries—postpatronal networks, outside technology, connections to private foundations and stakeholders, and social entrepreneurs—to found their own sansthans to access resources for themselves and the Manganiyar community.

Neoliberal power relations have been recognized as inherent within development (Ferguson 2006). Similarly, Manganiyar involvement in and founding of NGOs provides an example of the ways that development can be both reconstituted and entrenched in neoliberalism. The more outspoken Manganiyar musicians were now delivering development to their community, instead of demanding it from the welfare state and top-down NGOs. Using resilience as a neoliberal guiding principle for their sansthans, they were able to reject the paternalism of the state and top-down NGOs in favor of individual action. Examining resilience as a neoliberal principle raises crucial questions about intracommunity dynamics. Who bestows power, and who receives it? Who holds knowledge, and who passes it on—and to whom? As Manganiyars started founding their own sansthans to make up for the resources that were no longer provided for them, their development imaginaries collided with the common teleological development narrative and top-down structure, as demonstrated by Gazi Barna's work in development and his sansthan.

GAZI BARNA AND PEHCHAN LOK SANGEET SANSTHAN

Gazi Barna is a prominent *khartal* player and ensemble conductor who has performed internationally since childhood. In 1997 he founded his own organization, Pehchan Lok Sangeet Sansthan (Identity or Recognition Folk Music Institute, or PLSS) (figure 3.3). He chose this name for his organization because at the time he believed that the Manganiyar community was still trying to create its identity in the world of music. He wanted his organization to help the community realize its full potential and receive recognition for its cultural contributions. As one of the earliest Manganiyar-initiated organizations drawing on development rhetoric, PLSS was supported by foreign donors, wealthy businesspeople, Bollywood film actors, and Manganiyar musicians. PLSS and other organizations like it laid the groundwork for a Manganiyar brand of development. It should be noted that the desire for uplift of the Manganiyar community is not unique to Gazi Barna. Over a hundred Manganiyar musicians (including Thanu Khan, discussed above in this chapter) founded their own organizations in the first decade after Kothari's death. However, not all of them were as successful as Gazi Barna's initiative.[14] In this section, I use Gazi Barna and his sansthan as a case study for examining the proliferation of development and development imaginaries within the Manganiyar community.

Gazi Barna's father, Chuga Khan, had enjoyed a close relationship with Ko-

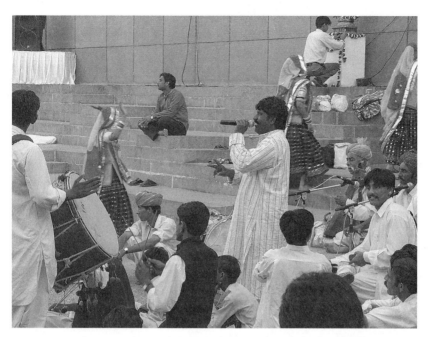

FIGURE 3.3 Gazi Barna (center, with microphone) conducting his "Desert Symphony,"
a showcase of Manganiyar music featuring more than thirty musicians on stage
at the multi-arts center, Jawahar Kala Kendra. Jaipur, 2007. Photo by author.

thari, and Gazi Barna continued to maintain close ties with Kothari until he died
in 2004. In an interview I conducted with Gazi Barna in 2005, he expressed the
impact that Kothari had on him as a musician and community leader: "Komalda
[Kothari] took me under his wing after my father died. In the last years of Kom-
alda's life, I spent many weeks by his side—watching him, listening to him, and
learning from him. I observed how he did his work with musicians and how he
was able to teach them new things in an unimposing way, while also allowing
them to be themselves and express their music personally."[15]

Experiences inside and outside of India while on tour influenced how Man-
ganiyar musicians like Gazi Barna saw the ever-present and increasing develop-
ment in the Thar Desert. Gazi Barna had an expanded worldview because of
touring abroad with Kothari, and this led him to development and eventually
inspired him to found his own sansthan. Along with other Manganiyar musicians
who gained a broader worldview through performing on national and global
stages, Gazi Barna possesses the seemingly contradictory characteristics of being

both low-caste and cosmopolitan, a position that I referred to as subaltern chic in chapter 2. Shaped by postpatronage, Manganiyar musicians looked inward through the cosmopolitan lens of development to their own local traditions and viewed their music as not just a remnant of an antiquated patronal tradition but as cultural and economic capital for their futures.

Taking on development meant that the musicians had to acquire the tools of dominant development discourse to empower them to use their music making to implement a resilient future for themselves and their community. How did musicians harness development in the early 2000s? How did artists like Gazi Barna become mediating figures between the arenas of culture and development? During this time, many Manganiyar musicians were experimenting with different forms of development imaginaries, and Gazi Barna's PLSS demonstrates one way that development shaped music.

Gazi Barna founded PLSS to grapple with the cultural, economic, political, and ecological changes that the Manganiyar community was facing. Founded and headed by a member of the community, PLSS aimed to create a local Manganiyar brand of development, in which concerns about musical sustainability in postpatronal contexts and autonomy to adapt musical culture were coupled with concerns about modernization and development (Fisher 1997). In our conversations, Gazi Barna articulated three aims for PLSS: providing formal education and music education for underprivileged children in the Manganiyar community; preserving Manganiyar culture, history, and music through collection, documentation, and archiving; and harnessing the cultural tourism market as a way for Manganiyar musicians to earn a living.

The first aim, education, involved musical preservation to keep traditional Manganiyar musical knowledge in circulation in contemporary musical practice. Until recently, music was not taught systematically in a formal setting: Manganiyar children gained a musical education from watching, listening, and imitating their older male family members and accompanying them to patronal functions (Jairazbhoy 1977). Extended travel for concert tours has disrupted this traditional way of learning. With their older male relatives away from their villages for months at a time, how are young Manganiyar boys expected to learn music? To solve this dilemma, in 2007 Gazi Barna established a small schoolhouse in his village as part of PLSS. The establishment of a Manganiyar school was, at the time, unique in a community as the first school administered by and for the Manganiyar community. This was well-received in a community whose children did not routinely go to school beyond the sixth grade. In an interview,

the development imaginary Gazi Barna described as shaping the curriculum in his Barna Village school included English terms such as "preserve," "empower," and "sustainable." He used this language to demonstrate his engagement with development and to attract donors, national recognition, and international attention to his organization.

The children who attended PLSS's school were taught by a select group of elders considered to be master musicians in the community. Most of them had been chosen by Kothari to perform on foreign tours in previous decades, and thus they represented a brand of postpatronal Manganiyar music. At the school, children were taught a more standardized mode of performance and a limited repertoire of songs that were popular with tourists and foreign audiences. Not coincidentally, these songs focused more on vocal virtuosity and acrobatics than on nuanced poetry, and more on rhythm and *sawal-jawab* than on expressing individual moods of the *raga*. In contrast to a performance tradition that counted on connoisseur audience familiar with the language being sung, the ragas being interpreted, and the slow build of a long *kacheri*, PLSS students were taught a fast, virtuosic, and boisterous style of performance designed to appeal to nonspecialist audiences that might be hearing this music for the first time. In addition to music, Manganiyar children attending PLSS's school were taught how to hold their bodies, use hand gestures, and sit in particular positions while performing.

The second aim of PLSS was the preservation of Manganiyar culture through collection, documentation, and archiving. Gazi Barna saw his first task with this project as the collection and transcription of Manganiyar *dohas*. Because dohas form a central part of Manganiyar musical knowledge, jajmans' genealogical histories, and have been sung by Manganiyar musicians for their patrons for centuries Gazi Barna saw this as one of the most important aspects of Manganiyar musical practice that needed preserving. Often sung in the context of shubhrajs, dohas could also be performed in honor of the raga, as the subject of the song, or to tell stories of the patron's family (Kothari 1994). As younger musicians moved into postpatronal performance contexts, they never learned much of the knowledge of dohas, which survived only as oral traditions among older Manganiyar musicians still involved in traditional patronage. Gazi Barna therefore hired a musician from the community to travel throughout the region, collect, transcribe, and archive dohas transmitted orally by older Manganiyar musicians. His goal was to preserve musical knowledge that he deemed to be dying out in the community. In this way, development promoted preservation efforts rather than destroying them.

On a visit to Barna Village in 2008, I asked Gazi Barna about the results of the doha preservation project. He proudly showed me several books filled with transcribed dohas and told me he had plans to teach dohas to children at the PLSS school. For Gazi Barna, these transcriptions served as a symbol of the productivity of PLSS and represented an effort toward promoting and collecting local community knowledge. Gazi Barna used his cultural preservation efforts to stimulate feelings of self-worth among Manganiyars.[16] Gazi Barna took on the role of cultural arbiter, deciding what to preserve and for whom.By transforming the doha from a symbol of their low-caste status and ingrained servitude to part of a musical tradition worth preserving, Gazi Barna hoped that he could help give Manganiyars a sense of pride.

The third aim of PLSS was to focus on cultural tourism as an important form of postpatronage and development. As discussed in chapter 2, for many Manganiyar musicians, cultural tourism was the most prominent and lucrative form of postpatronage in the first few years of the twenty-first century. During the annual tourism season in the Thar Desert (October through February), musicians perform nightly in hotels in Jaisalmer City and at village campsites on camel safaris for both Indian and foreign tourists. Other musicians regularly tour outside of India, performing in concert halls around the world for five or six months of the year. These forms of postpatronage have greatly changed the way musicians perform.

Development in the form of cultural tourism has required Manganiyar musicians to revise their music accordingly. They must cater to non-Indian audiences that do not understand the nuances of their traditional music, as well as to upper-class Indian tourist audiences that may appreciate only more standardized classical forms of Indian music and dance. Manganiyar musicians therefore change their music through processes of Westernization and classicization. Gazi Barna used his sansthan to teach young Manganiyar musicians how to perform for Indian and non-Indian audiences and to promote new forms of music based in postpatronage.

I have identified three musical changes that Gazi Barna initiated through PLSS interventions for the purpose of innovating postpatronal performance. These changes involve shifts in repertoire, raga, language, and instrumentation. First, through doha preservation and musical education at PLSS, musical repertoire learning was based on what would appeal to postpatrons as nonspecialist audiences. Songs that require specialist knowledge on the part of the audience were passed over in nontraditional performance contexts and not passed down to the

younger generations of musicians in favor of repertoire deemed appropriate for nonspecialist audiences. Second, PLSS stressed music that emphasized percussion. In performances, Gazi Barna used multiple dholak drummers and khartal players in his ensembles. Within the musical form, space was made for percussion solos because Gazi Barna, as a khartal player, believed that nonspecialist audiences found it easier to appreciate percussion virtuosity than other aspects of Manganiyar music performed speficially for jajmans. As a result, sawal-jawab began to be incorporated into Manganiyar postpatronal performances. Third, Gazi Barna revised the traditional small Manganiyar ensemble. Under the auspices of his organization, he formed a large group of musicians collectively called "Desert Symphony." This group premiered in 2003 at the Jaisalmer Desert Festival, showcasing a variety of instruments and featuring instrumental sections made up of many musicians performing on the same instrument, like sections in a symphony orchestra.[17]

The work that Gazi Barna took on through PLSS attests to his being directly influenced by Kothari and Rupayan Sansthan. While Rupayan Sansthan as an NGO was innovative in the 1960s for its engagement with low-caste communities like the Manganiyar, it maintained a top-down model of international development. Although Kothari was intimately involved with the Manganiyar community, he was not Manganiyar and seemed to be everything Manganiyar musicians were not: he did not perform music, he was from a high caste and class, he had a graduate-level education, he had traveled extensively, and he was from a wealthy and prominent family.

In our conversations, Gazi Barna often reminded me that Kothari could do what he did for the Manganiyar community because he was an outsider and had the financial means to do so. In this reminder, I sensed that Gazi Barna felt an affinity with Kothari as an outsider. My suspicions were confirmed when Gazi Barna told me that touring abroad and seeing the world through postpatronal opportunities had allowed him to see his own community from the perspective of an outsider. Thanks to these diverse experiences, Gazi Barna had an international frame of reference for development, while he still maintained connections with his community and retained his identity as an insider. It was this unique position of being a powerful, cosmopolitan insider that allowed Gazi Barna to draw on his own development imaginary in his work through PLSS.

Thoroughly entrenched in development and postpatronal networks, Gazi Barna's formation of his sansthan and its work was the result of intention, action, and the use of music and development. Gazi Barna and other Manganiyar

musicians who founded their own sansthans in the wake of Kothari's death and an increase in localized development in the Thar Desert realized that by using the tools of dominant development discourse and neoliberal resilience, they could empower themselves to provide resources to and sustain musical livelihood for themselves and their community.

JUGAAD, RECONSIDERING RESILIENCE

My understanding of the word "jugaad" was purely contextual, since I never formally learned its meaning. I first heard the word used in the Thar Desert to refer to a vehicle that consisted of a tri-motorcycle: a vehicle with a front driver's seat, a two-wheeled carriage at the back, and a leaf-spring suspension system that allows the vehicle to handle both heavy loads and difficult terrain. Over the years of my Thar Desert fieldwork, I had seen many jugaad vehicles used to transport village children to school over distances too far to walk and too rugged for cars and buses to travel. Soon after I learned about jugaad vehicles, Gazi Barna dispelled my belief that jugaad was the name of a brand of vehicle: he showed me a pair of khartals made from white acrylic instead of the traditional *sheesham* (Indian rosewood), which he called "jugaad khartal."[18] Thus, jugaad, a hybrid word coming from Punjabi, means innovation, hack, or work-around. Jugaad vehicles are often decorated with black tassels hanging from rearview mirrors and handlebars, colorful sequined fabrics adorning metal grilles, colorfully painted side panels, and flower garlands strung along edges, signaling the whimsical nature of the invention. In this section, I consider Manganiyar development organizations like Gazi Barna's PLSS as jugaad innovation.

In the Thar Desert and throughout the Hindi Belt of north India, jugaad refers to the act of using meager resources to cleverly create new things out of old ones—an innovative, improvisatory, creative, and unconventional way to solve a problem or at least provide a quickly improvised and temporary fix (Rai 2019, 2). The Manganiyar community has always functioned within an informal economy. While most of its members have acquired bank accounts by now, access to credit, savings, insurance, health care, education, or pensions are still uncommon. It is in this context that jugaad innovations become important for communities like the Manganiyar to function in everyday life.

Despite the positive attributes of innovation and making things work, jugaad can also be interpreted negatively (Kaur 2016). To critics of jugaad innovations, it implies making do using low-quality and provisional solutions that bend the

rules or take a short cut (Prahalad and Mashelkar 2010). In everyday conversations I have heard the Hindi phrase *"jugaadu mat bano"* (don't make jugaad, or don't take the easy way out). Because of localized, contextual, and situated specificity, jugaad innovations are often criticized as being unsustainable and unscalable, as well as ultimately not making significant dents in the numerous economic and social challenges facing the communities that depend on jugaad solutions in their everyday lives.

Jugaad is a concept ingrained in Manganiyar daily life, musical practices, and development interventions. From learning how to charge their cell phones using car batteries when there was no electricity to taking advantage of opportunities first afforded by Kothari, and from initiating their own international touring to making financial ends somehow meet in the face of a fading patronage system, I constantly saw Manganiyar musicians like Gazi Barna employing jugaad innovations. In these terms, postpatronage can be considered jugaad, as can the development discourse and initiatives that flourished among the Manganiyar community in the first decade of the twenty-first century.

Jugaad requires ingenuity, resourcefulness, and uniqueness in the ways people think, act, and respond to challenges. Jugaad innovations enable people to transform scarcity into opportunity and overcome harsh constraints with limited resources (Ramendra Singh, Gupta, and Mondal 2012). Under neoliberal conditions during the rise of development in the Thar Desert in the first part of the twenty-first century, progress, success, and class mobility became dependent on self-reliant and productive jugaad entrepreneurship, like that of Gazi Barna (Kapila 2010, 768). Not only was Gazi Barna a jugaad entrepreneur, through PLSS's development initiatives and relief efforts, but he was also resilient because of the demise of traditional patronage and the death of Kothari.

Resilience means autonomous, self-organized, and individually initiated responses to events to maintain a continued musical livelihood. It is often assumed that subaltern communities like the Manganiyar have an innate capacity for innovation to solve their own problems without outside interventions. But Manganiyar musicians were increasingly resilient the more steeped in neoliberalism they were, maintaining music as a livelihood in the face of waning patronage through the formation of their own self-sufficient organizations. Here, I turn resilience around to reveal a more pessimistic view of the dynamics at play. Rather than equating resilience to overcoming obstacles and escaping subjugation from traditional patronage, I use resilience to refer to a new mode of subjugation. Neoliberalism is not just a political economic state but a cul-

tural project of reshaping the nature of social relationships and subjectivities (Zebrowski 2016, 88).

In the case of members of the Manganiyar community, when individuals are resilient, they often become entrepreneurs. Through individually overcoming difficulties, accessing resources, and innovating through jugaad, resilient Manganiyars not only acquire wealth (having earned it individually without the help of outside forces such as government assistance or welfare) but are rewarded for their resilience with increased capital, status, and recognition. They then become less marginalized. In contrast, those Manganiyars who are not resilient are viewed as not having worked hard enough or not having been resourceful enough. Ultimately, those who are not resilient do not usually garner entrepreneurial wealth and are seen as not deserving it. They often become further marginalized and dependent on the more resilient Manganiyar musicians and outside interventions for needed resources.

Neoliberal resilience assumes that the problems the Manganiyar community faces in relation to access to resources and subaltern position should be evaluated in terms of risk, reward, and responsibility but are ultimately surmountable. But surmountability is dependent on responsibilization and personal resilience. While responsibilization can be empowering, it also creates a dichotomy between those who are resilient and those who are not (Bulley 2013). In this context, the ideal Manganiyar musician becomes one who is independent and entrepreneurial (Clarke 2005, 226). Access to resources no longer hinges on the welfare state but on musicians' personal ingenuity and individual capacity. This is not to say that state welfare resources are not available. There has not been a significant state withdrawal of welfare, public services, or resources from communities like the Manganiyar in recent decades (Kruks-Wisner 2018). Yet the neoliberal mentality related to development has encouraged communities like the Manganiyar to be skeptical of government services and resource allocation.

Manganiyar musicians then see themselves as citizens who have been abandoned by the state and feel the need to find resources for themselves through activation, empowerment, and responsibilization. Because communities like the Manganiyar fend for themselves in a neoliberal state, governments, development organizations, and welfare agencies do not need to intervene. This emphasis on individualism and entrepreneurship represented a new phase in the neoliberal shift from the state as welfare provider to the state as promoter of self-reliance and producer of self-regulating subjects (Chandler 2014; Dean 1999; Neocleous 2013). Resilience, then, becomes a moral and ethical issue. Manganiyar subjects

become enactors of resilience, but it is only the autonomous, organized subjects who can be resilient and are in turn rewarded for their resilience. Resilient Manganiyars are considered morally good. Just like jugaad, resilience becomes individualistic and neoliberal at its core.

A MOMENT OF ETHNOGRAPHIC FAILURE, A MOMENT OF JUGAAD

The 2006 Thar Desert floods had repercussions that changed the desert's landscape, environment, and people. No longer do Manganiyar musicians and other Thar Desert inhabitants utter the phrase *"jaankhiyon laare meh"* (good rains always follow dust storms). The monsoon rains don't always follow dust storms anymore. They tend to come later than they used to. If and when they do come, they are now heavy and short rather than spread out over several days or weeks. In 2007, I made a trip to Barmer City for a recording session and to meet musicians. From my window on the public bus, I still saw traces of the floods that had happened more than a year before. Grass and everyday objects were still caught high above in electrical power lines and wires. A layer of white silt covered bushes, remnants of houses, and old vehicles. Roads continued to be broken, with abrupt and crumbling dead ends dropping off into desert sand.

In 2007, I witnessed a resilience like that of the local Thar Desert environment among the Manganiyar community. I saw many musicians carrying and playing harmoniums and dholaks with the names of donating institutions painted on the side — including Gazi Barna's PLSS and other Manganiyar organizations as well as *Dainik Bhaskar* and *Rajasthan Patrika* (Hindi-language Rajasthan State daily newspapers). Musicians played these harmoniums that had been donated in the aftermath of the 2006 floods with pride. I interpreted this pride as coming from a sense of resilience. Manganiyar musicians had experienced a disaster, and some had not only survived but even prospered because of it.

In 2013, I made the same trip to Barmer City and was shocked to see a different landscape than I had seen before the 2006 floods. In some areas, flora previously indigenous to the Thar Desert was gone, having been submerged in water for too long in the floods' aftermath. The soil and the water quality had changed, and various marsh- and water-loving plants were growing and thriving. Bird species like cormorants and egrets that had never lived in the Thar Desert could now be seen, and species like the northern shoveler and white wagtail had started to stop in the area during their migrations.

On that 2013 trip, I witnessed a completely different Manganiyar community. Musicians no longer talked about development as they had when I was conducting fieldwork in the early 2000s. Those musicians who had previously been at the center of development proliferation in the Thar Desert were now individually networking and furiously making personal connections with foreign tourists, tour promoters, and organizations to perform more both in India and abroad. Those sansthans that continued to exist were used in name only, seemingly to legitimize tour bookings by the Manganiyar sansthan leaders. Manganiyar musicians' calendars contained trips to a festival in France, visits to the United Arab Emirates embassy in New Delhi to secure visas for a one-night show in Abu Dhabi, studio rehearsals for commissioned Bollywood playback film songs in Mumbai, and local seasonal festival performances throughout Rajasthan. With their busy touring schedules, some musicians no longer had time for their village jajmans, let alone for local development. Their aspirations, it seemed, had shifted from solving the water crisis in their desert village through the building of wells to leaving their village altogether and relocating to a high-rise apartment in Mumbai where they could have easier access to film and popular music industries or be able to hop on a plane at the snap of a finger to travel out of India for a concert.

Gazi Barna no longer spent time working on development initiatives for the Manganiyar community through PLSS. Instead, he was occupied with touring, performing, and promoting his youngest son as a star and playback singer in the Bollywood film industry. Although he claimed that PLSS was still in existence, its website was defunct, and the buildings he had constructed for his organization in Barna Village sat empty. No children were in the classrooms learning music from senior Manganiyar musicians, and the notebooks filled with traditional Manganiyar dohas lingered in dusty locked cabinets. What had happened to aspirations for localized development? Was development dead, having failed the Manganiyar community? Had people's aspirations for development and Manganiyar development initiatives been just a bump in a long road to becoming world-class postpatronal musicians?

While a few organizations founded by Manganiyars persisted through the years, most were never taken beyond an idea or an initial attempt. Even the longest running and strongest sansthans like Gazi Barna's PLSS could not survive the power struggles, uneven access to resources across the community, and neoliberal underpinnings inherent in localized, community-based forms of development. While those Manganiyar musicians involved in development like

Gazi Barna had tried to enhance their community's political position and access to resources, their involvement sometimes had the opposite effect by reinforcing the marginalization of themselves and the community members the sansthans aimed to help (Kapoor 2005).

Individual musicians who had founded their own sansthans were sometimes credited for the access to resources the sansthans had provided. However, more often those sansthan-founders were blamed and ridiculed when promised resources did not appear, whether it was their fault or not. Those not involved in development became more marginalized in the community (Miraftab 1997). Afterr Manganiyar sansthans became a common occurance in the Thar Desert in the early 2000s, a gap arose between those musicians who were involved in postpatronage and development and those who were not and continued to depend on traditional patronage to make livings as musicians. This gap caused gaps in wealth, intercommunity power struggles, and uneven access to resources, detracting from the unified community action so many of the Manganiyar sansthan founders initially claimed to desire as part of their development imaginary.

Community-based participatory development processes tend to function best when the community involved in development is positioned in the middle — between the outsider project implementers, who provide technical support and political advice, and the local citizens. Studies have shown that the kinds of development efforts that are neither top-down nor bottom-up can be the most effective and lasting (Mansuri and Rao 2012). Gazi Barna strove to be the leader of his sansthan. However, as an insider in the community PLSS aimed to help, he could never be a successful outside implementer. The Manganiyar brand of development only masked already existing power relations within the community and thus not only maintained local power differentials but exacerbated the dominance of one faction of Manganiyar musicians over others.

When I left the Thar Desert in 2007 after my dissertation fieldwork, at the height of Manganiyar development, I ascribed my own teleological narrative of development to the Manganiyar community. I assumed that I would return and find that Manganiyar sansthans would be flourishing and the sansthans would be providing resources to those in need in the community. But when I returned in 2013 and saw that development was no longer at the heart of Manganiyar cultural innovation, I first wondered if development had failed the Manganiyar community. Failure can be viewed as a moment of breakdown (Ingold 2010). It is in this space of breakage and slippage where something ceases to be what it was. In its place emerges radical and productive newness. According to Rubio,

"The ecological approach...aims, precisely, at locating our inquiry at the level of the processes and negotations through which different material and symbolic arrangements come into being and are constantly renegotiated within different regimes of value and meaning" (Rubio 2016, 64). I quickly realized that I had witnessed a breaking point in a much larger narrative and history of the Manganiyar community's response to major structural changes in a postcolonial and postpatronage India. The proliferation of Manganiyar sansthans in the first decade of the twenty-first century can be viewed as a case study of a moment in time, not as a failure of development. As a form of jugaad innovation, Manganiyar development enabled some Manganiyar musicians to continue to make financial ends meet, make music as a livelihood, and enliven their community for a short time. But it was also jugaad in its lack of sustainability and scalability. Ultimately it did not eliminate poverty, casteism, or problems of access to resources in the community.

However, just because Manganiyar musicians were no longer involved in development and NGO work by 2013, this did not mean that development as a form of postpatronage had not had a substantial effect on the community. Development changed the Manganiyar community. Arturo Escobar (1992, 21), the first scholar to have used the term "imaginary" in relation to development, claimed that "despite the recognition of [development's] demise, the imaginary of development — still without viable alternatives although somewhat weakened by the recent crisis — continues to hold sway." Manganiyar musicians were able to take the skills they learned from local development initiatives and their development imaginaries (which involved innovating with small amounts of capital, resources, and power) and apply them to new musical practices. These new applications were manifested as part of an emerging neoliberal regime of commercial self-promotion and touring. The failure of development was recontextualized as resilience. Jugaad innovations like development provided Manganiyar musicians with the opportunity to imagine new futures for themselves as social entrepreneurs. Even though development ended for the Manganiyar community, many musicians continued to prosper through music making.

NEOLIBERAL RESILIENCE

I opened this chapter with the 2006 Thar Desert floods and its aftermath because that served as a seminal moment, one of the first public displays that I witnessed of Manganiyars caring for and taking care of their own community without the

support of traditional patronal ties. It also laid bare the neoliberal enterprise that development became for the Manganiyar. While the Manganiyar victims of the 2006 floods did not want to take help from the government of Rajasthan, they still expected the government to provide it. While this seems like an alternative to neoliberal notions of individual sustenance, it also affirms the neoliberal mentality. Musicians expected government assistance but did not want to take it, because they did not want to feel indebted to the government. They preferred to get assistance from within the community. In the years since the 2006 floods, resilience for those Manganiyar musicians who were involved in development has meant not returning to their lives before the floods but taking advantage of the 2006 catastrophic moment to establish postpatronal networks, secure access to resources, and continue making a living through music. Neoliberalism has enabled marginalized populations like the Manganiyar to acquire new forms of knowledge, skills, and income generation—which collectively have been referred to as the "unintended consequences of neoliberal governmentally" (Akhil Gupta 2012, 237). But gender disparities, caste discrimination, and inequity continue to limit Manganiyar community members' ability to take advantage of economic opportunities (Kamat 2004).

In this chapter, I have shown that the Manganiyar community is not passive in the face of development and neoliberal restructuring of welfare, but neither do the so-called opportunities of development empower community members evenly or result in the radical overturning of structural inequalities. Exploring development from the perspective of Manganiyar musicians in the first decade of the twenty-first century provides insights into the ways institutions (including the state) and networks function locally, demonstrating that paying attention to local contexts can both complicate and add to our understanding of how neoliberalism manifests itself in music culture (Desai-Stephens and Reisnauer 2020, 104). In chapter 4, I continue to think through more recent incarnations of postpatronage and resilience as the Manganiyar community turned to local and national politics to access resources, gain status, and find a voice.

FOUR

Politics

ON THE CAMPAIGN TRAIL

In the early morning hours of March 14, 2014, I arrived at my hotel room in Delhi from the international airport. I had plans to catch an overnight train to the Thar Desert the next day for fieldwork. At the time, I did not realize that my trip had aligned with the run-up to the Lok Sabha elections, nor did I realize how important this political moment was for the Manganiyar community.[1] In a fog of jet lag, I turned on the television. I flipped through the channels with the volume muted, but I stopped flipping when I saw what looked like a Manganiyar musician in a national news story. He had a mustache, wore a colorful turban tightly wrapped around his head, and sat on the ground behind a harmonium. With one hand raised in a musical gesture, he used the other to operate the harmonium bellows. Just as I managed to unmute the television, the clip ended, and another video was broadcast of Jaswant Singh, a well-known political figure, disembarking from a camel and waving at onlookers in what looked like a Thar Desert village. Why was a video of a low-caste Muslim Manganiyar musician being juxtaposed with that of a founding member of the Hindu right-wing Bharatiya Janata Party (BJP)?

With a quick scroll through my Manganiyar interlocutors' social media posts on my phone, I learned that the Manganiyar musician featured in the news was Jamat Khan, a Barmer City–based Manganiyar music who had composed songs in honor of Jaswant Singh in his run for Barmer's seat in the Lok Sabha. Over the next month of fieldwork, I learned that in addition to Jamat Khan, many other musicians from the Manganiyar community were integral to Jaswant

Singh's campaign. It seemed that for the first time, Manganiyar musicians were working to organize their community as a bloc of voters. They showed up at Jaswant Singh's campaign appearances and in many cases performed songs and *shubhrajs* on stage in support of Jaswant Singh and his campaign. Manganiyar musicians were even at the forefront of political rallies, speaking about issues important to low-caste and Muslim communities. And Jaswant Singh addressed many of those issues in his political platform, including increased water access, improved electricity, social welfare programs, antidiscriminatory programs, and the right to education.

In previous chapters, I articulated numerous outcomes of musical resilience in relation to Manganiyar postpatronal practices, some of which included the diversification of income, partial decoupling of religio-caste position and occupation, comingling of rural and urban spaces, international cosmopolitan linkages, and new digital spaces for participation. In chapter 3, I presented neoliberal resilience as a framing for what turned out to be a decade of community-led development initiatives in the Manganiyar community. But by 2013 it was clear to me that instead of the intended results of Manganiyar-led development—namely, independence from the servitude inherent in traditional patronage and open access to community resources—development had partitioned the community into those members who were resilient and those who were unresilient. People who devoted their lives to postpatronage and became involved in development by working closely with Komal Kothari and Rupayan Sansthan, working with other cultural organizations and NGOs in the region, or founding their own *sansthans* to grapple with issues specific to the Manganiyar community alienated themselves from the rest of the community. Those who continued to perform for traditional patrons and did not get involved in development for various reasons became even more disenfranchised than previous generations of Manganiyar musicians had been. The community's abandonment of development as an internal infrastructure was in response to neoliberal resilience's being an integral part of development in the Thar Desert. By the time of the 2014 Lok Sabha elections, Manganiyar musicians were reconnecting to an older welfare state model through which they were creating avenues of resource access now based in a defiant and resilient act of refusing neoliberal self-development.

It is through political engagement that Manganiyar musicians in recent years have built new avenues for receiving welfare for themselves and their community. In this chapter, I explore key moments from my ethnographic fieldwork that demonstrate forms of Manganiyar political involvement that became prevalent

after the 2014 elections. In many ways this political involvement can be viewed as another form of postpatronage. I begin by asking what did it mean for the Manganiyar community to be political before 2014? I then examine the 2014 Lok Sabha election in Barmer District as a watershed moment in which Manganiyar musicians for the first time publicly supported a candidate running for office. Why were musicians who, for the most part, had always claimed to be nonpolitical not only providing music for a political campaign but also pushing political agendas and speaking out about resources and attention that their community wanted and needed? I analyze the conditions of this political involvement and point to more inclusive and normalized ways that Manganiyar musicians are now using music to harness politics and, in turn, instigate reform, spur action, and cultivate a greater sense of self and community through involvement in local and national politics.

MUSIC AND POLITICS

Music Is Not Political

The summer before the 2014 Lok Sabha elections, I spoke with Khete Khan Hamira, a Manganiyar musician, about the nature of politics in the Manganiyar community (figure 4.1). Khete Khan was the first Manganiyar musician I ever met in 2002. Hailing from Hamira Village, Khete Khan is a son of Pempe Khan, a renowned *murli* player, and a nephew of Sakar Khan. Because of his father's and uncle's connections to Komal Kothari, Khete Khan has had decades of experience performing and working in postpatronal contexts that include close ties to Kothari and Rupayan Sansthan; interventions in development and the subsequent founding of his own organization, Manganiyar Sansthan; many years of touring abroad and performing for foreign audiences; and a central role in the preservation of Manganiyar traditions and repertoire.

When I first asked Khete Khan about the relationship between music and politics, he did not seem interested in my question. We were sitting on a *charpai* in the inner courtyard of his home in Hamira Village. It was a hot evening in June 2013. His three children and two children of his brother, Chuge Khan, ran circles around us playing ball, while his wife and mother prepared dinner in the small, dark kitchen off the courtyard. Khete Khan told me that Manganiyar musicians are not political because they make their livings by pleasing *jajmans*. I interpreted his response in relation to the nature of musical patronage. He-

FIGURE 4.1 Khete Khan
Manganiyar playing dholak. Hamira
Village, 2005. Photo by author.

reditary professional musicians are intrinsically at the whim of their patrons.
They must align their own loyalties and preferences with those of their jajmans.
Other Manganiyar musicians had also expressed to me the view that music is
antithetical to politics. Jeffrey Snodgrass (2004, 278) echoed this observation
in the context of the Bhat hereditary performing community in eastern Rajast-
han, who claimed they were too clever to be swayed by political ideologies and
therefore had exhibited resistance to politics for centuries. Indeed, resistance to
political involvement and deliberate separation of music and politics is a com-
mon position among musicians in India. A.R. Rahman famously said, "I am
politically illiterate by choice" ("AR Rahman" 2020).

I refined my question to Khete Khan, directing it away from his opinion and
asking generally about Manganiyar music. I asked him if, for example, a shubhraj
could express a political outlook. He responded with a disgruntled and firm "no."
He was quiet for a few minutes, and when he proceeded to describe the nature
and purpose of a shubhraj, I assumed he thought that I did not know what a
shubhraj was and if I had known, I would not have linked it to politics. He de-
scribed the ways that Manganiyar social structures and individual subjectivities
are innately built into a Manganiyar shubhraj performance. The purpose of a
shubhraj, according to Khete Khan, was praise of a jajman through the remem-

brance of his ancestors. I followed up by asking if it was possible to give more praise for a good jajman and less praise for a bad jajman.

Without answering me, Khete Khan stood up, cleared his throat, and proceeded to recite a shubhraj for a jajman, which consisted of a recitation of the names of the jajman's ancestors. He recited a quick succession of syllables, some of which rhymed, at a quick tempo and in a singsong style, using just a few pitches in a short, repeated melody. The rhythm was sometimes steady but would then break off to allow him to take a breath. Khete Khan's children suddenly stopped playing and quietly watched their father. After thirty seconds, he seemed to get into a groove with the syllables and names as they rolled off his tongue at a fast tempo. He swayed on his feet and had a furrowed brow as he went on reciting nonstop for over three minutes. When he had finished, he sat back down on the chair in front of me, cleared his throat, and took a sip of water from a stainless-steel glass. Then he said, "That is a shubhraj. It is not political."[2] Our conversation about the relationship between politics and music ended there, but I was left wondering how Khete Khan defined politics based on our conversation.

While Khete Khan claimed that Manganiyar music was not political in 2013, he demonstrated how musicians can exert power through everyday acts of musical performance. Ana Hofman (2020, 304) has called this a "paradigm of the politics of the apolitical" in her description of experiences of music that may be dismissed as not political but that are "able to make a rupture or open a possibility for new forms of political belonging and identifications." Recent research concerning affective politics in relation to music examines diverse frameworks for engaging with music and sound without making overt political statements (Cusick 2017; Eidsheim 2015; Guilbault 2011 and 2019; Hesmondhalgh 2013). Khete Khan articulated the ways in which he is a resilient musician, and he told me that a musician must be assertive to protect and provide for his family through musical patronage.

Jaagaran: *A Sonic Political Awakening*

Ethnomusicological literature emphasizes music's role as an inherent site for politics (Berger 2014; Guilbault 2014). It is often assumed that music making is a torchbearer for political awareness, representing or reproducing politics as a way of communicating social phenomena or agendas. Studies of music related to electoral politics often depict music as a reproductive mechanism that communicates what already exists rather than as a transformative act or

performance that has the potential to change people's ideas about governance, the distribution of resources in society, and other social issues that are often involved in political elections. For example, scholars have presented music as a tool for political propaganda within electoral campaigns and shown the ways that music mediates certain political messages (Ciantar 2016). Research on US elections in the twenty-first century examines the use of music in television commercial backgrounds to drive specific agendas (Love 2015) and reinforce party narratives (Deaville 2015). Instead of foregrounding the activities, agendas, and impetus from musicians, much of the literature on music and politics focuses on political candidates and parties (Saffle 2015). Other literature focusing on music reinforces the idea that politics is embedded only in lyrics, implying that music cannot be innately political (Reuster-Jahn 2008). While some musicians participate in political campaigns and perform for political candidates whom they support and vote for, this is not always the case. Musicians often participate regardless of their own personal political convictions (Karan 2017, 225).

In India specifically, music has always had the potential to transform community capacity, the applications of power, and the distribution of resources. For this reason, it has had an integral role in political campaigns. Indian musicians have long been involved in electoral politics. Before independence, live music performed by small itinerant musical theater troupes was a powerful tool used to mobilize masses of people and spread campaigns related to political and social issues (Kinnear 1994, 9). Because of the informal nature of their performances, these musicians often operated under the radar of British censorship and regulations (ibid., 65). By the 1930s, as part of the struggle for independence, street theater was used throughout India to present to audiences dissident ideas of social activism and anti-imperialism (Sabyasachi Bhattacharya 1983; Garlough 2008). After independence, live music, with its established political reputation, continued to be important for advertising and campaigns in the context of political rallies. With the advent of recording technology, recordings began to be played at political rallies, and beginning in the 1980s, campaign propaganda mixed with music was distributed via cassette tape (Booth 2011; Manuel 1991 and 1993). In campaign contexts, music not only provided entertainment for audiences but also supplied information about political parties, candidates, platforms, and voting locations (Ahuja and Paul 1992; Karan, Gimeno, and Tandoc 2009). In regions of the country with especially low literacy rates, like the Thar Desert in western Rajasthan, music has been an essential element of political campaigns.

When I spoke with Khete Khan less than a year after our initial conversation

about politics and music, he had changed his tune. In a conversation during the 2014 Lok Sabha elections, he told me that the conversation we had had a year earlier had awakened him to his music and actions not just as *lachila*, but also as a form of politics. He used the word "jaagaran" to describe this awakening, or realization that his music and traditional patronage interactions could indeed be considered political in nature. His choice of the word connected with his experiences as a Manganiyar musician performing at jaagarans, or all-night ceremonial performances of Hindu religious music. Manganiyar musicians in traditional patronal contexts are often commissioned by their jajmans to perform jaagarans at Rani Bhatiyani temples and other shrines, as Aamad Khan was called on by his jajman to perform during Navratri (see chapter 1). Thus, the word "jaagaran" refers to both staying awake for an all-night vigil and the spiritual awakening that occurs during all-night musical ceremonies. Khete Khan used this word not only as an appropriate musical term familiar to the Manganiyars but also to express the idea of awakening through music.[3]

Picking up where he had left off in our previous conversation, Khete Khan told me that while he does not consider all forms of Manganiyar music to be innately or intentionally political, some could be. He told me that Manganiyar musicians must have lachila in the strategies they apply to their performances because of the nature of their profession. They must balance the needs of their families with their obligations to their jajmans while attending to their personal politics and beliefs. For Khete Khan, lachila relates to the successful balance of these three factors—family, jajmans, and politics—in their lives as professional musicians. Music, then, is not just a medium to express political ideas through lyrics, instrumentation, or melodies. Instead, music can be a political act in and of itself. I read Manganiyar music and practices in patronal and postpatronal contexts as being innately political. Politics, like music, involves power, self-interest, and the public interest, reaching well beyond formal political systems into spaces where people live, work, learn, worship, and perform music. Music can thus generate its own brand of politics.

ACCESS TO RESOURCES

Historically, low caste communities were educationally and economically disadvantaged. After independence, the First Backward Classes Commission of 1953, popularly known as the Kaka Kalekar Commission, set out to improve low-caste communities' economic conditions (Ministry of Home Affairs 1956).[4] While

the commission supposedly alleviated intercommunal tensions and the inaccessibility of resources through reservation systems in political representation and education, caste was still treated as a "static or residual problem addressed through remedial provisions, protections, safeguards, and complaint-handling, rather than as a dynamic relational problem that might be subject to the state's general duty to address inequality and discrimination in economy and society" (Mosse 2018, 424).

As Muslims who at the national level were not considered to have caste, members of the Manganiyar community were initially excluded from caste-based government benefits like quotas and reservations in public services, universities, and government postings. As a result, they experienced political inequality, being less able to exercise political power and exert influence on the state. Affirmative action for Muslim castes and communities to be considered as part of the Other Backward Classes (OBCs) was not put into place until the 1990s (Rahman 2019). At this time, the Manganiyar community was officially designated as a Muslim OBC.[5]

A related issue is remoteness. The Thar Desert on the northwestern border with Pakistan is considered one of India's most remote areas, "where the [Indian] government doesn't reach for development purposes" (Jakimow 2012, 1021). This has been partially due to the governmental cost of intervention there. While remoteness has lessened in recent years due to an increased military presence on the border with Pakistan that led to improvements in transportation, the relationship to the state of people living and working there is inherently a distant one, in the sense of both physical and social distance. "Remote" does not always imply "rural," however, as there is unequal distribution of power in different spaces (Massey 1991). For example, even in a Thar Desert village, people who are high caste, high class, and Hindu have homesteads that are more central than those of other people. Their land is higher in elevation (to prevent flooding), is near a well, and is close to other village services. Communities like the Manganiyar have experienced isolation, a lack of governmental investment, and weak local governance and accountability much more so than other high caste communities who live in the same villages as Manganiyar families. In addition, the Manganiyar community has experienced extreme disenfranchisement, which has led to them knowing little about the resources that might be available to them or how to access such resources.

Because of this disenfranchisement, Manganiyars have depended on their traditional patrons for centuries rather than the state for resources. Patronal

relations existed where the postindependence national welfare state was not helping small and remote communities, like the Manganiyar. As a result, Manganiyar musicians depended on their jajmans for job security, goods, services, and insurance in times of need (Kumar 2016; Omvedt 1995; Vikas, Varman, and Belk 2015). Patronal relations most likely remained in place in the Thar Desert for so long in part to provide resources for service communities like the Manganiyar. While some Manganiyars did not require additional political resources or capital because their jajmans took care of them financially and otherwise, others languished in poverty in postindependent India, having not been taken care of by their jajmans and not having been reached by the government. This situation was compounded for members of the Manganiyar community who had experienced a decline in patronage and then a turn to neoliberalism. As patronage faded after independence, much of the Manganiyar community was left powerless and in need of access to resources.

When Manganiyars can no longer depend on their patrons for resources, they must turn elsewhere to meet their needs. As discussed in chapters 2 and 3, this is where postpatronal institutions became important for the Manganiyar community and neoliberal development filled in where patronage was lacking. With travel and exposure to people, places, and situations outside of their own villages, Manganiyar musicians are now enfranchised and able to make claims on the state in ways that they previously could not. Other similarly positioned low-caste communities have not been as successful in making such claims, including other hereditary musician communities in the Thar Desert. Why have the Manganiyars been able to do so? According to the political scientist Gabrielle Kruks-Wisner (2014), "Knowing if a person is rich or poor, high or low-caste, or a man or a woman, does not adequately predict whether or how that person will engage the state. In fact, far from being determined by such features, claim-making activity appears to be shaped, in part, by exposure to people and places across such divides."

Here, I define "state" as a political entity that holds sway over a delineated territory. The state has the power to tax and coerce people within its borders, but it also is expected to deliver public goods and ensure well-being. However, the idea of the state is constantly shifting, with unclear contours and boundaries: it is not a unitary or cohesive entity, and its actors and practices change depending on politics, elections, policies, and relationships with other states. The state can be understood as a "relationship of forces, or more precisely the material condensation of such a relationship among classes and class fractions"

(Poulantzas 2000, 128–29). I therefore employ a loose idea of the state as an amalgam of actors, institutions, and practices through which governmental power is exercised. I define "welfare state" in relation to governmental agencies, policies, infrastructural services, and resource distribution.

Based on my ethnographic observations and interviews with Manganiyar musicians, I found that the community has located other avenues of access to resources without support from traditional patronage. In postpatronal contexts, Manganiyar musicians have had opportunities not just to observe but also to move beyond their immediate community and interact with various heterogeneous groups of people. This has enabled them to create dense social networks embedded in their deep and generation-spanning relations with multiple patron families spread out in villages across the desert, their movements between rural and urban locations, and their postpatronal relations forged from touring inside India and abroad. Compared to other similarly positioned hereditary occupational communities like the Langa community of hereditary musicians, Manganiyar musicians appear to have both more and better information about public services and resources and how to claim them, and they have greater opportunities to do so.

As a result, Manganiyars are learning about and forming expectations of the state through the accounts and experiences of others. Even in traditional patronal contexts, Manganiyar musicians have a small window through which they could observe their patrons' lives, practices, and access to resources and aspire to have lives like those of their patrons.[6] The move from traditional patronage, in which Manganiyars depended on patrons and feudal caste relations for their socioeconomic survival, to postpatronage, in which access to resources hinges on a neoliberal sense of personal initiative, gave the Manganiyars a new sense of being.

Manganiyars today interact with jajmans and postpatrons in a variety of contexts. They still perform for jajmans in their villages as well as jajmans who have moved from their hereditary villages in the Thar Desert to cities or even outside India, where the traditional relationship and dynamics remain intact. In the context of contemporary musical production, the relations Manganiyars have created with cultural tourists, participants on national reality television shows, and international concertgoers and festival organizers have replaced traditional patronal relations for some musicians. Manganiyars' reputations as famous musicians and the winners of national and international awards have given them the platforms to reach wide audiences and make their community

circumstances known. In addition, Manganiyars' experiences in traveling the world for performances have given them the insights and managerial experience to work in resource development through NGOs and other local organizations. All these postpatronal circumstances have changed how Manganiyars view themselves. Many musicians now see themselves as empowered and awakened political actors. These conditions have made it possible for Manganiyars to have a new political vision for themselves and their community, which in turn opens opportunities to participate in electoral politics.

However, political power is not always about economic capital: it can also be about the numerical strength of people, cohesive organizational unity, common ideological orientation, and effective leadership. The participation in electoral politics in 2014 by Maganiyars was overdetermined by several factors—meaning that more causes were present than necessary to effect Manganiyar electoral political participation. Those causes included Manganiyars' loss of power through the decline in traditional patronage; an awakened sense of political conscious-ness; eagerness to seek power, resources, and status through new channels; and a compelling political figure, Jaswant Singh, who was running for election.

THE 2014 ELECTION AS A WATERSHED MOMENT

Jaswant Singh's Campaign Platform

Political scientists wrote about Barmer District's 2014 Lok Sabha election as part of a larger significant trend of realigning Indian politics (Chacko and Mayer 2014) and as signifying a new beginning in an India no longer dominated by the Congress Party (Palshikar 2014).[7] This election for a seat in the lower house of Parliament, whose members are directly elected by the public through general elections, made national history due to the number of registered voters and their rate of voting; the mobilization of women voters; the new "none of the above" voting option that allowed people who did not want to vote for any candidate to still take part in the election process; and the BJP's winning all twenty-five districts in Rajasthan State (Jaffrelot 2015).[8]

Perhaps less significant for larger national election trends but of the utmost importance for this chapter, Manganiyar community members turned out in unprecedented numbers to vote and were generally much more involved in this election than in previous ones. They were, for the most part, supporters

of Jaswant Singh. Although Jaswant Singh called the Manganiyar musicians who performed for his campaign his "akeertit naayak" (unsung heroes), little attention has been paid to the unprecedented role that the Manganiyar community played in Jaswant Singh's election.[9] Nor has this election been analyzed as a watershed moment for Manganiyar political participation (J. Singh 2014).

After a long career in Indian national politics that included service as a member of Parliament (MP) for many districts throughout India and holding various offices in the national cabinet, Jaswant Singh—a native of Barmer District—ran for office for the tenth and final time in his career with high hopes of finally representing his native constituency of Barmer for the first time. As a founding member and political leader of the BJP, Jaswant Singh hoped to be backed by that party.[10] He was denied what would be his last political wish.[11] Jaswant Singh was not given the support of the BJP, which placed Colonel Sonaram Choudhary on the party's ticket instead. In retaliation in March 2014, Jaswant Singh declared that he would still run for election from Barmer, but this time as an independent candidate. For refusing to withdraw his nomination as an independent candidate when asked to do so by the BJP, he was officially expelled from the party for the fourth time in his career (Rashpal Singh 2014).[12]

It may seem counterintuitive that a community of Muslim musicians would support a founding member of the BJP in this election. However, based on interviews and conversations with musicians, ethnographic participation, and observations of musical and social life in 2014, the Manganiyars were supporting Singh rather than the BJP. I identified several reasons why members of the Manganiyar community were drawn to Jaswant Singh's political platform and supported his bid to become Barmer's MP. One musician, Fakira Khan, said: "I am a staunch supporter of the Congress Party, but I will still vote for Jaswantji [an honorific title for Jaswant Singh] and I am not scared to say so publicly. He is the one who has worked for the welfare of our community. We will vote only for those who are locals and have good knowledge about the problems of people in Barmer."[13] Manganiyar support of Jaswant Singh was based on four factors that set him apart from other candidates for the Manganiyar community.

First, Jaswant Singh came from a long line of royal ancestors who were involved in politics, what the political scientist Kanchan Chandra has referred to as "democratic dynasties" (2004, 12). Because of Jaswant Singh's familial and local royal connections, I posit that even though he was not a direct jajman

of the Manganiyar musicians who supported him, they supported him as if he had been, using what resembled a traditional style of patronage (Piliavsky 2014; Richter 1975). Royalty in Rajasthan's former princely states continues to be important in influencing politics in the state after independence (Lodha 2008 and 2011). Many former royals and landowners became involved in national and regional politics after India's independence in 1947 and Rajasthan's integration into the Indian nation-state in 1949 (K. Bhargava 1972, 413; K. Chandra 2004; L. Rudolph and Rudolph 2016).

Jaswant Singh's Rajput familial jajmani heritage is the second factor that influenced the Manganiyar community's decision to support Jaswant Singh. He was a direct descendent of the Rajput princess and locally worshipped *sati ma*, Rani Bhatiyani (locally known as Majisa). She was originally from Jogidas Village, where her family were Rajput jajmans to a Manganiyar family. Once she married, she moved to Jasol, where her husband and his family lived. She spent her adult life in Jasol and her maternal family's Manganiyar musicians often visited her there.[14] When her husband died, she committed sati by immolating herself on her husband's funeral pyre. Her husband's family built a shrine in her honor in Jasol. Over the centuries her popularity, like that of other sati mas in the region, has grown throughout Rajasthan, Gujarat, and even over the border in Pakistan.

Today Rani Bhatiyani's original shrine in Jasol is home to the largest temple complex dedicated to her. Although rights at this temple belong to Dholi musicians rather than Manganiyar musicians, the latter still associate their community with Rani Bhatiyani, worshipping her as their community's *pir* (patron deity).[15] Small shrines and temples dedicated to Rani Bhatiyani dot the Thar Desert, and in them Manganiyar musicians perform daily and have the right to collect alms, food, and sacrifices donated to the goddess (Chaudhuri 2009; Trembath 1999). One such temple is in Dantal Village, where Aamad Khan performed his last jaagaran performance (described in chapter 1). Jaswant Singh was from Jasol, and as descendents of Rani Bhatiyani, his family now plays an important role in Jasol's temple. Jaswant Singh's brother is the director of the Rani Bhatiyani Temple's trust. Therefore, even though Jaswant Singh was not a direct jajman of a Manganiyar family, many Manganiyar musicians consider him to be a jajman due to his historical, familial, and devotional connections to Rani Bhatiyani.

Third, Jaswant Singh was a staunch supporter of the Muslim population in India throughout his political career. During the 2014 Lok Sabha elections, he paid close attention and appealed to the Muslim vote in Barmer District.[16] The Muslim population in the Barmer Constituency tends to vote as an organized

bloc.[17] Jaswant Singh therefore worked hard to win the support of the Pir Pagara, the title given to both the spiritual leader of the Hurs (a Sufi Muslim community in eastern Sindh, Pakistan) and his premier religious family.[18] The fact that Jaswant Singh was concerned with the international influence and reach of Pir Pagara in Barmer speaks to his belief that the Barmer-based Muslim population indeed votes as a bloc. It also demonstrates the porous nature of the Indo-Pakistan border in the Thar Desert and the importance of viewing the transnational region as a borderland.[19]

Even though the Pir Pagara is in Pakistan, it has been influential in Indian politics and the Muslim vote in western Rajasthan for at least the past thirty years in Jaisalmer and Barmer Districts due to their proximity to Pakistan. The Pir Pagara issues a fatwa before every Indian election, listing the candidates favored by the organization and who should be supported by the Muslims in India. In Jaisalmer, Ghazi Fakir, the local representative of the Pir Pagara, is an influential religious and political leader. His family is deeply involved in local politics (members of the family have held various political positions in the Thar Desert region) and closely allied to the Manganiyar community. Ghazi Fakir came to political prominence in 1985, when he created interfaith and intercaste alliances as a political strategy to win elections in a district then dominated by Hindu Rajputs. With guidance from the Pir Pagara, Ghazi Fakir thus encouraged the Manganiyar community, as part of the larger Muslim bloc, to vote for Jaswant Singh.

Fourth, because the Manganiyar community have the paradoxical position of being both powerful and powerless in their traditional patronal relations (Ayyagari 2013), they were able to easily relate to Jaswant Singh's similarly paradoxical status of being both a prominent and a liminal politician. As one of the founding members of the BJP, he served in many levels of India's national government.[20] Despite his prominence and service in the BJP, he was expelled from the party four times and was therefore considered a liminal and controversial figure in Indian politics. In addition to these factors, which led Manganiyars to attend campaign rallies and to vote for Jaswant Singh, polls, social media, and new forms of technology encouraged them not only to pay attention to the 2014 elections but also to take part in them (Schoening and Kasper 2012).

Election Results

The election results from the contentious Barmer Districts were announced on May 16, 2014: Choudhary, the BJP candidate, won, and Jaswant Singh, the inde-

pendent candidate, came in a close second—just 87,461 votes behind ("Jaswant Singh Loses Barmer LS Seat in Rajasthan" 2014; "Expelled BJP Leader Jaswant Singh Meets Advani" 2014).[21] Over a year after the 2014 Lok Sabha elections and Jaswant Singh's loss, I heard from multiple sources that the day before the elections, an Indian representative of Makhdoom Shah Mehmood Qureshi, Pakistan's minister for foreign affairs, had visited Barmer. Using promises of attention, resources, and development that Jaswant Singh would not be able to provide, he persuaded many Muslims from the district, including members of the Manganiyar community, to vote for Choudhary. Manganiyar interlocutors corroborated this for me in off-the-record conversations. Pakistan's minister for foreign affairs was thus directly at odds with Pakistan's Pir Pagaro, who, through influence on the India side of the border encouraged local Muslims to support Jaswant Singh. While this Pakistani power struggle may have been about larger issues than Barmer District's seat in the Lok Sabha, it clearly effected the election and Jaswant Singh's chances of winning. Although Jaswant Singh did everything he could to show his support of Muslim populations in Barmer District, his Hindu Rajput identity and sordid past with the BJP stymied his win.[22]

An analysis of the 2014 national electoral results demonstrates that the national BJP campaign in 2014, led by Prime Minister Narendra Modi, tended to push Muslims out of the BJP rather than include them (Jaffrelot 2015, 32). The fact that the Indian Muslim population's vote against the BJP doubled nationally between 2009 and 2014 shows that the group was "trying to find a protector against Modi's BJP across the board" and that "class mattered much less than religion" (ibid.). Despite national trends, the BJP reached out to "backward sections" of the Muslim communities in the Thar Desert, urging them to take advantage of the party's pro-poor policies and welfare programs (K. Sharma 2017). Muslim OBCs like the Manganiyar community initially responded to the BJP's outreach. As an upwardly mobile community, the group's members expected to get from the BJP what they were no longer receiving from their jajmans, "jobs and development" (Jaffrelot 2015, 33).

CAMPAIGN SONG CIRCULATION

On the morning of March 25, 2014, I was rushing to an interview with a local political campaign financier in Jaisalmer City. I made my way through bustling Pansari Market, the oldest market in Jaisalmer City, which clings to cobblestone alleys up a hill to the regal gate of Jaisalmer Fort. The market is full of contrasts,

with some shops catering to tourists and being chock-full of colorful antiques, puppets, leather shoes, and handicrafts. However, most of the shops sell grain, spices, cloth, housewares, and gold to local people and those from nearby villages. One can easily imagine this bustling market as an important center of trade on the Silk Route many centuries ago. As I rushed through the market, a small music store stopped me in my tracks, and I knew that I was going to be late for my interview.

The size of a closet, the store was wedged between a traditional spice shop and a souvenir store for tourists. Music stores throughout urban markets like this in north India were nothing new, usually distinguished by walls lined with plastic cassette and CD jewel cases colorfully displaying the cover art for collections of Bollywood music, religious classics, and regional favorites (Manuel 1993). What stopped me was this store's resemblance to the ubiquitous stores of Apple, the multinational technology company, painted stark white with minimal furniture. A young man sat behind a small computer desk, working diligently on a laptop. I stopped and watched as clients, many of whom I later learned from the shopkeeper, were men working in the transportation industry as truck, bus, and auto rickshaw drivers, brought their smartphones or thumb drives to the kiosk, where the shopkeeper dumped hundreds of MP3 files onto their device for a small fee. The transfer took just a few minutes. The customers would then be able to plug their thumb drives or phones into their vehicle's sound system to broadcast the music. While the Apple-esque stark, sparkling, and newly whitewashed walls in the colorful and dusty old market drew my attention (Bloch, Brunel, and Arnold 2003), it was the song blaring from the shopkeeper's computer speakers that kept me there listening and watching as customers entered and left the shop.

I recognized the song immediately as a campaign song for Jaswant Singh. As I listened, I realized that it was "Woh Malani ro Saput Jathe" (Son of the Malani soil), sung by Jamat Khan—the same artist I had heard singing Jaswant Singh's campaign songs on television on the first night of my fieldwork trip. Through digital sharing and small music stores, Jamat Khan's campaign songs easily circulated throughout the region during the 2014 election cycle. This points to a stark change in the mediation and distribution of music over the course of just a few years: previously, campaign songs were publicly broadcast but not privately consumed. Songs like Jamat Khan's were now easily accessible through lightning-fast distribution and exchange of media files, as well as changes in listening and viewing technology like smartphones and the internet.

It was not unusual in 2014 to hear Jamat Khan's "Woh Malani ro Saput Jathe"

and other campaign songs sung by Manganiyar musicians throughout the region blaring from trucks, taxis, auto rickshaws, and tea stalls.[23] However, what struck me was the tremendous saturation of media usage in the Manganiyar community. Before 2014, while most Manganiyar musicians had cell phones, they used the phones just to make and receive calls about concerts and schedules with tour organizers. The musicians' use of social media and the internet generally was limited to Facebook—which was mostly accessed from urban internet cafés, whose owners musicians paid to post pictures of their performances, mainly as a neoliberalizing postpatronal self-promotion tactic. By 2014, with the increased affordability of smartphones and better access to cell phone towers and Wi-Fi, Manganiyars were using Facebook on their smartphones and accessing other forms of social media like WhatsApp (the cross-platform mobile messenger application), Twitter, and Instagram from the comfort of their own villages to consume as well as produce material. Older musicians depended on their younger and more computer literate relatives to help them. They were communicating with each other, getting their news, watching videos, streaming music, and even learning new songs via social media—all this despite high levels of illiteracy in the community. In the months leading up to the 2014 Lok Sabha elections, I heard about Manganiyar musicians' involvement in electoral politics on technology-driven social media platforms, as many Manganiyars began posting personal political messages, photographs, and videos of rallies and political events.

In the run-up to the 2014 Lok Sabha elections, many news sources focused on the essential and unprecedented role that social media played in these elections (Khullar and Haridasani 2014; Parkinson 2014; Mishra 2015).[24] In previous elections, social media was less accessible, having been slower to reach remote areas of the country than urban centers and populations of lower class or caste (like the Manganiyar) than other groups. In 2014, political parties used social media platforms like Facebook and Google Hangouts to answer questions about party events, encourage real-time Twitter feedback from the public, woo young first-time voters, and create larger-than-life images for candidates (Aditya Gupta 2014). Barmer District already had a high penetration of cell phone usage, so WhatsApp became the chosen mode for transmitting campaign material. Some 900,000 people from the Barmer District constituency were on WhatsApp. Campaign songs like "Woh Malani ro Saput Jathe," sung by Jamat Khan, were broadcast to a segment of the constituency so large that it could not have been reached without such technology (Sivaswamy 2014).[25]

Thus, access to and awareness of social media increased in the Manganiyar

community in the run-up to the 2014 elections, fostering a "new participatory folk culture by giving average people the tools to archive, annotate, appropriate, and recirculate content" (Jenkins 2001, 93). Only by using technology could the Manganiyar community have become as involved as it was in the election, spurring more widespread political involvement in the community. For Manganiyar musicians, their goal in using technology and social media was no longer to just share photographs and promote their music. They now wanted to express their political opinions, encourage others to participate in politics, and rally their community to support causes they believed in. Technology and social media were now resources that were sought after, used, and commoditized. Even this small act of political preference and speaking politically via social media was unusual for Manganiyar musicians—who, as Khete Khan demonstrated above in this chapter, previously had not deliberately involved themselves in anything overtly political.

A SOUNDTRACK FOR A CAMPAIGN

Jamat Khan's Khota *Sound*

Jamat Khan released his two campaign songs, "Woh Malani ro Saput Jathe" and "Hutata Damru Baaje, Bhule toh Pyaara Laage" (Exalt love through the playing of the *damaru* drum) in early 2014.[26] They quickly went viral, setting off a political awakening in the Manganiyar community. Jamat Khan composed these two campaign songs of his own volition, garnering Jaswant Singh the nickname the "Muse of Marwar" (figure 4.2). In a tweet, Jaswant Singh (2014) hailed Khan as "among the most unlikely heroes of our campaign." He was indeed considered an unlikely choice by several Manganiyar musicians with whom I spoke, whose responses ranged from amusement to jealousy when asked about the use of his music in Jaswant Singh's campaign. When I asked them to explain further, they cited various aspects of his musicianship, performance practice, and musical career. One went so far as to call Jamat Khan's music *khota* (doggerel), implying that his music was deliberately low class.

Jamat Khan seems to have none of the characteristics the Manganiyar community contemporarily values as being distinctly Manganiyar. He does not have close ties to his traditional jajmans and is not known for his renditions of traditional Manganiyar repertoire and shubhrajs in front of jajmans. Nor does he embody those characteristics that help garner the type of postpatronal success

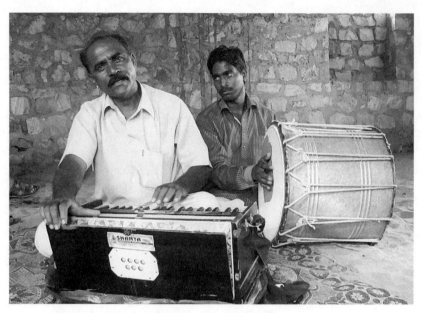

FIGURE 4.2 Jamat Khan (left, playing harmonium) with son (right, playing dhol)
performing Jaswant Singh's campaign songs during a recording session.
Barmer City, 2014. Photo by author.

that was crafted by Kothari in the 1960s: Jamat Khan is not a performer known
for his intimate stage presence, ostentatious showmanship, or praise of audi-
ences. He does not have personal connections in the cultural tourism industry,
performance circuits in Rajasthan or beyond, or with organizations like Rupayan
Sansthan. He lacks the valued characteristic of embodying a sense of tradition
and timelessness that I characterized as subaltern chic in chapter 2.

It was precisely this lack of dependence on jajmans or postpatronal audiences
that left Jamat Khan free to innovate his music in a kind of postpatronal perfor-
mance practice that is very different from others I have outlined thus far in this
book. Jamat Khan is instead well-known for his studio recordings of popular
interpretations of Manganiyar repertoire. When I asked Khete Khan about Ja-
mat Khan, claiming that I had never heard of the latter, Khete Khan responded,
"You haven't heard *of* him, but you have heard him."[27] Khete Khan was refer-
ring to Jamat Khan's prolific recording career. Indeed, once I heard his voice in
Jaswant Singh's campaign songs, I recognized it immediately as the voice of so
many regional songs I had heard in innumerable public transport vehicles like

buses and auto rickshaws. Beginning in the 1990s, he took advantage of recording technology and began a career of recording songs in the cassette industry. While other Manganiyar musicians were seeking postpatronal opportunities in Jaisalmer and abroad, Jamat Khan was recording song after song and even entire albums in small recording studios in Jodhpur City. His songs have been widely distributed via cassette tape and MP3 throughout Rajasthan State and beyond. They can be found in every small music kiosk and heard in trucks, taxis, and auto rickshaws throughout the region.

In terms of performance practice, Jamat Khan's songs are more akin to other kinds of neofolk styles of music found throughout north India than they are to Manganiyar music (Manuel 2008, 386). Many of his songs fit into the category of transportation songs—a type of neofolk music that makes up a very small sector of the larger recording industry in India. Beginning in the 1990s, transportation songs became one of a bewildering variety of "new cassette-based" musical styles that were aimed at "specific target audiences in terms of class, age, gender, ethnicity, region, and in some cases, even occupation (e.g., Punjabi truck drivers' songs)" (Manuel 1991, 191). Regional genres of music, like transportation songs, were in stark contrast to more popular genres that targeted broader Indian audiences of "undifferentiated film-goers" (ibid.).[28] In Rajasthan, transportation songs refer to songs that not only truck drivers listen to but that are played in buses, taxis, and auto rickshaws throughout the region. These songs are characterized by the use of the harmonium accompanying vocals, steady and repetitive drum rhythms, synthesized instruments, vocal reverberations with echos, and a smooth vocal timbre.

Jamat Khan's music is exemplary of this body of transportation songs in Rajasthan. The clear and crisp timbre, higher register, use of fast vibrato, and refined nature of Khan's voice stand out from the traditional Manganiyar style, which is characterized by acoustic instrumentation, a looser sense of rhythm, harsh vocal timbres, and the use of a deep *khola avaaz*. I met Jamat Khan in July 2014 after Jaswant Singh had lost the Lok Sabha election. The musician was shy and soft-spoken. He told me: "I sing differently than the Manganiyar style. Manganiyar means beggar and *khamaghani* to the jajman. I sing modern."[29] He implied that he used his style of performance and the venues in which he performed intentionally to express an identity emancipated from the bonds of patronage. Instead of shifting patronage from traditional jajmans to postcolonial institutions like Rupayan Sansthan, local cultural tourism performances, and international touring, he found a career in appealing to broader audiences through his reinterpretations of Manganiyar repertoire.

After I heard Jamat Khan's explanation, I no longer agreed with the many Manganiyar musicians with whom I had previously spoken about his campaign songs who claimed that Jamat Khan was an unlikely choice for Jaswant Singh's campaign. In fact, I came to see and hear that Jamat Khan was the logical musical voice of the campaign. Jaswant Singh's campaign team chose Jamat Khan precisely because he stood outside of both traditional patronage and postpatronage Manganiyar performance practice. His music could communicate Jaswant Singh's political messages while reaching regional and diverse audiences of potential voters. The transportation song style is not only widespread throughout Rajasthan, but it connotes movement, upward mobility, progress, and a particular kind of middle-class urbanism familiar in smaller cities and towns in western Rajasthan.

For Jaswant Singh's campaign team, Jamat Khan's performance style had the perfect balance of urbanity, mixed with a distinctly regional sound. Khan's campaign songs feature him as the vocalist accompanied by harmonium, *dholak*, and several other synthesized and studio-produced instrumental sounds like those of a piano, various stringed instrruments, sitar, and *shehnai*. This instrumentation can be contrasted with the acoustic and traditional sounds of Manganiyar music, in which just a few musicians perform on traditional instruments like the kamaicha, dholak, and *khartal*. This was important because Jaswant Singh was an older candidate who saw winning the post of Barmer's MP as his last political act before retiring. His campaign team determined that he needed modern and innovative sounds to represent his platform. Indeed, other Manganiyar musicians known for their traditional patronal and postpatronal performances also composed songs for Jaswant Singh and his campaign (Chari 2014). For example, Fakira Khan, a well-known Barmer City–based Manganiyar musician, composed a shubhraj for Jaswant Singh and performed it at a political rally. While Jaswant Singh listened attentively to this performance, Fakira Khan was not chosen to musically represent his political campaign. Jamat Khan and his songs were flexible, hybrid, malleable, and ultimately resilient.

At the same time, Khan's performance style was not so different from other regional music in Rajasthan as to suggest that Jaswant Singh was an outsider. He had served for many decades in various governmental offices in India outside of Rajasthan, and his campaign team needed to make sure that he was viewed as being local to the Thar Desert. For example, national campaign songs in north India in 2014 featured what Greg Booth has called "that Bollywood sound" (2008).[30] This style of song features a processed lead singer's voice and chorus,

driving rhythms, and Western instruments woven into a musical texture with traditional Indian instruments like the sitar and tabla, as well as characteristic Bollywood vocal timbres — smooth and deep for male voices and nasal for female voices. Booth describes this characteristic sound as involving "large orchestras, especially with large string sections playing unison melody lines and rapid passagework with impeccable intonation and ensemble, endless eclectic instrumental combinations of Indian and non-Indian instruments, unexpected harmonies, regular and extreme use of electronic reverberation effects, an idiosyncratic mix of Western and Indian stylistic features, and a facility with electronic instruments and amplification" (ibid., 85). Jaswant Singh's campaign team used Jamat Khan's music to sonically demonstrate and mediate Singh's courage and political savviness to run for Barmer's Lok Sabha seat after having been ousted from the BJP.

"Woh Malani ro Saput Jathe"

Jamat Khan's first campaign song for Jaswant Singh was "Woh Malani ro Saput Jathe." He adapted it from a traditional Manganiyar song sung for jajmans eulogizing the sixteenth-century Rajput king Maharana Pratap. According to oral tradition, Maharana Pratap chivalrously fought to protect Malani, the ancient name given to the Thar Desert region surrounding Barmer City, from the forces of Akbar's Mughal Empire at the Battle of Haldighati in 1576. Although Maharana Pratap lost the battle and had to retreat to the hills in exile, he built up his army again and won back much of his territory in the Battle of Dewair in 1582, freeing much of what is now Rajasthan State from Mughal rule (Bahuguna 2013; Snodgrass 2006).

More than four hundred years after his death, Maharana Pratap remains a revered and courageous hero for millions — an exemplar of Rajput pride and a paragon of resilience. His continuing relevance is evident in his mention in songs and poems sung by Manganiyar musicians. His exploits have been reinforced in the local public imaginary since the immensely popular Indian historical fictional drama serial *Bharat ka Veer Putra--Maharana Pratap* (India's brave son — Maharana Pratap) was filmed in and around Jaisalmer City and aired from 2013 to 2015 on Sony Entertainment Television in India. The analogy that Jamat Khan clearly draws between the historical Maharana Pratap's bravery in the face of battle and opposition and Jaswant Singh's contentious bid in the 2014 Lok Sabha elections was not lost on voters, some of whom referred to this

analogy repeatedly in conversation with me in the run-up to the elections. Many Manganiyar musicians as well as Jaisalmer and Barmer City locals reiterated Jaswant Singh's bravery after being ousted by the BJP and his decision to run as an independent candidate.

The prelude of Jamat Khan's song consists of a short shubhraj, typical of Manganiyar traditional music, which is sung without a steady rhythm or accompanying melody—although a harmonium can faintly be heard shadowing the voice and providing a drone accompaniment.[31] After the shubhraj, the synthesized keyboard, strings, and sitar play the melody or a variant of it in turn. These instruments introduce the voice, and an electronic synthesized shehnai repeats the melody of important sung vocal phrases. The dholak provides an ostinato in *kaharva tala* (rhythmic cycle), a swinging eight-beat rhythmic cycle with characteristic breaks at the ends of phrases leading back to beat one of the next sung phrase. This simple and common tala hints at rural provincial origins rather than giving an urban or national feel. It is often used in Bollywood film music to produce the same rural, bucolic, or regional effect (Manuel 1993; Morcom 2007, 63). However, the addition of a bass line, which is uncharacteristic in Manganiyar music, adds implied harmony, and the synthesized sounds of other instruments add to the song's contemporary and popular feel—which appeals to a broader and more urban audience.

While the song's recognizable melody conjures up images of chivalry and bravery in the local imagination, the lyrics were adapted to the 2014 elections and speak to Jaswant Singh's local roots in western Rajasthan ("Jaswant Singh Jasol athe" [Jaswant Singh comes from Jasol]), his unification of Hindus and Muslims in the region ("Hindu-Muslim ro saath jathe" [Hindus and Muslims come together]), and the general good work he did for the district. Khan reminds listeners of Jaswant Singh's electoral symbol of the torch of knowledge and his ballot number, so that his name will be easy to find when constituency members are voting on election day. In the lyrics, Khan does not name any of Jaswant Singh's competitors directly, but he uses the legend of Maharana Pratap to highlight themes of humiliation, war, and rivalry that were imposed by the BJP in the run-up to the elections.

"Hutata Damru Baaje, Bhule toh Pyaara Laage"

The second song composed, sung, and recorded by Jamat Khan for Jaswant Singh's campaign was "Hutata Damru Baaje, Bhule toh Pyaara Laage." Although

the song contrasts strikingly with "Woh Malani ro Saput Jathe" in terms of melody, it similarly uses the technique of attaching new campaign-appropriate lyrics to a well-known melodic structure. The attachment this time is not about bravery of historical heroes or a contemporary television show but about the locally worshipped Rani Bhatiyani. New lyrics concerning Jaswant Singh's campaign are set to the melody and structure of a locally familiar *olakh* (a religious song about a particular deity) dedicated to Rani Bhatiyani.[32] The song includes modern elements like autotuning and synthesized electronic instrumentation that provides background and melodic interludes between sung phrases. However, the use of the harmonium to accompany the vocal melody, the acoustic dholak to maintain the simple and pulsating rhythm, the repeated verse with changing lyrics, and the typical Manganiyar vocal style of khola avaaz brings to the listener's mind a Manganiyar musician singing a Rani Bhatiyani olakh. The song's melody comes directly from a well-known olakh.

Typically, Manganiyar songs devoted to Rani Bhatiyani are set apart from other items in the repertoire based on the specific olakh. Olakhs consist of "invocatory songs and usually lead the deity's followers into trance. The strong association of the olakh's melody (they are all similar) with the context probably creates the trigger for possession" (Chaudhuri 2009, 99). Manganiyar musicians claim that olakhs are important in bringing on trance and possession among Rani Bhatiyani's religious pilgrims visiting her shrines and temples, as well as among male and female Manganiyar musicians working in shrines dedicated to her.[33]

In the past few decades, Rani Bhatiyani has grown in popularity throughout the region—especially in Rajasthan, Gujarat, and eastern Pakistan, where she is seen as a powerful deity who can heal the sick and wounded. The connection that this song draws between Jaswant Singh and Rani Bhatiyani makes sense because he is her descendent. Using a type of sung melody associated with a highly popular local deity is a common technique used throughout north India. In this case the olakh encouraged potential voters to associate Jaswant Singh with Rani Bhatiyani. Furthermore, as suggested by my interlocutors, choosing a melody type that easily puts people into trance was a way of entrancing voters to vote for Jaswant Singh. The two songs discussed here demonstrate the use of local imaginaries (involving older songs, myths, and tropes that are common in the region) mixed with new instrumentation and electronics and presented in novel forms of media to produce another kind of postpatronal performance practice related to politics.

"MANGANIYAR-LANGAS USED TO BE FROM US"

I now turn to a very different political event that happened five years after the 2014 Lok Sabha elections, which demonstrates that they were a turning point in the way that members of the Manganiyar community thought of themselves as political actors. In July 2019, Ameen Khan—a member of the Rajasthan Legislative Assembly representing Sheo Tehsil, in Barmer District—made a derogatory statement about the Manganiyar community in a televised debate on the revised 2019–2020 budget in the assembly.[34] A member of a Muslim farming family, Ameen Khan said: "In our religion, Manganiyar-Langas used to beg from us. It is written in our religion that it is forbidden to eat food of a Manganiyar, whereas eating food at a Meghwal's house is not forbidden. The reason behind it is that begging and stealing are equal to sin. Manganiyars' food should not be eaten."[35] Ameen Khan's statement was in the context of a larger discussion about poor communities in the region. Despite the inaccuracies and misguided views that he expressed in his statement's conflation of religion, caste, class, and community, his rant reveals much about the complicated nature and perception of Manganiyar political involvement.

Calling Manganiyars beggars is not new, but the name continues to be a controversial issue, as discussed in the introduction (Bharucha 2003, 225; Kothari 1994, 205–6). Names carry political weight and value through their ownership, legitimacy, comprehension, and cultural legacy. Jajmans often casually refer to the hereditary musicians who traditionally perform for their family as their "manganiyar," using the term as a common noun rather than a proper name. In contemporary postpatronal contexts, Manganiyar is associated with self-affirmation and virtuosic musicianship rather than with begging.

Because members of the Manganiyar community have been lauded as national treasures and have had many prestigious awards bestowed on them, the community is less commonly abused verbally today than in the past. So why was Ameen Khan so quick to insult and condemn the Manganiyar community? As a member of a Sindhi Muslim farming community, he is a jajman to a Manganiyar musician himself.[36] This is the case even though the majority of the Manganiyar community's jajmans are Hindu. I posit that Ameen Khan's statement was an assertion of his jajman status at a time when jajman power was fading. The fame and fortune of so many Manganiyar musicians intimidates some jajmans and threatens their status at a time when they still depend on their superiority over Manganiyar musicians to define their caste and class status. This is especially

true for Muslim jajmans, who are already considered second-class citizens in the region due to their religious affiliation.

Two aspects of the aftermath of Ameen Khan's remarks are worth reflecting on. The first is the response that the speech elicited from members of the Manganiyar community. They heard the speech on social media, made it go viral in the community, organized to protest it, took to the streets, and demanded an apology from Ameen Khan. In a matter of hours after the original statement, members of the Manganiyar community had coordinated protest rallies in Jaisalmer, Barmer, and Jodhpur Cities, where they walked through the streets carrying banners and chanting demands for an apology. Manganiyars came from villages all over the region to represent the community, with Gazi Barna, Bax Khan, and Anwar Khan Baiya at the front making public statements to the community and news media.

Second, the community-wide response of anger and organization to Ameen Khan's derogatory comments could not have been mobilized without Manganiyar access to and comfort with technology. Within hours of Ameen Khan's speech, Manganiyar musicians had posted the video clip of his statement on forms of social media used in the community—particularly Facebook, Instagram, and Twitter. There was a flurry of activity over mobile phone SMS and WhatsApp Messenger, with Manganiyars sharing the video with each other and contacts outside of the community. The story was quickly picked up by national media because of the reach of technology. Extended interviews with well-known and award-winning Manganiyar musicians were broadcast on local and national news outlets, including India News Rajasthan, DCN Cable, NTI News, *Outlook India*, the *Times of India*, and News18 India. The story also made international news.[37]

Two days after Ameen Khan's speech, the Merasi Manganiyar Vikas Seva Samiti (Merasi Manganiyar Development Service Society) and the Mahindra Gunsar Lok Sangeet Sansthan (Mahindra Gunsar Folk Music Institute)—two noteworthy organizations in the Manganiyar community—submitted to the Jaisalmer district collector a memorandum addressed to Ashok Gehlot, the chief minister of Rajasthan, on behalf of the Manganiyar community.[38] The memorandum demanded an apology from Ameen Khan. There was no response from the chief minister, nor was there an apology from Ameen Khan. Some Manganiyars continue to wait for both a response and an apology. However, for the vast majority of Manganiyars involved in this issue, the organized actions of their community are more important than the responses of a few individuals.

Anwar Khan Baiya issued a public statement after Ameen's remarks: "We are

all equals. He is the one who went door to door begging for votes. We have seen the whole world, hundreds of countries. Ameen Khan has been to Jaipur and maybe Delhi. We are Muslims and the Muslim community trusts us and who we choose to represent."[39] With this statement, Anwar Khan not only invoked one of Islam's key tenets of egalitarianism, by appealing to Ameen Khan as an equal and fellow Muslim, but he also used his worldliness and access to resources through his musical postpatronal performances to draw attention to both the status of the Manganiyar community and their jajman. In addition, Anwar Khan acknowledged the power that the Manganiyar community now wields in electoral politics. Considering Anwar Khan's comments, Ameen Khan's statement suggests that he felt intimidated by the Manganiyar community and the electoral power its members wield—a lesson learned from Jaswant Singh's bid in the 2014 Lok Sabha elections.

Thus, while increasing electoral competition has begun to alter the political importance of caste, which previously played a more overt role in electoral politics, religio-caste position is being invoked in political ways to both alienate constituents with increasing power (as in Ameen Khan's statement) and increase status through organized bloc voting (as in the Manganiyar community's collective voting). Candidates now tend to bring together heterogeneous groups of people—members of different communities, classes, and castes—rather than appealing to single groups of people to capture greater electoral support. In the Thar Desert, religion has become even more important as mixed-caste coalitions proliferate, uniting their members through broader religious affiliations. Ameen Khan's statement demonstrates that the Manganiyar vote is an important one. With its power to spread the word of voting preference through their musical performance and social media, the Manganiyar community is now a force to be reckoned with in the swaying of Muslim votes in western Rajasthan. Ameen Khan's derogatory statement had the opposite effect that he wished it had. He created a platform for the Manganiyar community to demonstrate their organizing capability and clout.

SONIC POLITICS

The reaction to Ameen Khan's derogatory speech is just one of many examples of Manganiyar musicians' increasing politicization in the aftermath of the 2014 Lok Sabha elections. While they were political before 2014, these elections awakened their involvement in electoral politics, creating what Khete Khan called political

jaagaran. The attempts that musicians from the Manganiyar community have made in recent years to become involved in electoral politics through music, public support of candidates, and the lobbying of officials for access to resources show the beginnings of Manganiyar collective action.

Although the Manganiyar community supported Jaswant Singh as an independent candidate to fill Barmer District's seat in the lower house of Parliament in the runup to the election, in the end they were persuaded to change their minds as a community bloc and vote in support of the larger Thar Desert Muslim community interests. Perhaps Jaswant Singh would have lost the election even with support from the district's Muslim voting bloc. No matter what the outcome of the election was, Manganiyar involvement in it tells us two things. First, networking and communication via social media and technology in the Manganiyar community enabled its members to organize as a bloc: they were able to spread the word, express their opinions, and communicate via social media, text messaging, and phone calls. This ability to organize was later solidified and demonstrated in the protests surrounding Ameen Khan's statement. Manganiyar musicians are now able to imagine conditions of possibility that technology and social media could enable for their future musical careers in postpatronage, which include instigating political awareness, organizing, and steering political discourses for the Manganiyar community.

Second, in a region where religio-caste relations have been key determinants of community status and voting preferences, access to resources has taken precedence over religion and caste. In rural borderland areas like the Thar Desert, access to resources for communities like the Manganiyar has traditionally hinged on jajmans rather than political parties. This is because of the numerous small and spread-out communities with different needs, for whose members the key to gaining access to resources has often depended on finding a sympathetic ear rather than persuading a cumbersome party to legislate broadly in a particular way. The Manganiyar community viewed Jaswant Singh, running not with a political party but as an independent candidate, as just the person to enable them to voice their community concerns and grant them access to essential resources. They saw Jaswant Singh as not just a potential elected official but as a postpatron who could provide their community with specialized and individualized services and address their needs just as a traditional jajman or postpatron might. The fact that the Manganiyar community ended up voting for Choudhary, the BJP candidate, demonstrates that the promise of resources from the BJP won the community over.

As I have shown in this chapter, even if the Manganiyar community has not yet achieved significant political successes, the more critical realization has been the acknowledgement of the existence of Manganiyar politics by musicians and outsiders alike. Furthermore, since the 2014 elections, Manganiyar musicians have taken to politics themselves. Some have pushed for legislative reforms that would help the Manganiyar community, while others have been appointed to political positions of authority and have started to run for office in local elections. Ultimately, sonic politics can mean different things to different musicians. For some, it means being able to continue to make music when traditional patronage fails their family and community or choosing repertoire in traditional patronal contexts. For others, like Jamat Khan, it means performing campaign songs in support of a candidate. And for still others, it means rallying, protesting, and even running for political office. I have used examples of sonic politics in this chapter to demonstrate the implications and repercussions for Manganiyar musicians and their music as they become resilient musicians and political actors.

CONCLUSION
Ongoing Resilience

A SCHOLAR AS A POSTPATRON

I first conceptualized postpatronage as the framing for this book during encounters with interlocutors in January 2019, when I was living in Jaipur City. One of my interlocutors, Dara Khan, called to tell me that he had just arrived in Jaipur with a group of musicians from Hamira Village, near Jaisalmer, to perform at the wedding of a local police commissioner's daughter. Dara Khan is Sakar Khan's third son and a kamaicha player who learned kamaicha from his father and through traditional patronal relations in Hamira Village. However, early in his career as a kamaicha player, he had the opportunity to play in postpatronal contexts. While he continues to play kamaicha for his family's traditional patrons, he is also engaged with postpatronal relations.

The afternoon before his performance, I took a taxi from the center of Jaipur City, where I lived, to Dara Khan's hotel in the city's southwestern outskirts. When I arrived, the group of musicians traveling with Dara Khan filed into his tiny hotel room to greet me by chorusing "*khamaghani.*" Dara Khan motioned for me to sit down on one of the two beds and poured me a small cup of chai from a carafe on the nightstand between the beds. After serving me, he served the senior musicians who were present. We exchanged pleasantries over chai, and then he motioned for me to get my camera from my bag. Some of the musicians with whom I was less familiar took this as a cue to leave, while the rest, all of whom I knew well, crowded around, sat on the beds or floor, tied their turbans, and tuned their instruments.

Dara Khan waited for me to turn on my video camera and then, in a panegyric

manner, told me how much he appreciated my studying the Manganiyar community for so many years. He recounted what he called the *aacha kam* (good work) I was doing and told me that he considered me part of his family. The musicians then performed three *puraney git* (old or traditional songs) that they perform for traditional patrons at auspicious occasions in *kacheri*. After the performance, they put their instruments down and started talking with me about the songs' meanings, explaining each of the lines of sung poetry and translating them from Marwari or Sindhi into Hindi for my benefit.

Before the musicians left, I gave them money for their performance, as I usually do when I record performers. This is how most of my recording sessions had proceeded with these same musicians over the past twenty years: They expect me to videotape their performances. Afterward, they tell me the song names, *ragas*, and the stories being told through the lyrics. Before or after the performance, they compliment me on my research, recount how many years we have known each other, recite some of the work I have done for the community, and tell me I am part of their family. Do these interactions I have with my interlocutors constitute yet another form of postpatronage, unique to their interactions with scholars and ethnomusicologists like me?

(RE)ASSEMBLAGES

Since the 1960s, assembling artistic collections and archives has been important for a Manganiyar sense of community and identity. Kothari was the first person from outside the Manganiyar community to document and collect its intangible musical culture through artifacts and recordings (such as instruments; photographs; audio and video recordings; and written documentation of previously only oral material such as *dohas*, stories, and genealogies). Since then, numerous scholars, concert organizers, documentary filmmakers, and tourists have done the same. The collective archive is vast. Its influence goes beyond the collections to shape the ways Manganiyar musicians think about and present themselves in both traditional and postpatronal performance contexts. This archival effort has codified Manganiyar cultural traditions, musical practices, and community-defining characteristics for musicians, audiences, and scholars..

After so many years of being the subject of outsider archival efforts, Manganiyar musicians have been inspired to spearhead their own archival projects. Musicians like Gazi Barna have attempted to preserve their community's musical practices through development in the first decade of the twenty-first century.

Similarly, Manganiyar musicians in the younger and technologically savvy generations are engaging with technology in their own ways. Many of them were born in the postpatronal period and have been exposed to archival assemblages since birth through local cultural tourism, visiting scholars, Rupayan Sansthan, representatives of national and international organizations, and travels abroad from a young age. Beginning in 2015—as smartphones, Wi-Fi access, and data plans became more widespread in the Thar Desert—many young Manganiyar musicians began posting videos of themselves, their friends, and their family members performing music. Many of the videos I have seen via social media since 2015 are striking in their similarity to those made by me and other ethnographers working with the Manganiyar community in the mode of archival preservation. In these videos, the young Manganiyar musician behind the camera often asks the performer to state the song title, the raga in which it is performed, their name, and a brief description of the song.

It should come as no surprise that the many years of interaction between Manganiyar musicians and ethnographers have affected not only the way Manganiyar musicians perform for postpatronal audiences but also the way they organize their own recordings. They are assembling archives while also creating reassemblages of their own. Assemblage as a conceptual resource "has to do with the imaginaries for the shifting relations and emergent conditions of spatially distributed objects of study" (Marcus and Saka 2006, 106). Assemblages are at once ephemeral and emerging. Related to assemblage is reassemblage, which allows texts to be interpreted on their own. Trinh T. Minh-ha's (1999, 210) reflexive challenge to ethnographic authority through what she calls "speaking nearby" rather than "speaking about or speaking for" others allows audiences to intrinsically recognize the ambiguity of such texts. In addition, her resassemblage brings to the forefront questions about the conventions and expectations of the texts being presented (Minh-Ha 1982 and 1992).

In 2018, I began the next phase of my research, in which I hope to address this Manganiyar sense of reassemblage. I am working with young Manganiyar musicians on a collaborative transmedia filmmaking project (Jenkins 2007 and 2019). Transmedia involves a methodology of multiplatform production that relies on participatory media and collaborative storytelling to offer new paths for creating knowledge. It is a performative methodology that both involves the creation of content and uses various platforms and diverse techniques to present and consume stories. As my collaborators, I chose younger musicians who were already interested in technology and involved in postpatronal performance

networks and practices. By using transmedia as a methodology, we have been experimenting with participatory and collaborative storytelling across multiple media platforms to spur community outreach and engagement.

After a brief training session, Manganiyar musicians are given a recording kit that includes a videorecording tablet, lenses, microphones, headphones, and a tripod. They are asked to take the recording kit home and use it to create video and audio content of their choosing. I then ask them to begin a process of mediation by uploading chosen and edited clips from their footage onto the internet-based platforms and social media sites that already permeate their everyday networked lives. Because the next phase of the project was postponed due to the Covid-19 pandemic and has not yet begun, I have spent an extended period on the first phase of the project, discussing the recordings made by my interlocutors with them via social media.

One Manganiyar musician with whom I have been working closely on this project, Rais Khan, used the recording kit to record promotional videos for his new band, which consists of him and his younger brothers. A *morchang* player, Rais Khan has been performing in postpatronal contexts since he was a young child. He is known for his virtuosic and ingenious morchang solos as well as beatboxing, a skill he learned from Jason Singh (a British sound artist, composer, and beatboxer) while on tour in the United Kingdom. The decentralized nature of the videos Rais Khan showed me demonstrated the idea of reassemblage. After recording the songs in a fashion similar to that of an ethnographer, he used the tablet to edit the footage, adding drawings, images, and color schemes that he thought would help him advertise his band. During the pandemic lockdown in the Thar Desert, Rais Khan ingeniously posted these videos to promote online concerts to raise Covid-19 relief funds for his family and the Manganiyar community and to advertise his skills, so that he can pursue a career teaching people internationally through remote learning how to play the morchang.

Rais Khan's innovative use of the recording equipment to create a unique reassemblage of ethnographic recordings has inspired me to continue this project in the future. In the next phase of the project, musicians will be encouraged to continue sharing recorded content online and collaborate through the remixing, reusing, and repurposing of audio and video footage. I will also host workshops in the community to discuss future possibilities and uses of documenting, sharing, and collaborating with multimedia content. Through this project, Manganiyar musicians will be able to work as a commons, setting in motion the production,

assessment, and archiving of multiple layers of their own stories in the Manganiyar community and beyond.

ENDINGS AND BEGINNINGS

What does it mean to live a life that is resilient? That question, inspired by Manganiyar musicians who have demonstrated ways to be resilient through their prolific and diverse lives as musicians, has framed this book. I have challenged the notion that just because Manganiyar musicians perform on international stages and in cultural tourism circuits, they are no longer involved in traditional patronal relations. I have suggested that, instead, traditional patronage in the Thar Desert is a resilient practice (providing positive resilience for some and negative resilience for others). The relations of friendship, pride, historical ties, animosity, and hatred between Manganiyar musicians and their *jajmans*, which have been recounted in this book, have never been confined to a simple linear relation of dominance and subordination. Instead, traditional patronal relationships are complex, having evolved between families over hundreds of years and many generations of musicians and their jajmans. The relations keep evolving as postpatronal networks shape Manganiyar music and pull musicians in new directions. These interwoven connections are enmeshed in the Thar Desert borderland and the international world beyond their village.

By centering postpatronage firmly in a framework of traditional patronage, we can see how these cultural practices are interdependent on one another in the Thar Desert today. While postpatronage is indeed a performance practice that diverges from traditional patronage, musicians involved in postpatronal performance spaces and networks draw on traditional patronage for cultural capital and to provide a base on which to maintain the sustainability of Manganiyar music and the community's professional music careers.

My analysis, developed throughout this book, strengthens the argument that Manganiyar musicians can no longer solely depend on traditional patronage for sustenance, and as a result they are turning elsewhere for support and resources. What the Manganiyars call *lachila* can be used as a framework to help explain this dynamic. The strategies of resilience that Manganiyar musicians employ in traditional patronage and postpatronage provide a way for them not only to continue making a living through musical performance but to thrive as nationally and internationally renowned musicians. Instead of appealing to their jajmans,

Manganiyar musicians have found that performing in new contexts, involving themselves in local development initiatives, and participating in electoral politics enables them to voice their concerns and access much-needed resources. Postpatronage means resilience for the Manganiyar community.

Criticized in diverse fields of research as being too broad and transdisciplinary, resilience is an elusive concept. As a reaction or response in the present to something that happened in the past, resilience dialectically depends on disaster. For resilience to be sustainable, disaster must be a constant threat. Resilience demands that its practitioners are constantly in a state of precarity. By acknowledging that precarity is unstable and unpredictable, Manganiyar musicians increase their resilience and move from lives that are predictable to those that are contingent. Resilience allows Manganiyar musicians to adapt to cultural change and new technology, while simultaneously drawing on notions of tradition and nostalgia to keep music making a relevant livelihood in the contemporary world.

Participation in postpatronage has led Manganiyar musicians to envision personal and community futures in very different ways than they had previously. Designing desirable futures requires formulating what might be (Ackoff 1974, 66). Here, we return to sustainability and its relationship to resilience. Sustainability refers to a kind of stability, the establishment and continuation of patterns of actors (whether they are aspects of nature, animals, instruments, or musicians) and their interactions with the world around them (Blühdorn 2009, 2). The case of the Manganiyars recounted in this book demonstrates that the point of sustainability should surely be to sustain not what already exists but the capacity for growth and diversification of various ways of thinking and being.

The following questions can then be asked of Manganiyar futures: How can Manganiyar musicians find sustainability in musical livelihood through future imaginaries that go beyond the teleological fantasies of neoliberal development, global capitalism, and political freedom? Who will inhabit these futures, and how will they do so? How can communities like the Manganiyar fight for imagined dominant terrains of futurity from their marginalized and subaltern spaces? Imagining futures that are unencumbered by oppression of and discrimination against those who might already be colonizing Manganiyar futures opens a potential that lies "beyond historical, political, and biological determinism" (Arendt 1998, 9). But this future imagining is a daunting task without thinking about the now. Perhaps in the meantime we can ask how Manganiyar musicians

can make choices in the now that will affect their futures. What needs to happen in the present when one imagines possible futures different from their pasts?

Guided by ingenuity and capacity, many Manganiyar musicians are serving as role models for other musicians in the Manganiyar community as well as similarly low-caste communities. They are providing much-needed support for those Manganiyar musicians who have not had the opportunity or choose not to perform in postpatronal contexts, instead continuing to perform for traditional jajmans. Taking into consideration changing patrons, flows of cultural tourism in Rajasthan State, opportunities for touring abroad, uneven but increasing access to technology, exposure to development and NGO work, changing religio-caste and borderland identities, and increasing political action, this book has told stories of everyday and exceptional moments in the contemporary lives of Manganiyar musicians. These stories show that Manganiyar musicians are increasingly using resilience to thrive in their lives and music. Such stories of resilience ultimately have repercussions, resounding through the far reaches of the Thar Desert as well as effecting musical, social, economic, and political changes far beyond the Thar Desert.

APPENDIX

Organizations and Festivals

Sangeet Natak Akademi, the first academy of arts to be funded by the Indian national government, was established in 1952 by the Ministry of Education. It was a postcolonial project intended to establish a national identity through the arts. Although it was founded before Rupayan Sansthan, Sangeet Natak Akademi began supporting regional culture and the Manganiyar community as a result of Komal Kothari's influence and Rupayan Sansthan. By the 1980s, Sangeet Natak Akademi was flourishing as the largest and most powerful body of centralized performing arts in India through its work in the promotion and preservation of cultural heritage domestically at the national level, among diasporic populations around the world, and through international cultural performances, festivals, and tours (Cherian 2009). Sangeet Natak Akademi has continued to support musicians as an institution of postpatronage into the twenty-first century. Many Manganiyar musicians have benefited from Sangeet Natak Akademi's sponsorship of international concert tours and in this capacity have promoted the organization abroad.

Indian Council for Cultural Relations was founded in 1950 by Abdul Kalam Azad, the first Minister of Education in the Indian government, to demonstrate the diversity and richness of cultures in India and facilitate interactions with other cultures around the world in support of cultural diplomacy. An important feature of the Indian Council for Cultural Relations' interventions is its empanelment of artists: people who have proven themselves as skilled musicians and leaders in their given fields are placed on reference lists and can then be considered for state sponsorship on international tours and in cultural performances. Through empanelment, Indian Council for Cultural Relations was one of the first state-

run institutions to work with Manganiyar musicians, sponsoring many of their international tours. Thanks to the opportunities given by Indian Council for Cultural Relations, Manganiyar musicians increased their networks of international connections, which enabled them to establish their own postpatronage connections outside the circle of Kothari and Rupayan Sansthan.

In addition to the roles of the Sangeet Natak Akademi and Indian Council for Cultural Relations, that of All India Radio in the establishment of India as a postcolonial nation as well as a tapestry of regional cultures cannot be underestimated: All India Radio was one of the main instruments through which the national government disseminated a canon of regional music to promote the use of certain music from various parts of India to represent the nation (Baruah 2017; Lelyveld 1994). A number of Manganiyar musicians performed regularly at regional All India Radio stations in Jaipur and Jodhpur. Stefan Fiol (2012, 103) has recounted an important history of the indexing of regional and folk music's essentialized qualities of place through "sonic emblems that are packaged into sound commodities."

The Barefoot College at Tilonia is based in the village of Tilonia, in the Ajmer District of central Rajasthan. The organization was founded in 1972 by Bunker Roy, a social activist and educator, with the goal of finding sustainable solutions to local rural community problems. The Barefoot College was registered as an NGO under the name Social Work and Research Centre. While the organization emphasizes service, participation, and the empowerment of local rural people who attend the college, it is also a charity and provides free services and a platform on which locals can build their skill bases (B. Roy and Hartigan 2008). The barefoot icon is symbolic of the organization's focus on everyday skills that people in villages have—skills that typically go unrecognized and underused (O'Brien 1998). The first known collaboration between the Barefoot College and Rupayan Sansthan was in 1984, when a collaborative folk festival called Lok Utsav (folk festival) was presented. Following this, a number of performances, camps, and visits by Manganiyar musicians took place on the campus. These visits have been documented through audio and video recordings that are held in the college's archives. The archives also include a collection of surveys given to Manganiyar musicians in 1993 that detail villages' access to and use of certain resources, access to water and medical services, and crop growth (B. Roy 2012).

Uttari Rajasthan Milk Union Limited Trust represents a group of organizations under one roof working toward social and economic change in the Thar Desert. Originally a dairy collection and distribution organization spread out over six

villages in Bikaner District, it was founded by Sanjoy Ghose, a Bengali rural development organizer and activist. In the early 1990s, Uttari Rajasthan Milk Union Limited started a communications (*sanchar*) team made up of musicians and puppeteers who traveled with community health education teams to villages throughout the Thar Desert to promote and educate people about public health through the performance of dramas, puppet shows, songs, and plays (Ghai and Kumar 2008). As the group of musicians and puppeteers became more formalized, it came to be called Gaavaniyar, a name translated into English for me by a member of the group as "one from the village." However, he also noted that it is a play on the name Manganiyar, whose members he called "the most famous musicians in the Thar Desert."[1] A number of Manganiyar musicians noted Gaavaniyar as a model for their own organizations because of its combination of cultural activism, music making, and touring. The most famous musician to come out of the Gaavaniyar collective has been Muktiyar Ali.

The Jaipur Virasat Foundation is a Rajasthan-based multidisciplinary non-profit trust founded by John and Faith Singh, and dedicated to the conservation of Rajasthan's cultural and built heritage. The foundation was registered in 2002 as an Indian trust with the Prince of Wales as its international patron and in collaboration with UNESCO. More than thirty years prior to establishing Jaipur Virasat Foundation, the Singhs founded Anokhi in Jaipur in 1970 as an artisan-based wooden hand-block printing and natural dye business and clothing label. Anokhi's work with and investment in local artisans not only spurred a worldwide fashion trend of this kind of collaborative entrepreneurship, but revived the rapidly declining local tradition of natural dyed wood-block printing. Anokhi became an internationally recognized name, and the Singhs hoped to create a parallel business in collaboration with local artisans. Jaipur Virasat Foundation works creatively with people from traditional cultures to promote inclusive and sustainable development and support cultural diversity. Its mission is to create a bridge between traditional India and the new fast-emerging India that will benefit people with traditional skills and knowledge. Jaipur Virasat Foundation believes that people's skills can be applied in ways that work in modern life to provide new opportunities for livelihoods, the conservation of cultural heritage, support of cultural diversity, and inclusive and sustainable development.

In the early 2000s, the Singhs expanded Jaipur Virasat Foundation to include John Singh's personal interest in music and support of traditional musicians in Rajasthan through activities, events, advocacy forums, and networks. In the 1990s until Kothari's death, John Singh worked closely with Kothari, getting

to know the musical landscape of the Thar Desert. Jaipur Virasat Foundation's work with Rajasthani musicians was no doubt influenced by Rupayan Sansthan.

There are a number of festivals that have been organized by Jaipur Virasat Foundation, including the Rajasthan Festival, Jaipur Heritage Festival, and Rajasthan International Folk Festival, known as RIFF. Begun in 2007, RIFF is run in coordination with the Mehrangarh Fort Trust in Jodhpur and features regional, national, and international music performances in the picturesque Mehrangarh Fort. In addition, a number of smaller festivals have popped up throughout Rajasthan. While they are not affiliated with Jaipur Virasat Foundation, they have no doubt been influenced by that organization. Before the Covid-19 worldwide pandemic, the number of such festivals increased every year, with increasing diversity in theme and featured musical repertoire. The one constant was the participation of Manganiyar musicians. Their strategic resilience allows them to perform and collaborate whatever the occasion or theme. The privately funded festivals held annually in Rajasthan include the World Sufi Festival (in Jodhpur, established in 2007), Shekhwati Utsav Momasar (Momasar, 2011), Kabir Yatra (varying annual locations, 2012), Magnetic Fields (Udaipur, 2013), Flamenco and Gypsy Festival (Jodhpur, 2014), Ragasthan Festival (Jaisalmer, 2016), Udaipur World Music Festival (Udaipur, 2016), Taalbelia (Mandawa, 2017), and Ranthambore Music and Wildlife Festival (Ranthambore, 2019).

NOTE

1. Lal Khan personal communication, September 10, 2006.

NOTES

INTRODUCTION *Musical Resilience*

1. Sati refers to the immolation of a widow on her husband's funeral pyre. Although the practice is illegal, there were reported cases of sati in Rajasthan State through the 1980s. Historically among upper-class Hindus in western Rajasthan, immolated widows became sati and were worshipped as goddesses, known as *sati mas*. Rani Bhatiyani is one sati ma contemporarily worshipped in the Thar Desert. See Chaudhuri 2009 and Trembath 1999 for the historical ties and spiritual relationship between the Manganiyar community and Rani Bhatiyani.

2. The Hindu Dholi are a community of hereditary musicians similar to, but with a slightly higher social status than, the Manganiyars due to their being Hindu rather than Muslim.

3. Anonymous Manganiyar interlocutor, personal communication, June 15, 2019.

4. Bax Khan, personal communication, June 14, 2019.

5. The Marwari language and its dialects are spoken in western Rajasthan and eastern Sindh, in Pakistan. Marwari is related to other languages spoken in neighboring regions, namely Sindhi, Gujarati, and Rajasthani. The language is associated with the Marwari ethnic group whose members are originally from the Thar Desert region but migrated to other parts the Hindi Belt in the past two centuries.

6. Ghewar Khan, personal communication, August 10, 2003.

7. Here I am thinking of music as a tool to negatively shape social behavior (Turino 2009), incite violence, and serve as torture (Cusick 2016).

8. The following authors have made the same point outside the realm of music studies: Katrina Brown 2016; Jentoft 2007; Olsson et al. 2015.

9. The Manganiyar community is an endogamous community who marry through complicated networks of village and ancestral connections. *Khandan* (family) refers to the immediate Manganiyar family and lineage. Their subcaste designation, *nakh*, refers to extended family lineages within the Manganiyar community. The nakh name is added

to the end of a musician's name for easy identification and is sometimes called *khamp*. According to Ghewar Khan, there are over twenty Manganiyar nakhs. Manganiyars are not allowed to marry someone within their nakh. There are a number of nakhs that comprise the next larger community grouping, *khatmebhai*, which is based on a village's location. Each khatmebhai contains at least twelve Manganiyar families living in nearby villages. A Manganiyar family invites those families within their same khatmebhai to all social and religious functions. *Biradari* refers to the larger community circle within which marriages can be arranged.

10. In his narrative, Burton recounts a story of one he calls a Manganhar minstrel. The minstrel was consulted by the Sumra chiefs of the Sind region, who were in power until the middle of the fourteenth century. Thus, based on oral tradition, the Manganiyar community goes as far back as the fourteenth century (Burton 1877, 142).

11. For example, as early as the seventeenth century, Fray Sebastien Manrique wrote of the singing, dancing, and entertainment provided to travelers who stopped in Jaisalmer (Dodwell 1929). These unnamed performers could very well have been ancestors of today's Manganiyar community.

12. There are approximately 524 villages in western Rajasthan that are inhabited by Manganiyar families (Neuman and Chaudhuri, with Kothari 2006, 163). The number has not changed significantly since this research was done in the 1990s.

13. The Kalakar Colonies in Barmer and Jaisalmer were established by the Rajasthan government and were originally conceived of as temporary land for itinerant performance communities, but both have become permanent neighborhoods.

14. Because of postindependence reconfigurations and changing support systems at the state level, most of the Manganiyar community now live in India rather than Pakistan. Since the 1971 Indo-Pakistani War, Manganiyar musicians have found it difficult to cross the international border, since doing so now requires a passport and visa. I therefore refer to the region inhabited by the Manganiyar community as western Rajasthan (the portion of the Thar Desert in India), although history and imagined community through music expand out from this closely delimited political region.

15. One of the major differences between the Manganiyar and the Langa communities are their jajmans. While Manganiyar jajmans are mostly Hindu, Langa jajmans are Muslim. This has led to differences in musical repertoire, instrumentation, performance contexts, and power dynamics between jajmans and musicians.

16. Although scholarship about Manganiyar music and older Manganiyar musicians use this terminology to categorize their repertoire, none of my younger interlocutors used these terms.

17. Komal Kothari gives the names of each genre of song and the specific event within a jajman's wedding (1994, 218–19). Komal Kothari's son, Kuldeep Kothari told me that there

are songs sung by Manganiyar musicians for every small ritual, including the sewing of the bride's and groom's clothing.

18. Rana Khan divided mota git into four additional subcategories: *bhakti* (Hindu devotional songs), *sringar* (joyful songs having to do with love and beauty), *veer* (songs of bravery concerning maharajas and battles), and *shenihar* (songs sung about specific ragas).

19. In conversation, Manganiyar musicians often compare their music with Hindustani classical music. The Manganiyars generally theorize their musical repertoire into two distinct categories: "in raga" and "out of raga." This classification is not so much in relation to musical modes (as is the case in Hindustani classical music) as it is in relation to what they call *chello*, which are musical phrases unique to certain ragas. Like Hindustani classical music, ragas within the Manganiyar repertoire embody certain moods and are to be performed at certain times of the day; they can also be seasonal. However, unlike Hindustani classical music—in which the *rasa* (feeling) is communicated mainly through melodic scale, combinations of notes, and microtonal variations, Manganiyar ragas convey rasa through dohas. This was made apparent to me when Manganiyar musicians initially had difficulty demonstrating certain ragas in performance but were able to recall that raga after reciting its dohas. In other words, Manganiyar do not conceptualize ragas in the abstract but in the context of stories and texts (see Ayyagari 2013). Each doha is generally fixed and has been passed down from father to son. However, the singer can choose which lines of text he sings and in which order. After the dohas, the git begins. In the git, which consists of verses with repeated refrains, there is less improvisation. This section is also metered and is accompanied by a drum (usually a dholak).

20. Sarwar Khan Merasi, personal communication, February 17, 2006.

21. For example, in Jaisalmer District there is widespread consumption of music from Sindh, which creates a musical borderland. While there is evidence that cassette tapes have been smuggled across the border (Manuel 1993; Schaflechner 2018), it can be assumed there is even more cross-border consumption now, with greater access to digital music and online performances. Television shows like *Coke Studio Pakistan* have increased interest in Sindhi Sufi music in India.

22. Some Manganiyar musicians have told me that the name Manganiyar comes from *mangalhar* (auspicious necklace) and refers to the jewelry given to musicians by their jajmans for their performances.

23. The term "Dalit" has its origins in the Hindu caste system. It refers to the lowest caste, the untouchables. The term is used today to describe a large group of diverse low-caste communities in India. The government uses the census term "Scheduled Castes" to describe Dalits.

24. Burton conflates the names Langha and Manganhar, viewing them as referring to the same community. Nazir Jairazbhoy disputes this conflation and assumes that Burton

was mistaken (1980, 101). While the contemporary Langa and Manganiyar communities are distinct from each other in terms of their cultural practices and patronage, there is evidence that the two were historically one community (Neuman and Chaudhuri, with Kothari 2006, 218–20).

25. Because of the egalitarian nature of Islam and its eschewing of hierarchical caste relations, many Hindu communities on the subcontinent have at different times in history converted to Islam.

26. Several Manganiyar musicians have recounted to me stories about their ancestors performing in Hindu temples, where they touched the animal skin of a drum and therefore had to convert to Islam. Others have told me stories about performing in Mughal and regional Muslim courts and having to cut off relations with Hindu caste mates due to these close relations with Muslims in court settings.

27. Manganiyar attempts to improve their social status can be described using either Narasimhachar Srinivas's (1966) concept of Sanskritization (the upward mobility of lower-caste Hindus) or the concept of Ashrafization (adopting names and titles or other social and ritual practices from higher-status communities and retelling histories and genealogies). Both Sanskritization and Ashrafization took place after independence and Partition, when groups saw opportunities for change that helped facilitate the embodying of new identities. These practices should not be confused with the acculturation that occurred between Islam and Hinduism through the mingling of Sufi and Bhakti religious practices.

28. Music is not considered antithetical to the kind of Islam that most members of the Manganiyar community practice. However, Komal Kothari noted that several musicians from the neighboring Langa community gave up singing under the influence of the Pir of Pagaro yet were still entitled to receive presentations or offerings from the patron (Bharucha 2003, 219). I have heard similar secondhand stories about Manganiyar musicians giving up musical performance in the name of Islam and turning to nonmusical occupations like carpentry, driving, and manual labor.

29. I have been told by several Manganiyar musicians that Deobandi fundamentalist Islam, brought to the Thar Desert region through madrassas, has started to spread in the Manganiyar community among the younger generation, some members of which are abandoning music as a profession due to its *haram* (forbidden) nature.

30. This may be more a result of changes in musical taste, the influence of Bollywood, and international trends than a result of Islamization.

31. Peter Manuel claims that Indian patronage has tended to transcend sectarianism (1996, 123). Conversion to Islam has been identified by other scholars as an adaptive strategy of musical resilience—a way for musicians to expand their range of employment possibilities to Muslim patrons (and postpatrons) while still holding onto their Hindu patrons (Jairazbhoy 1977, 65).

32. This was made easier when land was given to musicians and other members of artist

communities in what are today called Kalakar Colonies (which have been established in both Jaisalmer and Barmer Cities).

33. Many Manganiyar musicians claim that the women in their community have never worked. This is most likely indicative of recent transformations in caste and religious narratives centered on gender practices and may be a part of upward mobility narratives according to which Manganiyar musicians emulate their jajman, whose Hindu Rajput wives do not work outside the home. This could be considered a form of Sanskritization, where a low-caste group changes their lifestyle in an act of upward mobility (Srinivas 1966).

34. This is not necessarily uncommon. Songs from the Bhakti tradition that recount Radha's devotion for Lord Krishna and are sung by men are often from the viewpoint of women. A similar tradition can be heard in the Sindhi Sufi repertoire, where male musicians sing of their love of and devotion to God from the viewpoint of a woman (Bond 2020).

35. Temples and shrines seem to be exceptional contexts where some Manganiyar women do sing publicly, although the singers tend to be older women, and most of them are widows.

36. I speculate that Mai Dhai is an anomaly among women Manganiyar public performers in Pakistan, as Rukma Bai was in India. However, more research needs to be done on the role of traditional patronage, governmental endorsement, and cultural support of Manganiyar artists in the Tharprakar Desert region in Pakistan. It may have been easier for Manganiyar women to perform publicly in Pakistan than in India, due to an even greater loss of traditional patronage.

37. *Rupayan* translates to giving shape or form to something and *sansthan* translates to organization or institute.

ONE *(Post)Patronage*

1. Among the many honors Sakar Khan received for his musical talent were the Sangeet Natak Akademi Award (1991) from the Indian government and the Padma Shri (2012), the highest possible civilian award awarded by the Indian government.

2. Sakar Khan, personal communication, January 3, 2012.

3. Patronage has a long history in South Asia, rooted in religious notions of kingship and other kinds of sovereignty. In medieval India, Hindu kings used religious and cultural patronage to tie themselves to divine sovereignty and gain increased authority (Aquil 2020; Raheja 1988). Later, during sultanate and Mughal rule, Islamic rulers turned to patronage as a key way to consolidate their presence on the predominantly Hindu subcontinent and establish the legitimacy of Islamic rule.

4. I choose to not use the term "jajmani system" to describe the relationships Manganiyars have with their patrons, due to its power-laden anthropological genealogy. However,

I do use the term "jajman" interchangeably with "patron," because the former is the term Manganiyar musicians use to refer to their patrons.

5. I am referring specifically to patronage of music, and mostly to that of Hindustani classical music. The term "patronage" is sometimes used in the South Asian context more generally to refer to services provided in caste-specific contexts outside of the arts.

6. Other possible castes or communities were included in kasabis, such as *suthars* (carpenters), *hauzurias* (illegitimate children of Rajput men), *khawas* (barbers), *Meghwals* (leather workers and herders), *Darjis* (tailors), *Bhils* (watchmen), and *Lohars* (metal workers).

7. For example, Sakar Khan told me that it was Hamir Singh, a jagirdar and younger brother in the Jaisalmer royal family, who settled Hamira Village along with his kasabi families. Many descendants of the original kasabi settlers remain in Hamira Village and were Sakar Khan's jajmans (after Sakar Khan passed away, his jajmans were divided among his four sons). Those who have moved away from Hamira Village are still considered Sakar Khan's patrons. Khete Khan, one of Sakar Khan's nephews, told me about a performance tour in the United Arab Emirates, where he visited a jajman who had left Hamira Village many years before to settle abroad. Khete Khan was paid by the jajman for his reciting of his family's shubhraj.

8. To get a sense of how long this has been going on, according to Sakar Khan, his family settled in Hamira Village five generations before his career there as a village musician for his jajman.

9. Scholars of Rajasthan have coined the term, "Rajputization" (Sinha 1962) in direct relationship to "Sanskritization," a term coined by Narasimhachar Srinivas. Srinivas later claimed to have put too much emphasis on Brahminical caste status as a goal, but the term is still often used to describe general caste mobility in South Asia.

10. The Rajputs are generally thought to be divided into three broad groups or clans: the Suryavanshi lineage (allegedly descended from Surya, the sun god), the Chandravanshi lineage (descended from Chandra, the moon god), and the Agnivanshi lineage (descended from Agni, the fire god). In western Rajasthan, the Rathors (Suryavanshi) and Bhati (Chandravanshi) dominate (Kothiyal 2016). Jaisalmer City was founded by the Bhati Rajput clan, and the Jaisalmer royal family still consists of descendants of this Bhati Chandravanshi lineage.

11. Princely state privileges included privy purses (perhaps the most important privilege that affected patronage), royal titles, and other rulers' privileges.

12. I have met Manganiyar musicians with as few as five patron families and those with as many as a hundred.

13. There are four branches of the Alamkhana, categorized by *nakh*. While these differentiations no longer have any significance in the royal court, they determine marriage

and familial relations: *Mir,* belonging to the *Dagga jati,* accompanied royal soldiers into battle and sang songs of bravery and rituals. They also alerted the city to invasions and battles by playing *dagga,* a large stationary kettle drum played in pairs; *Nagarchi,* belonging to the *Gela* jati, played *nagara,* a small kettle drum usually played in pairs while processing in festivals; *Bhand,* belonging to the *Dedhra* jati, played *shehnai,* a wooden double-reeded wind instrument, and provided entertainment inside the courts; and *Chandani,* belonging to the *Kaalet* jati, played the dhol in royal court celebrations. Sarwar Khan, a musician, told me that this last group is said to have moved to Hyderabad, in Pakistan, after Jaisalmer's merger into Rajasthan State.

14. For example, once a year during the season of *bhado* (in August–September), a jajman will give his Manganiyar payment called *bilona,* which consists of the total milk produced in one day from the jajman's livestock (cows, goats, sheep, and camels) in the form of ghee. The Manganiyar musician can choose to receive this payment in the form of ghee or may take money instead. Manganiyars also receive a share of sheep's wool that is shorn at certain times of the year, called *joti.* And a Manganiyar is entitled to a certain share of crops by weight directly from the field, a payment called *jholi* that depends on the yearly yield and the economic position of the jajman. The importance of landownership is also reflected in the Manganiyar repertoire, much of which focuses on ideas of landownership, animal husbandry, and agrarian cycle celebrations like Akhatij, an annual spring harvest festival.

15. I witnessed an example of a Manganiyar family using this form of private insurance in 2011, when one of my musician interlocutors needed a kidney transplant. Money was needed not just for the surgery but also for the months of aftercare for the patient in Delhi; medical treatment for his wife, who donated the kidney; and lifelong sustained care and medication. The musician's jajman provided some of the funds that were raised for the successful procedure and its aftermath.

16. Gazi Khan Harwa, personal communication, October 14, 2008.

17. Anonymous jajman, personal communication, November 6, 2019.

18. I witnessed instances where this was all show. The jajman and the musician know the truth, but they all still put on an act.

19. While *talaq* (divorce) between a Manganiyar and his jajman has been described as a viable way for musicians to protest crimes or mistreatment by a jajman, I have never heard about talaq happening.

20. Musical refinement is put on display at jajmans' functions in a variety of ways. One way is for a jajman to demonstrate his musical acumen by playing the game of *kankari* with his Manganiyar. In kankari, a Manganiyar musician hides an object and then directs his jajman to the object by playing only ragas that are associated with the cardinal directions. The musician must be able to skillfully transition from one raga to the next on his

kamaicha. Likewise, the jajman must be able to deduce the raga being performed just by hearing its musical characteristics, translate that raga to the cardinal direction, and locate the object (Kothari 1994, 220–21; Ayyagari 2012).

21. Most of this narrative has been pieced together from conversations with Kuldeep Kothari, Shubha Chaudhuri, and various Manganiyar musicians.

22. The Kothari family owns the Patrika Group, which publishes the *Rajasthan Patrika* (magazine), a nationally read Hindi daily newspaper. Komal Kothari's early education and training were in Hindi literature, which he used during India's struggle for freedom as a young author of Hindi-language pamphlets issued by the Indian National Congress Party.

23. In Calcutta, Marxism was centered in the urban, upper-caste, Hindu, middle-class communities, or Bhadralok (Ghosh 2006). The Bhadralok founded organizations like the Progressive Writers and Artists Association and the Indian People's Theatre Association, which had as their aim the propagation of Marxist ideals and broader postcolonial cultural awakening.

24. Kuldeep Kothari, personal communication, August 14, 2012.

25. According to Kothari, many artists who were then little known performed at this concert and became well-known. For example, Kothari invited Gavari Bai to perform for the first time on stage at the concert. She went on to receive two Sangeet Natak Akademi Awards in Folk Music, in 1976 and 1986.

26. It was during this time that AIR became one of the main avenues for new national governmental curation, dissemination, and promotion of regional, nonclassical artists as part of a larger mission to create a national identity (Fiol 2012, 267).

27. Kuldeep Kothari, personal communication, August 14, 2012.

28. In addition to his own extensive work and his collaborations with scholars, he taught at the University of California, Berkeley for one semester as a visiting scholar.

29. Rupayan Sansthan began coordinating an archive of audio and video recordings in 1964 with the help of the international scholars Deben Bhattacharya and Genevieve Dournon. The archive today contains over seven thousand hours of audio and video recordings, a library, an extensive instrument collection, and various other objects of interest to the organization.

30. His representative publications include Kothari 1972, 1982, 1989, 1990a, 1990b, 1994, and 2004; and Neuman and Chaudhuri, with Kothari 2006.

31. Detha went on to win numerous awards for his writing and promotion of Rajasthani literature, including the Sahitya Akademi Award for Rajasthani (1974) and the Padma Shri (2007).

32. Mame Khan, personal communication, January 12, 2019.

33. *Coke Studio* is a popular music-based reality television series and online platform hosted by YouTube. It features live and studio-recorded collaborative performances by various artists backed by a house band. Started in 2007 as a Brazilian show, it spread to

various countries around the world, including India in 2011 (for an analysis of *Coke Studio India*, see Williams and Mahmood 2019).

34. Mame Khan, personal communication, January 12, 2019.

35. The Wishberry campaign sought to acquire 250,000 rupees, or approximately $3,500, for recording, mixing, and mastering the album. Contributions started as low as 200 rupees (approximately $4). According to Mame Khan, he received 30 percent more than the target amount after only twenty days.

36. Ibid.

37. Mame Khan won a Global Indian Music Academy award for the best folk single for "Saawan" in 2015.

38. Sakar Khan, personal communication, January 5, 2012.

TWO *Performance*

1. The Padma Shri Award is the fourth highest civilian award in India, given in recognition of a distinguished national contribution.

2. Rooted in dominance and subordination, subalternity centers the histories of those who have been silenced and are not represented in dominant historical narratives. Subaltern historiography appeals to experience as evidence for agency that can be expressed through counter- and alternative histories (J. Scott 1990, 7).

3. One of the first documented uses of the term "Indo-chic" was in 1997 in the *New York Times*. Saadia Toor (2000, 3) traces the term back to 1952, when it was used by the postindependence Indian Handicrafts Board, which aimed to stimulate the appreciation, support, and revival of Indian handmade clothes and crafts through urban upper-class consumption.

4. One of the best-known examples of Indo-chic is Bina Ramani's 1987 transformation of Hauz Khas Village, on the outskirts of Delhi, from a small village to a bustling couture fashion market and community. Ramani crafted an urban and international style that drew inspiration from the village attire (Tarlo 1996, 296).

5. Kothari ensured that Manganiyar musicians shared programs in India and abroad with Hindustani classical musicians to demonstrate that the formers' professionalism and quality of musical performance were on par with those of the latter. Since Kothari's death, numerous Manganiyar musicians have continued to collaborate, perform, and tour with Hindustani classical musicians like Vishwa Mohan Bhatt (Mohan veena player) and Zakir Hussain (tabla player).

6. Most of this narrative has been pieced together from conversations with Kuldeep Kothari, Shubha Chaudhuri, and various Manganiyar musicians.

7. Kothari was recognized for his contributions to Rajasthani and Indian culture throughout his later life. He received numerous awards, including a Nehru Fellowship

(1977–79); the Padma Shri Award, a national award presented by the president of India (1983); a fellowship at the National Sangeet Natak Akademi (1986); the Hakim Khan Suri Award, awarded by the Mewar Foundation, in Udaipur (1989); the Fie Foundation Award (1990); the Shrthi Mandal (1992); and the Padma Bhushan (2004).

8. Kothari worked with only a select group of Manganiyar musicians. According to two musicians from the Alamkhana subcaste, he had a falling out with Alamkhana musicians. They told me that due to the Hindustani classical influences on their court music, Kothari did not consider their music traditional enough for staged performances. This classical influence may have originated in connections and interactions with musicians from other courts in Rajputana before independence (Ayyagari 2012, 11). Musicians from the Alamkhana generally do not speak fondly of Kothari, since he did not give them the same performance opportunities that he afforded to other Manganiyar musicians.

9. Anwar Khan Baiya, personal communication, July 23, 2016.

10. Ibid.

11. Chanan Khan, personal communication, July 17, 2012.

12. The musical technique of sawal-jawab as practiced in the Hindi Belt refers to a musical conversation between two different instruments. While sawal-jawab is sometimes referred to as call-and-response, call-and-response can include more than two instruments.

13. Kothari's feelings about the harmonium may have stemmed from a larger national project of banning the harmonium on All India Radio for its foreign origin and imperial associations (Matthew Rahaim 2011).

14. It is not clear whether Manganiyar women's keeping purdah was influenced by increasing Islamization in the region or by Rajputization, in which musicians emulated their Hindu Rajput jajman's practice of keeping women at home.

15. Susanne and Lloyd Rudolph, personal communication, October 10, 2007.

16. According to Lloyd and Susanne Rudolph, Major General Raja Bahadur Thakur Amar Singh of Kanota was the commander in chief of the Jaipur maharaja's army and the first Indian to serve as a British army officer in World War I. The Jaipur royal family granted him land, on which he built the Narain Niwas Palace as his country resort in 1928. His nephew, Mohan Singh Kanota, inherited the palace and worked closely with the Rudolphs in publishing his uncle's extensive diaries. He is credited with converted the palace into a heritage hotel.

17. While heritage tourism was the first brand of tourism in Rajasthan, with cultural tourism closely connected to it, many other brands of tourism have become popular there in recent years—including adventure, ecology, spiritual tourism. In addition, Rajasthan has been become to be a go-to location for shopping, conferences, and exhibitions.

18. See Government of Rajasthan 2022 for a typical Rajasthan State government sponsored tourism advertisement campaign that leaves out the lived realities of Jaisalmer City.

19. This festival emerged as a result of conversations between the President Ronald Reagan of the United States and Prime Minister Indira Gandhi of India in 1982, when the United States was pushing India to become part of the global market as a way to move India away from its alignment with the Soviet Union (R. Brown 2017, 214). India was redefining itself as a tourist and trade destination. The Festival of India, then, can be read retrospectively as foreshadowing India's 1991 economic deregulation and liberalization.

20. JVF was registered as a trust in India in 2002, with the Prince of Wales as its international patron.

21. Faith Singh, personal communication, December 2, 2018.

22. www.jaipurvirasatfoundation.org/ (Accessed January 2022).

23. Not a member of the Manganiyar community. Abel is an internationally known playwright from Kerala, India. After graduating from the Indian National School of Drama, he apprenticed with the Royal Shakespeare Company in London and founded the Indian Shakespeare Company in 1995. He quickly moved on from traditional Shakespearean productions, using Indian street performers (magicians, jugglers, acrobats, puppeteers, and musicians) in some of his first original works. It was this early work that informed the casting for "The Manganiyar Seduction." Now based in Delhi, Abel has written, produced, and directed a plethora of theatrical productions, many of which feature Manganiyar musicians.

24. In the summer of 2006, after the premier, Abel took the group and production on tour to various large cities throughout India. In 2008, the group toured Europe, with the climax of the tour being a concert at Villa Adriana in Tivoli, Italy. Since 2009, the group has toured various world cities almost every year, having performed at several international theaters and festivals. The production has been featured in the Perth International Arts Festival, Sydney Festival, Maximum India Festival (in Washington, DC), World of Music, Art and Dance Festival, and most recently the Lincoln Center's White Light Festival in New York in 2019, before going on hiatus due to the Covid-19 pandemic.

25. Roysten Abel, personal communication, January 12, 2009.

26. Ibid.

27. In Rajasthan, purdah has historically been practiced by both Hindu and Muslim women. The word literally means "curtain," and purdah is a figurative curtain that sharply separates the worlds and spaces of men and women, the street and home, and the public and private (Guindi 2003, 9–11). In 1940, Rajmata Gayatri Devi became the first woman from the Jaipur royal family to stop keeping purdah.

28. Jaipurites have told me that the Hawa Mahal was designed to resemble the Hindu Lord Krishna's crown of peacock feathers. In India the peacock has long been a symbol of romantic love in Hindu mythology, iconography, and *bhajans* (religious songs).

29. When the production is staged in Muslim countries, the word "seduction" is dropped from the title and it is called "Manganiyar Connection," to remove the sexual connotations of the production.

30. However, in its first few incarnations, the performance featured Rukma Bai, one of the few Manganiyar women who performed publicly.

31. The word "tihai" refers to a rhythmic or melodic phrase that lasts a certain number of beats and is repeated three times, with the last iteration ending on beat one of the fixed rhythmic cycle of the piece of music. The term is often used in classical Hindustani music. It is not clear if the word was borrowed from Hindustani music or has its roots in Manganiyar music.

32. Chuga Khan Hamira, personal communication, June 23, 2016.

33. Mame Khan, personal communication, January 12, 2019.

34. Roysten Abel, personal communication, January 12, 2009.

THREE *Development*

1. Gazi Barna, personal communication, August 28, 2006.

2. Gazi Barna, personal communication, August 30, 2006.

3. Only cases of malaria and chikungunya were reported in the region in the months after the floods.

4. Anonymous Manganiyar interlocutor, personal communication, October 23, 2006.

5. Second anonymous Manganiyar interlocutor, personal communication, October 23, 2006.

6. Khuri is a surprisingly bustling village during the winter months, when tourism—the main seasonal support for the local economy—booms. Its proximity to Jaisalmer City, the well-established road leading to it from the city, and its location forty-eight kilometers south of the city rather than to the west (toward the Pakistan border, which is off limits to foreigners) make it easy for tourists to access.

7. Thanu Khan, personal communication, September 27, 2006.

8. My narrative starts here, but it is important to acknowledge that much of the development studies literature wrongly emphasizes 1945 as the beginning of development in postwar India (Farrington, Bebbington, and Lewis 1993; Fisher 1997). Using 1945 as a starting point for a development narrative in postcolonial India is misleading because it does not account for the colonial legacy of development and social transformations that began long before independence (Pandian 2009, 8). In addition, using 1945 as a starting point relies on a Western-centric narrative that puts institutions like the World Bank and the International Monetary Fund, as well as the Bretton Woods agreement, at the center of a teleological narrative, undermining other historical narratives and paths to development.

9. For nuanced discussions of feudalism under the jagirdari land tenure in Rajasthan, see A. Gold and Gujar 2002; Levien 2018.

10. In popular culture studies of contemporary India, liberalization is often depicted in a positive light due to the increase in the production of music and films (Beaster-Jones 2011; A. Roy 2020; Sarrazin 2014).

11. There is significant overlap in the meanings and actions of NGOs, civil society organizations, and community-based organizations, which are sometimes used interchangeably in everyday language.

12. There was an increase in citizen engagement that resulted in the flourishing of civil society organizations such as the URMUL (in Bikaner), Social Work Research Centre (in Ajmer and Tilonia), Gramin Vigyan Vikas Samiti (in Jodhpur), and Sewa Mandir (in Udaipur). These organizations were initially established to complement the welfare state's delivery of public services, but in recent decades they have broadened their focus to become important partners in implementing projects for international aid and other organizations working in the development sector in Rajasthan. These organizations have become so successful that they are now influencing national legislation. For example, the 2005 National Right to Information Act was shaped by the Mazdoor Kisan Shakti Sangathan, a spin-off group of the Social World Research Center near Ajmer, in Rajasthan.

13. Rajasthan was considered to be a late democratizer and backward state, lagging behind other states in development-measured indexes like poor maternal and infant health and literacy rates (Government of Rajasthan 2002). In Jaisalmer District, the number of NGOs or similarly structured organizations went from fewer than ten to over two hundred in just a few years (Meena 2020). The reasons for this proliferation at that time are complex, related to neoliberal practices' finally being absorbed in rural contexts and various other interlinking social, commercial, environmental, and governmental factors that coalesced because of improvements in overland transportation and access to technology, cultural tourism, and various state initiatives that promoted development.

14. Although PLSS is not currently functioning, it is still an important case study for examining Manganiyar development imaginaries.

15. Gazi Barna, personal communication, January 5, 2005.

16. Ibid.

17. I speculate that Gazi Barna's innovative Desert Symphony inspired the internationally successful "The Manganiyar Seduction," a production by Roysten Abel discussed in chapter 2, through its production values and large ensemble of Manganiyar musicians.

18. Gazi Barna, personal communication, June 6, 2008.

FOUR *Politics*

1. Lok Sabha elections to India's lower house of Parliament take place every five years. The 2014 elections were the sixteenth in India's history.

2. Khete Khan, personal communication, June 16, 2013.

3. Khete Khan, personal communication, April 1, 2014.

4. As defined by the Kaka Kalelkar Commission, the First Backward Classes Commission, the Other Backward Class (OBC) category is made up of those citizens who have been affected by "ideas of ceremonial purity, restriction on inter-caste marriages, taboos on food and drink, social segregation and feeling of caste loyalty and superiority, all of which have contributed to the backwardness of a large number of communities in Indian society" (Rana 2008, 101). OBCs are different from scheduled castes (SCs) and scheduled tribes (STs) because members of OBCs, while socially and educationally disadvantaged, supposedly do not suffer from the same degree of social deprivations and untouchability as members of SCs and STs. While government reservations for SCs and STs were put into place to end centuries of discrimination, provisions for OBCs are meant to remove social and educational handicaps and secure adequate representation in government services (ibid., 102).

5. The Muslim community remains deeply divided in its views of the reservation system. Many Muslims believe that being forced to fit into a caste-based system is discriminatory to begin with. To complicate matters, Muslims have not been differentiated into appropriate subcommunities through this system (Vatuk 1996).

6. This can be seen in the aspirational practices of the Manganiyar community, which include dress (both men and women), the foods they eat, and various other cultural practices.

7. The Barmer Lok Sabha constituency (the second-largest in the country) covers the following eight geographical segments: Barmer, Baytoo, Chohtan, Gudha Malani, Jaisalmer, Pachpadra, Sheo, and Siwana, all located in Jaisalmer and Barmer Districts.

8. Nationally, there were 814 million registered voters, 554 million of whom voted, across the country. The Barmer Lok Sabha constituency experienced an increase in voter turnout from 36.57 percent in 2009 to 54.90 percent in 2014 (Basu and Misra 2014, 8). Additionally, women's voting rate increased from 55.82 percent in 2009 to 65.30 percent in 2014 (Press Information Bureau 2014). The BJP won 282 of the 543 seats in the country, a record number for the party since 1984 (Jaffrelot 2015).

9. Jaswant Singh, personal communication, March 23, 2014.

10. The BJP is closely associated with ideologies of Hindutva, as espoused by the Rastriya Sevak Sangh. Literally meaning Hinduness, Hindutva is a political philosophy that essentializes and naturalizes Hindu culture as inherently Indian through political rhetoric. While the Hindu nationalist movement has grown in number and intensity in

the past several years under the leadership of Prime Minister Narendra Modi, a member of the BJP, it has been successful in recent decades largely because it has continually been repackaged and recirculated over time in postcolonial India (A. Chatterji, Hansen, and Jaffrelot 2020).

11. In August 2014, Jaswant Singh fell and suffered a severe head injury (Manvendra Singh 2018). He remained in a coma from then until his death in September 2020.

12. According to Jaswant Singh's critics, he not only put his own legacy at stake through this political move but he also jeopardized the political career of his son, Manvendra Singh (Rashpal Singh 2014). When Jaswant Singh was ousted from the BJP, the party also suspended the membership of Manvendra Singh for assisting his father in the election (Parihar 2014a and 2014b). Ironically, a decade earlier in 2004–2009, Manvendra Singh had served as MP for Barmer District and been staunchly backed by the BJP.

13. Fakira Khan, personal communication, April 2, 2014.

14. When the daughter of a jajman marries and relocates to her husband's home in another village, the Manganiyar musician associated with her father still has rights to her as a jajman in her new village and married life. Manganiyar musicians sometimes visit the daughters of their jajmans once they have been married, perform for her, receive payment, and report back to the jajman father as to her condition and health.

15. Pir usually refers to the title for a Muslim Sufi master and is often translated into English as "saint." Because the Manganiyars are Muslim and identify as Sufi, many of them call Rani Bhatiyani a pir although she was Hindu.

16. Most of the Muslims in Jaisalmer and Barmer Districts are Sindhi Muslims. In the two districts together, there are approximately 500,000 Muslims, or 15 percent of the total population (Chandramouli 2011).

17. While scholars have argued that Muslim bloc voting in north India is a myth (Ahmad 2014), Jaswant Singh thought otherwise. The Indian Muslim population is heterogeneous, consisting of many castes and having diverse social and economic aspirations, but this does not discount the possibility of a united Muslim voting bloc in the Thar Desert.

18. Pir refers to an elder or a saint, and *pagara* refers to a chieftain's turban. The Pir Pagara is best known for the guerrilla campaign he waged against the British Raj in the 1940s. It was led by spiritual leader Syed Sibghatullah Shah Rashidi II, Pir of Pagara VI, who was hanged by the British colonial government in 1943 (Ansari 1992, 58). After independence and Partition in 1947, his son and successor as Pir Pagara, Syed Shah Mardan Shah II (1928–2012), played a central role in national politics after a controversial presidential election in 1965, when he was declared leader of the Pakistan Muslim League. His son and successor, Sibghatullah Shah Rashdi III, has been in power and an influential figure in international politics since 2012.

19. Jaswant Singh is rumored to have met with the Pir Pagara on a pilgrimage to the Hinglaj Mata temple in Sindh in 2006.

20. During his political career, Jaswant Singh held the following offices: member of the Rajya Sabha (upper house) of Parliament (1980), MP for Jodhpur in the Lok Sabha (1989), MP for Chittogarh in the Lok Sabha (1991), various offices in the national cabinet beginning in 1998 (deputy chairman of the Planning Commission of India, minister of external affairs, and minister of defense), financial minister (2002–2004), leader of the opposition in the Rajya Sabha (2004), and MP for Darjeeling State in the Lok Sabha (2010–2014) (J. Singh 2006).

21. Choudhary had left the Indian National Congress Party and joined the BJP just months before the 2014 elections. He had previously held the position of MP for Barmer as a member of the Congress Party for three terms (1996–1998, 1998–1999, and 1999–2004).

22. Jaswant Singh was outspoken in his views concerning Partition and the relations between India and Pakistan—views that supported Muslims and did not align with the BJP's predominantly right-wing conservative Hindu rhetoric. In my conversations with Manganiyar musicians before the 2014 election, many expressed appreciation for Jaswant Singh's unwavering pro-Muslim views during his lengthy political career.

23. Media technologies have featured significantly in political discourse and campaigns in India since the early 2000s, influencing the political socialization of voters and sparking online conversations and debates about politics (Bentivegna 2006; Chadwick 2009; Powell, Richmond, and Williams 2011). The use of new media technologies has been the hallmark of Indian political parties since the 2004 elections (Karan, Gimeno, and Tandoc 2009), when Indian political parties began using the internet, mobile phones, and social media to send messages to potential voters.

24. Although Jaswant Singh's campaign was run in a predominantly traditional fashion, with the candidate traveling by jeep and camel to villages for meet-and-greet sessions, campaign speeches, and interactions with his constituency, Jaswant Singh's social media presence was helped by numerous campaign team members who had previously worked on marketing for the World Bank, KPMG (an international financial and business advisory company), and Kingfisher Airlines (Sivaswamy 2014).

25. It should be noted, however, that because of processes of uneven development, women in low-caste communities like the Manganiyar often do not possess smartphones. Therefore, the increase in participation refers primarily to the participation of men.

26. The damaru drum is an instrument used in Hindu devotional music and is associated with the Hindu deity Shiva (Reck and Reck 1982, 39–40).

27. Khete Khan, personal communication, April 1, 2014.

28. Transportation songs have briefly been mentioned in other literature as a subgenre of Punjabi music but have been defined only by lyrical and subject content: "Much of [K. Deep and Jagmohan Kaur's] repertoire spoke to the so-called driver (i.e., truck, bus demographic). This subgenre remains what is played in most trucks and buses through-

out East Punjab. A common theme in the lyrics involves the interaction between a truck driver and a female hitchhiker" (Schreffler 2012, 344).

29. Jamat Khan, personal communication, April 3, 2014.

30. An example of a BJP campaign song from 2014 that demonstrates "that Bollywood sound" is "Achchey Din Aane Waley Hain" (Good days are coming our way), which was released in the 2014 electoral period.

31. "Woh Malani ro Saput Jathe" can be heard here at https://soundcloud.com/scroll-in /woh-malani-ro-sapoot-jathe.

32. "Hutata Damru Baaje, Bhule toh Pyaara Laage" can be heard at https://soundcloud .com/scroll-in/hutata-damru-baaje-bhule-toh-pyaara-laage?utm_source=soundcloud &utm_campaign=share&utm_medium=twitter.

33. One of the few contexts in which Manganiyar women openly and publicly perform music is in temples and shrines dedicated to Rani Bhatiyani.

34. The Rajasthan Vidhan Sabha, or Rajasthan State Legislative Assembly, is the sole legislative body in the state.

35. Meghwal refers to a low-caste Hindu community. Meghwals in the Thar Desert have historically been leather workers and herders. There are numerous Meghwal musicians who sing Hindu *bhajans* professionally, many of whom perform in postpatronage contexts with Manganiyar musicians.

36. While the Langa community of hereditary musicians performs exclusively for Sindhi Muslim patrons from the Sipahi community, the Manganiyar community's jajmans are predominantly Hindu Rajputs—although some are Muslim.

37. For examples of national and international coverage, see "Beggar Slur: Folk Musicians Submit Memorandum" 2019 and "Manganiyar's Tribes Stage Protest Against Cong MLA's Remarks in Rajasthan Asssembly." timesofindia.indiatimes.com/city/jaipur/beggar -slur-folk-musicians-submit-memorandum/articleshow/70268017.cms, www.business -standard.com/article/pti-stories/manganiyar-s-tribes-stage-protests-against-cong-mla-s -remarks-in-rajasthan-assembly-119071801269_1.html, and www.outlookindia.com /newsscroll/manganiyars-tribes-stage-protests-against-cong-mlas-remarks-in-rajasthan -assembly/1577898 (All websites accessed November 10, 2018).

38. The "Mahindra" in Mahindra Gunsar Lok Sangeet Sansthan refers to the Mahindra Corporation, which financed the founding of the organization. "Gunsar" refers to a *nakh* of the Manganiyar community, of which Bax Khan is a member.

39. This interview with Anwar Khan Baiya and other artists can be found here: www .youtube.com/watch?v=sZNfpOa4ZaM/.

BIBLIOGRAPHY

Ackoff, Russell. 1974. *Redesigning the Future.* London: Wiley.

Adger, W. Neil. 2000. "Social and Ecological Resilience: Are They Related?" *Progress in Human Geography* 24 (3): 347–64.

Ahmad, Hilal. 2014. "What Is Muslim Vote Bank?" *Economic and Political Weekly*, March 8. www.epw.in/blog/hilal-ahmed/what-muslim-vote-bank.html.

Ahuja, M. L., and Sharda Paul. 1992. *1989–1991 General Elections in India.* New Delhi: Associated Publishing House.

Allen, Aaron, and Jeff Titon. 2019. "Anthropocentric and Ecocentric Perspectives on Music and Environment." *MUSICultures* 46 (2): 1–6.

Allen, Aaron, Jeff Titon, and Denise Von Glahn. 2014. "Sustainability and Sound: Ecomusicology Inside and Outside the University." *Music and Politics* 8 (2): 1–26.

Ansari, Sarah. 1992. *Sufi Saints and State Power: The Pirs of Sind, 1843–1947.* New York: Cambridge University Press.

Appadurai, Arjun, and Carol Breckenridge. 1999. "Museums Are Good to Think: Heritage on View in India." In *Representing the Nation: A Reader, Histories, Heritage, and Museums*, edited by David Boswell and Jessica Evans, 404–20. London: Routledge.

Aquil, Raziuddin. 2020. *Lovers of God: Sufism and the Politics of Islam in Medieval India.* New York: Routledge.

Arendt, Hannah. 1998. *The Human Condition.* 2nd ed. Chicago: University of Chicago Press.

Arnold, Allison. 2013. *Precarious Japan.* Durham, NC: Duke University Press.

"AR Rahman: 'I Am Politically Illiterate by Choice, Rather Invest My Energy to Create What I Am Creating.'" 2020. *Hindustan Times*, February 21. www.hindustantimes.com/music/ar-rahman-i-am-politically-illiterate-by-choice-rather-invest-my-energy-to-create-what-i-am-creating/story-kVoXBnMGHydGlAG8JiImKN.html.

Ashworth, Gregory, Paul White, and H. M. Winchester. 1988. "The Red-Light District in the West European City: A Neglected Aspect of the Urban Landscape." *Geoforum* 19 (2): 201–12.

Attali, Jacques. 1985. *Noise: The Political Economy of Music*. Translated by Brian Massumi. Minneapolis: University of Minnesota Press.

Ayyagari, Shalini. 2012. "Spaces Betwixt and Between: Musical Borderlands and the Manganiyar Musicians of Rajasthan." *Asian Music* 43 (1): 3–33.

———. 2013. "At Home in the Studio: The Sound of Manganiyar Music Going Popular." In *More than Bollywood: Studies in Indian Popular Music*, edited by Bradley Shope and Gregory Booth, 256–75. New York: Oxford University Press.

Bacon, Francis, and William Rawley. 1670. *Sylva Sylvarum, or, A Natural History in Ten Centuries: Whereunto Is Newly Added, the History Natural and Experimental of Life and Death, or the Prolongation of Life*. 9th ed. London: Printed by J. R. for William Lee.

Bahadur, Aditya, Maggie Ibrahim, and Thomas Tanner. 2013. "Characterising Resilience: Unpacking the Concept for Tackling Climate Change and Development." *Climate and Development* 5 (1): 55–65.

Baho, Didier, Craig Allen, Ahjond Garmestani, Hannah Fried-Petersen, Sophia Renes, Lance Gunderson, and David Angeler. 2017. "A Quantitative Framework for Assessing Ecological Resilience." *Ecology and Society* 22 (3): 1–14.

Bahuguna, Renu. 2013. "James Tod's Portrayal of the Life and Deeds of Rana Pratap: A Critical Examination." *Proceedings of the Indian History Congress* 74: 229–39.

Bake, Arnold. 1963. "Sangeet-Shiksha-Seminar (Rajasthan Sangeet-Natak-Akademi, Jodhpur, 1960)." *Journal of the International Folk Music Council* 15 (1): 117.

Bandyopadhyay, Jayanta. 1987. "Political Ecology of Drought and Water Scarcity: Need for an Ecological Water Resources Policy." *Economic Political Weekly* 22 (50): 2159–69.

Baruah, U. L. 2017. *This Is All India Radio*. New Delhi: Ministry of Information and Broadcasting.

Barz, Gregory, and William Cheng, eds. 2019. *Queering the Field: Sounding Out Ethnomusicology*. New York: Oxford University Press.

Basu, Deepankar, and Kartik Misra. 2014. "BJP's Demographic Dividend in the 2014 General Elections: An Empirical Analysis." Economics Department Working Paper Series 172. Amherst: University of Massachusetts.

Beaster-Jones, Jayson. 2011. *Bollywood Sounds: The Cosmopolitan Mediations of Hindi Film Song*. New York: Oxford University Press.

"Beggar Slur: Folk Musicians Submit Memorandum." 2019. *The Times of India*, July 18. timesofindia.indiatimes.com/city/jaipur/beggar-slur-folk-musicians-submit-memo randum/articleshow/70268017.cms/.

Bentivegna, Sara. 2006. "Rethinking Politics in the World of ICTs." *European Journal of Communication* 21 (3): 331–43.

Berger, Harris. 2014. "New Directions for Ethnomusicological Research into the Politics of Music and Culture: Issues, Projects, and Programs." *Ethnomusicology* 58 (2): 315–19.

Bhamra, Ran, Samir Dani, and Kevin Burnard. 2011. "Resilience: The Concept, a Literature Review, and Future Directions." *International Journal of Production Research* 49 (18): 5375–93.

Bhargava, Kusum. 1972. "Rajasthan Politics and Princely Rulers: An Analysis of Electoral Processes." *Indian Journal of Political Science* 33 (4): 413–30.

Bhargava, Pradeep. 2007. "Civil Society in Rajasthan: Initiative and Inhibitions." In *Rajasthan: The Quest for Sustainable Development*, edited by Vijay Vyas, Sarthi Acharya, Surjit Singh, and Vidya Sagar, 257–82. New Delhi: Academic Foundation.

Bharucha, Rustom. 2003. *Rajasthan: An Oral History—Conversations with Komal Kothari*. New York: Penguin Books.

Bhattacharya, Sabyasachi. 1983. "History from Below." *Social Scientist* 11 (4): 3–20.

Bhattacharya, Snehashish, and Surbhi Kesar. 2020. "Precarity and Development: Production and Labor Processes in the Informal Economy in India." *Review of Radical Political Economics* 52 (3): 387–408.

Bigenho, Michelle. 2012. *Intimate Distance: Andean Music in Japan*. Durham, NC: Duke University Press.

Bloch, Peter, Frederic Brunel, and Todd Arnold. 2003. "Individual Differences in the Centrality of Visual Product Aesthetics: Concept and Measurement." *Journal of Consumer Research* 29 (4): 551–65.

Blühdorn, Ingolfur. 2009. "Locked into the Politics of Unsustainability." *Eurozine* 3: 1–8.

Bonanno, George. 2005. "Resilience in the Face of Potential Trauma." *Current Directions in Psychological Science* 6 (14): 135–38.

Bond, Brian. 2020. "Teaching Islam in Song: Storytelling and Islamic Meaning in Sindhi Sufi Poetry Performance." *Asian Music* 51 (2): 39–71.

Booth, Gregory. 2008. "That Bollywood Sound." In *Global Soundtracks: Worlds of Film Music*, edited by Mark Slobin, 85–113. Middletown, CT: Wesleyan University Press.

———. 2011. "Preliminary Thoughts on Hindi Popular Music and Film Production: India's 'Culture Industry(ies)', 1970–2000." *South Asian Popular Culture* 9 (2): 215–21.

Bracke, Sarah. 2016. "Bouncing Back: Vulnerability and Resistance in Times of Resilience." In *Vulnerability in Resistance*, edited by Judith Butler, Zeynep Gambetti, and Leticia Sabsay, 52–75. Durham, NC: Duke University Press.

Brown, Katherine Butler. 2007. "The Social Liminality of Musicians: Case Studies from Mughal India and Beyond." *Twentieth-Century Music* 3 (1): 13–49.

Brown, Katrina. 2016. *Resilience, Development, and Global Change*. New York: Routledge.

Brown, Rebecca. 2017. *Displaying Time: The Many Temporalities of the Festival of India*. Seattle: University of Washington Press.

Bulley, Dan. 2013. "Producing and Governing Community (through) Resilience." *Politics* 33 (4): 265–75.

Burton, Richard Francis. 1877. *Sind Revisited*. London: Richard Bentley and Sons.

Butler, Judith. 1993. *Bodies That Matter: On the Discursive Limits of "Sex."* New York: Routledge.

———. 2016. "Rethinking Vulnerability and Resistance." In *Vulnerability in Resistance*, edited by Judith Butler, Zeynep Gambetti, and Leticia Sabsay, 12–27. Durham, NC: Duke University Press.

Carpenter, Steve, Brian Walker, J. Marty Anderies, and Nick Abel. 2001. "From Metaphor to Measurement: Resilience of What to What?" *Ecosystems* 4 (8): 765–81.

Chacko, Priya, and Peter Mayer. 2014. "The Modi Lahar (Wave) in the 2014 National Election: A Critical Realignment." *Australian Journal of Political Science* 49 (3): 518–28.

Chadwick, Andrew. 2009. "The Internet and Politics in Flux." *Journal of Information Technology and Politics* 6 (3): 195–96.

Chakravorty, Pallavi. 2020. "Thrive with the Crowd." *Times of India*, April 23. timesofindia.indiatimes.com/business/international-business/thrive-with-the-crowd/articleshow/75313310.cms.

Chandler, David. 2014. *Resilience: The Governance of Complexity*. New York: Routledge.

Chandra, Kanchan. 2004. *Why Ethnic Parties Succeed: Patronage and Ethnic Head Counts in India*. New York: Cambridge University Press.

Chandramouli, C. 2011. *Census of India 2011: Provisional Population Totals*. Office of the Registrar General and Census Commissioner. New Delhi: Government of India.

Chari, Mridula. 2014. "Pinched for Funds, Jaswant Singh Gets Help from Unlikely Quarter: Rajasthan's Manganiyar Musicians." Scroll.in, April 17. https://scroll.in/article/661992/pinched-for-funds-jaswant-singh-gets-help-from-unlikely-quarter-rajasthans-manganiyar-musicians.

Chatterjee, Partha. 1986. *Nationalist Thought and the Colonial World*. New Delhi: Oxford University Press.

Chatterji, Angana P., Thomas Blom Hansen, and Christophe Jaffrelot. 2020. *Majoritarian State: How Hindu Nationalism Is Changing India*. London: Hurst and Company.

Chatterji, Roma. 2020. *Speaking with Pictures: Folk Art and the Narrative Tradition in India*. New Delhi: Routledge.

Chaudhuri, Shubha. 2009. "The Princess of the Musicians: Rani Bhatiyani and the Manganiyars of Western Rajasthan." In *Theorizing the Local: Music, Practice, and Experience in South Asia and Beyond*, edited by Richard Wolf, 97–112. New York: Oxford University Press.

Cherian, Anita. 2009. "Institutional Maneuvers, Nationalizing Performance, Delineating Genre: Reading the Sangeet Natak Akademi Reports 1953–1959." *Third Frame* 2 (3): 32–60.

Churchman, West. 1967. "Wicked Problems." *Management Science* 14 (4): 141–42.

Ciantar, Philip. 2016. "The Singer as Individual: Pop Singers, Music and Political Pro-

paganda in Contemporary Maltese Electoral Campaigns." *Music and Politics* 10 (1): 1–15.

Clarke, John. 2005. "Performing for the Public: Desire and Doubt in the Evaluation of Public Services." In *The Value of Bureaucracy*, edited by Paul du Gay, 211–32. Oxford: Oxford University Press.

Collins, Patricia Hill. 2016. "Black Feminist Thought as Oppositional Knowledge." *Departures in Critical Qualitative Research* 5 (3): 133–44.

Corbridge, Stuart. 2007. "The (Im)Possibility of Development Studies." *Economy and Society* 36 (2): 179–211.

Crona, Beatrice, and Örjan Bodin. 2010. "Power Asymmetries in Small-Scale Fisheries: A Barrier to Governance Transformability?" *Ecology and Society* 15 (32): 1–17.

Cumming, Douglas, Sofia Johan, and Yelin Zhang. 2019. "The Role of Due Diligence in Crowdfunding Platforms." *Journal of Banking and Finance* 108: 1–17.

Cusick, Suzanne. 2016. "Music as Torture / Music as Weapon." In *The Auditory Culture Reader*, edited by Michael Bulland and Les Back, 393–404. Oxford: Berg.

———. 2017. "Musicology, Performativity, Acoustemology." In *Theorizing Sound Writing*, edited by Deborah Kapchan, 24–45. Middletown, CT: Wesleyan University Press.

Damodaran, Sumangala. 2017. *The Radical Impulse: Music in the Tradition of the Indian People's Theatre Association*. New York: Columbia University Press.

Dean, Mitchell. 1999. *Governmentality: Power and Rule in Modern Society*. London: Sage.

Deaville, James. 2015. "The Sound of Media Spectacle: Music at the Party Conventions." *Music and Politics* 9 (2): 1–24.

DeNora, Tia. 1991. "Musical Patronage and Social Change in Beethoven's Vienna." *American Journal of Sociology* 97 (2): 310–46.

Desai, Vandana. 1996. "Access to Power and Participation." *Third World Planning Review* 18 (2): 217–42.

Desai-Stephens, Anaar and Nicole Reisnour. 2020. "Musical Feeling and Affective Politics." *Culture, Theory and Critique* 61 (2-3): 99–111

Dhabhai, Garima. 2020. "Paramount State and the 'Princely Subject': Privy Purses Abolition and Its Aftermath." In *Dimensions of Constitutional Democracy*, edited by Anupama Roy and Michael Becker, 169–81. Singapore: Springer Singapore.

Dodwell, Henry. 1929. Review of Books, *The English Historical Review* 44 (174): 324–26.

Dolson, John, Stuart Burley, V. R. Sunder, V. Kothari, Budapati Naidu, Nicholas Whiteley, Paul Farrimons, Andrew Taylor, Nicholas Direen, and B. Ananthakrishnan. 2015. "The Discovery of the Barmer Basin, Rajasthan, India, and Its Petroleum Geology." *American Association of Petroleum Geologists Bulletin* 99 (3): 433–65.

Dumont, Louis. 1980. *Homo Hierarchicus: The Caste System and Its Implications*. Chicago: University of Chicago Press.

Edwards, Lee, and Anandi Ramamurthy. 2017. "(In)credible India? A Critical Anal-

ysis of India's Nation Branding." *Communication, Culture, and Critique* 10 (2): 322–43.

Eidsheim, Nina. 2015. *Sensing Sound: Singing and Listening as Vibrational Practice*. Durham, NC: Duke University Press.

Ellmeier, Andrea. 2003. "Cultural Entrepreneurialism: On the Changing Relationship between the Arts, Culture and Employment." *International Journal of Cultural Policy* 9 (1): 3–16.

Erdman, Joan. 1985. *Patrons and Performers in Rajasthan*. Delhi: Chanakya.

———. 1994. "Becoming Rajasthani: Pluralism and the Production of Dhart Dhoran Ri." In *The Idea of Rajasthan: Explorations in Regional Identity*, edited by Karine Schomer, Joan Erdman, Derrick Lodrick, and Lloyd Rudolph, 1:45-79. New Delhi: Manohar.

Erlmann, Veit. 1996. "The Aesthetics of the Global Imagination: Reflections on World Music in the 1990's." *Public Culture* 8 (3): 467–87.

Escobar, Arturo. 1992. "Imagining a Post-Development Era? Critical Thought, Development and Social Movements." *Social Text* 31/32: 20-56.

———. 2012. *Encountering Development: The Making and Unmaking of the Third World*. Princeton, NJ: Princeton University Press.

"Expelled BJP Leader Jaswant Singh Meets Advani." 2014. *Times of India*, May 23. timesofindia.indiatimes.com/india/Expelled-BJP-leader-Jaswant-Singh-meets-Advani /articleshow/35517484.cms.

Farrell, Gerry. 1993. "The Early Days of the Gramophone Industry in India: Historical, Social and Musical Perspectives." *British Journal of Ethnomusicology* 2 (1): 31–53.

Farrington, John, Anthony Bebbington, Kate Wellard, and David Lewis. 1993. *Reluctant Partners? NGOs, the State and Sustainable Agricultural Development*. New York: Routledge.

Feld, Steven. 1994. "From Ethnomusicology to Echo-Muse-Ecology: Reading R. Murray Schafer in the Papua New Guinea Rainforest." *Soundscape Newsletter* 8: 4–6.

Feld, Steven, and Keith Basso, eds. 1996. *Senses of Place*. Santa Fe: School of American Research Press.

Ferguson, James. 2006. *Global Shadows: Africa in the Neoliberal World Order*. Durham, NC: Duke University Press.

Fernandes, Leela. 2006. *India's New Middle Class: Democratic Politics in an Era of Economic Reform*. Minneapolis: University of Minneapolis Press.

Fiol, Stefan. 2010. "Sacred, Polluted, and Anachronous: Deconstructing Liminality among the Baddi of the Central Himalayas." *Ethnomusicology Forum* 19 (2): 137–63.

———. 2012. "All India Radio and the Genealogies of Folk Music in Uttarakhand." *South Asian Popular Culture* 10 (3): 261–72.

Firstpost Staff. 2017. "20 Muslim Families Forced to Leave Village in Rajasthan after Threats, Social Boycott from Upper Caste Hindus." *Firstpost*, October 11. www.first

post.com/india/20-muslim-families-forced-to-leave-village-in-rajasthan-after-threats
-social-boycott-from-upper-caste-hindus-4130381.html.

Fisher, William. 1997. *If Rain Doesn't Come: An Anthropological Study of Drought and Human Ecology in Western Rajasthan*. Delhi: Manohar.

Fleuckiger, Joyce Burkhalter. 1996. *Gender and Genre in the Folklore of Middle India.* Ithaca, NY: Cornell University Press.

Folke, Carl, Stephen Carpenter, Brian Walker, Marten Scheffer, Terry Chapin, and Johan Rockström. 2010. "Resilience Thinking: Integrating Resilience, Adaptability and Transformability." *Ecology and Society* 15 (4): 1–9.

Fressoli, Mariano, Rafael Dias, and Hernán Thomas. 2014. "Innovation and Inclusive Development in the South: A Critical Perspective." In *Beyond Imported Magic: Essays on Science, Technology, and Society in Latin America*, edited by Eden Medina, Ivan da Costa Marques, and Christina Holmes, 45–63. Cambridge, MA: MIT Press.

Fuller, C. J. 1989. "Misconceiving the Grain Heap: A Critique of the Concept of the Indian Jajmani System." In *Money and the Morality of Exchange*, edited by Jonathan Parry and Maurice Bloch, 33–63. Cambridge: Cambridge University Press.

Garber, Marjorie. 2008. *Patronizing the Arts*. Princeton, NJ: Princeton University Press.

Garlough, Christine Lynn. 2008. "On the Political Uses of Folklore: Performance and Grassroots Feminist Activism in India." *Journal of American Folklore* 121 (480): 167–91.

Ghai, Rahul, and Sanjay Kumar. 2008. "Cultural Perspectives on Sustainable Rural Livelihoods: Situating Cultural Practices of Marginal Communities in India." Deshkal Society.

Ghosh, Anindita. 2006. *Power in Print: Popular Publishing and the Politics of Language and Culture in a Colonial Society, 1778–1905*. New York: Oxford University Press.

Gold, Ann Grodzins, and Bhoju Ram Gujar. 2002. *In the Time of Trees and Sorrows: Nature, Power and Memory in Rajasthan*. Durham, NC: Duke University Press.

Gold, Daniel. 1995. "The Instability of the King: Magical Insanity and the Yogis' Power in the Politics of Jodhpur, 1803–1843." In *Bhakti Religion in North India: Community Identity and Political Action*, edited by David Lorenzen, 120–32. Albany: State University of New York Press.

Gott, Samuel. 1670. *The Divine History of the Genesis of the World Explicated and Illustrated*. London: E. C. and A. C. for Henry Eversden.

Government of Rajasthan. 2002. *Rajasthan Human Development Report*. Jaipur: Office of the Chief Minister.

Guilbault, Jocelyne. 2011. "Discordant Beats of Pleasure amidst Everyday Violence: The Cultural Work of Party Music in Trinidad." *MUSICultures* 38: 7–26.

———. 2014. "Politics of Ethnomusicological Knowledge Production and Circulation." *Ethnomusicology* 58 (2): 321–26.

———. 2019. "Keynote: Party Music, Affect and the Politics of Modernity." *Journal of World Popular Music* 6 (2): 173–92.

Guindi, Fadwa El. 2003. *Veil: Modesty, Privacy and Resistance*. New York: Berg.

Gunderson, Lance. 2000. "Ecological Resilience—In Theory and Application." *Annual Review of Ecology and Systematics* 31: 425–39.

Gunderson, Lance, Craig Allen, and Crawford Stanley Holling. 2009. *Foundations of Ecological Resilience*. Washington: Island Press.

Gupta, Aditya. 2014. "No Facebook and Twitter Election: The Impact of Social Media on Electoral Outcomes in the Lok Sabha Polls Was Marginal." *Indian Express*, August 22. https://indianexpress.com/article/opinion/columns/no-facebook-and-twitter -election/.

Gupta, Akhil. 2012. *Red Tape: Bureaucracy, Structural Violence, and Poverty in India*. Durham, NC: Duke University Press.

Hall, C. Michael, Stefan Gossling, and Daniel Scott, eds. 2015. *The Routledge Handbook of Tourism and Sustainability*. New York: Routledge.

Hamel, Gary, and Lisa Välikangas. 2003. "The Quest for Resilience." *Harvard Business Review* 81 (9): 52–63.

Harlan, Lindsey. 2003. *The Goddesses' Henchmen: Gender in Indian Hero Worship*. New York: Oxford University Press.

Hellige, Hans Dieter. 2019. "The Metaphorical Processes in the History of Resilience Notion and the Rise of the Ecosystem Resilience Theory." In *Handbook on Resilience of Soci-Technical Systems*, edited by Matthias Ruth and Stefan Goessling-Reisemann, 30–51. Cheltenham, UK: Elgar.

Henderson, Carol, and Maxine Weisgrau. 2007. "Introduction: Raj Rhapsodies, Tourism and Heritage in India." In *Raj Rhapsodies: Tourism, Heritage and the Seduction of History*, edited by Carol Henderson and Maxine Weisgrau, xxv–xxi. Burlington, VT: Ashgate.

Hesmondhalgh, David. 2013. *Why Music Matters*. Chichester, UK: Wiley-Blackwell.

Hocart, Arthur. 1968. *Caste, a Comparative Study*. New York: Russell and Russell.

Hofman, Ana. 2020. "The Romance with Affect: Sonic Politics in a Time of Political Exhaustion." *Culture, Theory and Critique* 61 (2–3): 303–18.

Holling, Crawford Stanley. 1973. "Resilience and Stability of Ecological Systems." *Annual Review of Ecology and Systematics* 4 (1): 1–23.

Hun, Bharat. 2020. "Borderland People and the Rise of the State: A Case Study of Thar Desert." In *Re-Imagining Border Studies in South Asia*, edited by Dhananjay Tripathi, 144–54. London: Routledge.

Ingold, Tim. 2010. "The Textility of Making." *Cambridge Journal of Economics* 34 (1): 91–102.

Jaffrelot, Christophe. 2015. "The Class Element in the 2014 Indian Election and the BJP's Success with Special Reference to the Hindi Belt." *Studies in Indian Politics* 3 (1): 19–38.

Jaipur Virasat Foundation. 2022. www.facebook.com/jaipurvirasatfoundation.

Jairazbhoy, Nazir. 1977. "Music in Western Rajasthan: Continuity and Change." *Yearbook of International Folk Music Council* 9: 50–66.

———. 1980. "Embryo of a Classical Music Tradition in Western Rajasthan." In *The Communication of Ideas*, edited by S. Yadav and Vinayshil Gautam, 91–110. New Delhi: Concept Publishing Company.

Jakimow, Tanya. 2012. "Peddlers of Information: Unintended Consequences of Information-Centred Development for North Indian Non-Government Organizations." *Voluntas* 23 (4): 1014–35.

James, Robin. 2015. *Resilience and Melancholy: Pop Music, Feminism, Neoliberalism*. Lanham, UK: John Hunt.

Jamison, David. 1999. "Tourism and Ethnicity: The Brotherhood of Coconuts." *Annals of Tourism Research* 26 (4): 944–67.

Jassal, Smita Tewari. 2012. *Unearthing Gender: Folksongs of North India*. Durham, NC: Duke University Press.

"Jaswant Singh Loses Barmer LS Seat in Rajasthan." 2014. News18, May 16. https://www .news18.com/news/india/jaswant-singh-loses-barmer-ls-seat-in-rajasthan-688322.html.

Jenkins, Henry. 2001. "Convergence? I Diverge." *MIT Technology Review*. June: 93.

———. 2007. "Transmedia Storytelling 101" henryjenkins.org/blog/2007/03/transmedia _storytelling_101.html.

———. 2019. *Participatory Culture: Interviews*. Cambridge, UK: Polity Press.

Jentoft, Svein. 2007. "In the Power of Power: The Understated Aspect of Fisheries and Coastal Management." *Human Organization* 66 (4): 426–37.

Jhala, Jayasinhji. 2007. "From Privy Purse to Global Purse: Maharaja Raj Singh's Role in the Marketing of Heritage and Philanthropy." In *Raj Rhapsodies: Tourism, Heritage and the Seduction of History*, edited by Carol Henderson and Maxine Weisgrau, 141–60. Burlington, VT: Ashgate.

Jodha, Narpat. 1985. "Population Growth and the Decline of Common Property Resources in Rajasthan, India." *Population and Development Review* 11 (2): 247–64.

Joncheere, Ayla. 2017. "Kalbeliya Dance from Rajasthan: Invented Gypsy Form or Traditional Snake Charmers' Folk Dance?" *Dance Research Journal* 49 (1): 37–54.

Joseph, Jonathan. 2013. "Resilience as Embedded Neoliberalism: A Governmentality Approach." *International Policies, Practices and Discourses* 1 (1): 38–52.

Kamat, Sangeeta. 2004. "The Privatization of Public Interest: Theorizing NGO Discourse in a Neoliberal Era." *Review of International Political Economy* 11 (1): 156–76.

Kapila, Uma. 2010. "Assessment of the Growth Experience: Poverty, Unemployment and Inflation." In *Indian Economy since Independence*, 21st ed., edited by Uma Kapila, 744–87. New Delhi: Academic Foundation.

Kapoor, Dip. 2005. "NGO Partnerships and the Taming of the Grassroots in Rural India." *Development in Practice* 15 (2): 210–15.

Karan, Kavita. 2017. "Cultural Political System: Popular Culture and Films in Indian Election Campaigns." In *Music as a Platform for Political Communication*, edited by Uche Onyebadi, 221–37. Hershey, PA: Information Science Reference, IGI Global.

Karan, Kavita, Jacques Gimeno, and Edson Tandoc. 2009. "Internet and Social Networking Sites in Election Campaigns: Gabriela Women's Party in Philippines Wins the 2007 Elections." *Journal of Information Technology and Politics* 6 (3): 326–39.

Kaur, Ravinder. 2016. "The Innovative Indian: Common Man and the Politics of Jugaad Culture." *Contemporary South Asia* 24 (3): 313–27.

Khullar, Arshiya, and Alisha Haridasani. 2014. "Politicians Slug It out in India's First Social Media Election." CNN, April 10. https://www.cnn.com/2014/04/09/world /asia/indias-first-social-media-election/index.html.

Kinnear, Michael. 1994. *The Gramophone Company's First Indian Recordings, 1899–1908*. New Delhi: Popular Prakashan.

Kolenda, Pauline. 1978. *Caste in Contemporary India: Beyond Organic Solidarity*. Menlo Park, CA: Benjamin/Cummings.

Kolko, Jon. 2012. *Wicked Problems: Problems Worth Solving: A Handbook and Call to Action*. Austin, TX: Austin Center for Design.

Kothari, Komal. 1972. *Monograph on Langas: A Folk Musician Caste of Rajasthan*.Borunda, India: Rupayan Sansthan, Rajasthan Institute of Folklore.

———. 1982. "The Shrine: An Expression of Social Needs." In *Gods of the Byways: Wayside Shrines of Rajasthan, Madhya Pradesh and Gujarat*, edited by Uma Anand, 4–31. Oxford, UK: Museum of Modern Art.

———. 1989. "Performers, Gods, and Heroes in the Oral Epics of Rajasthan." In *Oral Epics in India*, edited by Stewart Blackburn and Peter Claus, 102–18. Berkeley: University of California Press.

———. 1990a. "Patronage and Performance." In *Folk, Faith and Feudalism*, edited by Narendra Kumar Singh and Rajendra Joshi, 55–66. New Delhi: Rawat Publications.

———. 1990b. "Introduction: A View on Castes of Marwar." In *The Castes of Marwar: Being a Census Report of 1891*, edited by Munshi Hardyal Singh, i–xiii. Second edition, Jodhpur: Book Treasure.

———. 1994. "Musicians for the People: The Manganiyars of Western Rajasthan." In *The Idea of Rajasthan: Explorations in Regional Identity*, edited by Karine Schomer, Joan Erdman, Deryck Lodrick, and Lloyd Rudolph, 1: 205–37. New Delhi: Manohar.

———. 2004. "Copyright of Folk and Indigenous Art Forms: Need for Accountability." *Indian Folklife* 3 (3): 6–7.

Kothiyal, Tanuja. 2016. *Nomadic Narratives: A History of Mobility and Identity in the Great Indian Desert*. Cambridge: Cambridge University Press.

Kruks-Wisner, Gabrielle. 2014. "A Not So Distant State." *Indian Express*, January 8. indian express.com/article/opinion/columns/a-not-so-distant-state/.

———. 2018. *Claiming the State: Active Citizenship and Social Welfare in Rural India.* Cambridge, UK: Cambridge University Press.

Kumar, Mukul. 2016. "Contemporary Relevance of Jajmani Relations in Rural India." *Journal of Rural Studies* 48: 1–10.

Lelyveld, David. 1994. "Upon the Subdominant: Administering Music on All-India Radio." *Social Text* 39 (39): 111–27.

Lentzos, Filippa, and Nikolas Rose. 2009. "Governing Insecurity: Contingency Planning, Protection, Resilience." *Economy and Society* 38 (2): 230–54.

Letwin, Lorissa, and Michael Silverman. 2017. "No Between-Group Difference but Tendencies for Patient Support: A Pilot Study of a Resilience-Focused Music Therapy Protocol for Adults on a Medical Oncology/Hematology Unit." *The Arts in Psychotherapy* 55: 116–25.

Levien, Michael. 2018. *Dispossession without Development: Land Grabs in Neoliberal India.* New York: Oxford University Press.

Li, Tanya Murray. 2007. *The Will to Improve: Governmentality, Development, and the Practice of Politics.* Durham, NC: Duke University Press.

Linnenluecke, Martina. 2015. "Resilience in Business and Management Research: A Review of Influential Publications and a Research Agenda." *International Journal of Management Reviews* 19 (1): 4–30.

Linnenluecke, Martina, and Andrew Griffiths. 2010. "Corporate Sustainability and Organizational Culture." *Journal of World Business* 45 (4): 357–66.

Lodha, Sanjay. 2008. "Caste Politics and Hindu Nationalism in a Closed Society: Limits of Electoral Politics in Rajasthan." In *Globalization and the Politics of Identity in India*, edited by Bhupinder Brar, Ashutosh Kumar, and Ronki Ram, 127–52. New Delhi: Pearson.

———. 2011. "Subregions, Identity and Nature of Political Competition in Rajasthan." In *Rethinking State Politics in India: Regions within Regions*, edited by Ashutosh Kumar, 399–429. New York: Routledge.

London, Ted, and Stuart Hart. 2004. "Reinventing Strategies for Emerging Markets: Beyond the Transnational Model." *Journal of International Business Studies* 35 (5): 350–70.

Lordi, Emily. 2020. *The Meaning of Soul: Black Music and Resilience since the 1960s.* Durham, NC: Duke University Press.

Love, Joanna. 2015. "Branding a Cool Celebrity President: Popular Music, Political Advertising, and the 2012 Election." *Music and Politics* 9 (2): 1–24.

Lybarger, Lowell. 2011. "Hereditary Musician Groups of Pakistani Punjab." *Journal of Punjabi Studies* 18 (1): 97–130.

Mahalingam, Ramaswami. 2003. "Essentialism, Culture, and Power: Rethinking Social Class." *Journal of Social Issues* 59 (4): 733–49.

Mahmood, Saba. 2005. *The Politics of Piety: The Islamic Revival and the Feminist Subject.* Princeton, NJ: Princeton University Press.

"Manganiyar's Tribes Stage Protest Against Cong MLA's Remarks in Rajasthan Asssembly." 2019. *Business Standard.* July 18. www.business-standard.com/article/pti-stories /manganiyar-s-tribes-stage-protests-against-cong-mla-s-remarks-in-rajasthan-as-sembly-119071801269_1.html/.

Mansuri, Ghazala, and Vijayendra Rao. 2012. *Localizing Development: Does Participation Work?* Washington: World Bank.

Manuel, Peter. 1991. "The Cassette Industry and Popular Music in North India." *Popular Music* 10 (2): 189–204.

———. 1993. *Cassette Culture: Popular Music and Technology in North India.* Chicago: University of Chicago Press.

———. 1996. "Music, the Media, and Communal Relations in North India, Past and Present." In *Contesting the Nation: Religion, Community, and the Politics of Democracy in India,* edited by David Ludden, 119–39. Philadelphia: University of Pennsylvania Press.

———. 2008. "North Indian Sufi Popular Music in the Age of Hindu and Muslim Fundamentalism." *Ethnomusicology* 52 (3): 378–400.

Marcus, George, and Erkan Saka. 2006. "Assemblage." *Theory, Culture and Society* 23 (2–3): 101–6.

Markham, Annette. 2021. "The Limits of the Imaginary: Challenges to Intervening in Future Speculations of Memory, Data, and Algorithms." *New Media and Society* 23 (2): 382–405.

Massey, Doreen. 1991. "A Global Sense of Place." *Marxism Today,* June, 24–29.

Mattison, Mines. 1975. "Islamisation and Muslim Ethnicity in South India." *Man,* n.s. 10 (3): 404–19.

Mayaram, Shail. 2003. *Against History, Against State : Counterperspectives from the Margins.* New York: Columbia University Press.

———. 2004. "On Komal Kothari."

Indian Folklife 3 (3): 8–10.

———. 2011. "Beyond Ethnicity? Being Hindu and Muslim in South Asia." In *Perspectives on Modern South Asia: A Reader in Culture, History, and Representation,* edited by Kamala Viswaswaran, 16–22. Malden, MA: Wiley-Blackwell.

Mazzarella, William. 2003. "'Very Bombay': Contending with the Global in an Indian Advertising Agency." *Cultural Anthropology* 18 (1): 33–71.

McCarthy, James. 2005. "Scale, Sovereignty, and Strategy in Environmental Governance." *Antipode* 37 (4): 731–53.

McNeil, Adrian. 2007. "Mirasis: Some Thoughts on Hereditary Musicians in Hindustani Music." *Context* 32: 45–58.

———. 2018. "Hereditary Musicians, Hindustani Music and the 'Public Sphere' in Late Nineteenth-Century Calcutta, South Asia." *Journal of South Asian Studies* 41 (2): 297–314.

Meena, Krishnendra. 2020. "Borders and Bordering Practices: A Case Study of Jaisalmer District on India-Pakistan Border." *Journal of Borderlands Studies* 35 (2): 183–94.

Minh-ha, Trinh T., dir. 1982. *Reassemblage*. New York: Women Make Movies.

————. 1992. *Framer Framed*. New York: Routledge.

————. 1999. *Cinema Interval*. New York: Routledge.

Ministry of Home Affairs. 1956. *Memorandum on the Report of the Backward Classes Commission*. Delhi: Government of India Press.

Miraftab, Faranak. 1997. "Flirting with the Enemy: Challenges Faced by NGOs in Development and Empowerment." *Habitat International* 21 (4): 361–75.

Mishra, Prerna Kaul. 2015. "How Social Media Is Transforming Indian Politics." World Economic Forum, February 27. www.weforum.org/agenda/2015/02/how-social-media-is-transforming-indian-politics/.

Morcom, Anna. 2007. *Hindi Film Songs and the Cinema*. New York: Routledge.

Mosse, David. 2005. *Cultivating Development: An Ethnography of Aid Policy and Practice*. London: Pluto Press.

————. 2013. "The Anthropology of International Development." *Annual Review of Anthropology* 42 (1): 227–46.

————. 2018. "Caste and Development: Contemporary Perspectives on a Structure of Discrimination and Advantage." *World Development* 110: 422–36.

Mosse, David, and David Lewis. 2005. *"The Aid Effect": Giving and Governing in International Development*. London: Pluto Press.

Nair, Geeta. 2008. "Post-Reform Labour Market Paradoxes in India." *International Review of Business Research Papers* 4 (4): 396–405.

Neocleous, Mark. 2013. "Resisting Resilience." *Radical Philosophy* 1 (178): 2–7.

Neuman, Daniel. 1980. *The Life of Music in North India: The Organization of an Artistic Tradition*. Chicago: University of Chicago Press.

Neuman, Daniel, and Shubha Chaudhuri, with Komal Kothari. 2006. *Bards, Ballads and Boundaries: An Ethnographic Atlas of Music Traditions in West Rajasthan*. New York: Seagull Books.

O'Brien, Catherine. 1998. "Education for Sustainable Community Development: Barefoot College, Tilonia, India." PhD diss., McGill University.

Olsson, Lennart, Anne Jerneck, Henrik Thoren, Johannes Persson, and David O'Byrne. 2015. "Why Resilience Is Unappealing to Social Science: Theoretical and Empirical Investigations of the Scientific Use of Resilience." *Science Advances* 1 (4): 1–12.

Omvedt, Gail. 1995. *Dalit Visions: The Anti-Caste Movement and the Construction of an Indian Identity*. New Delhi: Orient Longman.

O'Reilly, Kathleen. 2007. "Where the Knots of Narratives Are Tied and Untied: The Dialogic Production of Gendered Development Spaces in Rajasthan, India." *Annals of the Association of American Geographers* 97 (3): 613–34.

———. 2010. "The Promise of Patronage: Adapting and Adopting Neoliberal Development." *Antipode* 42 (1): 179–200.

Pal, Parthapratim, and Jayati Ghosh. 2007. "Inequality in India: A Survey of Recent Trends." DESA Working Paper No. 45, ST/ESA/2007/DWP/45. New York: United Nations.

Palshikar, Suhas. 2014. "A New Phase of the Polity." *Hindu*, May 22.

Pandian, Anand. 2009. *Crooked Stalks: Cultivating Virtue in South India.* Durham, NC: Duke University Press, 2009.

Panini, M. N. 1996. "The Political Economy of Caste." In *Caste: Its Twentieth Century Avatar*, edited by M. N. Srinivas, 28–68. New Delhi: Viking.

Parihar, Rohit. 2014a. "BJP Shows Jaswant's Son Manvendra Singh the Door." *India Today.* April 10. indiatoday.intoday.in/story/jaswant-singh-bjp-manvendra-singh-barmer-lok-sabha-election-rajasthan/1/355023.html/.

———. 2014b. "Jaswant's Revolt May Jeopardise Son Manvendra's Future." *India Today,* March 21. indiatoday.intoday.in/story/jaswant-singh-rebel-manvendra-singh-bjp-barmer-sonaram-chaudhary/1/350598.html/.

Parkinson, Christian. 2014. "Is This India's First Social Media Election?" BBC News, April 20. www.bbc.com/news/av/world-asia-india-27071776/is-this-india-s-first-social-media-election/.

Piliavsky, Anastasia. 2014. "India's Democratic Democracy and Its 'Depravities' in the Ethnographic Longue Durée." In *Patronage as Politics in South Asia*, edited by Anastasia Piliavsky, 154–75. Delhi: Cambridge University Press.

———. 2013. "Borders without Borderlands: On the Social Reproduction of State Demarcation in Rajasthan." In *Borderland Lives in Northern South Asia*, edited by David Gallner, 24–46. Durham, NC: Duke University Press.

Pimm, Stuart. 1991. *The Balance of Nature? Ecological Issues in the Conservation of Species and Communities.* Chicago: University of Chicago Press.

Planning Commission of India. 2006. *Rajasthan Development Report.* New Delhi: Academic Foundation.

Poulantzas, Nicos. 2000. *State, Power, Socialism.* London: Verso.

Powell, Larry, Virginia Richmond, and Glenda Williams. 2011. "Social Networking and Political Campaigns: Perceptions of Candidates and Interpersonal Constructs." *North American Journal of Psychology* 13 (2): 331–42.

Prahalad, Coimbature, and Raghunath Mashelkar. 2010. "Innovation's Holy Grail." *Harvard Business Review* 88 (7–8): 132–41.

Press Information Bureau, Government of India, Election Commission. 2014. "State-Wise Voter Turnout in General Elections 2014." May 210. pib.gov.in/newsite/PrintRelease.aspx?relid=105116/.

Qureshi, Regula. 2002. "Mode of Production and Musical Production: Is Hindustani

Music Feudal?" In *Music and Marx: Ideas, Practice, Politics*, edited by Regula Qureshi, 81–105. New York: Routledge.

Rahaim, Matthew. 2011. "That Ban(e) of Indian Music: Hearing Politics in the Harmonium." *Journal of Asian Studies* 70 (3): 657–82.

Rahaim, Matthew. 2012. *Musicking Bodies: Gesture and Voice in Hindustani Music*. Middleton, CT: Wesleyan University Press.

Raheja, Gloria Goodwin. 1988. *The Poison in the Gift: Ritual, Presentation, and the Dominant Caste in a North Indian Village*. Chicago: University of Chicago Press.

Rahman, Abdur. 2019. *Denial and Deprivation: Indian Muslims after the Sachar Committee and Rangnath Mishra Commission Reports*. London: Taylor and Francis.

Rai, Amit. 2019. *Jugaad Time: Ecologies of Everyday Hacking in India*. Durham, NC: Duke University Press.

"Rains, Floods Claim 85 Lives in Rajasthan." 2006. Outlook, August 25. www.outlookindia.com/newswire/story/rains-floods-claim-85-lives-in-rajasthan/410044/.

Rana, Mulchand. 2008. *Reservations in India: Myths and Realities*. New Delhi: Concept.

Reck, Carol, and David Reck. 1982. "Drums of India: A Pictorial Selection." *Asian Music* 13 (2): 39–54.

Reuster-Jahn, Uta. 2008. "Bongo Flava and the Electoral Campaign 2005 in Tanzania." *Wiener Zeitschrift für kritische Afrikastudien* 14 (8): 41–69.

Richter, William. 1975. "Electoral Patterns in Post-Princely India." In *Studies in Electoral Politics in the Indian States*, edited by Myron Weiner and John Field, 3:1–77. Delhi: Manohar Book Service.

Rittel, Horst, and Melvin Webber.1973. "Dilemmas in a General Theory of Planning." *Policy Sciences* 4 (2): 155–69.

Robbins, Paul. 2001. "Fixed Categories in a Portable Landscape: The Causes and Consequences of Land-Cover Categorization." *Environment and Planning A* 33 (1): 161–79.

Rosin, R. Thomas. 1981. "Land Reform in Rajasthan." *Current Anthropology* 22 (1): 75–76.

———. 1987. *Land Reform and Agrarian Change: Study of a Marwar Village from Raj to Swaraj*. Jaipur: Rawat.

———. 2018. "Thinking Through Livelihood: How a Peasantry of *Rajputana* Became Educated and Activist Rural Citizens of Rajasthan, India." In *The Impact of Education in South Asia: Perspectives from Sri Lanka to Nepal*, edited by Helen E. Ullrich, 219–44. Cham: Springer International Publishing AG.

Roy, Anjali. 2020. "Consuming Bollywood." *Journal of Religion and Film* 24 (2): 1–41.

Roy, Bunker. 2012. "The Barefoot Professionals of Tilonia." *Rajagiri Journal of Social Development* 4 (1): 26–36.

Roy, Bunker, and Jesse Hartigan. 2008. "Empowering the Rural Poor to Develop Themselves: The Barefoot Approach (Innovations Case Narrative: Barefoot College of Tilonia)." *Innovations* 3 (2): 67–93.

Roy, Debayan. 2017. "Mapping Killings That Make Rajasthan 'Hate Crime Capital of India.'" News18 India, December 10. www.news18.com/news/india/mapping-killings -that-make-rajasthan-hate-crime-capital-of-india-1599777.html/.

Rubio, Fernando Domínguez. 2016. "On the Discrepancy between Objects and Things: An Ecological Approach." *Journal of Material Culture* 21 (1): 59–86.

Rudolph, Lloyd, and Susanne Rudolph. 1984. *The Modernity of Tradition: Political Development in India*. Chicago: University of Chicago Press.

———. 2011. "From Landed Class to Middle Class: Rajput Adaptation in Rajasthan." In *Elite and Everyman: The Cultural Politics of the Indian Middle Classes*, edited by Amita Baviskar and Raka Ray, 108–39. New York: Routledge.

———. 2016. "The 'Old Regime' Confronts Democracy." In *Democratic Dynasties: State, Party, and Family in Contemporary Indian Politics*, edited by Kanchan Chandra, 56–82. New York: Cambridge University Press.

Rudolph, Susanne. 1963. "The Princely States of Rajputana: Ethic, Authority and Structure." *Indian Journal of Political Science* 24 (1): 14–32.

Sachs, Wolfgang. 1992. *The Development Dictionary: A Guide to Knowledge as Power*. London: Zed Books.

Saffle, Michael. 2015. "User-Generated Campaign Music and the 2012 US Presidential Election." *Music and Politics* 9 (2): 1–27.

Saria, Vaibhav. 2019. "Begging for Change: Hijras, Law and Nationalism." *Contributions to Indian Sociology* 53 (1): 133–57.

Sarrazin, Natalie. 2013. "Global Masala: Digital Identities and Aesthetic Trajectories in Post-Liberalization Indian Film Music." In *More than Bollywood: Studies in Indian Popular Music*, edited by Bradley Shope and Gregory Booth, 38–59. New York: Oxford University Press.

Schafer, R. Murray. 1977. *The Tuning of the World: Toward a Theory of Soundscape Design*. Philadelphia: University of Pennsylvania Press.

Schaflechner, Jürgen. 2018. *Hinglaj Devi: Identity, Change, and Solidification at a Hindu Temple in Pakistan*. New York: Oxford University Press.

Scheienbacher, Armin, and Benjamin Larralde. 2010. "Crowdfunding of Entrepreneurial Ventures." In *The Oxford Handbook of Entrepreneurial Finance*, edited by Douglas Cumming, 369–91. New York: Oxford University Press.

Schippers, Huib, and Catherine Grant. 2016. *Sustainable Futures for Music Cultures*. New York: Oxford University Press.

Schoening, Benjamin, and Eric Kasper. 2012. *Don't Stop Thinking about the Music: The Politics of Songs and Musicians in Presidential Campaigns*. Lanham, MD: Lexington Books.

Schreffler, Gibb. 2012. "Migration Shaping Media: Punjabi Popular Music in Global Historical Perspective." *Popular Music and Society* 35 (3): 333–58.

Scott, James. 1990. *Domination and the Arts of Resistance: Hidden Transcripts.* New Haven, CT: Yale University Press.

Scott, Suzanne. 2015. "The Moral Economy of Crowdfunding and the Transformative Capacity of Fan-Ancing." *New Media and Society* 17 (2): 167–82.

Shah, Alpa. 2017. "Ethnography: Participant Observation, a Potentially Revolutionary Praxis." *HAU Journal of Ethnographic Theory* 7 (1): 45–59.

Sharma, Anshu, and Sahba Chauhan. 2013. "Incorporating Traditional Knowledge in Post Disaster Recovery to Integrate Climate Change Adaptation and Disaster Risk Reduction." In *Disaster Recovery: Used or Misused Development Opportunity,* edited by Rajib Shaw, 265–86. Tokyo: Springer.

Sharma, Kritika. 2017. "BJP Urges Backward Muslims to Take Advantage of Pro-Poor Policies." DNAIndia, May 10. www.dnaindia.com/india/report-bjp-urges-backward -muslims-to-take-advantage-of-pro-poor-policies-2433120/.

Shaw, Jessica, Kate McLean, Bruce Taylor, Kevin Swartout, and Katie Querna. 2016. "Beyond Resilience: Why We Need to Look at Systems Too." *Psychology of Violence* 6 (1): 34–41.

Shukla, Pravina. 2015. *The Grace of Four Moons: Dress, Adornment, and the Art of the Body in Modern India.* Bloomington: Indiana University Press.

Singh, Jaswant. 2006. *A Call to Honour: In Service of Emergent India.* New Delhi: Rupa.

———. 2014. "Jamat Khan, a folk singer and among the most unlikely heroes of our campaign." Twitter. April 19. twitter.com/mpjaswantsingh/status/457471500803510272.

Singh, Manvendra. 2018. "My Dad Jaswant Singh at 80: Sad How Vajpayee's 'Hanuman' Can No Longer Fly." *Print,* January 3. theprint.in/opinion/vajpayee-jaswant-lifelong-friends-separated-age-coma/26190/.

Singh, Munshi Hardyal, ed. 1990. *The Castes of Marwar: Being a Census Report of 1891.* Second edition. Jodhpur: Book Treasure.

Singh, Ramendra, Vaibhav Gupta, and Akash Mondal. 2012. "Jugaad—From 'Making Do' and 'Quick Fix' to an Innovative, Sustainable and Low-Cost Survival Strategy at the Bottom of the Pyramid." *International Journal of Rural Management* 8 (1–2): 87–105.

Singh, Rashpal. 2014. "History Repeats Itself in Barmer, Scindia Scion Takes on a Rajput." *Hindustan Times,* April 14. www.hindustantimes.com/jaipur/history-repeats-itself-in -barmer-scindia-scion-takes-on-a-rajput/story-4DfFAY9d8ZLsooAqAOmfjP.html/.

Sinha, Surajit. 1962. "State Formation and Rajput Myth in Tribal Central India." *Man in India* 42 (1): 36–80.

Sivaswamy, Saisuresh. 2014. "For Jaswant, technology, music and family fill the gap left by BJP." Rediff.com, 26 April. www.rediff.com/news/report/ls-election-for-jaswant -technology-music-and-family-fill-the-gap-left-by-bjp/20140416.htm/.

Snodgrass, Jeffrey. 2004. "The Centre Cannot Hold: Tales of Hierarchy and Poetic Com-

position from Modern Rajasthan." *Journal of the Royal Anthropological Institute* 10 (2): 261–85.

———. 2006. *Casting Kings: Bards and Indian Modernity*. New York: Oxford University Press.

Spivak, Gayatri. 1996. "Subaltern Studies: Deconstructing Historiography?" In *The Spivak Reader*, edited by Donna Landry and Gerald MacLean, 203–37. London: Routledge.

Spry, Tami. 2016. *Autoethnography and the Other: Unsettling Power through Utopian Performatives*. New York: Routledge.

Srinivas, Narasimhachar. 1966. *Social Change in Modern India*. Berkeley, CA: University of California Press.

Stokes, Martin. 2004. "Music and the Global Order." *Annual Review of Anthropology* 33 (1): 47–72.

"Strategic Resilience: The Secret to Longevity." 2018. *Strategic Direction* 34 (6): 28–29.

Taft, Frances. 2003. "Heritage Hotels in Rajasthan." In *Institutions and Social Change*, edited by Surjit Singh and Varsha Joshi, 127–49. Jaipur: Rawat.

Tan, Marcus Cheng Chye. 2013. "Between Sound and Sight: Framing the Exotic in Roysten Abel's *The Manganiyar Seduction*." *Theatre Research International* 38 (1): 47–61.

Tarlo, Emma. 1996. *Clothing Matters: Dress and Identity in India*. Chicago: University of Chicago Press.

———. 2000. "Fashion Fables of an Urban Village." In *Development: Critical Concepts in the Social Sciences*, edited by Stuart Corbridge, 5:68–91. New York: Routledge.

Taylor, Charles. 2004. *Modern Social Imaginaries*. Durham, NC: Duke University Press.

Taylor, Timothy. 2015. *Music and Capitalism: A History of the Present*. Chicago: University of Chicago Press.

Titon, Jeff Todd. 2009a. "Introduction." In *Worlds of Music: An Introduction to the Music of the World's Peoples*. Fifth edition. Belmont, CA: Schirmer Cenage Learning. 7–13.

———. 2009b. "Music and Sustainability: An Ecological Viewpoint." *The World of Music* 51 (1): 119–37.

———. 2015. "Sustainability, Resilience, and Adaptive Management for Applied Ethnomusicology." In *The Oxford Handbook of Applied Ethnomusicology*, edited by Svanibor Pettan and Jeff Titon, 157–99. New York: Oxford University Press.

———. 2016. "Orality, Commonality, Commons, Sustainability, and Resilience." *Journal of American Folklore* 129 (514): 486–97 and 502.

Tod, James. 1997. *Annals and Antiquities of Rajast'han: Or, the Central and Western Rajpoot States of India*. New Delhi: Rupa and Company.

Toor, Saadia. 2000. "Indo-Chic: The Cultural Politics of Consumption in Post-Liberalization India." *SOAS Literary Review* 2 (3): 1–33.

Trembath, Shirley. 1999. "The Rani Bhatiyani Songs: New or Recycled Material?" In

Religion, Ritual, and Royalty, edited by Narendra Kumar Singhi and Rajendra Joshi, 214–26. Jaipur: Rawat.

Turino, Thomas. 2009. "Four Fields of Music Making and Sustainable Living." *The World of Music* 51 (1): 95–117.

Unnithan, Maya, and Carolyn Heitmeyer. 2014. "Challenges in 'Translating' Human Rights: Perceptions and Practices of Civil Society Actors in Western India." *Development and Change* 45 (6): 1361–84.

Vatuk, Sylvia. 1996. "Identity and Difference or Equality and Inequality in South Asian Muslim Society." In *Caste Today,* edited by C. J. Fuller, 227–62. Delhi: Oxford University Press.

Vecco, Marilena. 2010. "A Definition of Cultural Heritage: From the Tangible to the Intangible." *Journal of Cultural Heritage* 11 (3): 321–24.

Vikas, Ram, Rohit Varman, and Russell Belk. 2015. "Status, Caste, and Market in a Changing Indian Village." *Journal of Consumer Research* 42 (3): 472–98.

Wade, Bonnie. 1998. *Imaging Sound: An Ethnomusicological Study of Music, Art, and Culture in Mughal India.* Chicago: University of Chicago Press.

Wade, Bonnie, and Ann Pescatello. 1977. "Music 'Patronage' in Indic Culture: The *Jajmani* Model." In *Essays for a Humanist: An Offering to Klaus Wachsmann,* 277–336. New York: Town House Press.

Walker, Jeremy, and Melinda Cooper 2011. "Genealogies of Resilience: From Systems Ecology to the Political Economy of Crisis Adaptation." *Security Dialogue* 42 (2): 143–60.

Weisgrau, Maxine. 1997. *Interpreting Development: Local Histories, Local Strategies.* Lanham, MD: University Press of America.

Williams, Richard David, and Rafay Mahmood. 2019. "A Soundtrack for Reimagining Pakistan? Coke Studio, Memory and the Music Video." *BioScope* 10 (2): 111–28.

Wiser, William. 1936. *The Hindu Jajmani System.* Lucknow: Lucknow Publishing House.

"Wishberry Crowdfunding Basics, What are the advantages of crowdfunding?" 2019. www.wishberry.in/how-it-works/.

Worster, Donald. 1993. *The Wealth of Nature: Environmental History and the Ecological Imagination.* New York: Oxford University Press.

Zebrowski, Chris. 2016. *The Value of Resilience: Securing Life in the Twenty-First Century.* New York: Routledge.

INDEX

Page numbers in *italics* indicate figures,
and page numbers with "n" indicates and endnote.

fixed rhyming poetic couplet (*doha*), 20–21, 125–26, 132, 166, 179n19

flooding, 107–12, 131, 135, 143, 188n3

folk music (*lok sangeet*), 68, 71, 174

Ford Foundation, 88

Gaavaniyar collective, 93, 175

Gandhi, Indira, 187n19

Gehlot, Ashok, 161

gender, 28–31, 34, 48, 98–100, 181n33

genealogy keeping, 16, 20, 52, 56, 60, 90

genealogy of the Manganiyar community, 24, 52

gharana (house), 67

ghol (money given as a tip), 44

globalization, 82, 91

Global North, 119

Global South, 115

governmentality, 12–13

Government of Rajasthan's Irrigation Department, 108

Great Britain, 17

Green Revolution, 114, 117–18

greeting (*khamaghani*), 44, 60, 68, 71, 155, 165

Gunsar Lok Sangeet Sansthan (Gunsar Folk Music Organization), 3, 161, 193n38

"Halariya," 101

harmonium: described, 2; banning of, 85, 88, 186n13; donations of, 111, 131; inclusion in ensemble, *19*, *51*, 136, *154*; instrumentation, 155. 156. 158, 159; musical role, 18–20; popularity of, 87–88. *See also* musical instruments

Hauz Khas Village, 185n3

Hawa Mahal (Palace of Winds), 96–100, *98*, 187n28

hereditary community, 1, 13–16, 46–50, 52, 93, 94, 139, 144, 145, 177n2, 193n36. *See also* Manganiyar community

hereditary patron. *See* jajman

heritage: cultural, 56, 92, 104, 173, 175; discourses of, 89–90; folk, 94; hotel, 90, 186n16; national, 93; performance of; Rajput, 48, 148; tourism, 186n17

hierarchy: caste, 105, 180; relationships, 25, 121; religious, 26–27, 48; social structure, 47, 65

Hinduism/Hindu society, 1–5, 23, 24, 25–26, 27, 46, 53, 60, 101, 136, 142, 158

Hindustani classical music: audiences of, 44; comparison with Manganiyar music, 22, 179n19; musical genre, 21–22, 186n8, 188n31; musicians of, 83, 185n5; organization, 67; patronage of, 182n5; performance of, 68, 73, 87; system, 10

classical musicians (kalakars), 78, 83

Hofman, Ana, 140

Holling, Crawford, 9

house (*gharana*), 67

Hurs (Sufi Muslim community), 149

"Hutata Damru Baaje, Bhule toh Pyaara Laage," 153, 158–59, 193n32

Identity or Recognition Folk Music Institute, 122–27

illiteracy, 152

imaginaries, development, 37–38, 115–17, 121, 122, 124–25, 127, 133, 134, 189n14. *See also* development

Indian Council for Cultural Relations, 36, 92, 173–74

Indian Heritage Hotel Association, 90

Indian People's Theatre Association, 65

India-Pakistan border, 16, 17, 31, 91, 120, 143, 148, 149, 150, 178n14, 179n21, 188n6

Indira Gandhi Canal, 108, 114, 118

Indira Gandhi National Centre for the Arts, 92

individuality, 69–70, 87, 130–31

Indo-chic, 82–83, 185nn3–4

Indo-Pakistani War, 17, 60, 178n14

institutions: cultural, 45, 46, 78, 117, 131, 173–75; national and state, 36, 92–94, 120, 145, 174, 188n8; postcolonial, 36, 45, 135, 155; postpatronal, 144

international development organizations, 119. *See also* development

international performance contexts, 45, 83–89, 101, 103, 111–113, 129, 169, 187n24; in Gambier, OH, 54–55; history of, 76–78, 123–27; international representatives of

Indian culture, 36; markets, 63; touring, 41, 66–67, 106, 132, 173–74; with renowned artists, 22; women musicians in, 30–31; world of, 24

intimate distance, 32

intricately carved stone latticework (*jharokha*), 96–97, *98*, 98

Islam: and caste, 190n5; and Hinduism, 2–5, 23, 180n27; conversion, 26, 180n26, 180n29, 180n31; egalitarianism, 25, 31, 162, 180n25; fundamentalist, 180n29; Islamization, 27, 186n14; Mughal Islamic rule, 181n3; Music and, 180n28; Muslim, 2–5, 15, 23–24, 25–26, 110, 143, 148–50, 158, 160–62, 191nn16–17; Sufism, 191n15, 192n22, 193n36

jaagaran (awakening), 2, 4, 140–42, 148, 163
jagir (estate), 47–48
jagirdar (sovereign intermediary landowner), 47–49, 50, 90, 117, 182
Jaipur City, 22, 65, 90, 93–94, 96–100, *98*, 109, 110, *123*, 162, 165, 174, 175–76, 186n16
Jaipur Heritage Festival, 94, 176
Jaipur Literature Festival, 94
Jaipur Virasat Foundation (JVF), 93–94, 175–76, 187n20
Jairazbhoy, Nazir, 179–80n24
Jaisalmer: Alamkhana, 51; death of Aamad Khan, 1–5; city, 1, 3, *17*, *21*, 34, *51*, 84, 91, 108, *114*; District, 4, 5, 6, 15–16, *109*, 189n13, 179n21, 189n13; District Collector, 5, 161; flooding, 107–12; history of, 8, 15–18, 67, 178n11, 182n10, 183n13; Lok Sabha elections, 149, 150, 157–58; Pansari Market, 150–51; tourism, 63, 91, 113, 126, 187n18; view of, *17*
Jaisalmer Desert Festival, 127
Jaisalmer Fort (Golden City), 16, *17*, *21*, 67–68, 91, 150–51
jajmani system. *See* jajman (hereditary patron)
jajman (hereditary patron): asymmetrical relationships with musicians, 58–59; casteism, 23; characteristics of traditional patronage, 52–54; continuing traditions, 50–54; of Dantal , 1–8, 13; economic transactions, 45, 104–105, 183n14; flooding,

108; history of, 46–50; Langa community, 179n15; marriage, 191n14; move away from, 6–7; musical refinement, 183–84n20; obligation, 12; overview, 13–15; patronal pathologies, 58–59; politics, 139–40; postcolonial India, 90–91; postpatronage, 31, 63, 145; reciprocity, 54–57, 104–5; relationships with musicians, 2; resources, 144; Sakar Khan, 41–45, 182n7; status of, 160–62; subalternity, 82; tactics of resilience, 59–61; traditional musical practice, 18–23; women, 88

Jasol, 148, 158
jharokha (intricately carved stone latticework), 96–97, *98*, 98
Jodhpur: city, 27, 64–66, *79*, 83, 84, 90, 155; district, 18
jugaad, 128–31, 134
JVF (Jaipur Virasat Foundation), 93–94, 175–76, 187n20

kacchi aarti and *pakki aarti* (raw and cooked sweets), 43
kacheri (connoisseur listening session), 21, 44, 88, 125, 166
Kaka Kalekar Commission, 142–43, 190n4
Kalakar Bhawan (Artist Building), 3–4
Kalakar (Artist) Colony, 3–6, 15, *17*, 178n13, 181–82n32
kalakars (Hindustani classical musicians), 78, 83
Kalbelia communities, 78
Kallu ki Hatta, 51
kamaicha, 18–20, 44, 56–57, 73, 84, 87–88, 100
Kanota, Mohan Singh, 90, 186n16
kasabi (families of service castes), 47, 60, 182n6-7
"Kenku Patri," 42
khamaghani (greeting), 44, 60, 68, 71, 155, 165
Khan, Aamad, 1–8, 12–13, 61, 142, 148
Khan, Akbar, *51*, 84
Khan, Ameen, 160–63
Khan, Bariyam, 2–4
Khan, Bax, 3–4, 6–7, 161, 177n4, 193n38
Khan, Chanan, *33*, 87, 186n11

Manganiyar community: Barmer District, 15–16, 18; casteism, 6, 23–27, 105, 142–44, 160–62; children, 22–23; continuing of traditional patronage, 50–54; cultural tourism, 89–91; death of Aamad Khan, 1–5; development and music, 112–15; flooding, 107–12; genealogy keepers, 20; as hereditary community, 13–15; Jaisalmer City, 16–18; *jugaad*, 128–31; Komal Kothari, 64–66; Lok Sabha elections, 136–37, 146–59; Mame Khan, 69–70, 71–72; "The Manganiyar Seduction," 94–103; institutions and festivals, 92–94; marriage, 177–78n9; media usage in, 152–53; musical patronage, 46–50; neoliberal resilience, 130–31; NGO culture, 119–22; politics, 138–42, 160–63; postpatronage, 31–32, 62–63, 77–78, 88; reciprocity, 54–57; religious identity, 25–27; subaltern chic, 80–89; traditional musical practice, 18–23; wicked resilience, 11–12; women, 28–31, 29, 34–35, 48, 88, 181n33, 181nn35–36, 186n14, 193n33

Manganiyar musicians: archival assemblages, 166–67; community participation, 121–22; cultural capital, 79–80; cultural tourism, 89–91, 126; development and music, 112–15; *dohas*, 125, 179n19; economic transactions, 45, 104–105, 183n14; electoral politics, 170; flooding, 108–12; institutions and festivals, 92–94; international tours, 76, 84–87; Islamization, 26–27; *jugaad*, 129; Komal Kothari, 83–89; Lok Sabha elections, 136–37, 147–59; Mame Khan, 67–74; Manganiyar designation, 24; "The Manganiyar Seduction," 95–103; musical practice, 18–23; neoliberal resilience, 130–31; Pakistan, 16; patronal pathologies, 58–59; politics, 139, 162–63; postcolonial India, 90–91; postpatronage, 31–32, 62–63, 145–46; Rajputs, 48, 98; reciprocity, 54–57, 74–75, 103–6; resilience, 7–9, 103–6; resources, 144; *sansthans*, 127–28; subaltern chic, 80–89; tactics of resilience, 59–61; ties with traditional patrons, 41–45; traditional patronage, 13–15, 50, 52–53; transmedia, 167–69. *See also* performance

Manganiyar Sansthan, 138
"The Manganiyar Seduction," 67, 81, 94–103, 95, 187n23–24, 188n29, 189n17
Manrique, Fray Sebastien, 179n11
Manuel, Peter, 180n31
"Ma-Raat," 42
Mardumshumari Rajmarwar (1891 Indian census), 15
marginalization, 4–5, 12, 25, 27, 91, 105, 130, 133, 135, 170
mars (poem of remembrance of the dead), 53
Marwari language and dialect, 8, 44, 65, 68, 72, 74, 101, 166, 177n5
Marxism, 184n23
masculinity, 34, 48, 98–100, 119
media technologies, 149, 152–53, 163, 167, 192n23
Meghwal, 160, 193n35
Merasi designation, 23–24
Merasi Manganiyar Vikas Seva Samiti (Merasi Manganiyar Development Service Society), 161
Merasi Samaj (Artists' Society), 3
metal mouth harp (*morchang*), 73, 168
migration, 15, 24, 117
Minh-ha, Trinh T., 167
mobility: history of, 16; social, 116, 182n9; transportation, 17; upward, 18, 25, 26–27, 48, 129, 156, 180n27, 181n33
modernization, 49–50, 120, 124
money given as a tip (*ghol*), 44
morality, 25, 82, 130–31
morchang (metal mouth harp), 73, 168
mota git (large song genre), 20–21, 179n18
Mughal Empire, 47–49, 157
mujra (acknowledgments and glorification of jajman), 61
musical communication, 102
musical instruments: *bansuri* (bamboo transverse flute), 73; *damaru* drum, 153, 192n25; *dhol* (double-headed frame drum), 21, 28, 29, 42–43, 45, 100, 154, 183n13; *dholak* (double-headed barrel drum), 14, 19, 20–21, 22, 43, 73, 86, 87, 96, 100, 111, 127, 131, 139, 156, 158, 159, 179; *kamaicha* (Manganiyar

bowed lute), 18–20, 44, 56–57, 73, 84, 87–88, 100; *khartal*, *19*, 20, 43, 86–87, 100, 122, 127, 128, 156; *morchang*, 73, 168; *sarangi* (bowed lute), 15, 88; *tambura* (plucked drone instrument), 73; *thali* (stainless steel plate), 56–57. *See also* harmonium

musical instrumentation, 36, 73, 74, 81, 86, 87–88, 126, 142, 155, 159, 178n15

musical interludes (*riyan*), 43

musical mistakes, 2–3

musical patronage. *See* traditional patronage

musical practice, 18–23

musical preservation, 37, 88, 115, 124

musical refinement, 183–84n20

musical transmission, 22–23

music and politics, 138–42

music connoisseurship, 21, 48, 63, 125

music cultures, 10–11, 135

Muslims. *See* Islam

nakh, 177–78n9, 182–83n13

Narain Niwas Palace, 90, 186

National Folklife Support Centre, 88

nationalism, 65–66

national sponsorship of regional culture and music, 92–94

Navratri, 1–2, 4, 5, 6, 8, 142

"Neendarli," 101

Nehru, Jawaharlal, 64

neocolonialism, 11, 119, 121

neofolk music, 155

neoliberalism, 121–22, 129–31, 135, 144

neoliberal resilience, 12–13, 59, 128, 130–31, 134–35, 144

Neuman, Daniel, 10, 21

nongovernmental organizations (NGOs). *See* organizations

nonmonetary barter system, 46, 50

nonverbal communication, 102

nostalgia, 39, 75, 79, 81, 102, 170

OBCS (Other Backward Classes), 143, 150, 190n4

occupation, 1, 16, 25, 155, 180n28

Ocean of Folk Music Organization (Lok Kala

Sagar Sansthan), 23

olakh (religious song genre), 159

open voice (*khola avaaz*), 73–74, 159

organizations: private-sector, 120–21; registered NGOs (*sansthans*), 107, 115, 116, 119–23, 126, 132–34, 173–76, 189nn12–13

orthodoxy, 26, 27

Other Backward Classes (OBCS), 143, 150, 190n4

Padma Shri Award, 73, *79*, 85, 181n1,184n31, 185n1, 185–86n7

pagh bandhai (tying of the turban), 52–53

Pakistan: border with India, 1, 91, 120, 143, 148, 188n6; nation of, 15, 16, 24, 26, 27, 31, 149, 150, 159, 177n5, 178n14, 181n36, 183–84n13, 191n18m 192n22

Palace of Winds (Hawa Mahal), 96–100, *98*, 187n28

panchayat (local self-governing council), 3–4, 5, 6, 12

"Panihari," 107

Pansari Market, 150–51

Parampara (Tradition) (magazine), 65

participant observation. *See* ethnography

pastoralism, 36, 82, 117–18

pathologies, 58–59

patronage: Western arts, 63

patronal pathologies, 58–59

patronal services (*birat*), 52

payment (*bhati*), 45. *See also* economics

Pehchan Lok Sangeet Sansthan (PLSS), 122–27, 128–29, 131, 132–33, 189n14

percentage of the harvest of a yearly crop (*dhan*), 53

performance: ceremonial, 2; cultural tourism, 89–91, 113; institutions and festivals, 92–94; international, 76–78, 83–89, 101, 103, 146; Jamat Khan, 155–56; Komal Kothari, 83–89, 186n8; "The Manganiyar Seduction," 94–103; musical practice, 18–23; performance futures, 81–82; politics, 140–42; postpatronal, 6–7, 31–32, 62–63, 67–74, 79–80, 94–103, 112, 125–27, 167–68, 169–70; reciprocity, 54–57; religion in

practice, 25–27; resilience (*lachila*), 61; resilience breaking, 59; theatrical, 1; traditional patronage, 52–54; women's role in, 28–31

personas, 80–82

Pescatello, Ann, 62

pheras (ceremonial walking around the marriage fire), 44–45

"Pili Chawal," 42

Pir Pagara, 149–50, 180n28, 191n15, 191nn18–19

PLSS (Pehchan Lok Sangeet Sansthan), 122–27, 129, 132–33

plucked drone instrument (*tambura*), 73

poem of remembrance of the dead (*mars*), 53

political mobilization, 120

politics, 138–42, 146–59, 192n23

postcolonial decline of courtly patronage, 49–51

postcolonial India, 36, 49, 63, 89, 134, 144, 174, 188n8, 190–91n10.

postcolonialism, 56, 62–64, 119

postdevelopment critique, 117, 119. *See also* development

postindependence India. *See* postcolonial India

postpatronage: archive material, 77–78; children, 125; crowdfunding, 71; institutions and festivals, 92–94; interactions with interlocutors, 165–66; *jugaad*, 129; Komal Kothari, 64–66, 83–89; Mame Khan, 67–74; "The Manganiyar Seduction," 94–103; neoliberalism, 59, 121–22; performance, 31–32, 62–63, 67–74, 79–80, 83–89, 94–103, 112, 125–27, 167–68, 169–70; postcolonialism, 62–63; postpatronal economy, 84, 104–105; presentational, 83–89; reciprocity, 55; resilience, 31–32, 169–71; strategic essentialism, 81–83; subaltern chic, 80–83; traditional patronage, 52, 71–72, 79–80, 91, 106, 133, 145; welfare state, 111–12

postpatronal audiences, 63, 74, 75, 79–81, 82, 83, 125–27, 154, 167

poverty, 12, 24, 31, 58, 62, 116, 117, 119, 134, 144

power: caste, 5; dynamics of, 8, 71, 119, 127, 132; exertion of, 61, 150; Mughal, 47, 49;

paradoxical, 31; patronal, 75, 78, 80, 82, 160; political, 3, 140–44, 146, 162, 178, 191n18; position of, 60, 90; relations of, 34, 38, 58, 59, 63, 116, 122, 133, 181n4; Rajput, 48; religious, 1, 159

Pratap, Maharana, 157–58

prejudice, 4, 6, 27

Prerna (Inspiration) (journal), 65

preservation: archival, 167; cultural, 88, 92, 94, 124, 125–26, 173; ecological, 10; in development, 114, 125; musical, 37, 115, 116, 166; structural, 81; of traditional, 24, 138;

printed word, 65

private foundations and organizations, 93–94, 121

privatized industrialization, 118–19

privilege (*adhikar*), 105

privy purses, 49, 90, 182n11

Progressive Writers and Artists Association, 65, 184n23

prostitution, 97–98

Punjab: language of (Punjabi), 128; music of, 155, 192–92n28; poet of, 101; State, 15, 117–18;

puraney git (old or traditional songs), 166

purdah, 28, 88, 96–98, 186n14, 187n27

question-and-answer (*sawal-jawab*), 87, 125, 127, 186n12

ragas: *Kamaichi*, 44, 68; Manganiyar concept of, 20, 21–22, 126, 166, 167, 179n19, 183n20, 184; moods of, 125; poetic setting of, 73; *Sameri*, 56–57; *Soob*, 57; *Sorath*, 73

Raheja, Gloria, 58

Rahman, A. R., 139

Rajasthan: borderland, 18; court musicians of, 22; cultural tourism, 36, 92, 114, 171, 186n17; development, 114, 120, 189nn12–13; festivals, 132; government, 108, 110, 114, 135, 157, 160, 193n34; institutions, 92–94, 174–76; masculinity, 98; origins of, 49; politics, 141, 146, 150; postcolonial 49, 66; regional culture, 16, 65–66, 69, 96; religion, 4, 149, 162, 177n1, 187n27; romanticization,

89–91; royal courts, 51, 148; geography of, 1, 15–18, 23, 33, 38, 55, 107, 112, 120, 146, 178n12, 183–84n13; traditional musical patronage in, 35, 46–47

Rajasthan Patrika, 131, 184n22

Rajasthan Rural Arts Programme (RRAP), 93–94

Rajasthan Vidhan Sabha, 193n34

Raje, Vasundhara, 110

Rajputana, 16, 47, 49, 186n8

Rajputization, 47–48, 182n9, 186n14,

Rajputs, 3, 5, 16, 47–4956, 89–91, 98, 148, 157, 181n33, 182n10, 193n36

Ramani, Bina, 185n4

Rambagh Palace, 90

Ramlila (Lord Ram's play), 1, 8

Rani Bhatiyani: goddess, 2, 148, 159, 177n1, 191n15; temples, 67, 142, 193n33

raw and cooked sweets (*kacchi aarti* and *pakki aarti*), 43

Rawal Jaisal, 16

Reagan, Ronald, 187n19

reassemblages, 166–69

reciprocity, 46, 52–53, 54–57

recording: equipment, 35, 39; field recordings, 64, 65, 84, 166, 174, 184; sessions, 19; 32, 57, 79, 131, 154, 167–68; studio, 72, 155, 185; technology, 141

regional genres of music, 155–57

religio-caste politics, 4, 6, 23, 25–27, 31, 48, 162–63

religious conversion, 25–26

religious festivals, 2

religious hate crimes, 1–8

religious identity of the Manganiyar community, 25–27, 162

remoteness, 143

remuneration, 53–54, 61, 74–75

repertoire, 20–21, 26, 28–31, 36, 48, 54, 61, 68, 74, 85–86, 88, 101–103, 125, 126–27, 153–55, 164, 178nn15–16, 179n19, 181n34, 183n14

representations of the female body, 98–100

reservation systems, 23, 143, 190nn4–5

resilience (*lachila*): breaking of, 59; death of Aamad Khan, 1–2; in development, 112–15;

ecological application of, 9–10; failure of development, 134; Islam, 180n31; *jugaad*, 129–31; narratives of, 7–8; neoliberal, 12–13, 59, 121–22, 128; pathologies of, 58–59; patronage, 31–32, 58–59, 62–63; postpatronage, 31–32, 58–59, 62–63, 169–71; postpatronage and traditional patronage, 105–106; psychological, 10, 12; reciprocity, 75; strategic, 80–83, 95, 100, 103–6; subaltern chic, 82–83; tactics of, 59–61; transdisciplinary framework, 8–13; wicked resilience, 11–12, 58–59

responsibilization, 130

rhythmic pattern (*rupak tala*), 73

rights-based language, 114–15

Rittel, Horst, 11–12

riyan (musical interludes), 43

Rock'n'Roots Project, 72

royal courts, 50–51

royal patronage, 47–52

RRAP (Rajasthan Rural Arts Programme), 93–94

Rubio, Fernando Domínguez, 133–34

Rudolph, Lloyd and Susanne, 90, 186nn15–16

rupak tala (rhythmic pattern), 73

Rupayan Sansthan, 31, 64, 66, 76, 79, 84–85, 89, 92–94, 107, 111–12, 114, 127, 137, 138, 176, 181n37, 184n29

"Saawan," 72–74, 185n37

salvage ethnomusicology, 11

"Sambela," 43

Sanawara Village, 14

Sangeet Natak Akademi, 36, 66, 84–85, 92, 173, 174, 181n1, 184n25, 185–86n7

"Sanji Dena," 42

Sanskritization, 180n27, 181n33, 182n9

sansthans (organizations): Manganiyar-founded, 3, 23, 37, 108, 109, 111, 113, 115, 116, 120–23, 126, 132–34, 137, 161; Rupayan Sansthan, 31, 64, 66, 76, 79, 84–85, 89, 92, 93–94, 107, 114; 119, 127–28, 138, 154, 155, 167, 173–76, 181n37, 184n29

sarangi (bowed lute), 15, 88

sarvodaya (upliftment of all), 64

sati, 148, 177n1

Satto, 67–68, 71

sawal-jawab (question-and-answer), 87, 125, 127, 186n12

Schafer, R. Murray, 10

seduction, 96

Seredeori Bazaar, 97

Shah, Bulle, 101

Shankar, Ravi, 22

shubhraj (acknowledgement of relationship), 20, 27, 44, 52–53, 57, 61, 73, 100, 125, 137, 139–40, 153, 156, 158, 182n7

Sindh, Pakistan, 15–16, 24, 149, 177n5, 178n10, 179n21, 191n19

Sindhi Sufi repertoire, 26, 101, 179n21, 181n34

Singh, Faith, 187n21

Singh, Hamir, 182n7

Singh, Jason, 168

Singh, Jaswant, 136–37, 146–59, *154*, 190n9, 191n17, 191n19, 191nn11–12, 192n20, 192n22, 192n24

Singh, John, 175–76

Singh, John and Faith, 93, 175–76

Singh, Manvendra, 191nn11–12

Singh, Raja Bahadur Thakur Amar, 186n16

small hamlet (*dhani*), *14*, 15

small table used for serving food (*bajotha*), 56

Snodgrass, Jeffrey, 60, 139

social contracts, 50

social imaginary, 116

social justice, 11, 117, 120

social media, 4–5, 33, 56, 136, 149, 152–53, 161, 162, 163, 167–68, 192n24

social mobility, 26–27, 116, 180n27, 181n33

social network, 145

social structure, 46, 54–56, 139

"Woh Malani ro Saput Jathe," 151–52, 153, 157–58

songs: "Alfat in bin un bin" (song title), 101; "Baawre" (song title), 72; *banni git* (bride song genre), 43; *bhund* (abuse song genre), 61; "Bichhudo" (song title), 73–74; campaign songs (genre), 147, 150–59, 164, 193n30, *chhota git* (small song genre), 20–21, 30, 43; "Halariya" (song

title), 101; "Kenku Patri," 42; "Lunagar" (song title), 72; "Ma-Raat" (song title), 42; mota git (large song genre), 20–21, 179n18; "Neendarli" (song title), 101; olakh (religious song genre), 159; "Panihari" (song title), 107; "Pili Chawal," 42; puraney git (old or traditional songs), 166; "Saawan" (song title), 72–74, 185n37; "Sambela" (song title), 43; "Sanji Dena" (song title), 42; "Toranio" (song title), 43; transportation songs (genre), 155–56, 192n28; "Woh Malani ro Saput Jathe" (song title), 151–52, 153, 157–58

Sony Entertainment Television, 157

sovereign intermediary landowner (*jagirdar*), 47–49, 50, 90, 117, 182

Srinivas, Narasimhachar, 180n27, 182n9

stainless steel plate (*thali*), 56–57

state sponsorship of the arts, 36, 92–94, 173

strategic essentialism, 80–83

strategic resilience, 80–83, 91, 103–6

street theater, 141, 187n23

subalternity: communities, 65, 129; histories, 13, 185n2; positionality, 78, 112, 130; spaces of, 170; subaltern chic, 36, 80–89, 91, 94–94, 104, 124, 154; subaltern past, 80–82, 83, 129–30

succession (*khan baras*) ceremony, 53

Sufi repertoire, 26, 101, 181

sustainability, 9–11, 38, 58–59, 87, 121, 124, 134, 169, 170

Suthar, Ramesh, 2–5

syncretic religious practices, 23–24, 26

talaq (divorce), 61, 183n19

tambura (plucked drone instrument), 73

Taylor, Charles, 116

technology, 8, 11, 39, 65, 80, 91, 119, 141, 153, 161, 163, 167–68, 171

thali (stainless steel plate), 56–57

Thar Desert: casteism, 23–24; continuing of traditional patronage, 50–54; cultural tourism, 31, 126; death of Aamad Khan, 1–5; development, 114–19, 123, 128; ethnographic failure, 131–34; ethnography,

Index **225**

MUSIC / CULTURE

A series from Wesleyan University Press
Edited by Deborah Wong, Sherrie Tucker, and Jeremy Wallach
Originating editors: George Lipsitz, Susan McClary, and Robert Walser

The Music/Culture series has consistently reshaped and redirected music scholarship. Founded in 1993 by George Lipsitz, Susan McClary, and Robert Walser, the series features outstanding critical work on music. Unconstrained by disciplinary divides, the series addresses music and power through a range of times, places, and approaches. Music/Culture strives to integrate a variety of approaches to the study of music, linking analysis of musical significance to larger issues of power—what is permitted and forbidden, who is included and excluded, who speaks and who gets silenced. From ethnographic classics to cutting-edge studies, Music/Culture zeroes in on how musicians articulate social needs, conflicts, coalitions, and hope. Books in the series investigate the cultural work of music in urgent and sometimes experimental ways, from the radical fringe to the quotidian. Music/Culture asks deep and broad questions about music through the framework of the most restless and rigorous critical theory.

Marié Abe
Resonances of Chindon-ya:
Sounding Space and Sociality
in Contemporary Japan

Frances Aparicio
Listening to Salsa: Gender, Latin Popular
Music, and Puerto Rican Cultures

Paul Austerlitz
Jazz Consciousness: Music, Race,
and Humanity

Shalini R. Ayyagari
Musical Resilience: Performing Patronage
in the Indian Thar Desert

Christina Baade and Kristin McGee
Beyoncé in the World: Making Meaning
with Queen Bey in Troubled Times

Emma Baulch
Genre Publics: Popular Music,
Technologies, and Class
in Indonesia

Harris M. Berger
*Metal, Rock, and Jazz: Perception
and the Phenomenology
of Musical Experience*

Harris M. Berger
*Stance: Ideas about Emotion, Style,
and Meaning for the Study
of Expressive Culture*

Harris M. Berger and
Giovanna P. Del Negro
*Identity and Everyday Life: Essays
in the Study of Folklore, Music,
and Popular Culture*

Franya J. Berkman
*Monument Eternal: The Music
of Alice Coltrane*

Dick Blau, Angeliki Vellou Keil,
and Charles Keil
*Bright Balkan Morning:
Romani Lives and the Power
of Music in Greek Macedonia*

Susan Boynton and
Roe-Min Kok, editors
*Musical Childhoods and the
Cultures of Youth*

James Buhler, Caryl Flinn,
and David Neumeyer, editors
Music and Cinema

Thomas Burkhalter, Kay Dickinson,
and Benjamin J. Harbert, editors
*The Arab Avant-Garde: Music,
Politics, Modernity*

Patrick Burkart
Music and Cyberliberties

Julia Byl
*Antiphonal Histories: Resonant Pasts
in the Toba Batak Musical Present*

Corinna Campbell
*Parameters and Peripheries of Culture:
Interpreting Maroon Music and Dance
in Paramaribo, Suriname*

Alexander M. Cannon
*Seeding the Tradition: Musical Creativity
in Southern Vietnam*

Daniel Cavicchi
*Listening and Longing: Music Lovers
in the Age of Barnum*

Susan D. Crafts, Daniel Cavicchi,
Charles Keil, and the
Music in Daily Life Project
*My Music: Explorations
of Music in Daily Life*

Jim Cullen
*Born in the USA: Bruce Springsteen
and the American Tradition*

Anne Danielsen
*Presence and Pleasure: The Funk Grooves
of James Brown and Parliament*

Peter Doyle
*Echo and Reverb: Fabricating
Space in Popular Music Recording,
1900–1960*

Ron Emoff
*Recollecting from the Past: Musical
Practice and Spirit Possession on the East
Coast of Madagascar*

Yayoi Uno Everett and
Frederick Lau, editors
Locating East Asia in Western Art Music

Susan Fast and Kip Pegley, editors
Music, Politics, and Violence

Heidi Feldman
*Black Rhythms of Peru: Reviving African
Musical Heritage in the Black Pacific*

ABOUT THE AUTHOR

Shalini R. Ayyagari is an assistant professor of music at the University of Pittsburgh. A companion website for this book, which includes media resources as well as additional information, commentary, and updates on musicians and their music can be found at www.weslpress.org/readers-companions/.